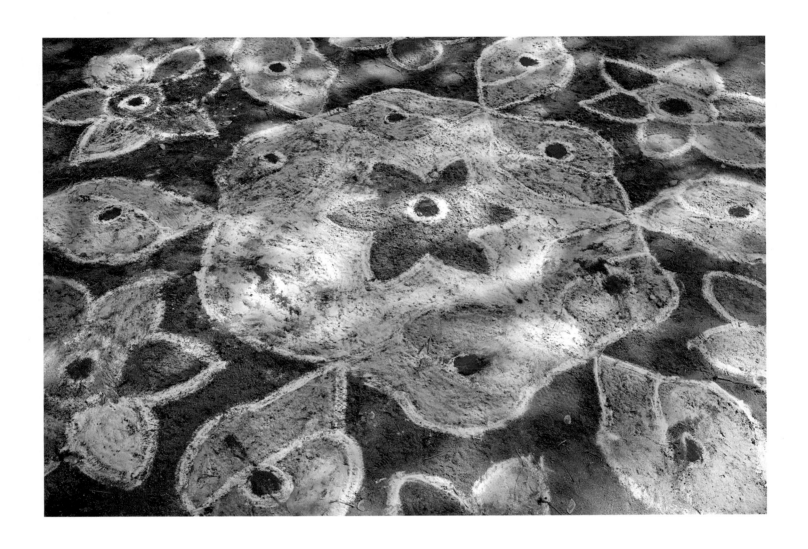

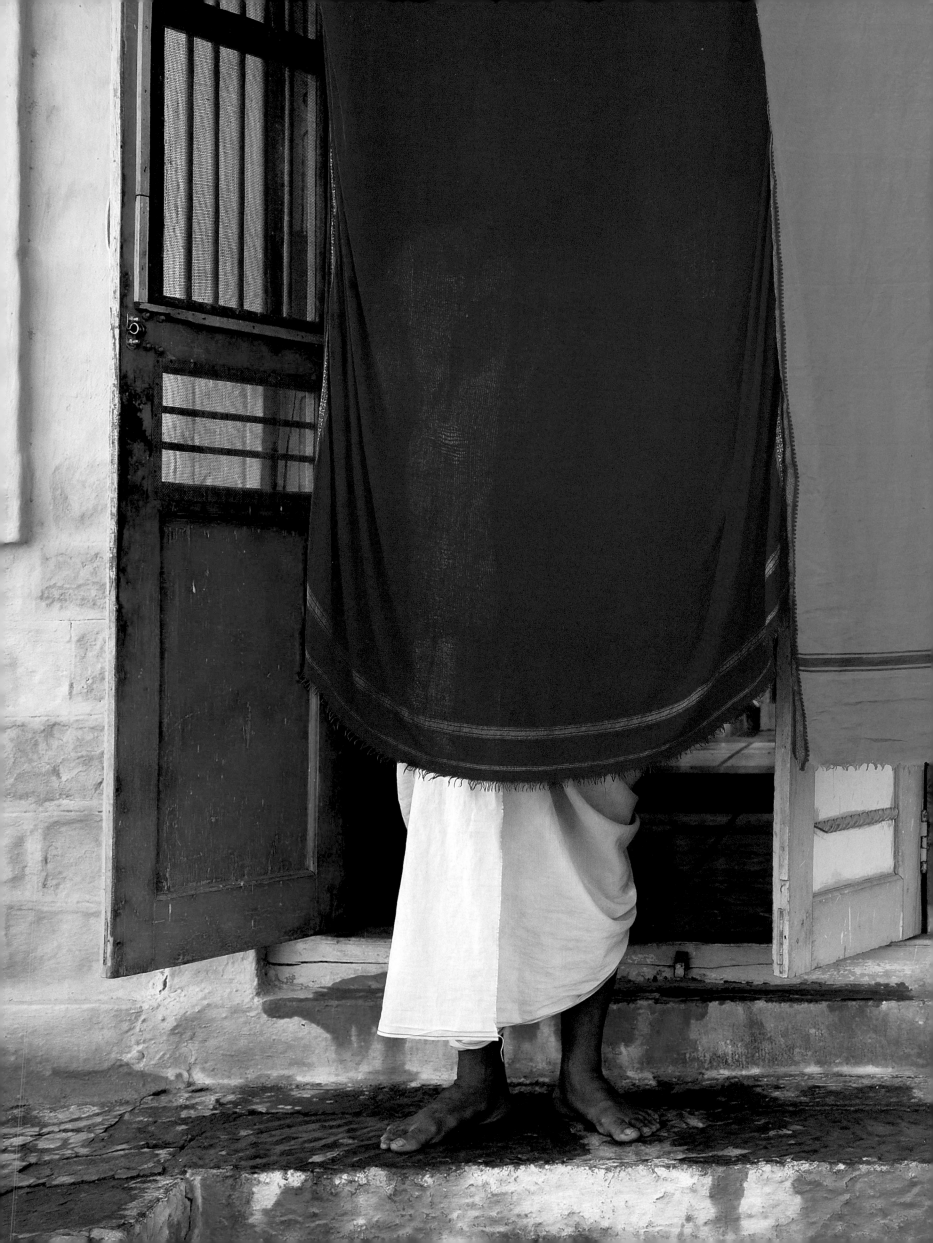

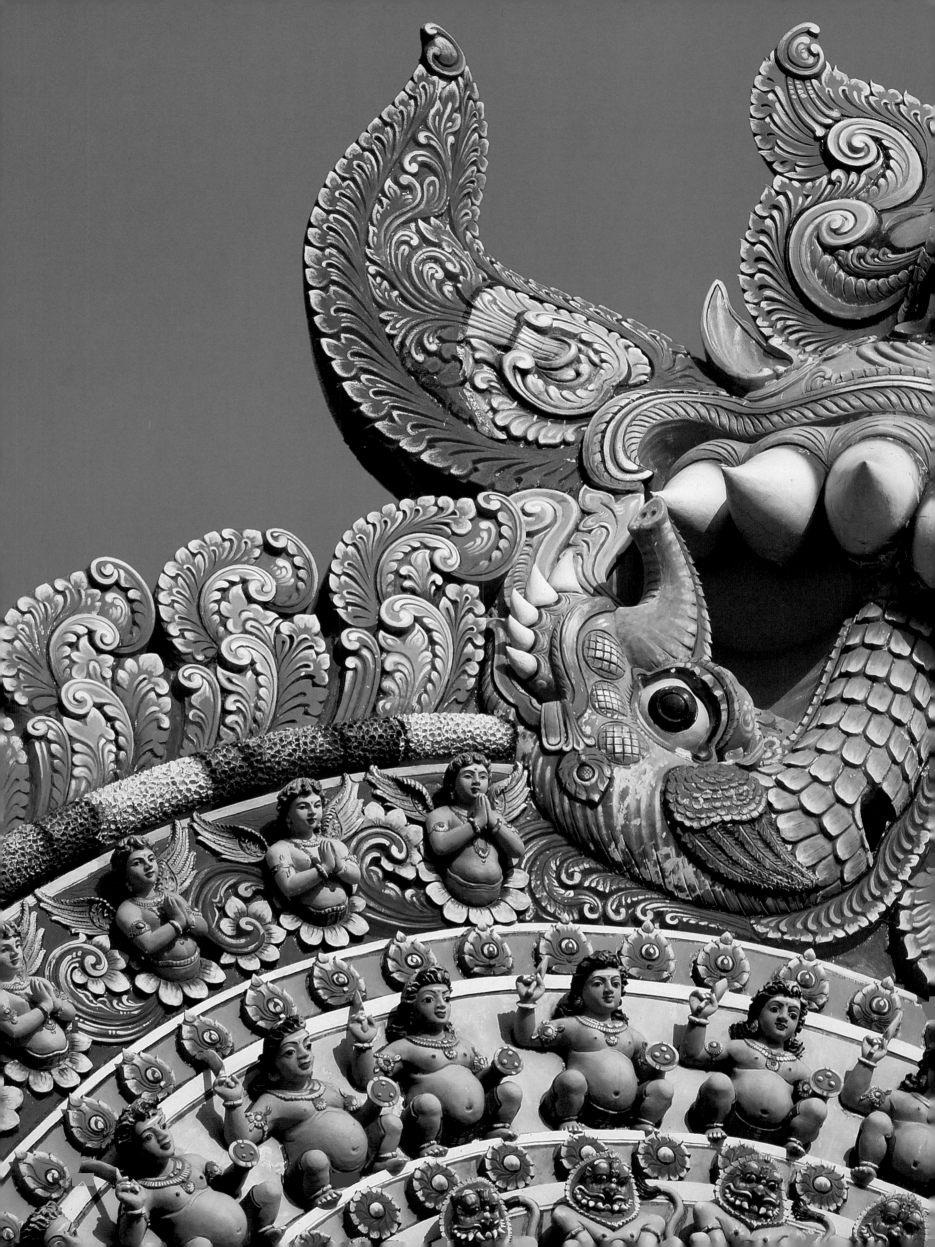

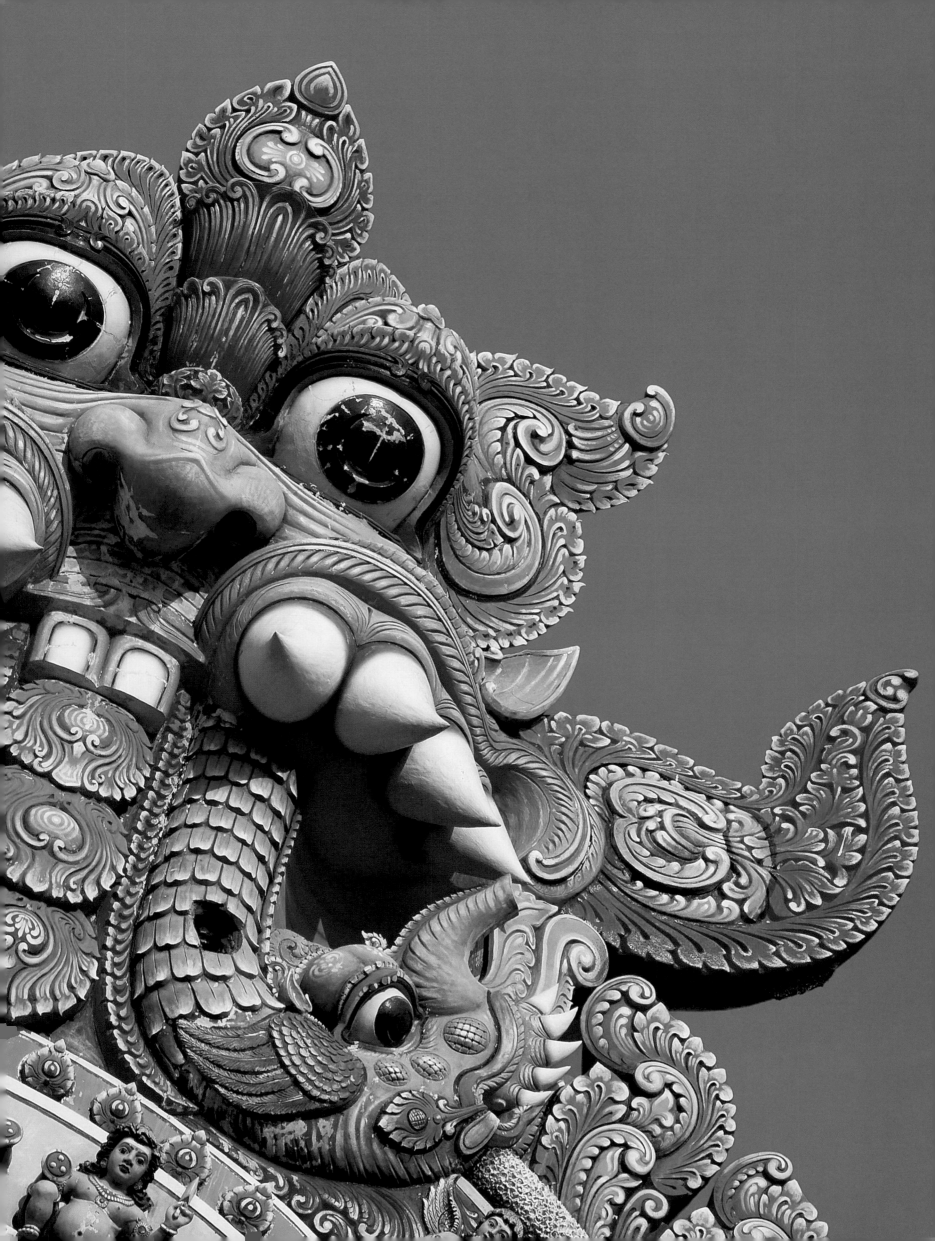

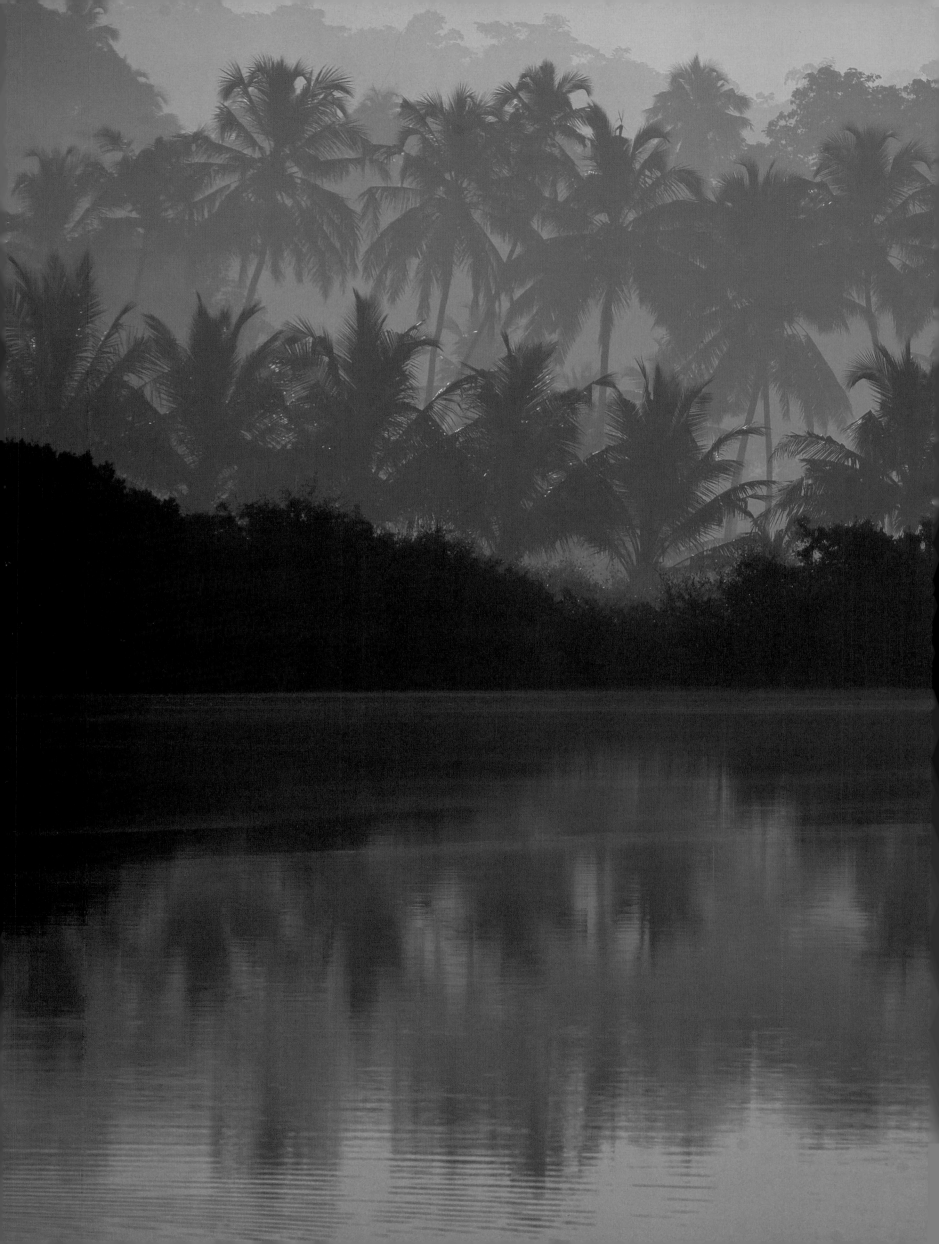

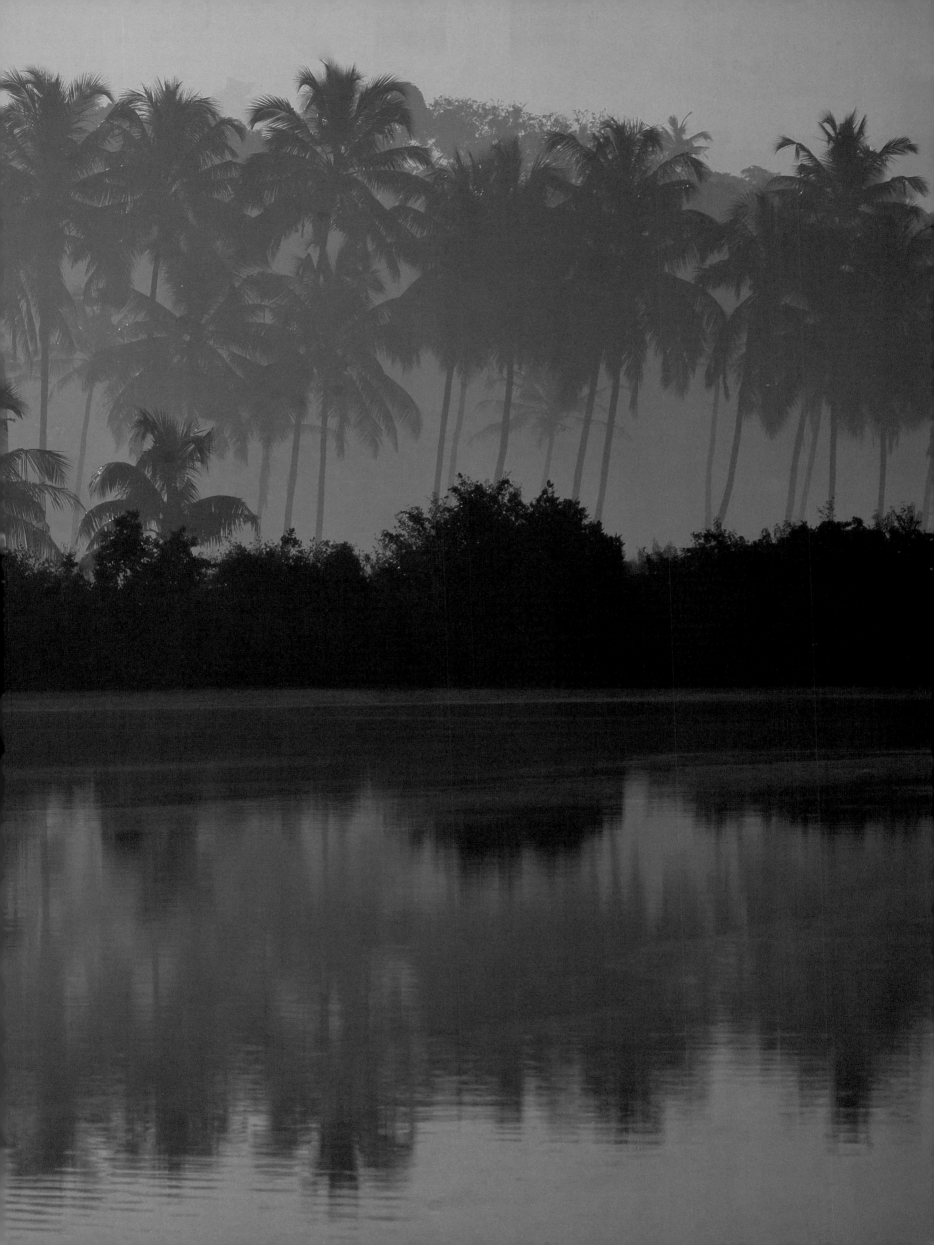

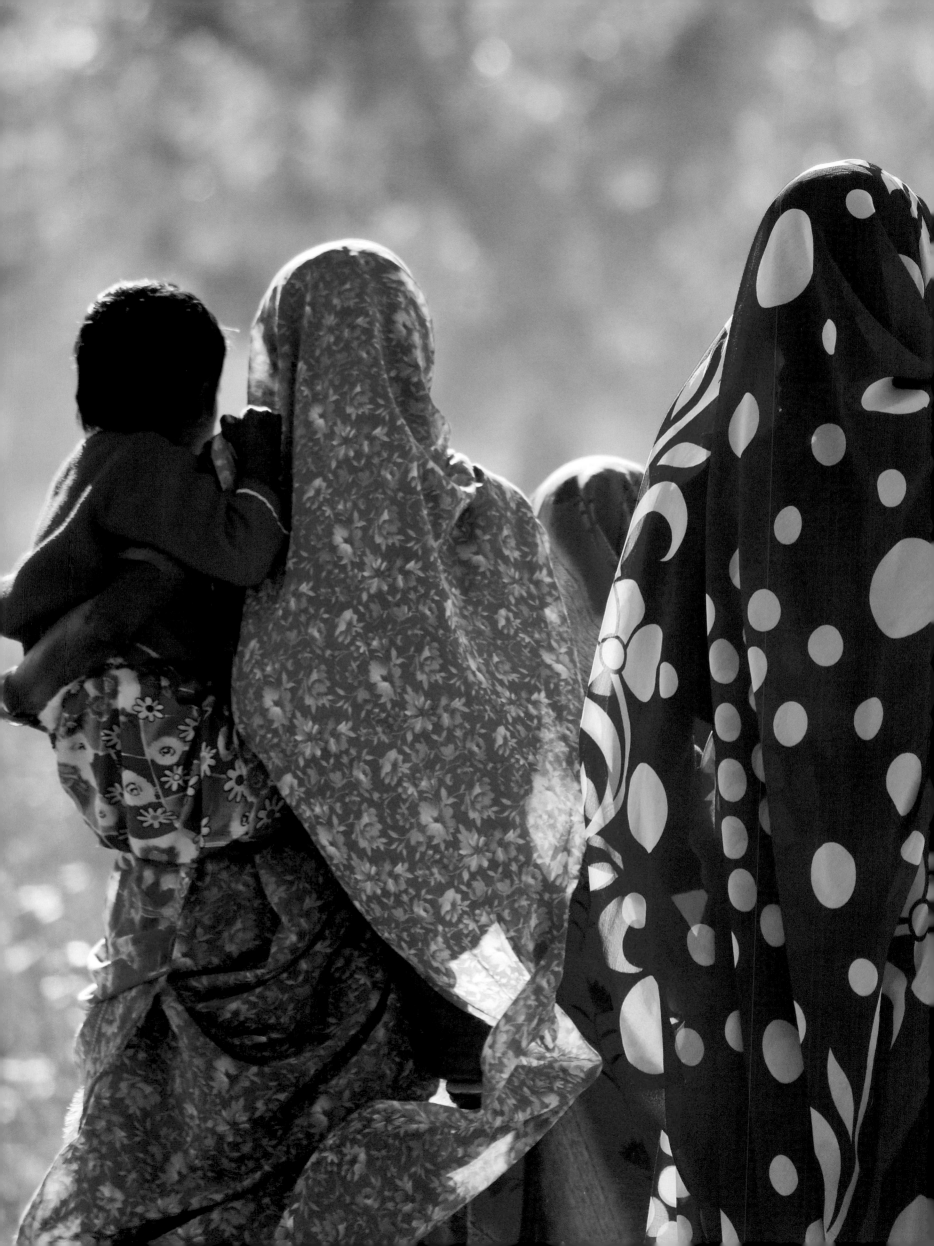

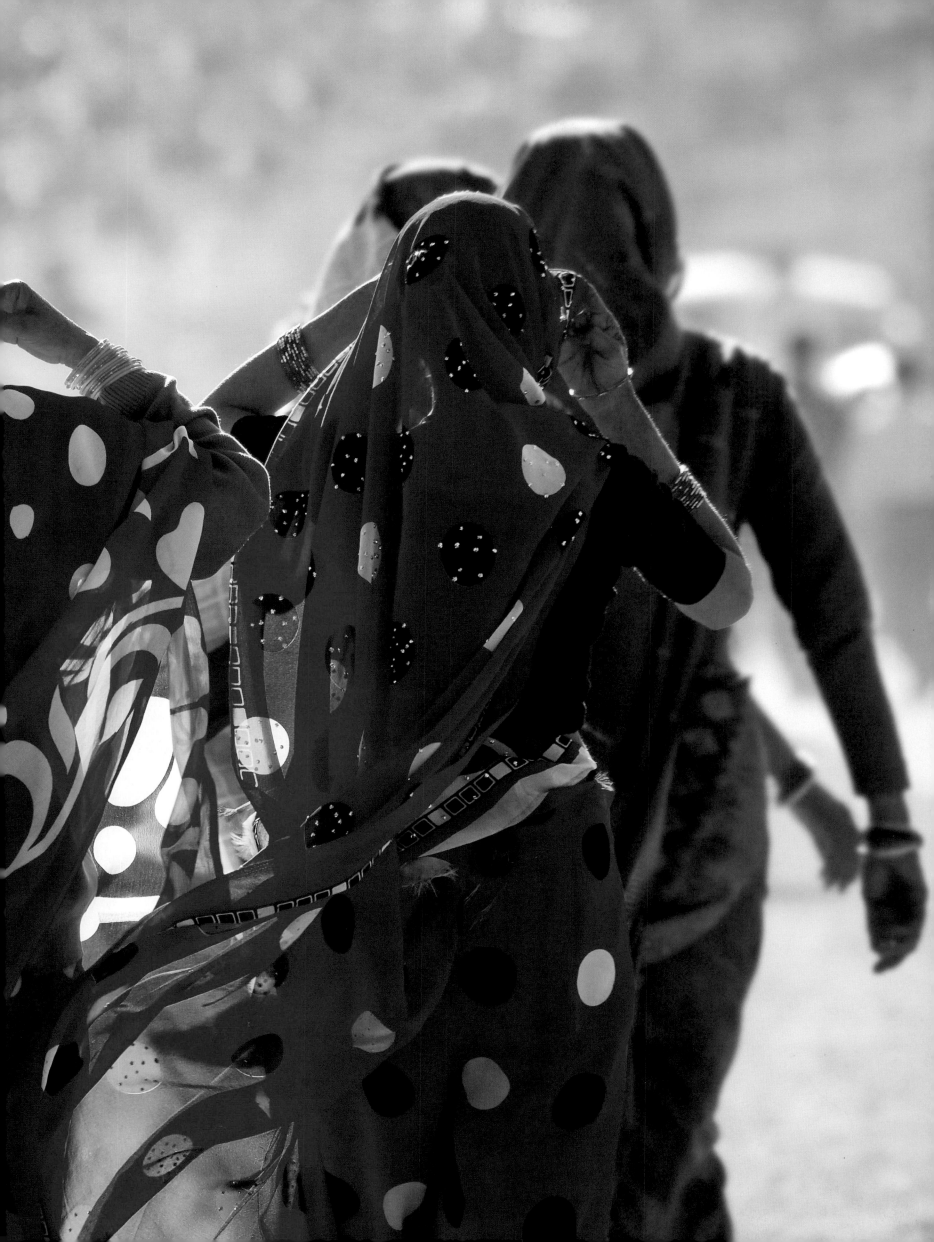

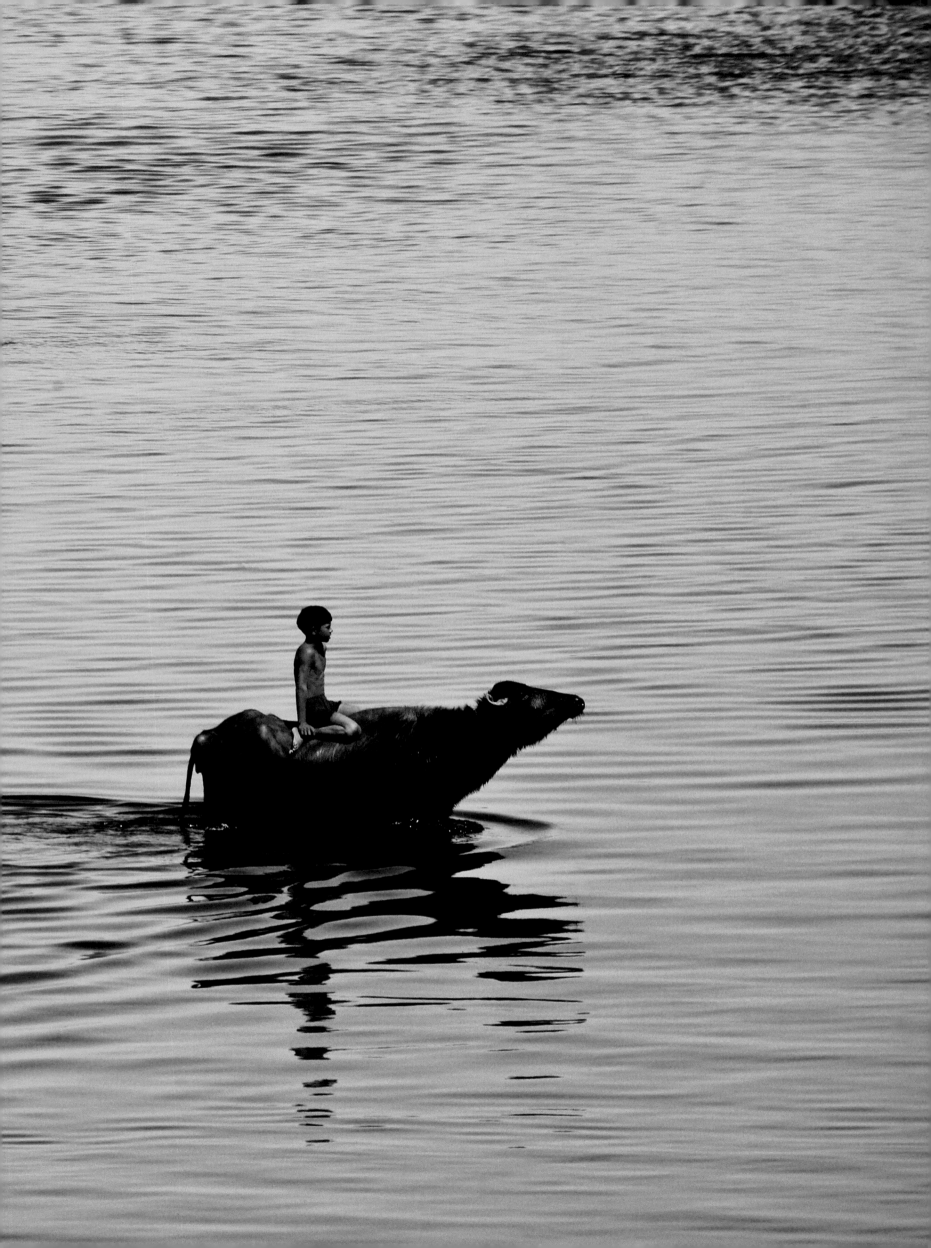

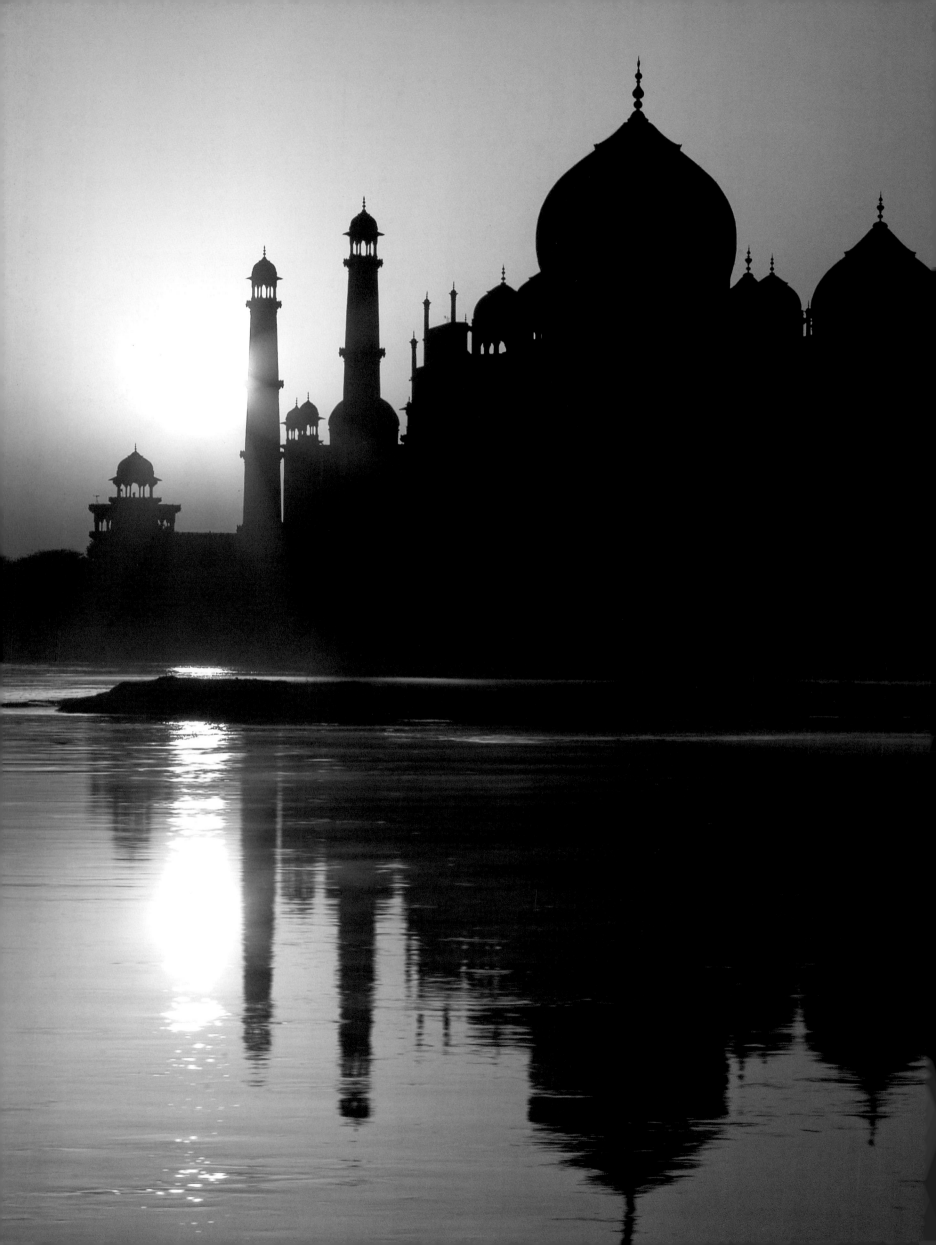

INDIA
IN WORD & IMAGE

PHOTOGRAPHS BY ERIC MEOLA

INTRODUCTION BY BHARATI MUKHERJEE

Welcome
BOOKS

NEW YORK • SAN FRANCISCO

Published in 2008 by Welcome Books
An imprint of Welcome Enterprises, Inc.
6 West 18th Street, New York, NY 10011
Tel: 212-989-3200; Fax: 212-989-3205
www.welcomebooks.com

Publisher: Lena Tabori
Project Director: Alice Wong
Designer: Jon Glick
Project Assistant: Robyn Curtis

Additional credits and copyright information available on page 272.

Library of Congress Cataloging-in-Publication Data

Meola, Eric.
 India : in word and image / by Eric Meola.
 p. cm.
 ISBN 978-1-59962-049-7 (alk. paper)
 1. India--Pictorial works. 2. India--Description and travel. I. Title.
 DS408.M47 2008
 954--dc22
 2008015542

Printed in China

First Edition
10 9 8 7 6 5 4 3 2 1

Canon

All of the images in this book were made with Canon EOS cameras
and lenses, primarily Canon's lightweight, full frame digital 5D, which
performed flawlessly for the tens of thousands of frames from which the
final images were selected. My first lens of choice was the 100-400mm
f/4.5-5.6L IS USM which I used in villages to capture intimate scenes
of everyday life. It was supplemented with the 70-200mm f/4L IS USM
which I used for portraiture and the 24-105mm f/4L IS USM and
16-35mm f/2.8L II USM lenses which I used for architecture, interiors
and landscapes.

PAGE 1: *A Rangoli pattern on the ground in a courtyard in the state of Tamil Nadu. Rangoli is a traditional art in which colored rice flour or powdered sandstone is used to draw patterns and designs on the ground. Floral and geometric patterns and images of temples and deities are commonly used. On festive occasions Rangoli marks the spot for pooja, or prayer, or where newlyweds receive guests.*

PAGES 2–3: *A Hindu priest stands on his doorstep behind a red lungi hanging out to dry in Dungarpur, Rajasthan. A lungi is a long piece of cloth wrapped around the waist. There is great significance to the colors: Yellow is worn when praying to Vishnu, the Preserver; orange when praying to Shiva (Mahesh), the Destroyer; and red when praying to Brahma, the Creator.*

PAGES 4–5: *The festival of Holi commemorates various events in Hindu mythology as well as the arrival of spring. People take to the streets and throw colored powders at one another, creating abstract works of art.*

PAGES 6–7: *A fierce monster guards the gopura, or gate, at the west entrance to the temple complex at Srirangam, in the Tiruchirapalli district of Tamil Nadu. Each towering entryway, rising more than 150 feet, denotes one of the four cardinal points. Smaller gopuras lead to the sanctums of Hindu deities.*

PAGES 8–9: *Early morning mist on the Mandovi river near Goa. Goa's Portuguese colonial past is evident in its language, cuisine, religion (Catholicism), and dress. Lush paddy fields, coconut plantations, whitewashed churches, and old mansions make this state a popular holiday destination for Indians.*

PAGES 10–11: *A common sight in India is a family walking alongside the road on their way to a wedding (sometimes many miles away), as here, near Agra in Uttar Pradesh. Filled with ritual as well as celebration, Indian weddings often continue for several days. Most marriages are arranged—though some are formed out of love—and the Indian wedding is really about the social marriage of two families.*

PAGES 12–13: *In a scene as old as India itself, a young boy crosses the Yamuna river on a water buffalo, near Agra. Domestic buffalos are used throughout India as draft and dairy animals, and to pull carts and plow fields. Their dung is used as fertilizer and, when dried, as fuel.*

PAGES 14–15: *The Taj Mahal at sunrise, near Agra. Completed around 1648, India's most recognizable piece of architecture was built entirely of white marble under Mughal Emperor Shah Jahan in memory of his favorite wife, Mumtaz Mahal. The Taj Mahal is considered the finest example of Mughal architecture, an eclectic style that combines elements from Indian, Turkish, Persian, and Islamic influences.*

CONTENTS

I am indebted to Venkatesan Dhattareyan as well as Snar Lyne Khyriem and Narendra Kothiyal of the Tourist Board of India in New York for their help in planning my itinerary throughout India.

In particular, Pankaj Singla of Eastbound Tours in New Delhi (www.eastbound.in) was my guardian angel in helping me wade through a schedule that was constantly changing, and he and his company showed incredible grace and patience in extending me every possible courtesy. Without Pankaj, and without Eastbound, I would not have been able to complete this book.

As well, I would like to thank MaryAnne Golon, the picture editor at Time magazine in New York, for introducing me to Deepak Puri, her counterpart in New Delhi, who was instrumental in helping me gain access to many of the sites that I photographed. I also wish to thank Ranjan P. Thakur, the secretary to the Minister of Tourism and Culture in New Delhi, who introduced me to the Chief Secretary of the Archaeological Survey of India.

I was also fortunate to have Ram Gopal Sharma as my guide in Jaipur. He opened doors that would otherwise have forever remained shut. I was honored to simply have him at my side.

Dr. Neena Malhotra, Press Counsellor of the Consulate of India in New York, graciously took time from her busy schedule and provided many insights as well as suggestions. My heartfelt thanks to my good friend Myrna Kresh, who was instrumental in making this dream come true. Chhaya Bhanti not only initiated the introductions to the tourist board in New York that began this long odyssey, but also continues her support through her Web site—www.greendesis.org— dedicated to raising worldwide awareness of the environmental issues India is facing now and in the coming years.

Alice Wong, my project editor, had a vision for the book that took it far beyond my own hopes and expectations and made a number of brilliant changes and suggestions; and Jon Glick, the art director, gave us a design that speaks to the beauty of a charmed country. I was twice blessed, not only to have Lena Tabori as a publisher, but also to benefit from her suggestion that we integrate the writings of great Indian authors with my photographs.

Last, my deep thanks to my Indian friends in America, who, through their own openness and enthusiasm, unwittingly planted in my mind the desire to see and document their extraordinary country. This book is for you and for all the people of that great country I have come to love: India.

My Private India

Eric Meola

October 2007

I am in an air-conditioned car somewhere in the streets of Kolkata, scrolling through the names on my cell phone: *Pankaj, Deepak, Namas, Saritha, Venkat, Narendra, Mahesh*...I ask the driver to turn off the cold air as my lenses will fog as soon as I jump out, which might be at any moment now.

The summer heat has wrapped itself around us, but inside the car there is only the ubiquitous, incessant sound of honking horns. I watch through the window as men in the street sell fruit, candy, pots, tires, rope...all manner of things. A woman walks by breast-feeding her baby. A man, completely naked, walks by in the opposite direction.

What seems like a thousand thousand cars are simmering in the heat, packed within fractions of an inch of one another. Bicyclists weave in and out of the interstices of space between. A man approaches a porter carrying a huge container of water strapped to his back; lifting a bowl to his mouth he drinks, then dips again, and lifting the bowl far above his head he empties a waterfall over his body. Another man is kneeling nearby, welding a car's axle. Yet another is squatting at the street's edge repairing shoes, the tools of his trade scattered in dull scraps at his feet.

Dogs, cattle, goats, monkeys, cats, and children scurry through the traffic-choked streets. A man sleeps on his back in a cart. A donkey falls asleep while standing up. In ultra-slow motion we drift by a spotless polished Rolls Royce sitting on a rotating pedestal in a showroom. Billboards for Gucci and Prada hang above a man sitting on the pavement, legs crossed, eyes closed...motionless. There are no two-way or one-way streets. There are only Everyway streets—left, right, forward, and back. And around and around.

A woman knocks on our window, begging. Just beyond her a bus driver is counting money, the bills crisply folded between fingers of a closed hand while the fingers of the other hand leaf through tightly packed 10-rupee notes.

Suddenly I remark to my guide about this seemingly infinite chaos, which somehow seems choreographed by some unknown force. In its own way, the way of India, there is an order to this world I see spinning out of control. Nowhere is anyone quarreling, nowhere does anyone seem unhappy. A bit impatient perhaps. The honking horns fill my ears again. My ears pick up the incongruous ring of an old thumb-operated bell on a bicycle's handlebars...and then a calliope, its high-pitched notes a perfect metaphor for the circus in front of me.

I comment to my guide about how thunderstruck I am that everything seems to keep going, that somehow, despite a million people moving in opposite directions, despite an overwhelming sense of "it" not working, everyone will get to where they are going. He breaks into a grin and says, "Well, your country gave us that, you know!"

Seeing my puzzled look he continues: "Your great writer from America, Thoreau. He taught us this, this sense of acceptance, this inner peace, this patience with life." It is not the first time I have been lectured about Thoreau by an Indian. Once, in a small village in the Rann of Kutch, a man came out of a doorway bent over from the blinding sun, which beat down mercilessly. He walked a few steps, then turned and asked me about Thoreau and told me how much Thoreau's writings meant to him. And to Gandhi.

Suddenly I am wrenched back to the present—the driver is beginning to make a U-turn! He not only has the audacity to consider it, but somehow in this sea of metal on metal he accomplishes the impossible.

January 2007

...Seven and a half hours to Paris, two hours on the ground, another seven and a half hours to Mumbai, a delayed flight, and five hours in a dreary, dark lounge before going on another two hours to Delhi. Two hours for the luggage to come off the plane, and three waiting in line to report my check-in luggage had been lost. On to customs and the rep from the tourist board. But customs agent Singh has something different in mind, and I am soon in the midst of the abyss of Indian bureaucracy. I watch as my camera pack is taken into a labyrinthine room and locked away. Three days later my luggage is found and the equipment released. Then a 14-hour night drive to Allahabad to see the Kumbh Mela, the blinding light of oncoming headlights erasing my body's need to collapse in exhaustion. The next day I am wedged in a mass of human flesh locked so tight that all movment is suspended by a simple law of physics: 10 million people cannot occupy the same space at the same time.

A few days later in Varanasi I watch as five women walk down the steps of the Sankatha ghat and with reverence place a diya at the water's edge. It floats out to me. I can feel my body's resistance give in to the week's endurance marathon...the sun is out now and all the colors are electric. An old man walks to the water's edge and pours water from a small copper pitcher into the Ganges. Life on the river is in ebb and flow....Suddenly my thoughts are interrupted by my guide's voice. "You take many, many 'snaps,' so many, many 'snaps.'"

...Amritsar, or the "pool of nectar," is the center of the Sikh religion; in the midst of a huge pool surrounded by water sits the Golden Temple, and for two days it's been obscured by fog. My train back to Delhi is a few minutes late that morning, so I rush to the temple and at last catch the glint of brilliant gold leaf reflected in the pool.

On the long train ride back to Delhi, a Sikh sits next to me and we talk the entire eight hours, discussing Sikh history, politics, Kashmir, Punjab, the war in Iraq and his life in Canada. He's a truck driver and lives in British Columbia, and he keeps me entertained with his stories of working for Wal-Mart and his encounters with redneck truckers in Los Angeles.

FEBRUARY 2007

At last, sand. The desert...the road to Jaisalmer...fifteen degrees warmer here. Alone on the road, no constant honking of horns. A new driver, "Vinay." We share a bag of cashews. No matter what I say he smiles and says yes. "*Great weather today, Vinay.*" "Yes." "*Uh, the car has five flat tires.*" "Yes." But Vinay has an uncanny ability to know what I want to shoot, and in the two hours before sunset on the road from Jodhpur to Jaisalmer, Vinay helps me make half a dozen roadside portraits and it's as if he's cheering me on, "*. . . Yes, yes, YES.*"

Jaisalmer sits on the western edge of Rajasthan, near the sand dunes of the Thar desert and near the border with Pakistan. The ramparts of the old fortress sit on a small mesa of crumbling sand, rising in a dusty pink mirage above the surrounding clay houses.

There is the sense of past glory, with entryways guarded by massive rusting iron doors. Long-forgotten empires are everywhere in this kingdom of color, in this nation obsessed with infinite detail and ambition and hope; each turn bedazzles more than the turn before, each nuance speaks of pageantry and celebration, of gods within gods, of maharajahs, of a sense of life and wonder unlike any other place on earth.

We are on the road—the rutted, dusty roads of an India exploding into the modern world. "She" appears from nowhere, patiently moving through a field of tall winter wheat, her backlit yellow sari unfurling in the sun, her arms outstretched, using a hand scythe to cut out weeds. I have Vinay pull over, and because I want to shoot from a somewhat higher angle I sit on top of the car on the luggage platform as traffic hurtles by. I had tried shooting a scene like this several days before, but this time the backlight is perfect, and although she is very much aware of me, I am able to shoot for several minutes before deciding my luck might run out with the traffic as the trucks are dodging cattle wandering on the highway.

A few days later Vinay and I are on the road again at 6:45 A.M. on a five-hour drive to Jodhpur from Deogarh. Twenty minutes after we start we pass a low stone wall in a field, with several peacocks walking along it toward an arched canopy on one end. I have Vinay maneuvering the car as the sun is about to rise over the Aravelli hills, when one of the peacocks abruptly jumps up on the dome. Just then a truck comes down the otherwise deserted road . . . and the peacock flies off. I change lenses, look up...the peacock has returned. I manage to get two shots before it jumps down again. Another auspicious beginning to another auspicious day—a peacock, the national bird of India!

The next day I am at my favorite place in India, the Juna Mahal, the fading 13th-century "old palace" of Dungarpur—almost as old as the town itself. It is one of the lesser-known treasures of India, and I spend an entire quiet, glorious afternoon photographing the crumbling interior without being disturbed. The only other person there is an Englishwoman who sits on the floor of a nave, pastels and watercolors spread around her, patiently drawing the myriad

details of inlaid tiles, mirrors, and colored glass. Each room is a phantasmagoria of a bygone era; hidden behind a small pair of nondescript wooden doors is a series of detailed paintings from the *Kama Sutra*.

NOVEMBER 2007

It has been just 10 years since my first trip to India. The population has now swelled to 1.2 billion people—300 million more than there were in 1998. One of every six people on the earth is Indian. In 10 years the population has increased by more than the entire population of the United States, and it took the States more than 200 years to reach that number.

I have been trying for more than a year to get permission to photograph Durbar Hall, at the Amba Vilas Palace in Mysore. At first the minister of Tourism and Culture told me that I have to get permission from the maharajah of Mysore. The maharajah then told me I would have to go to the chief minister of the State of Karnataka, but as I am not a native of India I would need to seek permission from the Department of Internal Affairs in Delhi, which I did. But they have sent me back to the chief minister.

I have for now given up all hope of photographing Durbar Hall and am now simply seeking permission to use my tripod in the great caves at Ellora and Ajanta.

Late one afternoon, my driver takes me to the nondescript offices in New Delhi of the Archaeological Survey of India. In a room that could have been constructed by David Lean at Shepperton Studios near London, men scurry about, each clutching sheaves of paperwork, each holding his agenda like a baby pressed to his chest, each wide-eyed in a nervous quest to push to the front of the line. I am at some point given a few sheets of hand-lined white paper and told to write an essay about who I am and what it is I want.

The object of all the attention in the room seems to be a man that Charles Dickens would have called a "scrivener," or clerk, or in this case the secretary to the secretary. This courtly old gentleman's glasses have slid precipitously to the very end of his nose, and one can only guess at what holds them there. A man pushes to the front of the line and with a gasp of relief drops what seems like three New York phone directories' worth of paperwork onto this man's desk. Strangely, the clerk does not look up but almost immediately proceeds to make notes. He pulls back 30 or 40 pages, immediately scans the entire page he has miraculously come to and with an almost imperceptible movement crosses out a word or two. Then he's on to the next invisible divider 20 or 30 pages later, and again, with a sharp clucking of his tongue, crosses out a word. All the while his body arcs forward as if his waist is a ball joint and his nose the beak of a bird, pecking out the words. *Peck, peck . . . peck, peck, peck.* In less than two minutes he has completely edited to his satisfaction what I guess is a 1,200-page document.

I complete my essay about who I am and what I want to photograph and the secretary to the secretary reviews it, makes a few notes and asks me to wait for the chief secretary, who will append his signature. I wait another two hours, my eyes glazing over, and then the clerk motions to me that my papers are now officially approved. As I am about to leave he begins listing, in a long, monotonous drone, a series of caveats. "You do understand, Sri Eric, that when you reach the State of Maharashtra, you will need to stop at the local office of the Archaeological Survey and fill out additional forms as each office has their own rules for granting permission..."

I walk out into the air and take a deep breath. I smile a small smile. In front of me rotting ancient file cabinets in a long row lean precariously, as if a mynah bird's weight would topple them in an instant. Papers bulge from every seam.

It begins to rain a soft, cooling rain.

Since my first trip to India, there have been so many changes, the changes that come with wealth and power and TV and cars and the modern world. I see rich and poor, but what I see more than anything else is an entire nation embracing life. Every day there is a celebration, if not dozens, throughout the country, for that is what India is about—a continuous celebration of life and its mysteries.

The light here is like no other place on earth, filtered by the dust of millions on the move, on fire with a sun that seems suspended in time and place. I love to wake before dawn and walk down to the ghats and watch the day, and the people, and India, come alive as the sun rakes across the Ganges.

As a photographer, I am drawn to India because of the psychedelic colors that seem to permeate every facet of life. I go there for all the contradictions of a place that is like no other I have been to; I am drawn to India because the people are blessed with childhood's sense of wonder, which they have never lost.

I was startled one day to realize that what I had seen as infinite chaos was, in fact, infinitely ordered, and in that simple truth I found the soul of India. A sadhu faced the rising sun. A young boy crossed the Yamuna river on the back of a water buffalo. A mother's hands gently cupped the face of her daughter. India is caught in the throes of change. But there will forever be a corner of the world that is my private India, the India in my eyes and of my heart.

INTRODUCTION
BHARATI MUKHERJEE

I AM A CITY GIRL, Kolkata born, Kolkata raised. I see my surroundings in muted urban colors. The Kolkata of my childhood was a subtropical metropolis with a crumbling infrastructure. In fact—shameful as it may sound—urban middle-class children of my generation deliberately insulated themselves from street and rural India. They learned to close their eyes. My neighborhood was my entire universe, and in art classes in grade school I painted it in the sooty grays of cow-dung-fueled cooking fires, the grainy tans of summer dust, the muddy greens of monsoon-churned lawns, the brackish blue of flooded streets, the sludgy browns of open sewers. Few neighbors owned cameras. When a young woman was considered ready to be launched into the matrimonial market, she was led into a photographer's studio and posed to look shyly desirable in front of props that included potted plants and peacock feathers.

In the winter of 1948, my father splurged on a second-hand camera. All snapshots from the late 1940s and through the 1950s in our family album are in fuzzy focus, black leeching into white, the corners yellow from an excess of glue. All are of groups of relatives staring earnestly at the lens. Film was too expensive to waste on landscape, strangers, or "compositions." The only photos of individual faces were of departed elders, isolated from the group photos and then enlarged, framed, garlanded, and paid homage to every evening with incense and prayers.

Growing up, I had little awareness of photojournalism and no experience of photography as art. The only images of Kolkata that I chanced upon in library books were reproductions of Samuel Bourne's and Henri Cartier-Bresson's black-and-white photographs. Bourne had lived in my hometown from 1863 to 1869, when the subcontinent was under British rule; Cartier-Bresson had visited India for the first time in 1947, commissioned to record the newborn nation's celebration of independence. The India of these two European professional photographers was simultaneously familiar and unfamiliar, each distinct from the other.

In Bourne's images I saw my universe distilled into colonial iconography. Cartier-Bresson's gravely humanistic images of post-Partition, post-independence refugees caught the wit and grace in the anonymous throngs of violently displaced, newly beggared men, women, and children who lived and slept on the sidewalk outside our house. What the well-housed urban-dwellers saw as chaos on the streets, photography showed as emergency-response choreography.

Even the willfully unobservant child can learn to open her eyes. For me, it began with the discovery of Mughal miniature paintings, with their vibrant colors and dense, inspired narratives. Later came moonless desert night skies and countless pin-sharp stars and cloudy galaxies—how could we not be persuaded by the myths they spawned?—and then at least one Eric Meola moment. In the mid-1970s, on a winter drive through the desert of western Rajasthan, our car came upon miles of saris drying on the concrete. As we approached (probably the first vehicle in an hour), word went out and the washerwomen arose magically from the dunes to pull the saris aside.

Eric Meola's India is at once contemporary and timeless. He uncovers the beauty (and the ballet) of survival embedded in the daily lives of ordinary citizens: a boy bathing his family's water buffalo, a man hanging up the day's laundry, wives toting *tiffin* carriers of food to husbands tilling fields; worshippers floating votive clay lamps in holy river water, a child being hugged by her mother, adults smearing each other with brilliantly hued powders during the annual spring "holi" festival, vendors hawking jasmine wreaths and marigold petals; an elephant painted to look like a tiger, lizards crawling up stone limbs of deities carved into temple walls.

The joy he takes in discovering his "private India" is infectious. Eric's vision embraces India's excess of color, complexity, and self-confidence, and I long for him to bring his all-discovering eye to my hometown and to the spectacular new cities of India, to find the vivid colors and subtle order we inattentive urban-dwellers missed the first time around.

OPPOSITE: *A mother's hands cup the face of her daughter during the festival of Batkamma, a celebration of womanhood, in the Telangana region of Andhra Pradesh. Batkamma begins just before Dussehra, with elaborate feasts and dances continuing for nine days.*

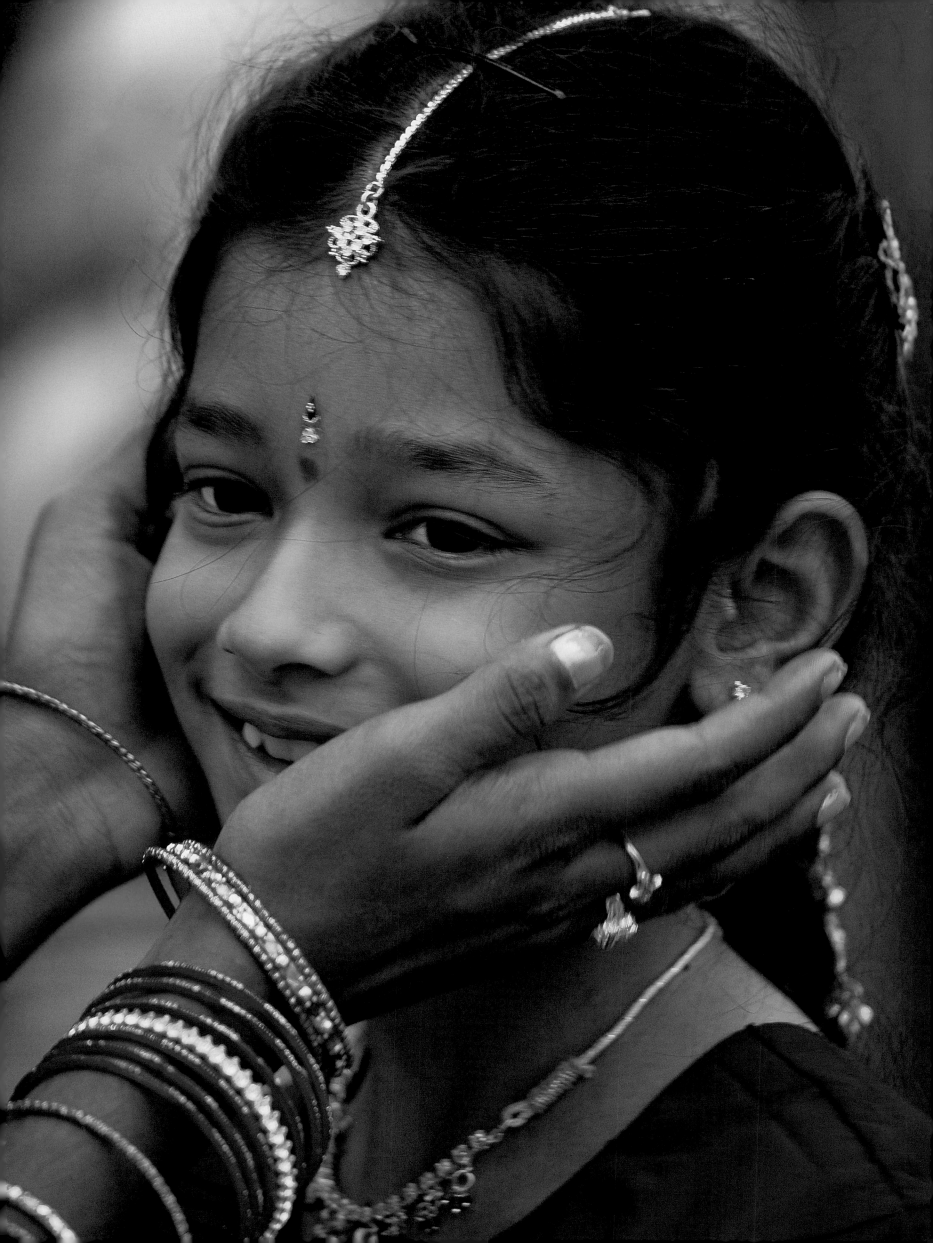

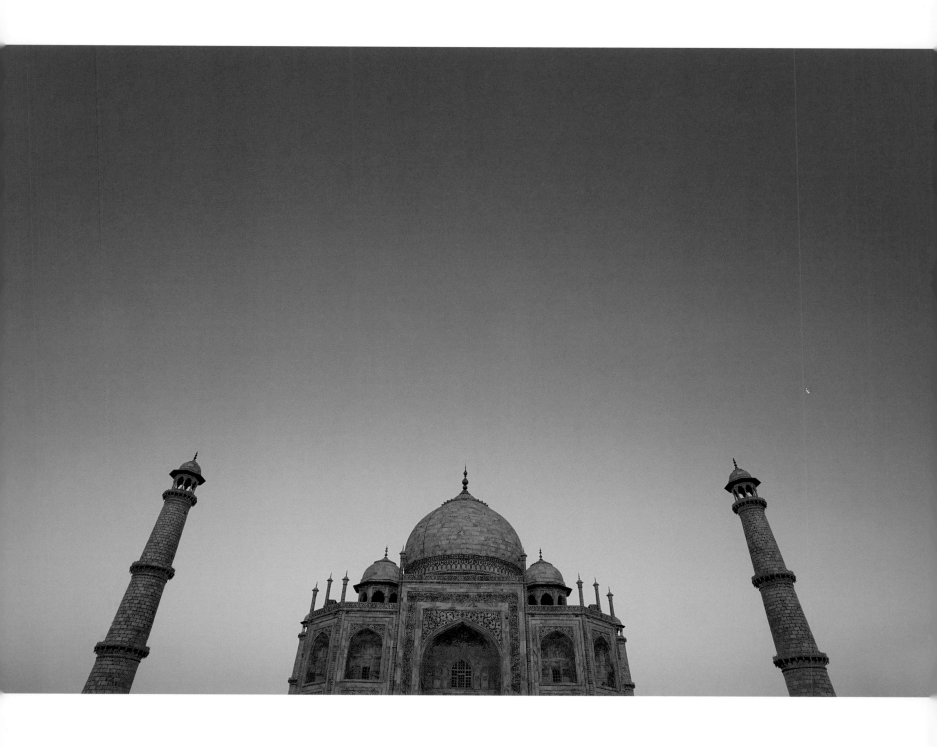

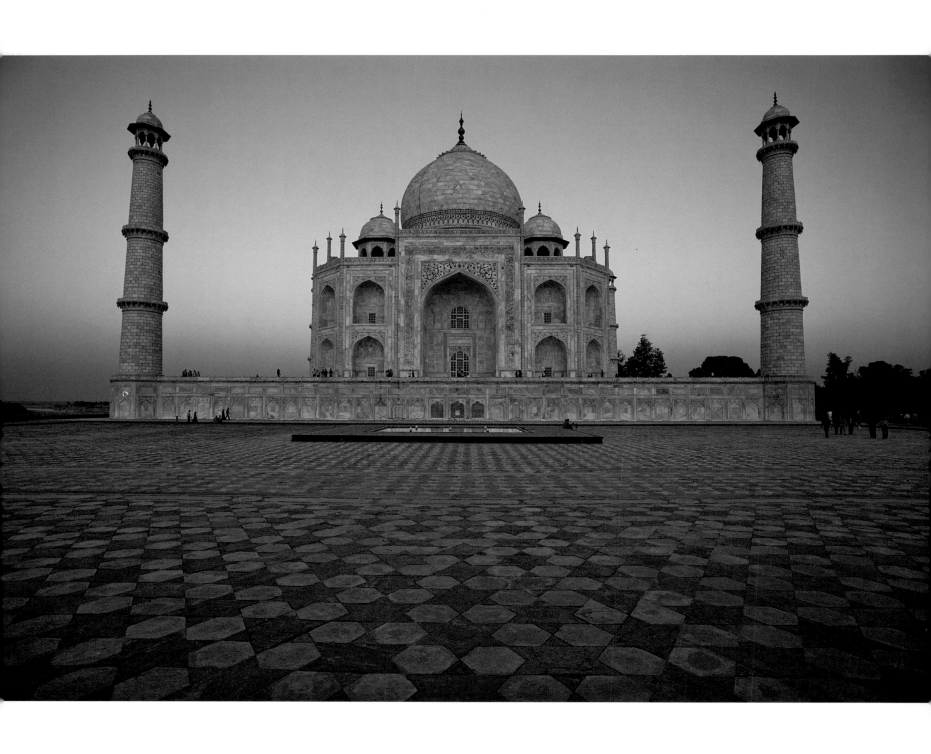

ABOVE AND OPPOSITE: *Two views of the Taj Mahal from the west at sunset.*

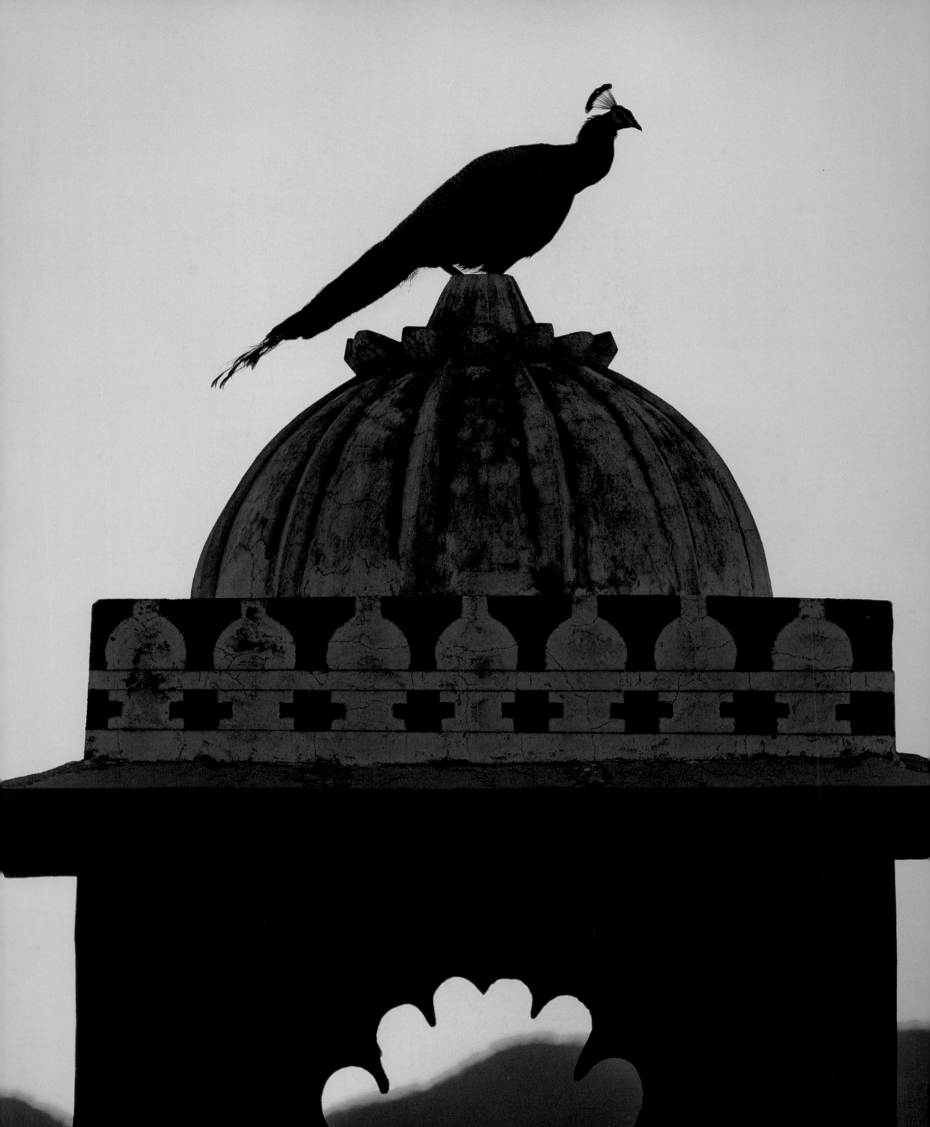

RUMORS IN THE CITY: "The statue galloped last night!"..."And the stars are unfavorable!"... But despite these signs of ill-omen, the city was poised, with a new myth glinting in the corners of its eyes. August in Bombay: a month of festivals, the month of Krishna's birthday and Coconut Day; and this year—fourteen hours to go, thirteen, twelve—there was an extra festival on the calendar, a new myth to celebrate, because a nation which had never previously existed was about to win its freedom, catapulting us into a world which, although it had five thousand years of history, although it had invented the game of chess and traded with Middle Kingdom Egypt, was nevertheless quite imaginary; into a mythical land, a country which would never exist except by the efforts of a phenomenal collective will—except in a dream we all agreed to dream; it was a mass fantasy shared in varying degrees by Bengali and Punjabi, Madrasi and Jat, and would periodically need the sanctification and renewal which can only be provided by rituals of new blood. India, the new myth...

—SALMAN RUSHDIE, *MIDNIGHT'S CHILDREN*

OPPOSITE: *Perched at sunrise on a small cupola near the rural village of Jojowar, in Rajasthan, a peacock basks in the pink glow of sunrise over the Aravelli hills. The national as well as the sacred bird of India, the peacock is protected under the Indian Wildlife Protection Act of 1972.*

PAGES 30–31: *The owner of an amla fruit orchard in the peaceful rural locale of Ganahera, near the grounds of the Pushkar camel fair.*

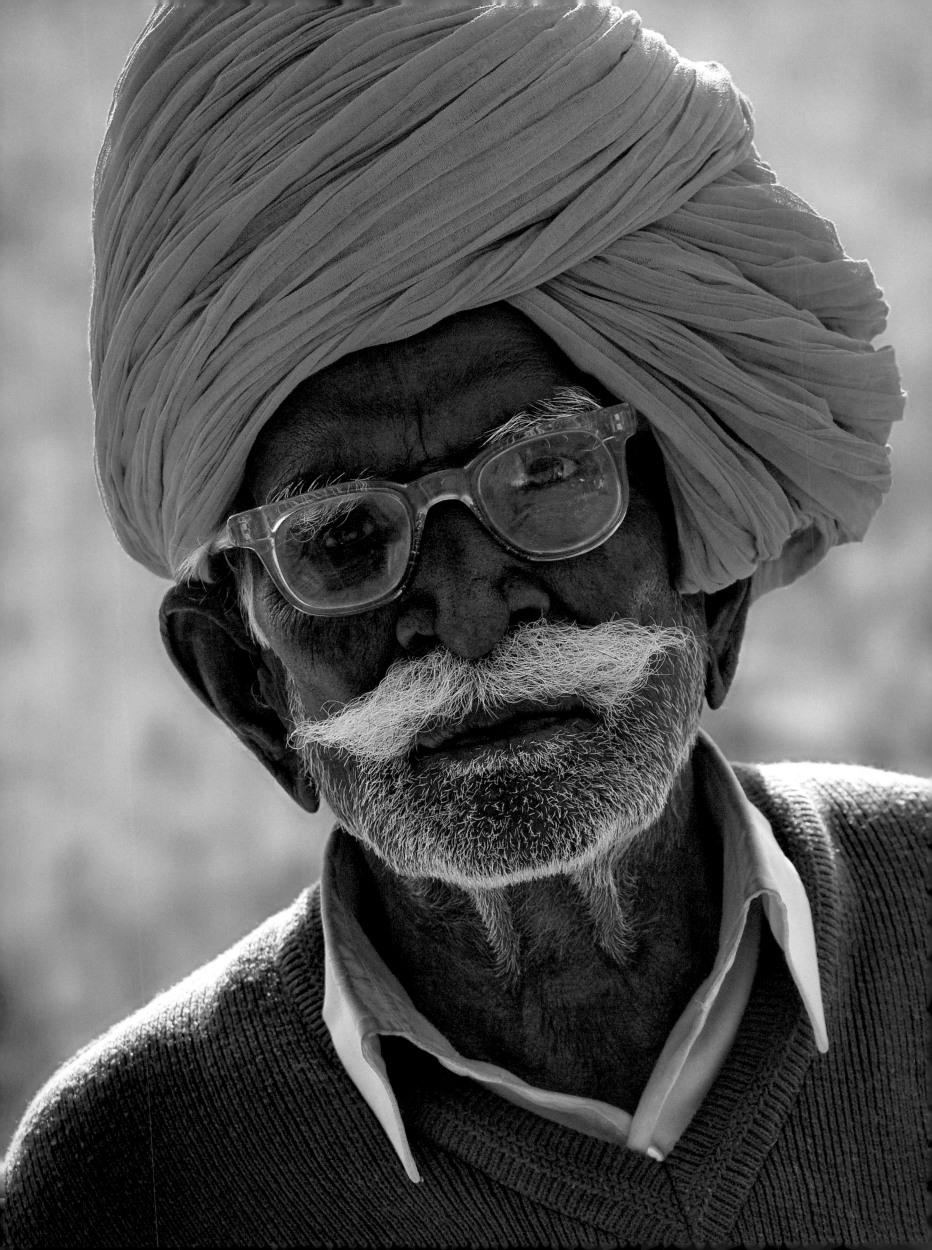

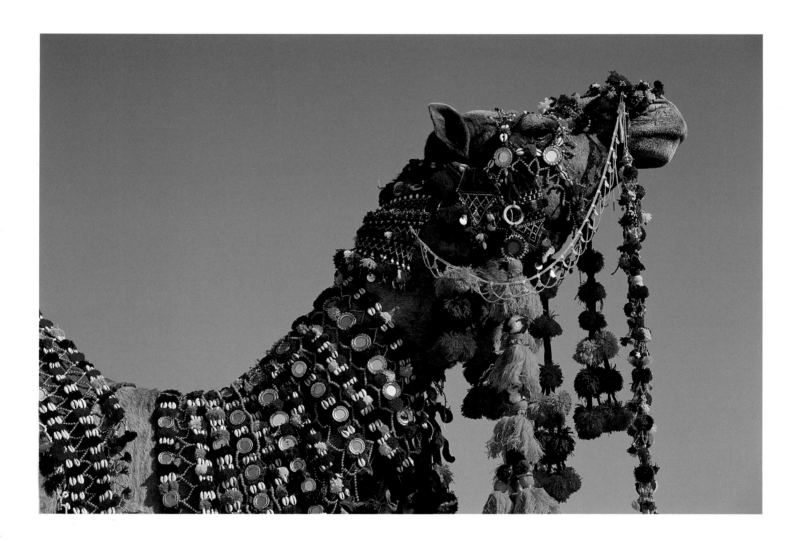

ABOVE AND OPPOSITE: *Each year, amid the sands of the Thar desert, the town of Jaisalmer comes alive with the brilliant color, music, and laughter of the desert fair. The rich and colorful folk culture here goes on show for a few days as Rajasthani men and beautiful women dressed in bright-hued costumes dance and sing ballads of valor and romance. Gaily dressed camels compete for attention, along with elegantly dressed horsemen, jugglers, magicians, and musicians.*

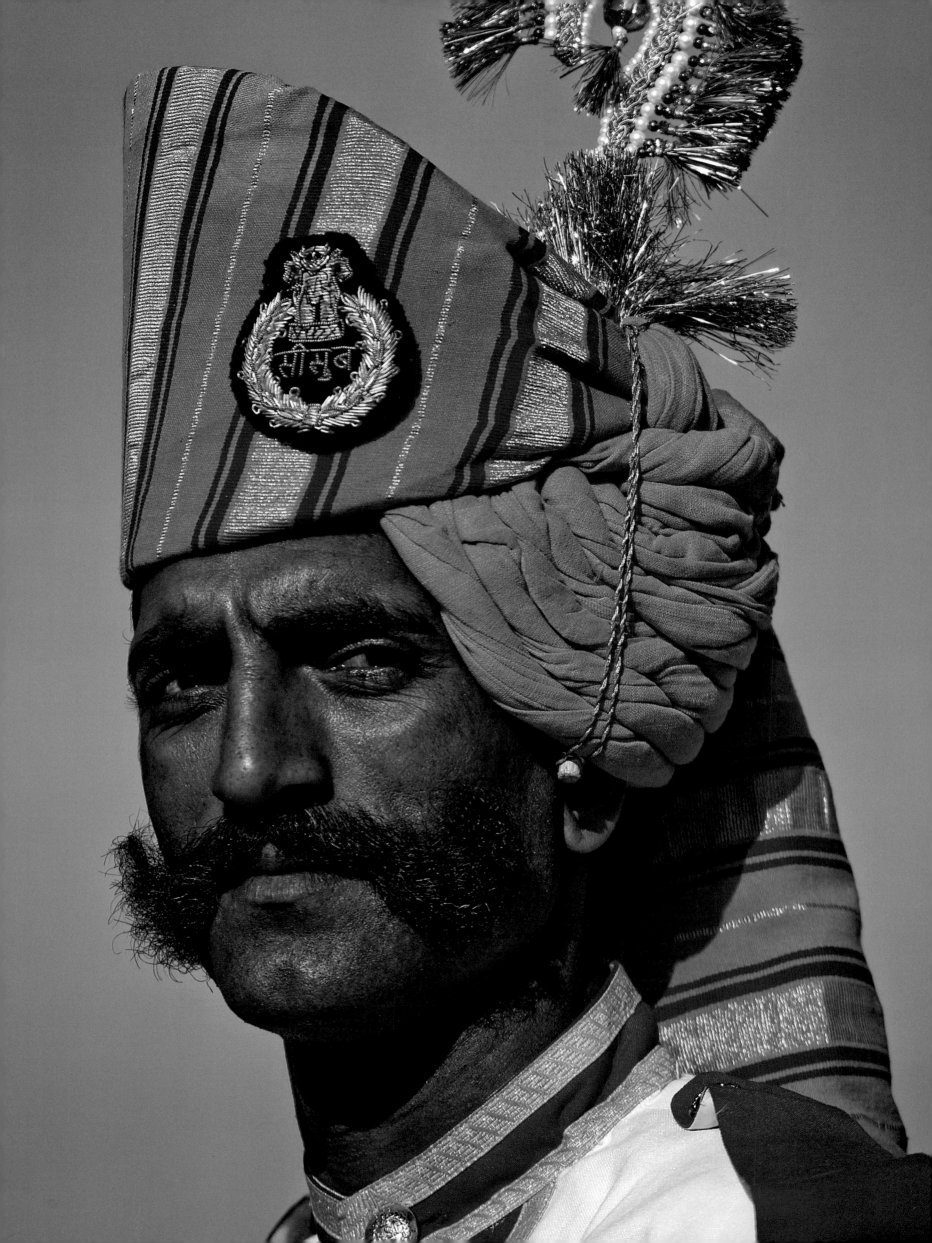

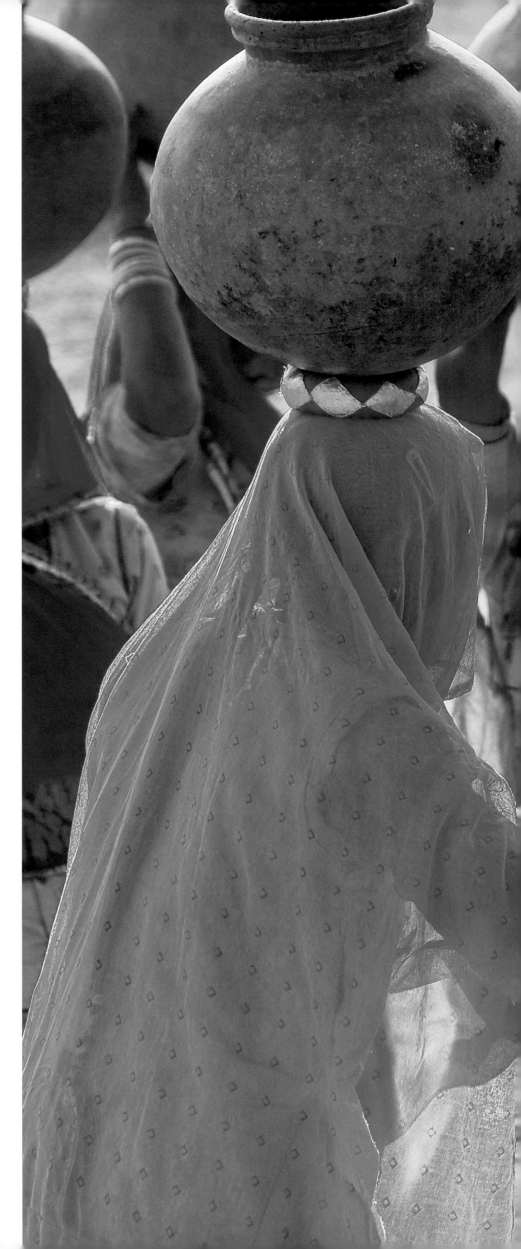

HERE, VEILED, pass heart-expanding women
with chaplets of flowers and comely boys with
languid gait. Here are bejeweled elephants and
haughty eunuchs, there frolic charioteers and
vegetable lambs. Here are pannikins of crushed
pearls, trays heavy with sweetmeats, the mouth-
rejoicing gulab jamun, the tongue-delighting jalebi,
the tooth-vibrating kulfi, the universe-arresting
Sandila laddu; the love philters, a thousand roses
distilled in a vial; here again are gossamer bodices,
chikan-worked, of which a courtesan may put on
twelve and still not be modestly clad. You who
have feasted on the coconuts of Cashmere,
who have lolled upon the nag-phan of Ceylon,
who have slumbered beneath the kamchors of
Thibet, and found no peace, stop in these scented
gardens. Pause by some twilit lake whose ripples
finely slice the clove-of-lahsan moon, whose
shores are fringed with rubber trees and broad-
leaved grasses where some dark lady clothed with
the night plays on her flute a solemn air and one
rapt bird stands unmolested by a company of
pythons. And when, borne on cool breezes,
the laughter of the citizenry wafts to you down
some perfumed canal, voices so mellifluous that
the traveler Kuo Chin-wu once asked where were
these heart-easing bells that he might buy one,
board you your sandalwood barge and hope to
leave. Alas! There is no leaving. Have not visitors...
stood speechless on the top of Lakshman Tila?
And do they not then burst into tears and
coming down disband their retinues, paying off
their ass-herds and muleteers, their cooks and
compote factors, their masalchis, sutlers, food-
tasters, scullions, guides, guards, unguent-mixers,
herbelots, mustard-oil-pressers and masseurs,
because after this there can be no travel?

—I. ALLAN SEALY, *THE TROTTER-NAMA*

*In the rural village of Sar, near Jodhpur, women begin each day by
getting water from a well or nearby pond. Sometimes they carry
these earthen pitchers several miles or more to their clay houses.*

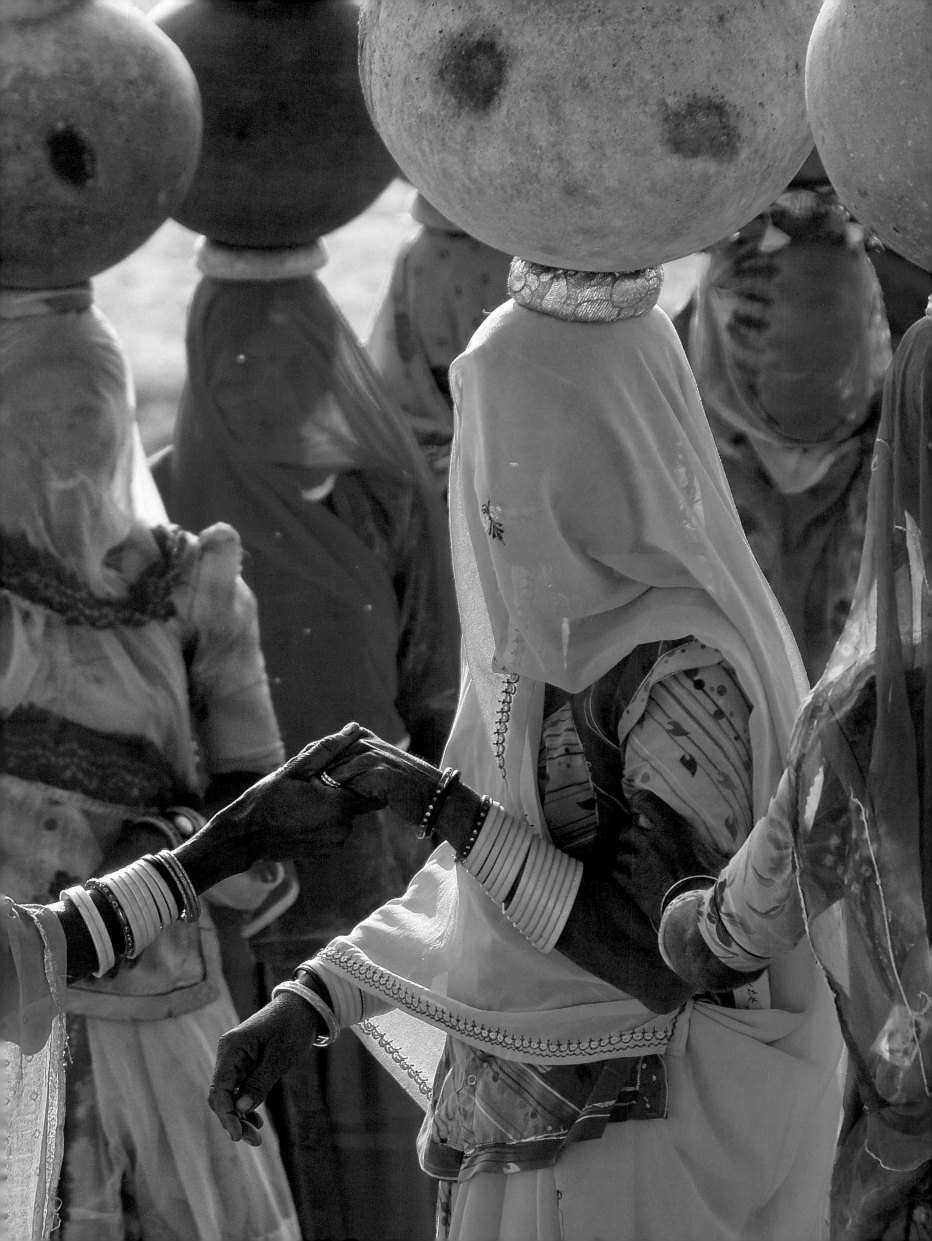

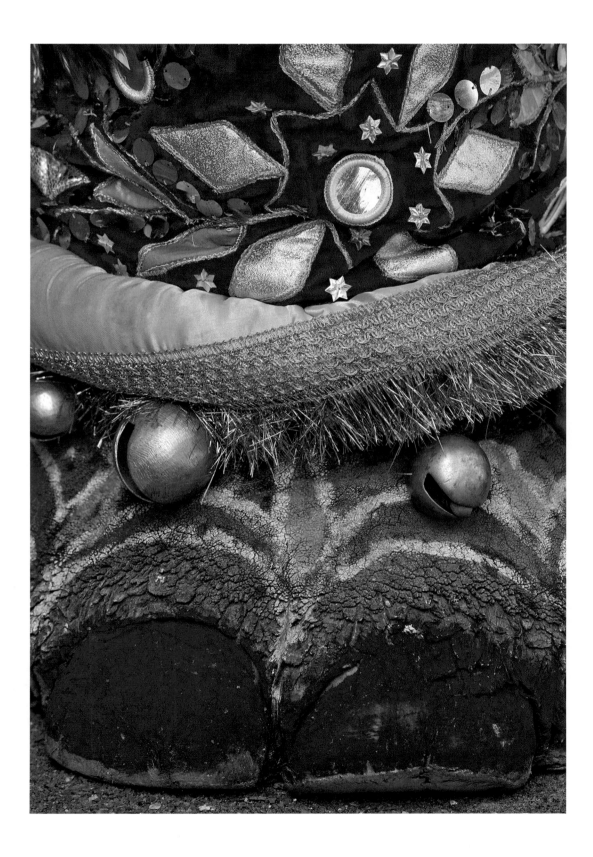

ABOVE: *Detail of a gaily-decorated elephant's foot at the annual festival of elephants held in Jaipur.*

OPPOSITE: *Elephants, a vital ingredient in India's ancient royal, religious, and mythological culture, have been the prime mode of transportation for kings and royals both in battle and in processions. The Indian people have a cultural and religious bond with the elephants, which are treated almost as royals themselves, gaily dressed and attended to during state ceremonies.*

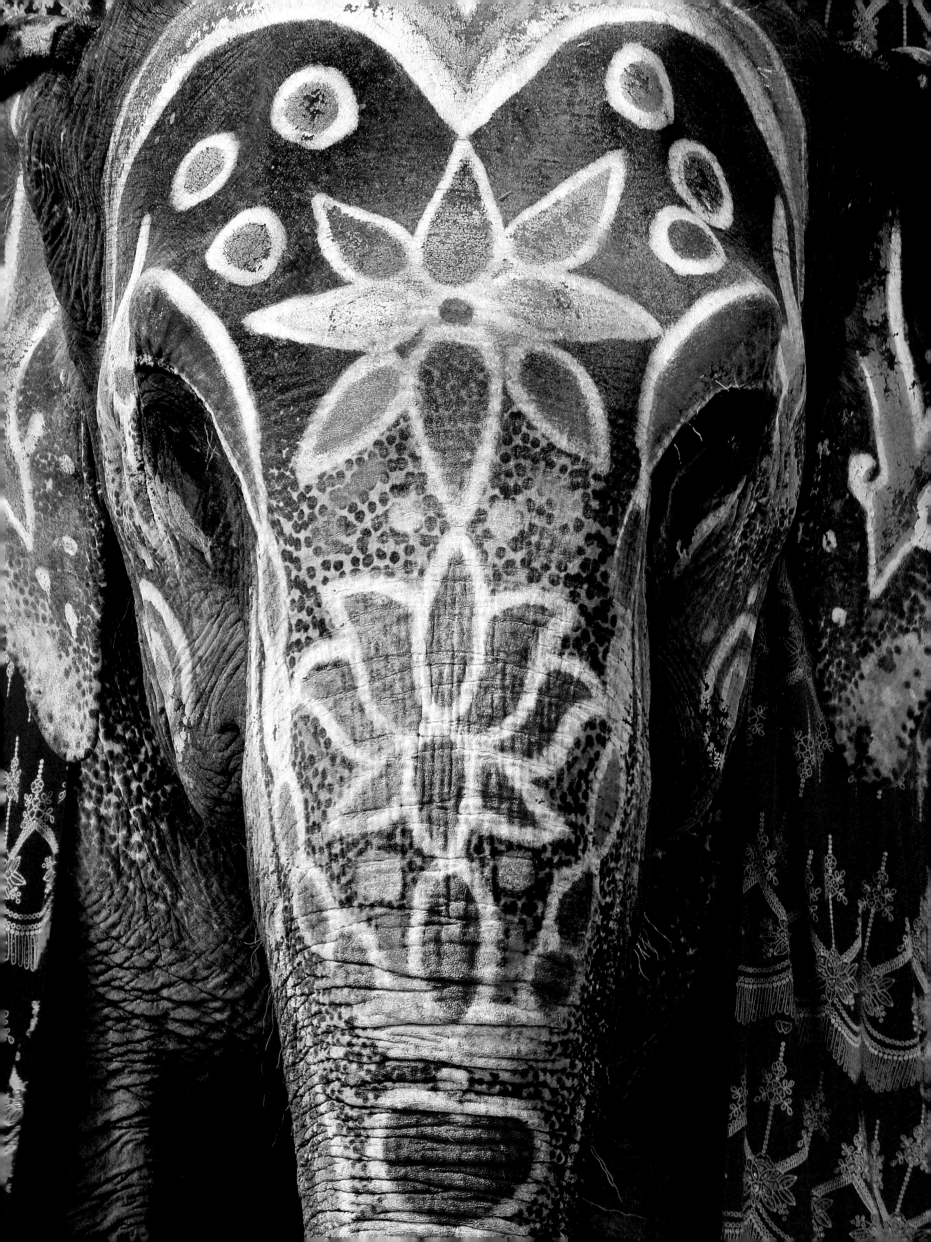

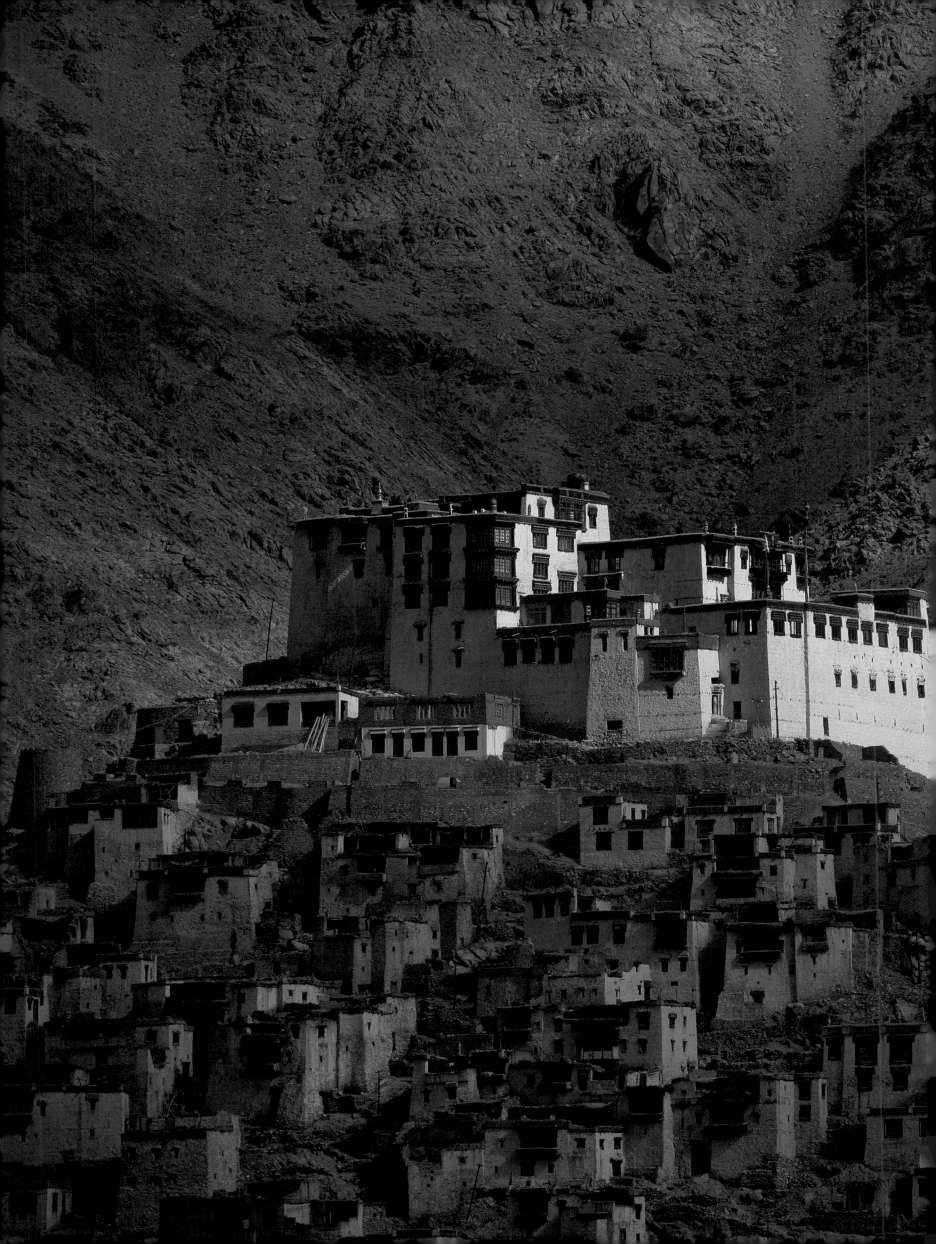

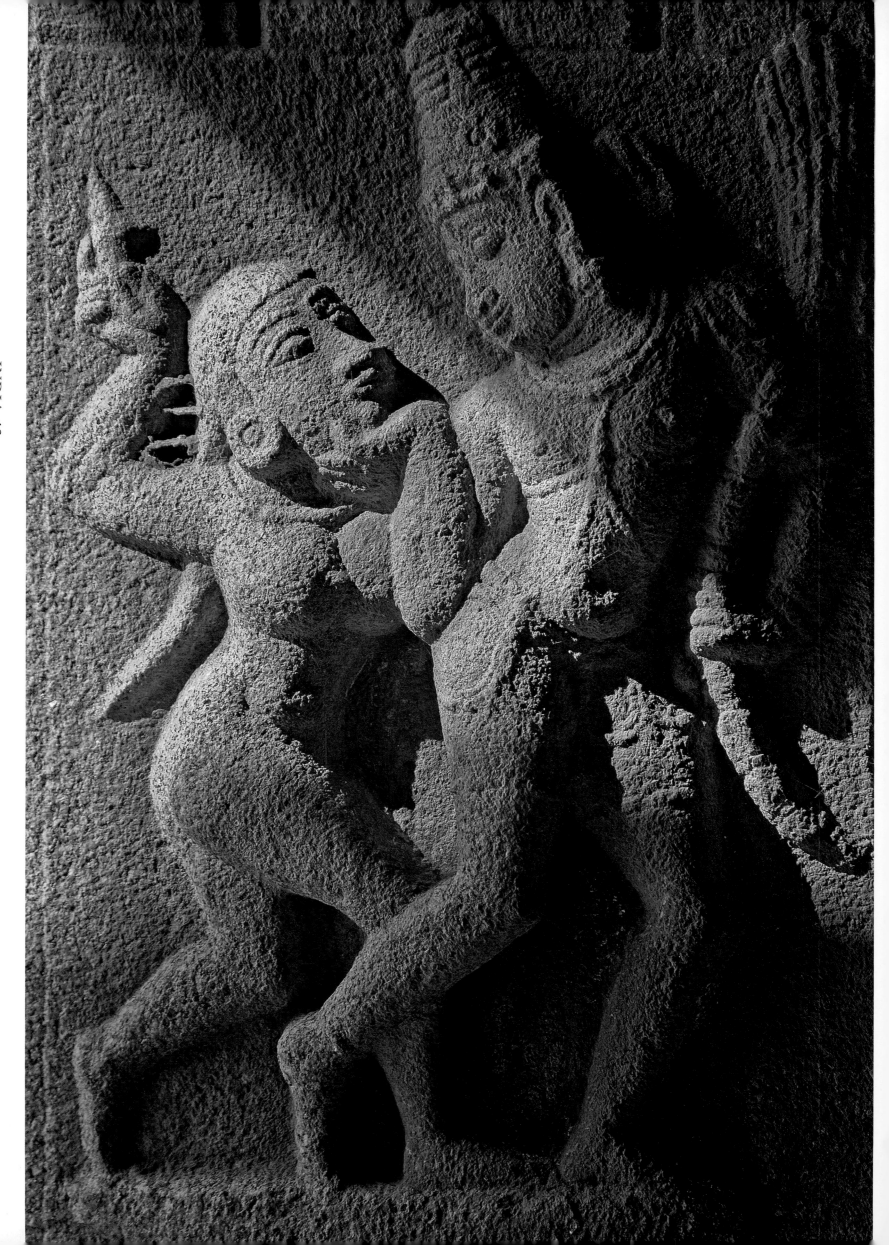

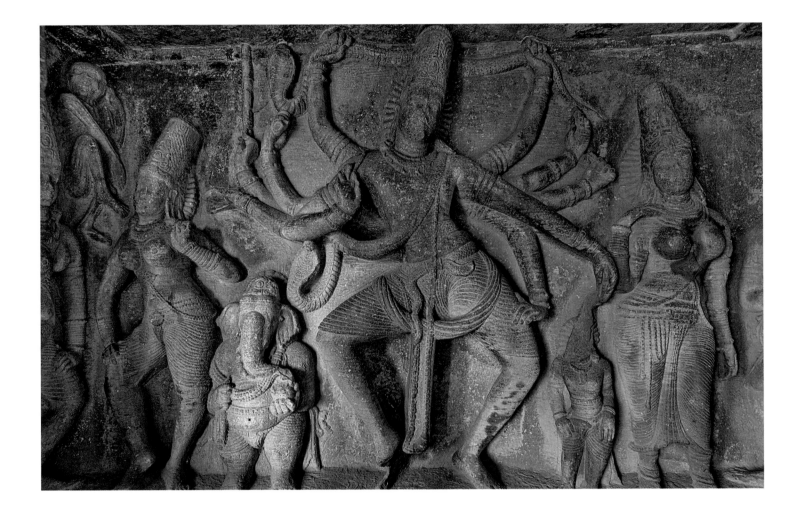

PAGES 38–39: *The Chemrey monastery of Ladakh dates to the 17th century. Approximately 25 miles east of Leh, this monastery belongs to the Drugpa Order of Buddhism and houses approximately 20 monks as well as their apprentices.*

ABOVE: *Dating to the late sixth century, this exquisitely carved dancing Shiva is in a shrine of the Ravala Phadi cave at Aihole, in Karnataka. The shrine also includes exquisite carvings of other Hindu deities.*

OPPOSITE: *Rathi and Manmata of Hindu mythology bask in a late afternoon shaft of warm sunlight in the Vitthala temple at Hampi. This temple complex in the state of Karnataka is set in a spectacular landscape of huge boulders comprising an area of more than eight square miles.*

PAGES 42–43: *This 18-foot-tall sixth-century carving of Shiva in his trinity of manifestations is located in the cave complex of Elephanta Island, six miles southeast of the coast of Mumbai. Chiseled into an alcove on the left is a cruel Shiva the Destroyer, in the middle a serene Shiva the Creator, and on the right a graceful Shiva the Preserver.*

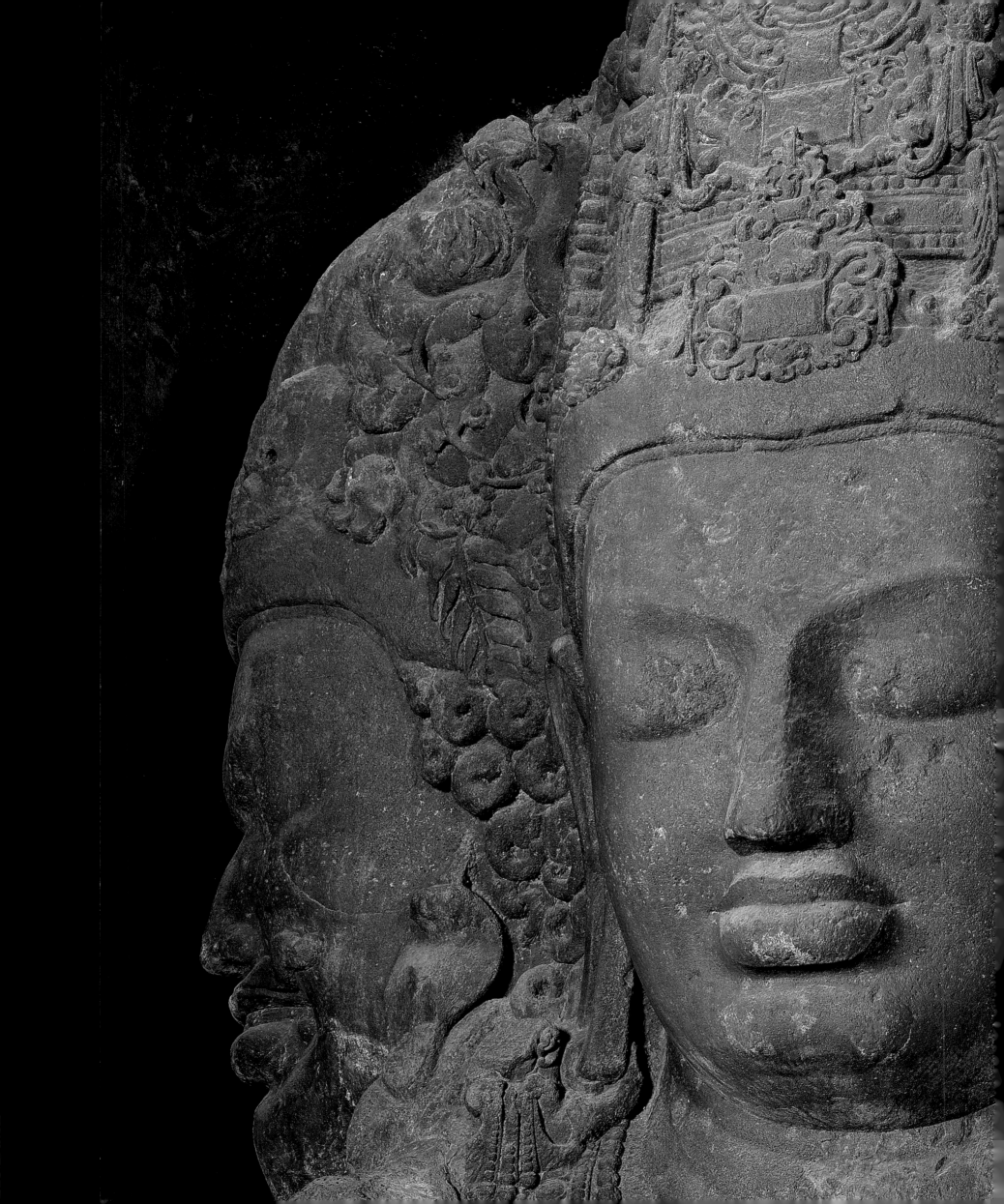

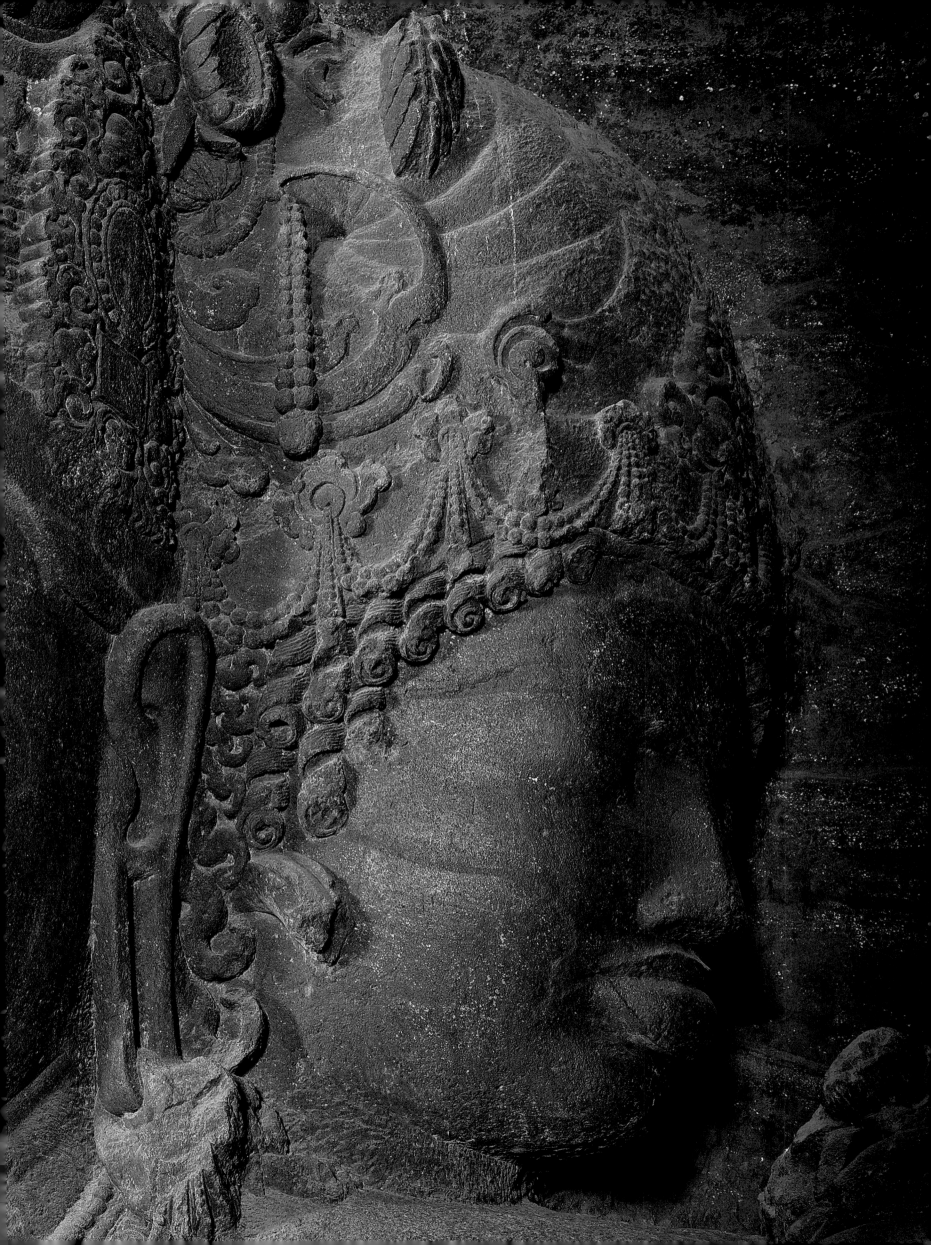

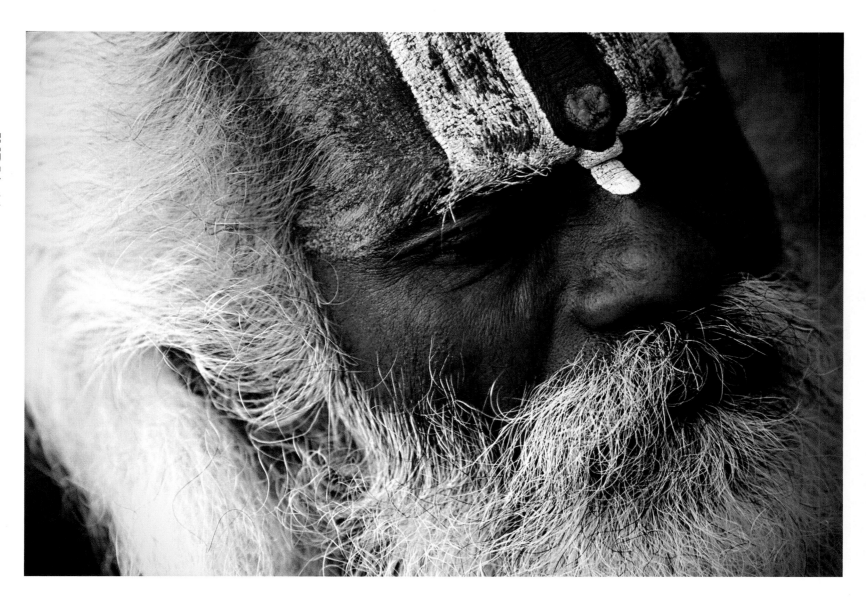

ABOVE: *A* sadhu, *an ascetic or practitioner of yoga, is an individual who leaves behind all material attachments in pursuit of liberation through meditation and contemplation of God. Sects are recognized by the symbols painted on the foreheads of members.*

OPPOSITE: *Sitting in the doorway of an old temple in Varanasi, Uttar Pradesh, this sadhu prays at dawn, facing the rising sun. To Hindus, spiritual enlightenment is the highest goal in life. Today there are 4 to 5 million sadhus in India, roughly half a percent of the total population.*

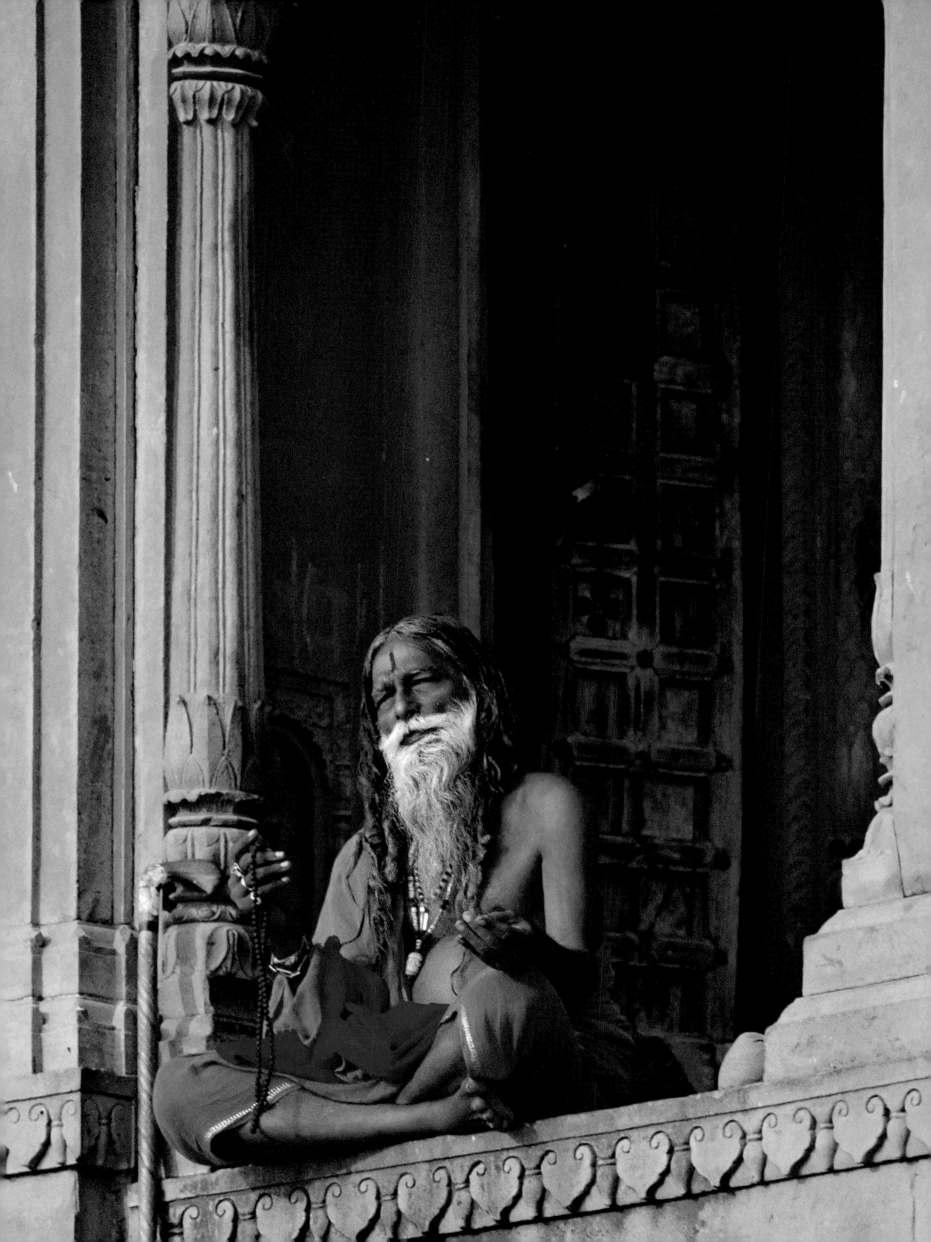

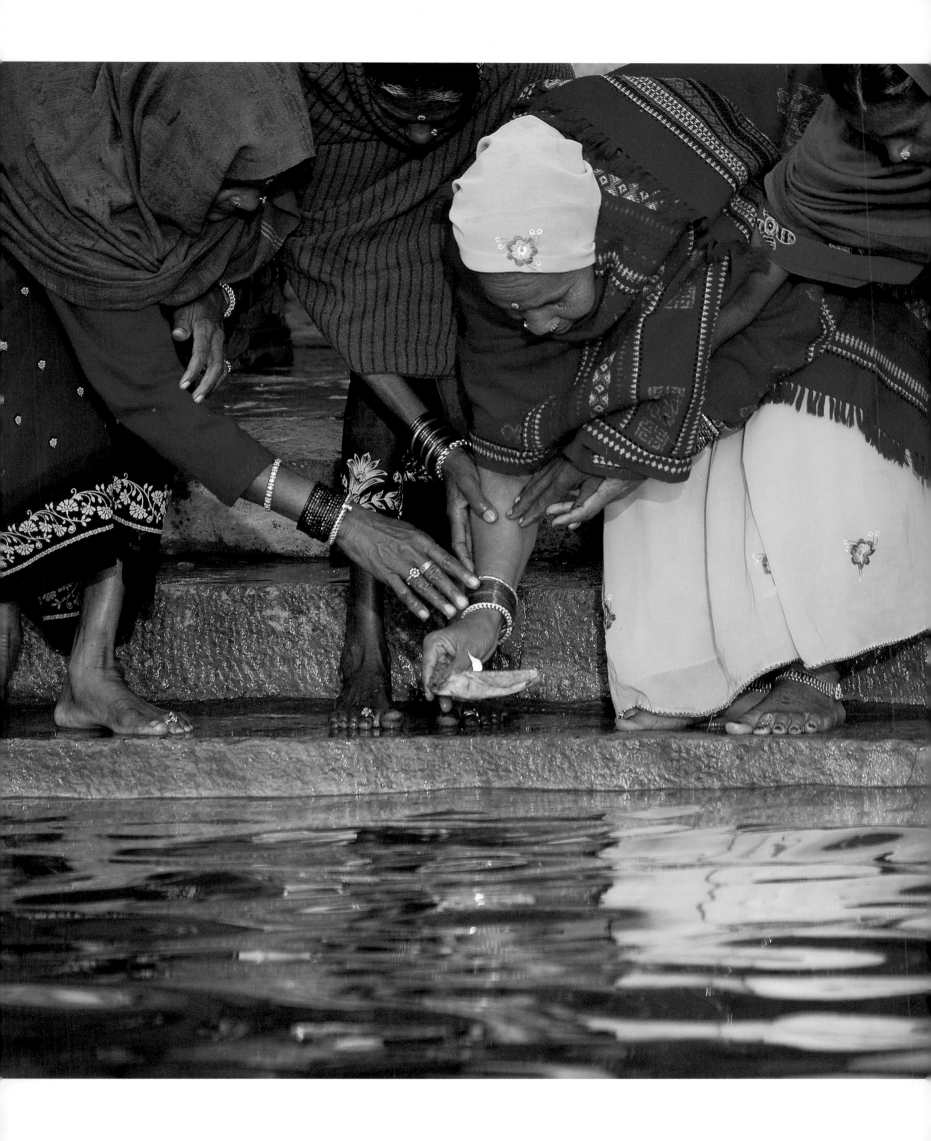

The steps of the ghats in Varanasi are as much a social gathering place as a place of worship. These women gather on the steps of the Sankatha ghat to reverently place a diya—a small lamp made of clay—on the serene and sacred waters of the Ganges river. The Ganges winds 1,560 miles through northern India, from the Himalayas to the Indian Ocean.

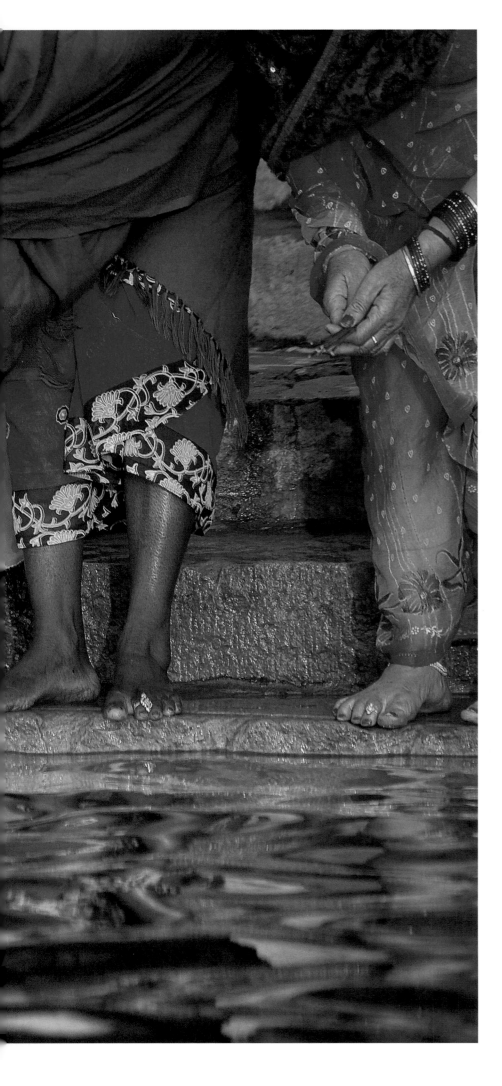

EVERY INCH OF GROUND ON EARTH, as you may have realized by now, has a divine association. Mother Earth has been there since the beginning of creation, being one of the five primeval elements. She has seen countless pairs of feet running about on thousands of aims and pursuits, both evil and good, and will continue until Time ("Kala") swallows and digests everything. Even after the participants have vanished, every inch of earth still retains the impress of all that has gone before. We attain a full understanding only when we are aware of the divine and other associations of every piece of ground we tread on. Otherwise it would be like the passage of a blind man through illuminated halls and gardens.... You see that river now. It is Ganga flowing along the valley, coming down from the Himalayas, carrying within her the essence of rare herbs and elements found on her way. She courses through many a kingdom, and every inch of the ground she touches becomes holy; Ganga cleanses and transforms; the dying person with a sip of that water or with the ashes of his bones dissolved therein attains salvation.

—R.K. NARAYAN, *GANGA'S STORY*

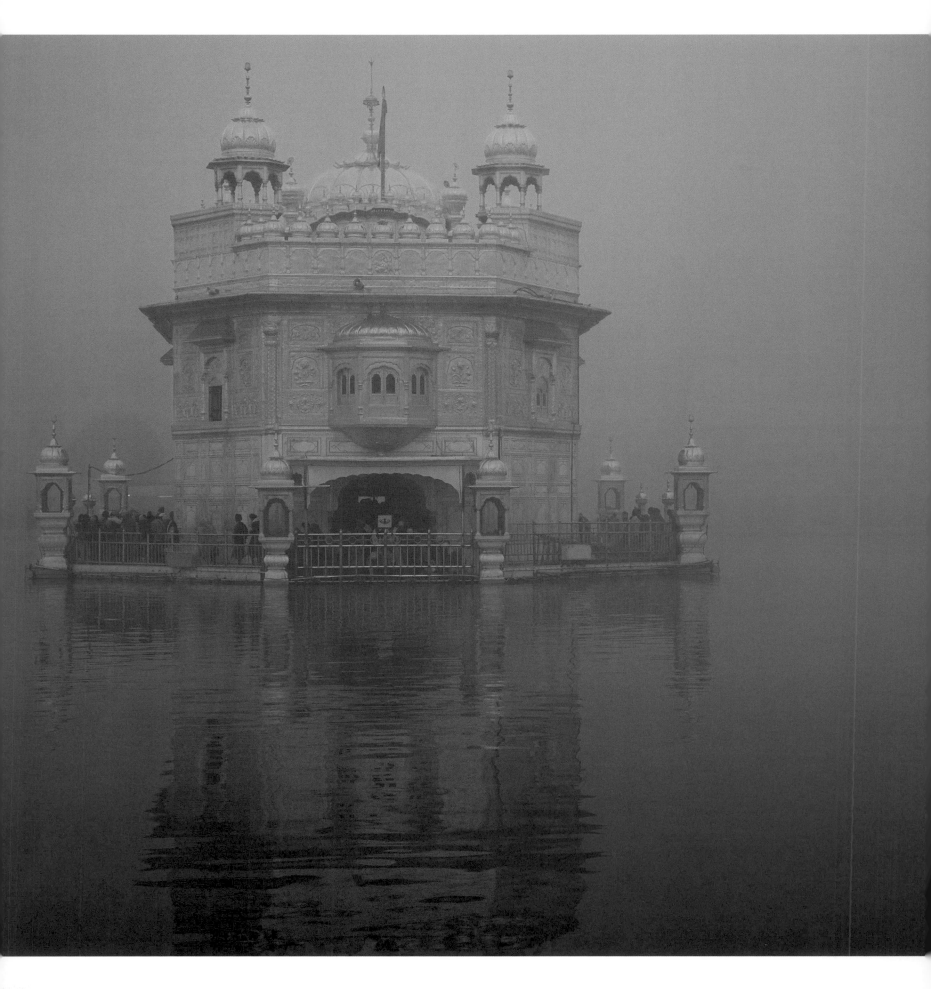

ABOVE AND OPPOSITE: *Bathed in the reflected light of sunset, a young sikh stands in the pool of water surrounding the Golden Temple of Amritsar and prays. Located in Punjab, in northwest India close to the city of Lahore, Pakistan, this shrine, the most famous pilgrimage site for sikhs in India, attracts more visitors than the Taj Mahal. Sikhism is the fifth-largest religion in the world. A key distinctive feature is its non-anthropomorphic concept of God, in which one may interpret God as the universe itself.*

PAGES 50–51: *A vision from a fairy tale, the 19th-century Bijayrajrajeshwar temple on Gaibsagar Lake in the town of Dungarpur, in Rajasthan, appears almost as a mirage in the late-afternoon sunlight.*

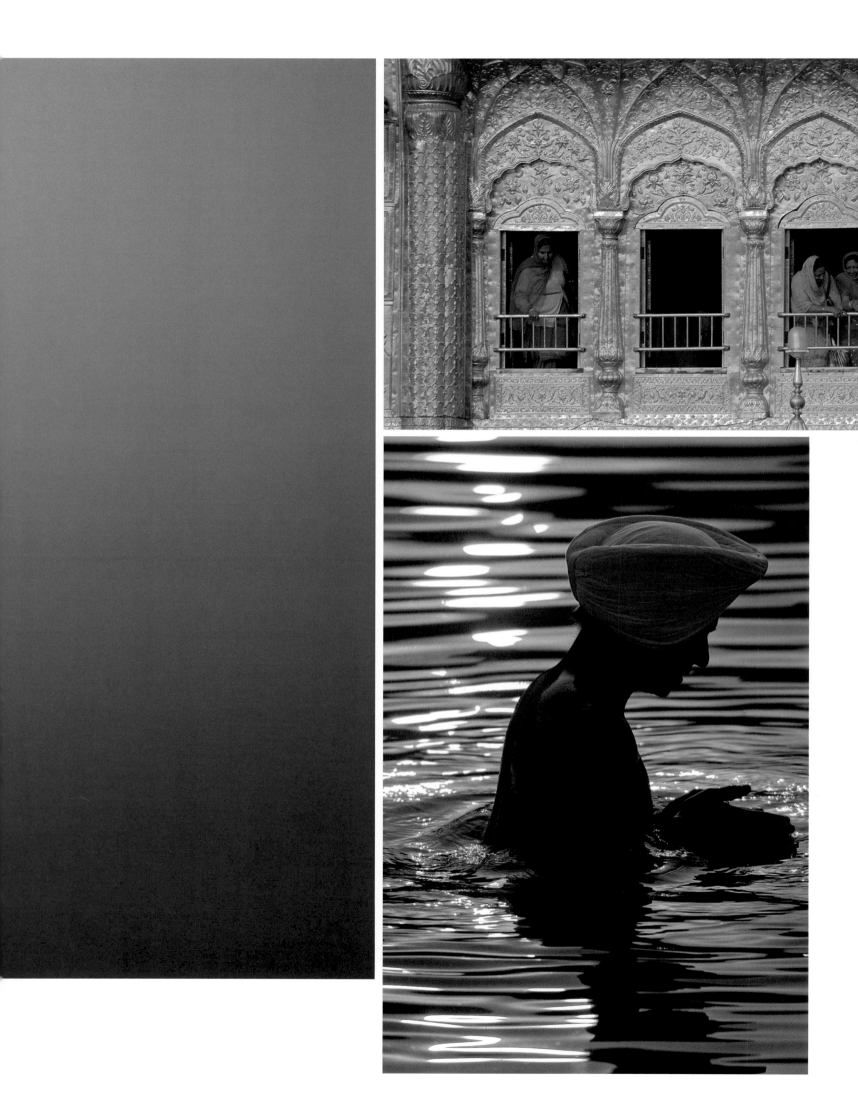

THEY CROSSED THE MOAT surrounding Janaka's palace, with its golden spires soaring above the other buildings of the city. Now Rama observed on a balcony princess Sita playing with her companions. He stood arrested by her beauty, and she noticed him at the same moment. Their eyes met. They had been together not so long ago in Vaikunta, their original home in heaven, as Vishnu and his spouse Lakshmi, but in their present incarnation, suffering all the limitations of mortals, they looked at each other as strangers. Sita, decked in ornaments and flowers, in the midst of her attendants, flashed on his eyes like a streak of lightning. She paused to watch Rama slowly pass out of view, along with his sage-master and brother. The moment he vanished, her mind became uncontrollably agitated. The eye had admitted a slender shaft of love, which later expanded and spread into her whole being. She felt ill.

Observing the sudden change in her, and the sudden drooping and withering of her whole being, even the bangles on her wrist slipping down, her attendants took her away and spread a soft bed for her to lie on.

She lay tossing in her bed complaining, "You girls have forgotten how to make a soft bed. You are all out to tease me." Her maids in attendance had never seen her in such a mood. They were bewildered and amused at first, but later became genuinely concerned, when they noticed tears streaming down her cheeks. They found her prattling involuntarily, "Shoulders of emerald, eyes like lotus petals, who is he? He invaded my heart and has deprived me of all shame! A robber who could ensnare my heart and snatch away my peace of mind! Broad-shouldered, but walked off so swiftly. Why could he not have halted his steps, so that I might have gained just one more glimpse and quelled his riotous heart of mine. He was here, he was there next second, and gone forever. He could not be a god—his eyelids flickered. . . . Or was he a sorcerer casting a spell on people?"

—R. K. NARAYAN, *The Ramayana*

OPPOSITE AND PAGES 54–55: *The annual three-day fair at Jaisalmer is a time for nearby Rajput tribes to socialize and dress in their most resplendent saris and jewelry.*

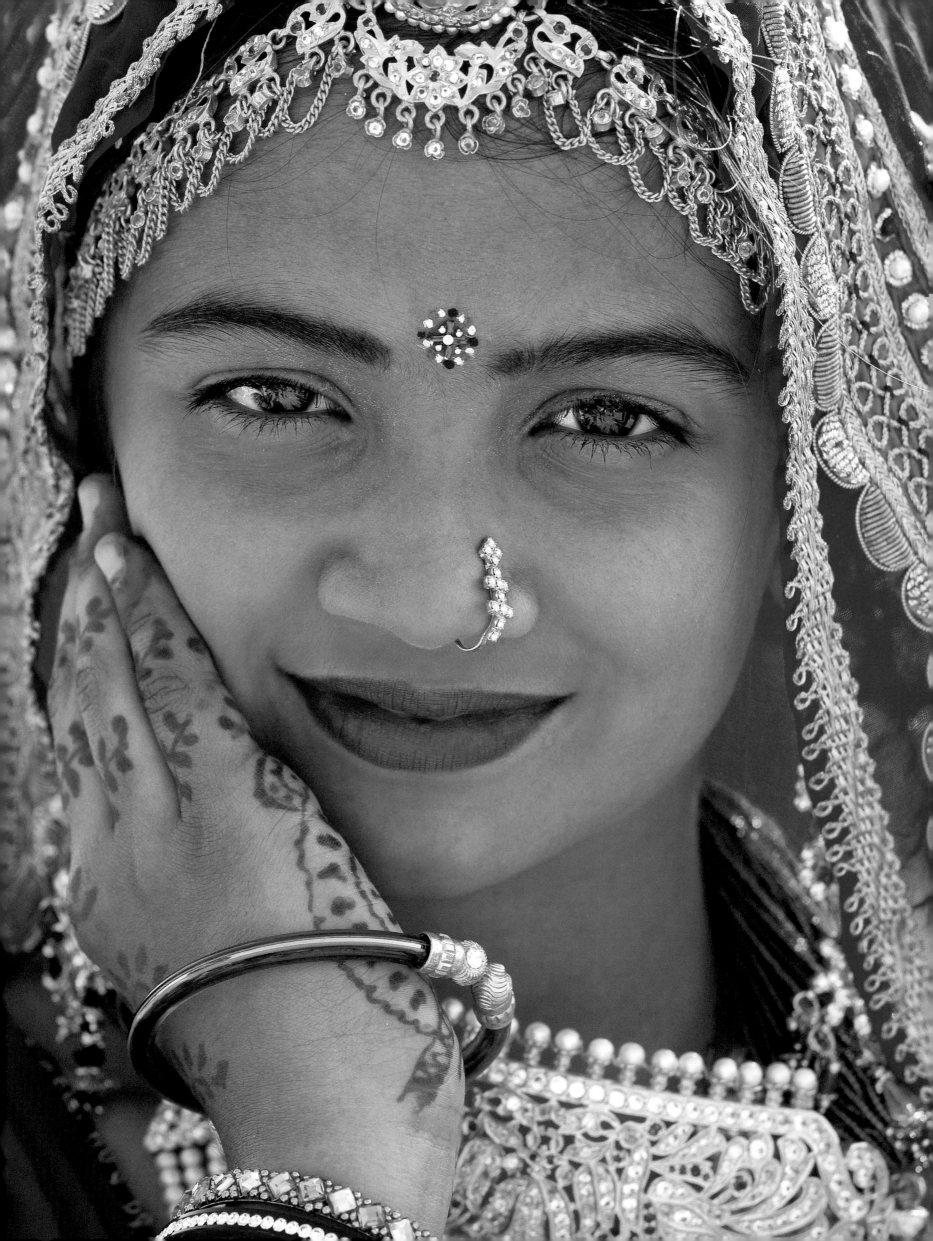

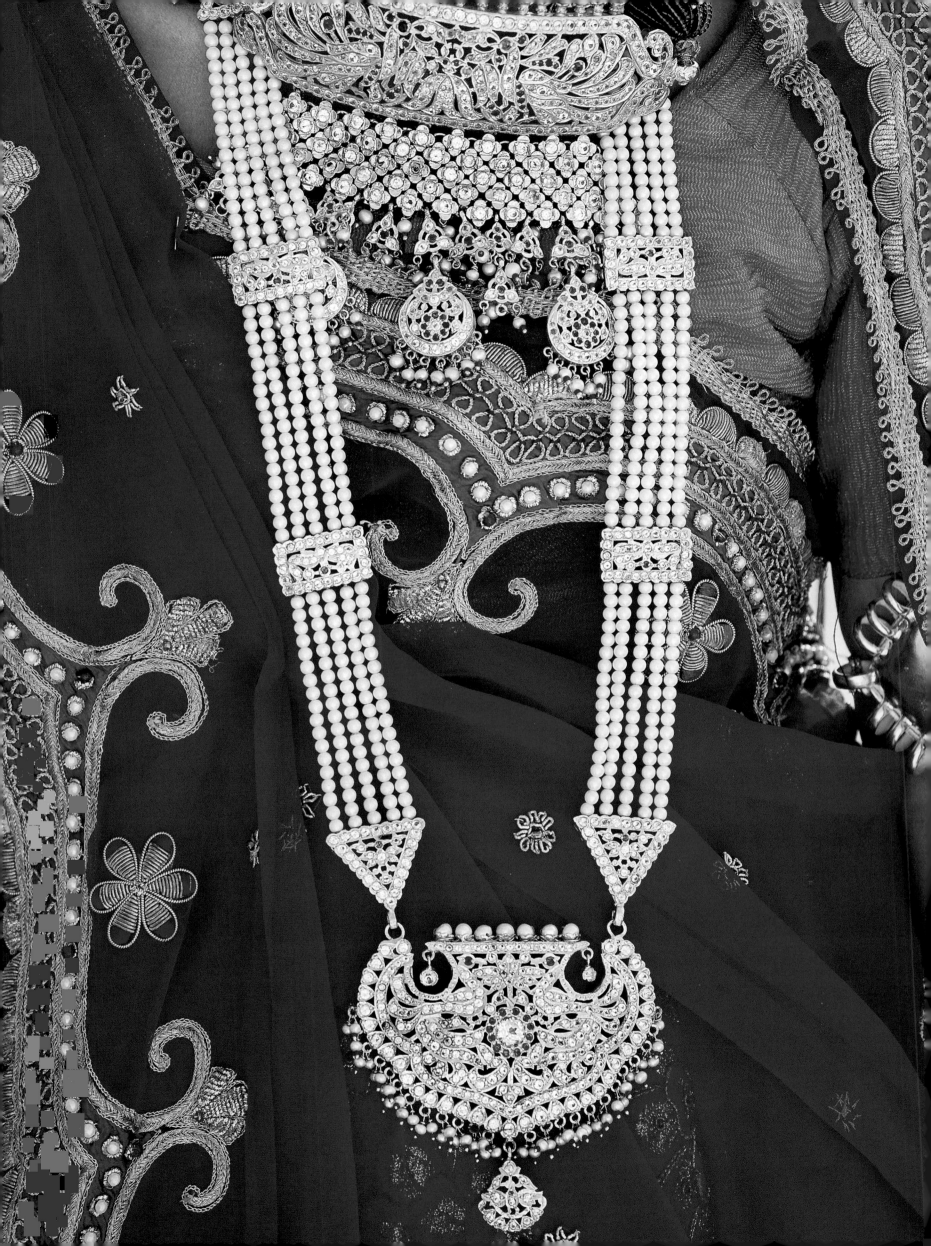

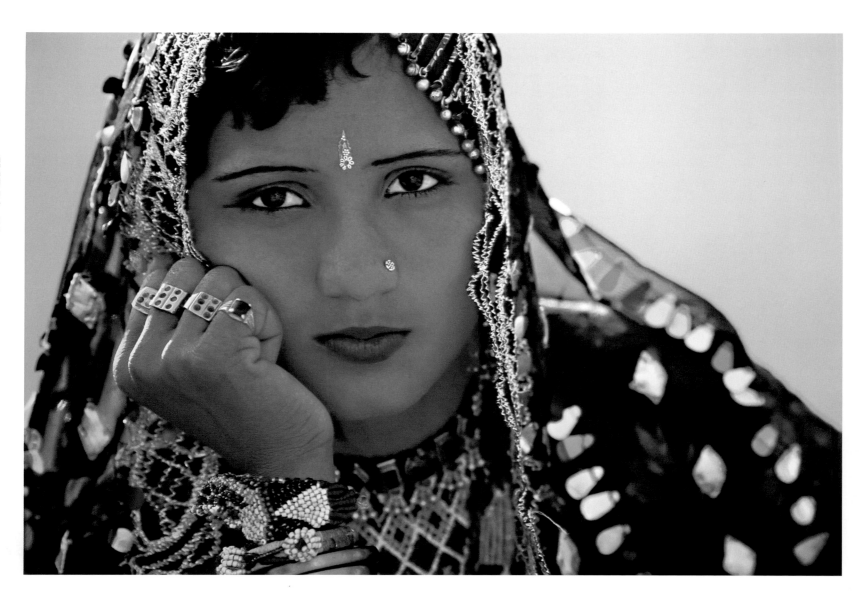

A nomadic woman on the sand dunes at Pushkar.

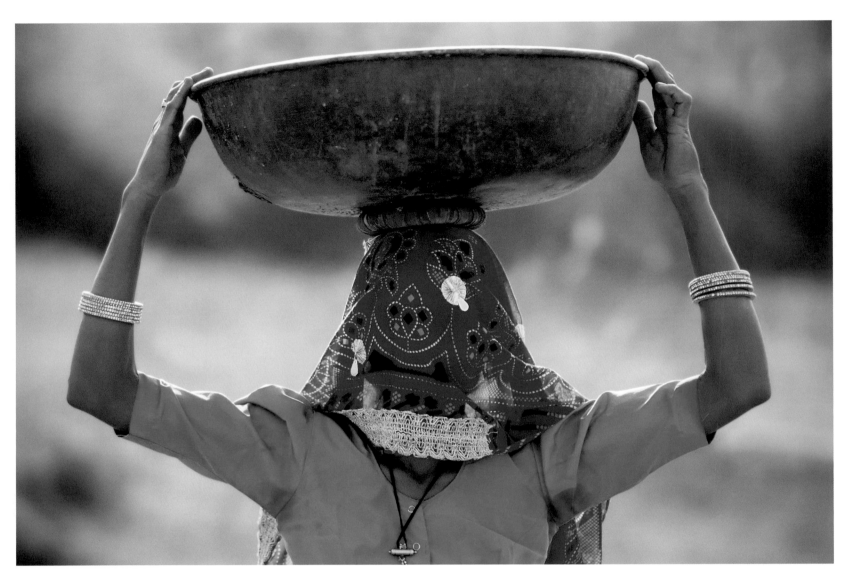

A veiled woman with a pan at Pushkar. Pushkar is a fascinating backdrop for an annual religious and cattle fair in which men and women dress in their most colorful clothes for the mela, *a Hindu pilgrimage.*

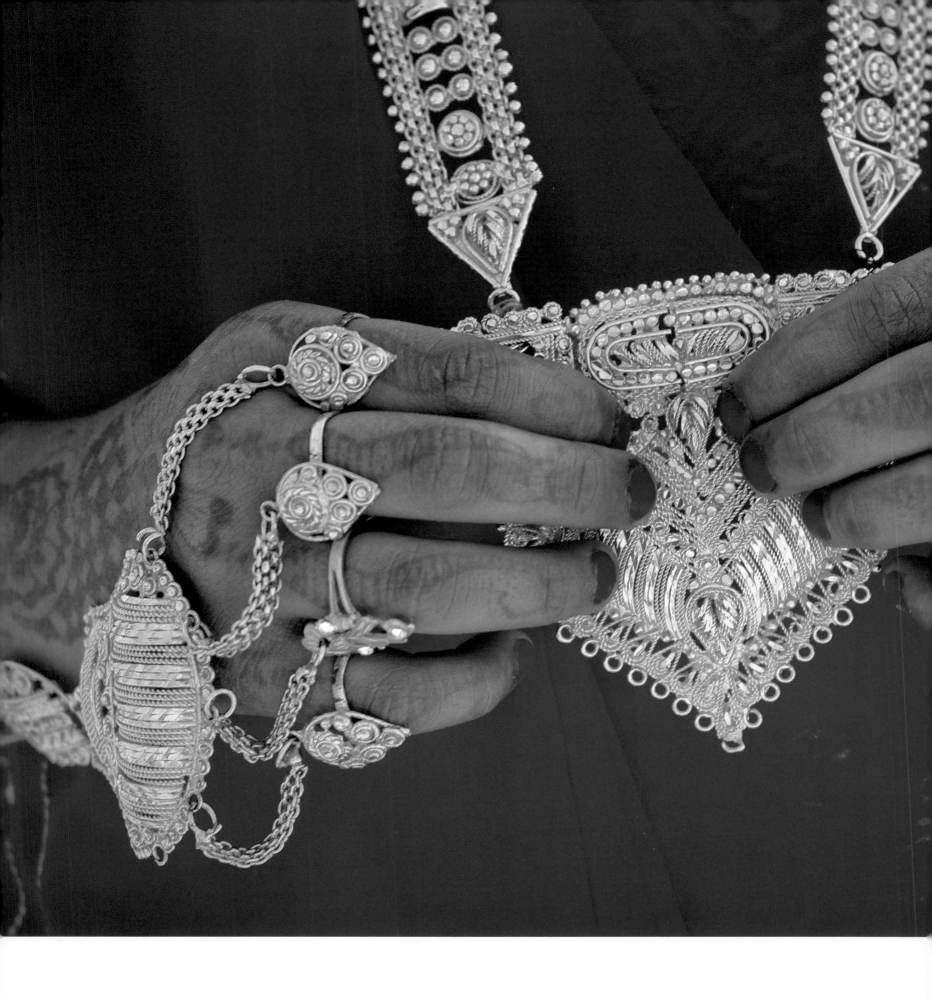

ABOVE AND OPPOSITE: *Rajput women display their finest jewelry at Jaisalmer's desert fair.*

PAGES 60–61: *At the festival of elephants in Jaipur, elephants are painted in fantastic patterns, sometimes as other animals. This one is a lion.*

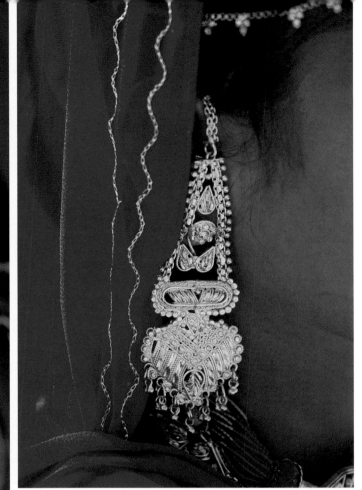

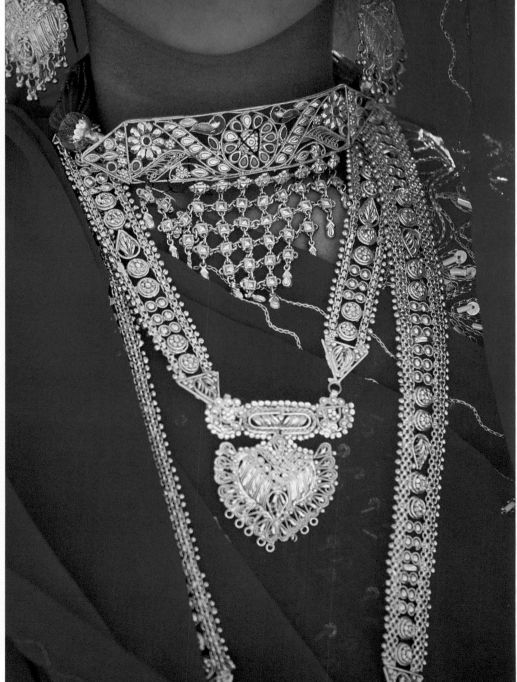

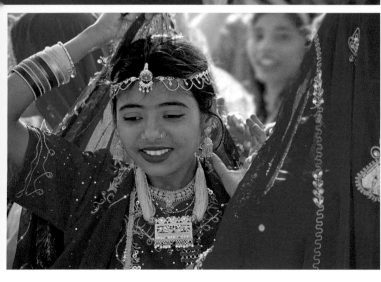

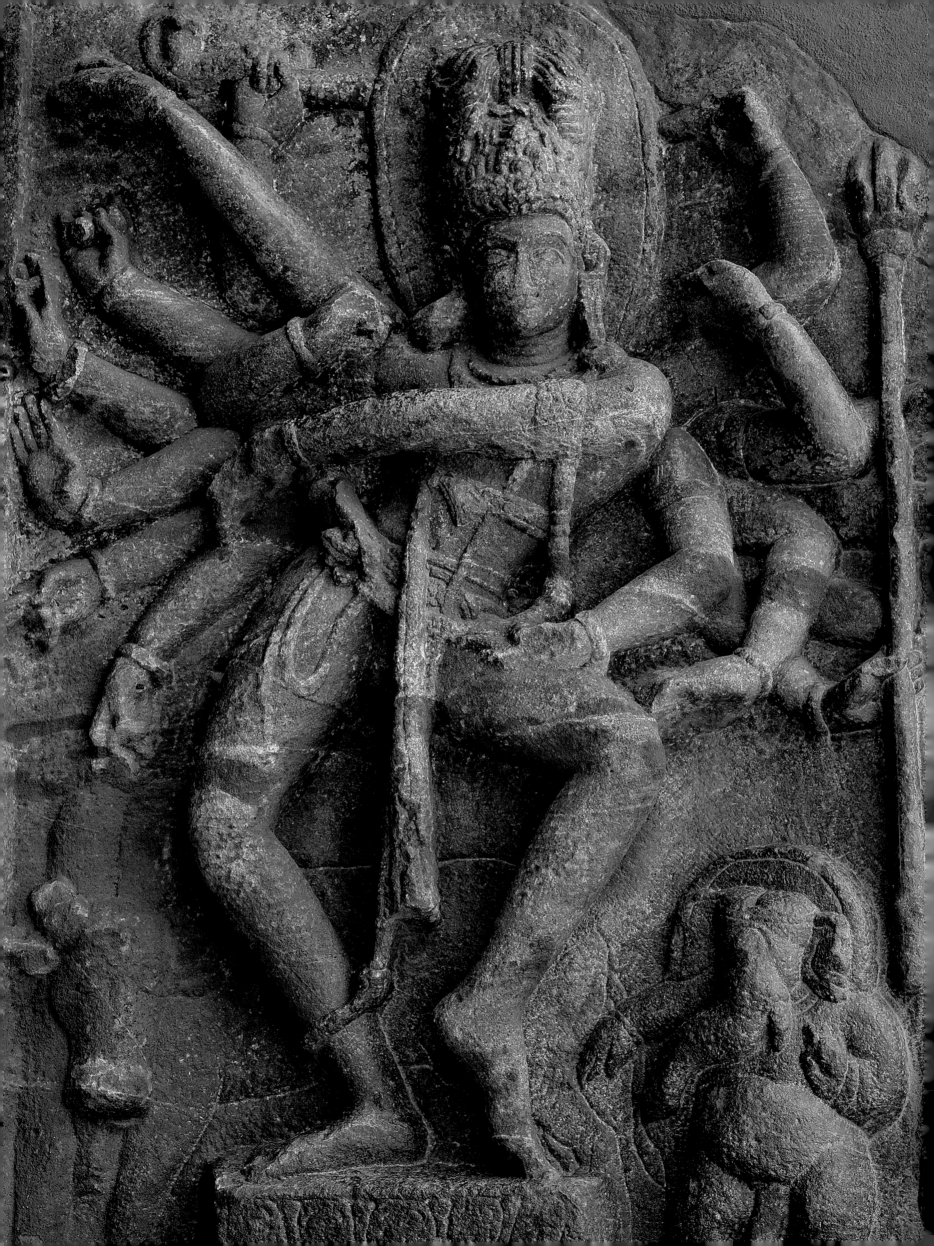

LISTEN—

I was born fullgrown from the dew of my mother's body. We were alone, and Devi told me, "Guard the door. Let no one enter, because I'm going to take a bath."

Then Shiva, whom I had never seen, came home. I would not let him into his own house.

"Who are you to stop me?" he raged.

And I told him, "No beggars here, so go away!"

"I may be half naked," he answered, "but all the world is mine, though I care not for it."

"Then go drag about your world, but not Parvati's mountain home! I am Shiva's son and guard this door for her with my life!"

"Well," he said, "you are a great liar. Do you think I don't know my own sons?"

"Foolishness!" I said. "I was only born today, but I know a rag picker when I see one. Now get on your way."

He fixed his eyes on me and very calmly asked, "Will you let me in?"

"Ask no more!" I said.

"Then I shall not," he replied, and with a sharp glance he cut off my head and threw it far away, beyond the Himalayas.

Devi ran out, crying, "You'll never amount to anything! You've killed our son!" She bent over my body and wept. "What good are you for a husband? You wander away and leave me home to do all the work. Because you wander around dreaming all the time, we have to live in poverty with hardly enough to eat."

The Lord of All the Worlds pacified her; looking around, the first head he saw happened to be an elephant's, and he set it on my shoulders and restored me to life.

—WILLIAM BUCK, *MAHABHARATA*

ABOVE: *The Ganesh Chaturthi festival in Mumbai celebrates the birthday of Lord Ganesha, the elephant-headed son of Shiva and Parvati. Lord Ganesha (also spelled Ganesh) is worshipped throughout India as the god of prosperity and good fortune. During the festivities, which last for 10 days, small statues and idols of Ganesh are sold from stalls and wagons.*

OPPOSITE: *Chiseled into the red sandstone complex of caves at Badami in Karnataka state, this twelve-armed figure dating from the sixth century is one of the earliest depictions of the Nataraj, or dancing Shiva.*

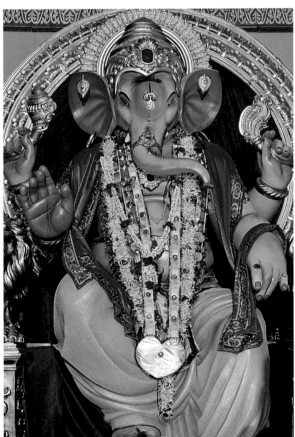

ABOVE: *During the festival of Ganesh Chaturthi, various mandals, or associations of Hindu temples, create pandals, or structures, to house idols of Lord Ganesha. Once simple bamboo structures, pandals have evolved into elaborate representations of all conceivable forms and building types.*

OPPOSITE: *A carved figure of Ganesh on the door at the entrance of the Karni Mata temple (the infamous "rat temple") near Bikaner. Here, the rats are fed milk by the priests, who believe they are reincarnated holy men.*

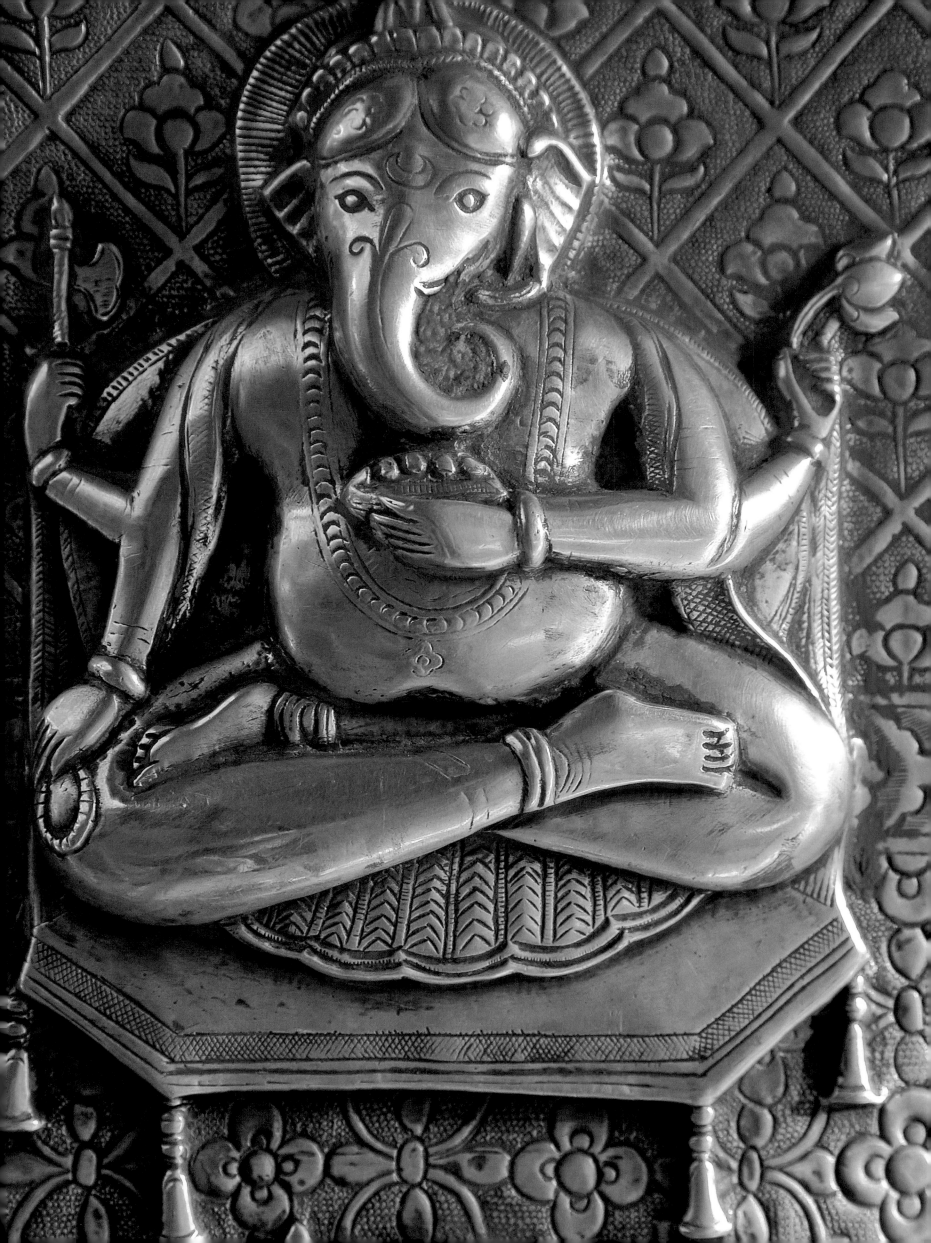

THE RIVER FLOWED ON. On its banks sprang up the thatched roofs of a hamlet—a pastoral community who grazed their cattle in the jungles and brought them back home before nightfall and securely shut themselves and their animals in from prowling tigers and jackals. The jungle, with its sky-touching trees, gradually receded further and further, and cornfields appeared in its place. The waving tufts of rice, standing to a man's height, swayed in the air and stretched away as far as the eye could see.

When the Buddha came this way, preaching his gospel of compassion, centuries later, he passed along the main street of a prosperous village. Men, women and children gathered around him. He saw a woman weeping. She had recently lost her child and seemed disconsolate. He told her he would give her consolation if she could bring him a handful of mustard from any house where death was unknown. She went from door to door and turned away from every one of them. Amongst all those hundreds of houses she could not find one where death was a stranger. She understood the lesson....A little crumbling masonry and a couple of stone pillars, beyond Lawley Extension, now marked the spot where the Buddha had held his congregation....

The great Shankara appeared during the next millennium. He saw on the river-bank a cobra spreading its hood and shielding a spawning frog from the rigor of the midday sun. He remarked: "Here the extremes meet. The cobra, which is the natural enemy of the frog, gives it succor. This is where I must build my temple." He installed the goddess there and preached his gospel of *Vedanta:* the identity and oneness of God and His creatures.

And then the Christian missionary with his Bible. In his wake the merchant and the soldier—people who paved the way for Edward Shilling and his Engladia Bank.

Dynasties rose and fell. Palaces and mansions appeared and disappeared. The entire country went down under the fire and sword of the invader, and was washed clean when Sarayu overflowed its bounds. But it always had its rebirth and growth.

—R. K. NARAYAN, *MR. SAMPATH—THE PRINTER OF MALGUDI*

OPPOSITE: *Chhatris, or cenotaphs, of the 16th-century Bundela kings, on the Betwa river at Orchha, in the state of Madhya Pradesh.*

ABOVE: *Jains praying at Ranakpur, in Rajasthan. Jainism, an offshoot of Hinduism and one of the oldest religions in the world, stresses the equality of all life and places particular emphasis on nonviolence.*

OPPOSITE: *The almost infinite detail of the white marble Adinath temple at Ranakpur distinguishes it as the most impressive example of Western Indian temple architecture.*

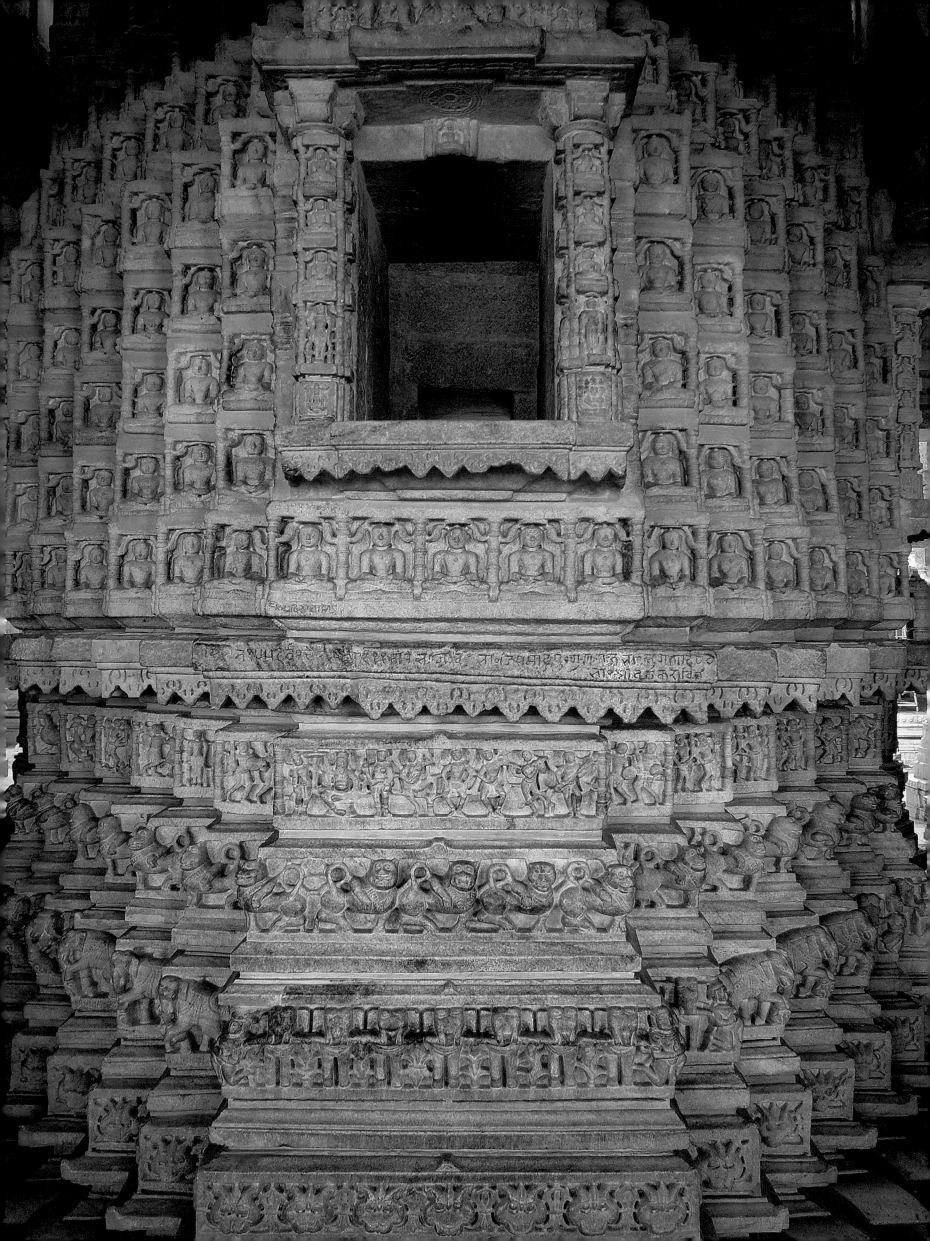

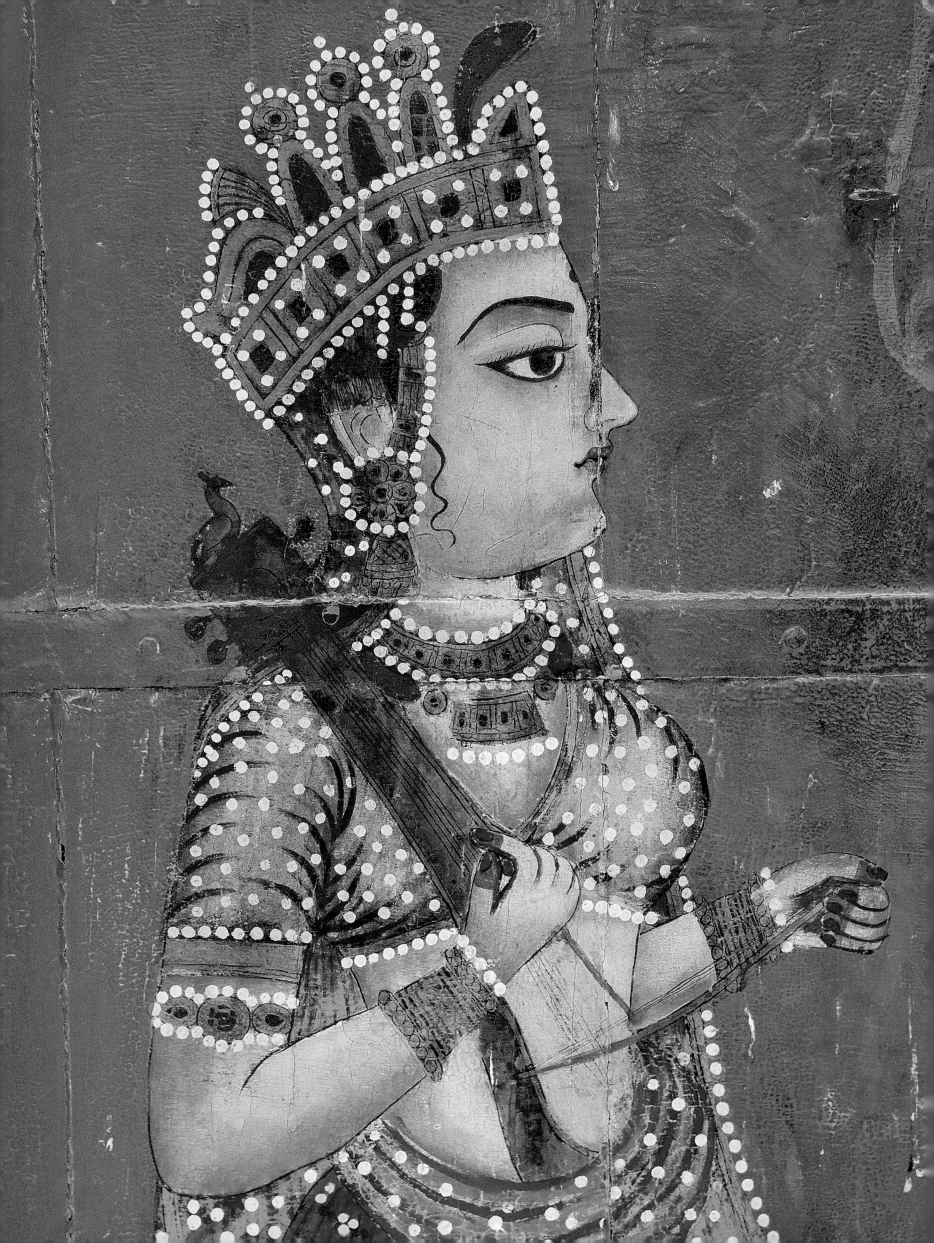

In truth, I did not care what happened next. My life was like a dreamless sleep, office routine following domestic routine without a tremor.

My wife adhered to the practice of fasting twice a week, and in an idle sort of way I began to fast myself, I only because I was dismayed at the weight I was gaining with my inactive life.

Convinced he had won the battle against my doubts, my father sent me an elderly Jain monk to sustain the efficacy of my fasts by discoursing on our traditions.

The old monk's air of contentment was so beguiling I became quite attached to him although I paid no attention to his discourses.

Every morning before I left for work I listened to his soft voice behind the muslin mask that covered his mouth, as one listens to a piece of music that is neither too loud nor too safe, too fast nor too slow.

"Do not trust the tranquility of your present mood," the old priest warned me one day. "Some upheaval most certainly awaits you."

I teased him for making astrological predictions like a Hindu. He silenced me with unexpected severity.

"You think I am only an old man reading the scriptures aloud. But I can see you are suppressing something. And what is suppressed will erupt."

I was astonished. We had never spoken of personal matters. "Why do you think so?"

"I see you withdrawing from your life, your possessions. You have even ceased eating."

I started laughing. "You came to these conclusions because I think I am too fat?"

The monk ignored my sarcasm. "You have traveled the world and think you have seen everything. Perhaps you have. But you have not yet learned the secrets of the human heart."

"How can you speak of secrets, with your blameless life?"

"My life is neither blameless nor unique. I have learned this from Mahavira's teachings."

"Ah, of course, the Great Teacher. What could he possibly know about mere mortals?"

"That they long to be free. Many men die before they learn the desire for freedom lies deep within them, like a dammed river waiting to be released. But once a man has had that momentary glimpse of freedom, he needs to be instructed further."

I sneered but at the same time I found myself intrigued by the possibility that this old monk, with his limited knowledge of the world, might know some secret of the heart that could shatter the shell of numbness that enclosed me.

As if reading my mind, the monk said slyly, "What do you lose by hearing Mahavira's description of the skepticism and nihilism that disturb a man when he finds he is not free, although he continues to perform the role that society requires of him?"

I was taken aback. "Mahavira spoke about these things?"

The monk was amused by my reaction and offered to instruct me further.

Over the months the monk's teachings continued to surprise me. He was able to predict how I would feel long before I arrived at the emotion myself, describing to me the states of my despair with greater accuracy than I seemed able to experience them. I told the monk I longed to share his knowledge.

"But I have no knowledge. I am only describing what has been observed by others wiser than myself."

—Gita Mehta, *A River Sutra*

OPPOSITE: *Detail of a painted figure in the Bhandashah Jain temple at Bikaner. Noteworthy for its use of color, this 16th-century temple is the oldest existing structure in Bikaner.*

PAGES 72–73: *More than a thousand Jain temples dating to the 16th century grace the summit of Palitana's Shatrunjaya Hill, Gujarat. Their ceilings and walls are covered with carvings of lotus blossoms, dancers, and musicians. The ascent to the summit takes more than two hours.*

PAGES 74–75: *Sikandra, or Akbar's tomb, set in a lush garden near Agra, is the last resting place of the Mughal emperor Akbar the Great. Its ceilings, richly decorated with fading stucco paintings in gold, blue, brown, and green, are almost unsurpassed in splendor by any other Mughal building.*

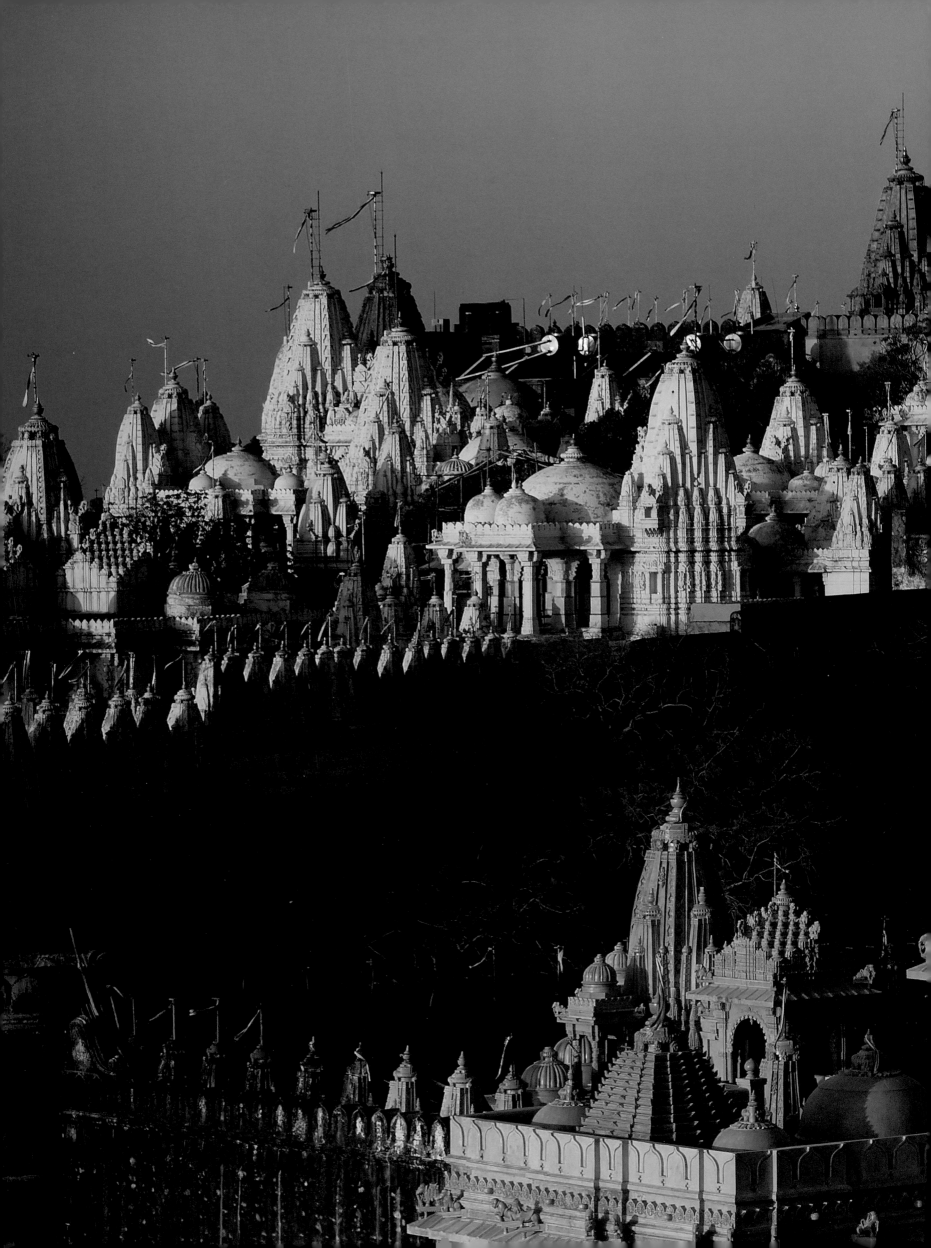

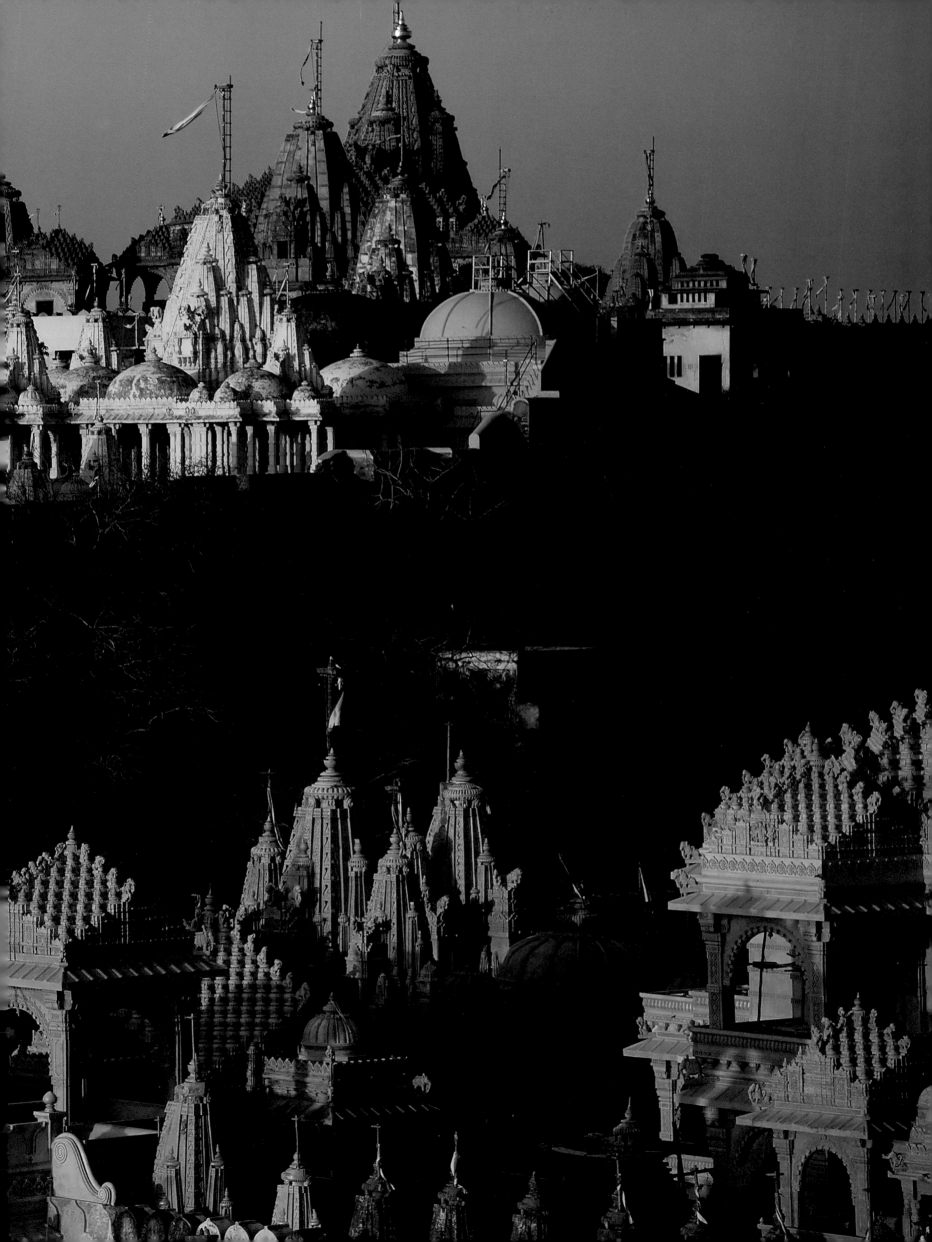

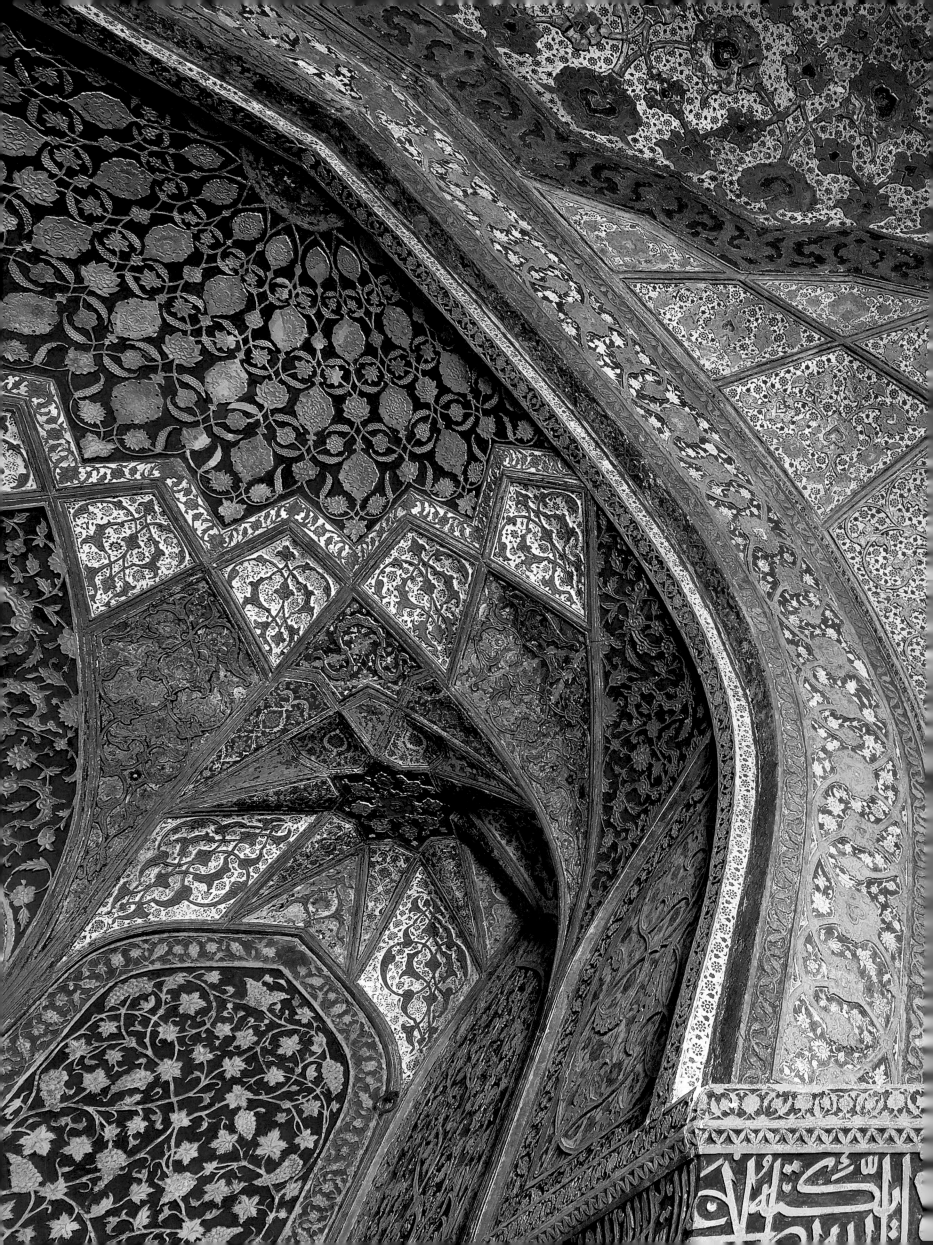

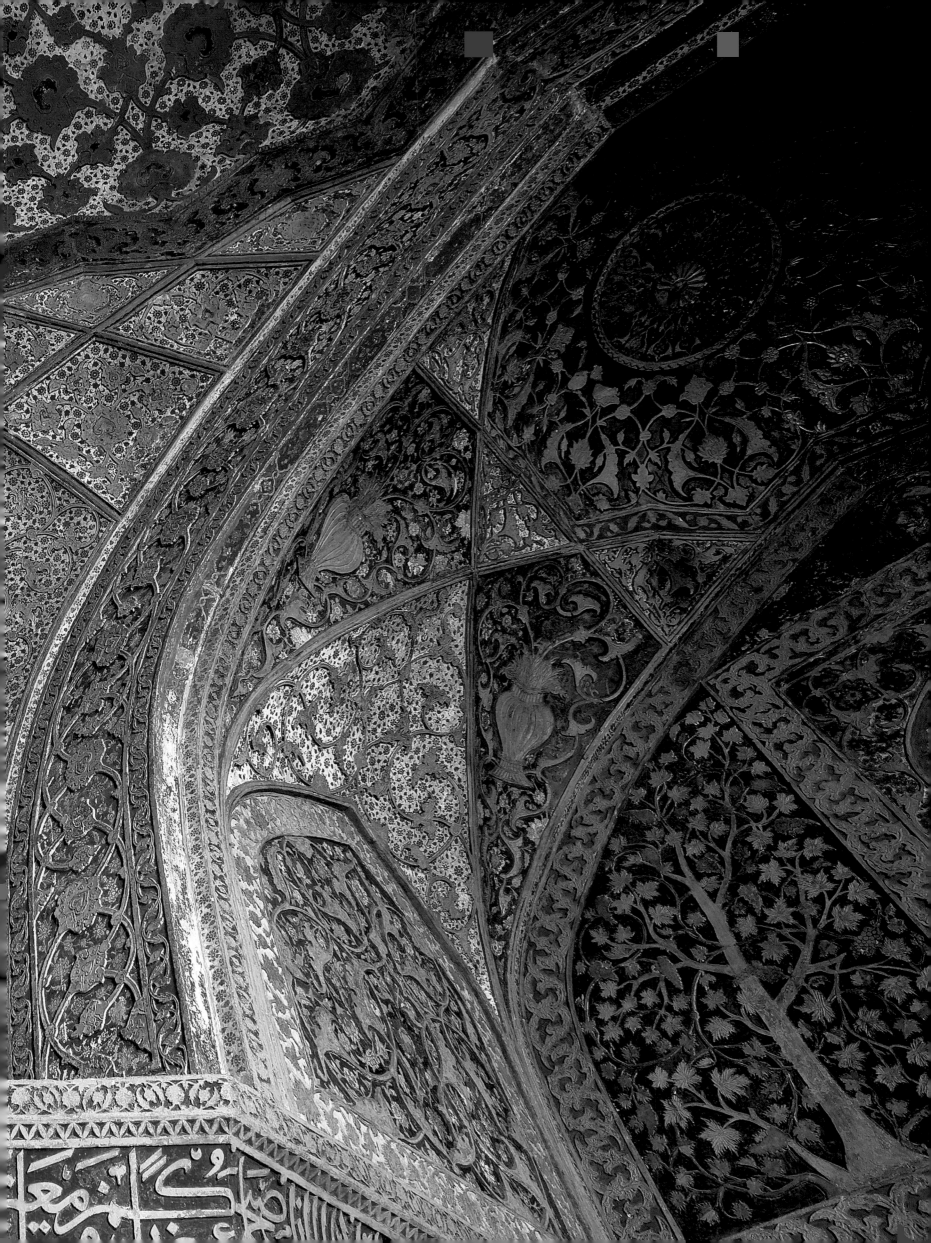

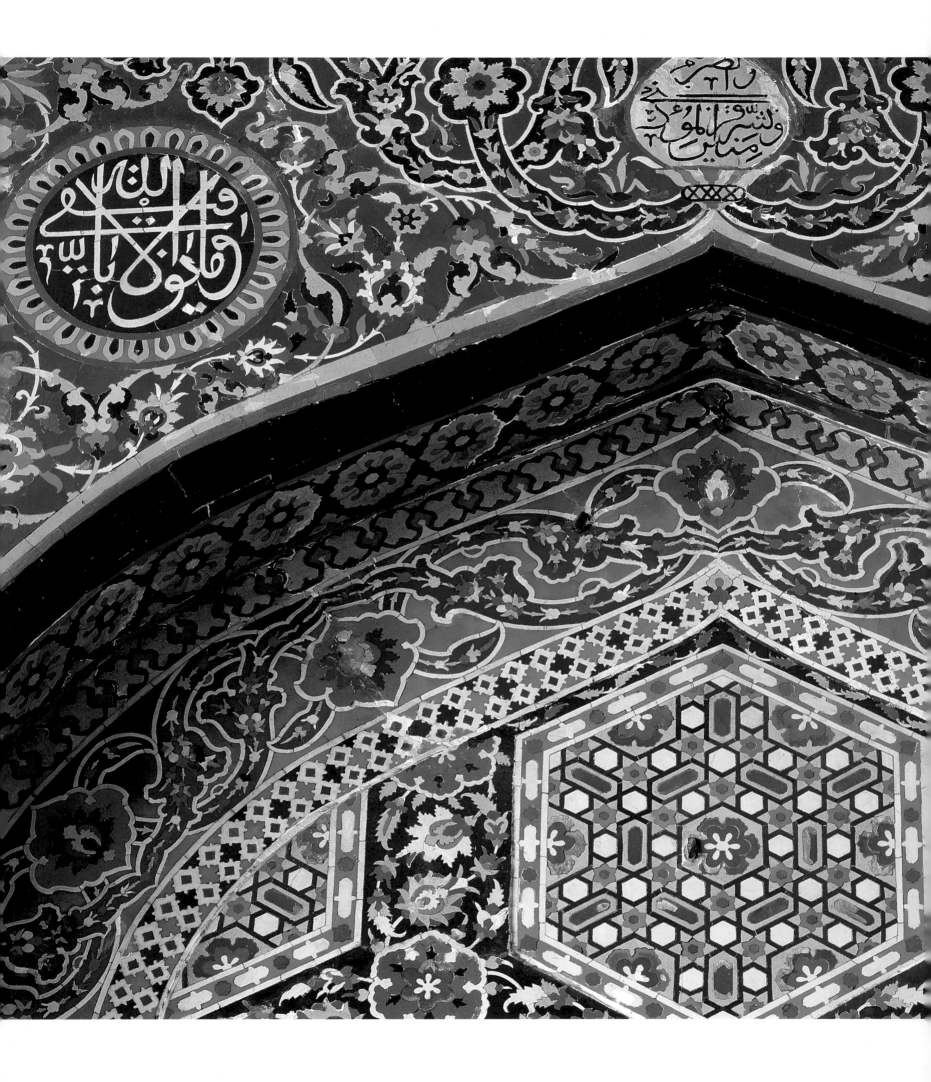

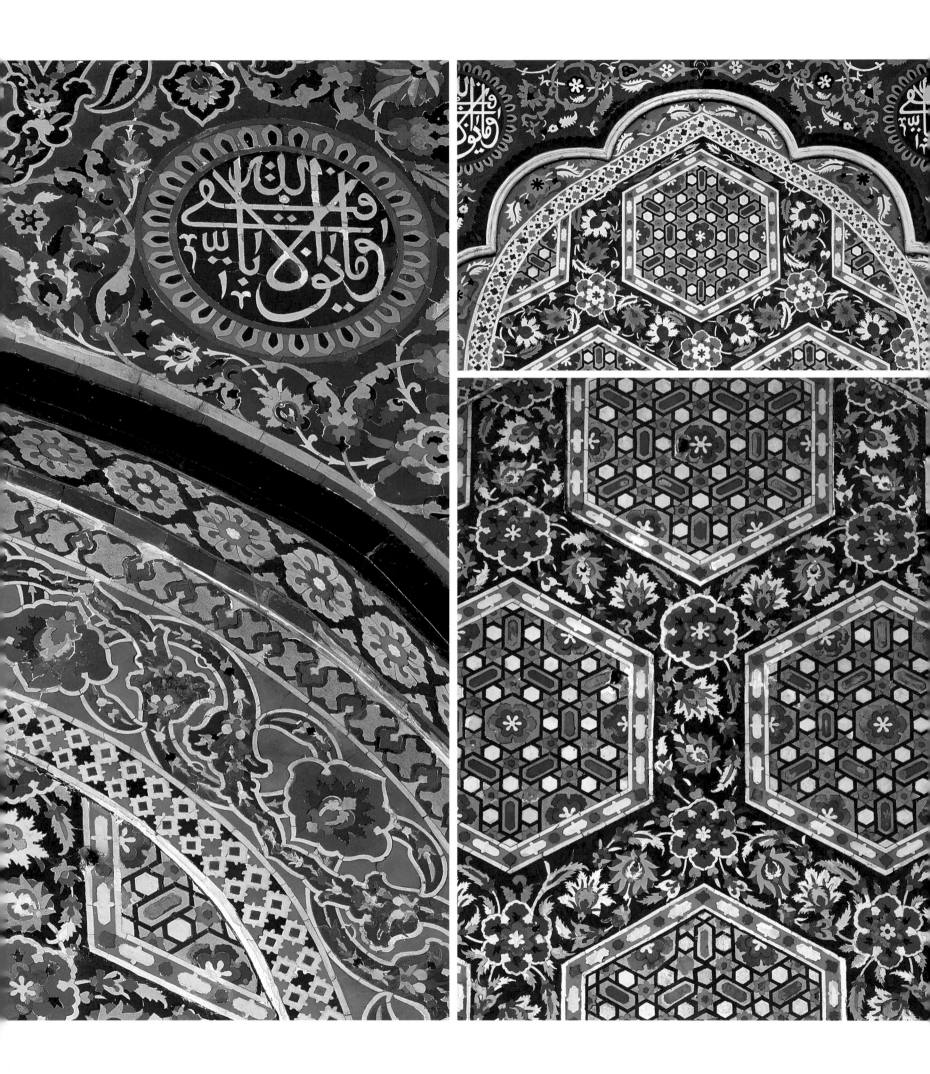

Intricate tiled mosaics adorn the niches of the fading Badshahi Ashurkhana, or "Royal House of Mourning," in Hyderabad, state of Andhra Pradesh. Mohammed Quli Qutb Shah built the structure in 1597 as a congregation hall for Shias.

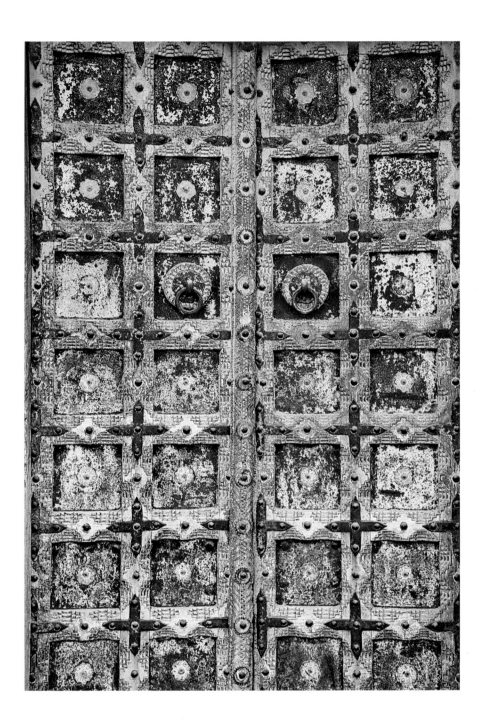

ABOVE: *This old weathered copper door is on a back street in the small town of Rohetgarh, in Rajasthan.*

OPPOSITE: *An intricately carved door in the town of Mandawa, in the Shekhawati region of Rajasthan.*

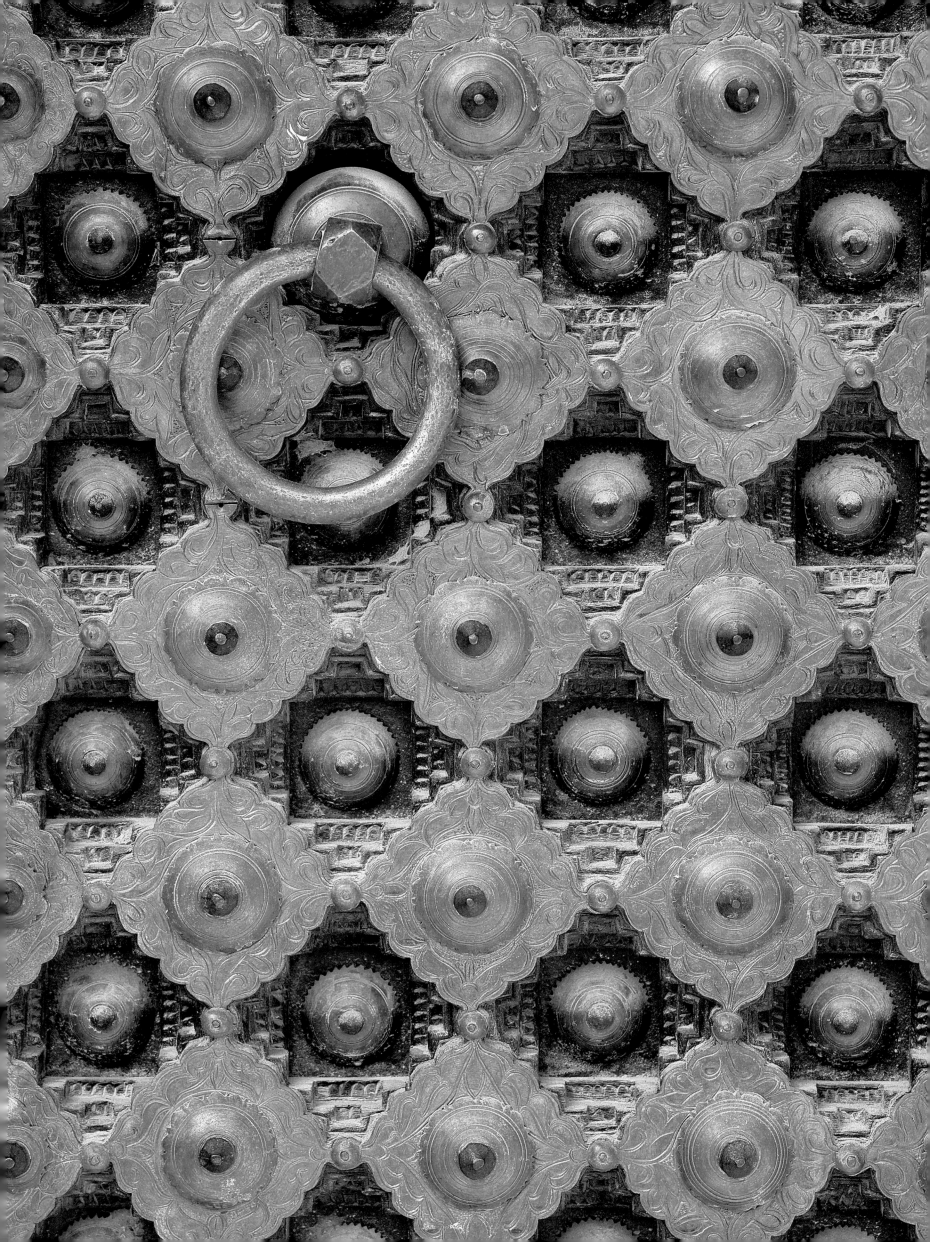

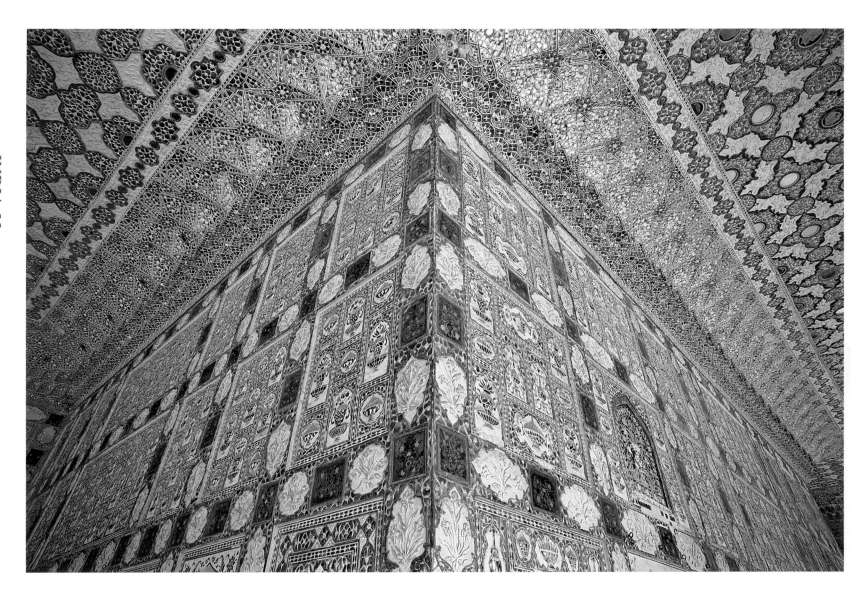

ABOVE: *The Amber Fort in Rajasthan, built in 1592, is one of the finest examples of Rajput architecture in existence. Perched high on a barren ridge, it commands extensive views of a deep, narrow valley. The Sheesh Mahal ("palace of mirrors") is named for its exquisitely inlaid mirrored walls.*

OPPOSITE: *Detail of the vaulted, mirrored ceiling of the Sheesh Mahal room of the 150-year-old Samode palace, which sits on a hilltop at the end of a dusty road an hour's drive from Jaipur. A magnificent example of Rajput-Mughal architecture, it boasts exquisite frescoes and mirror work.*

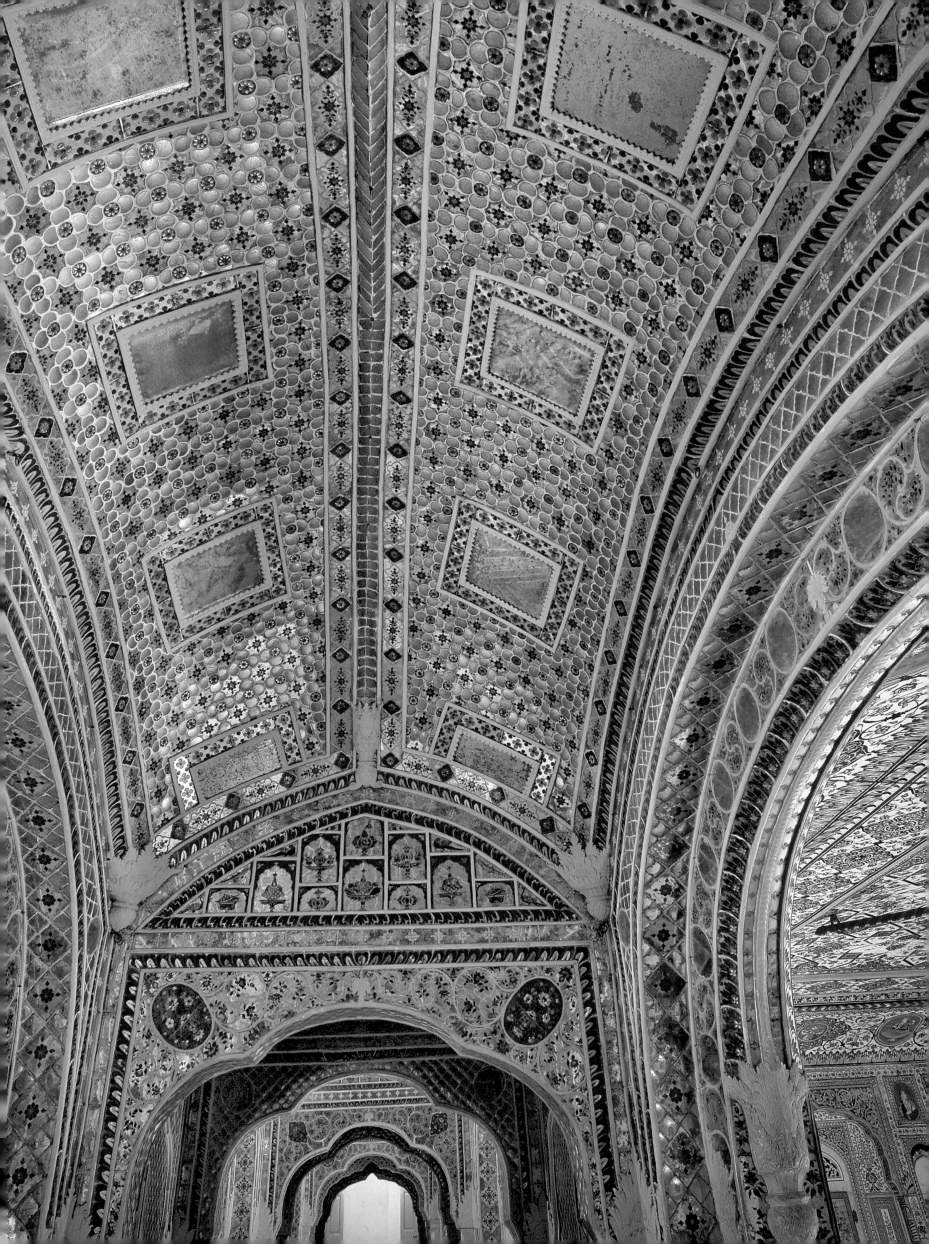

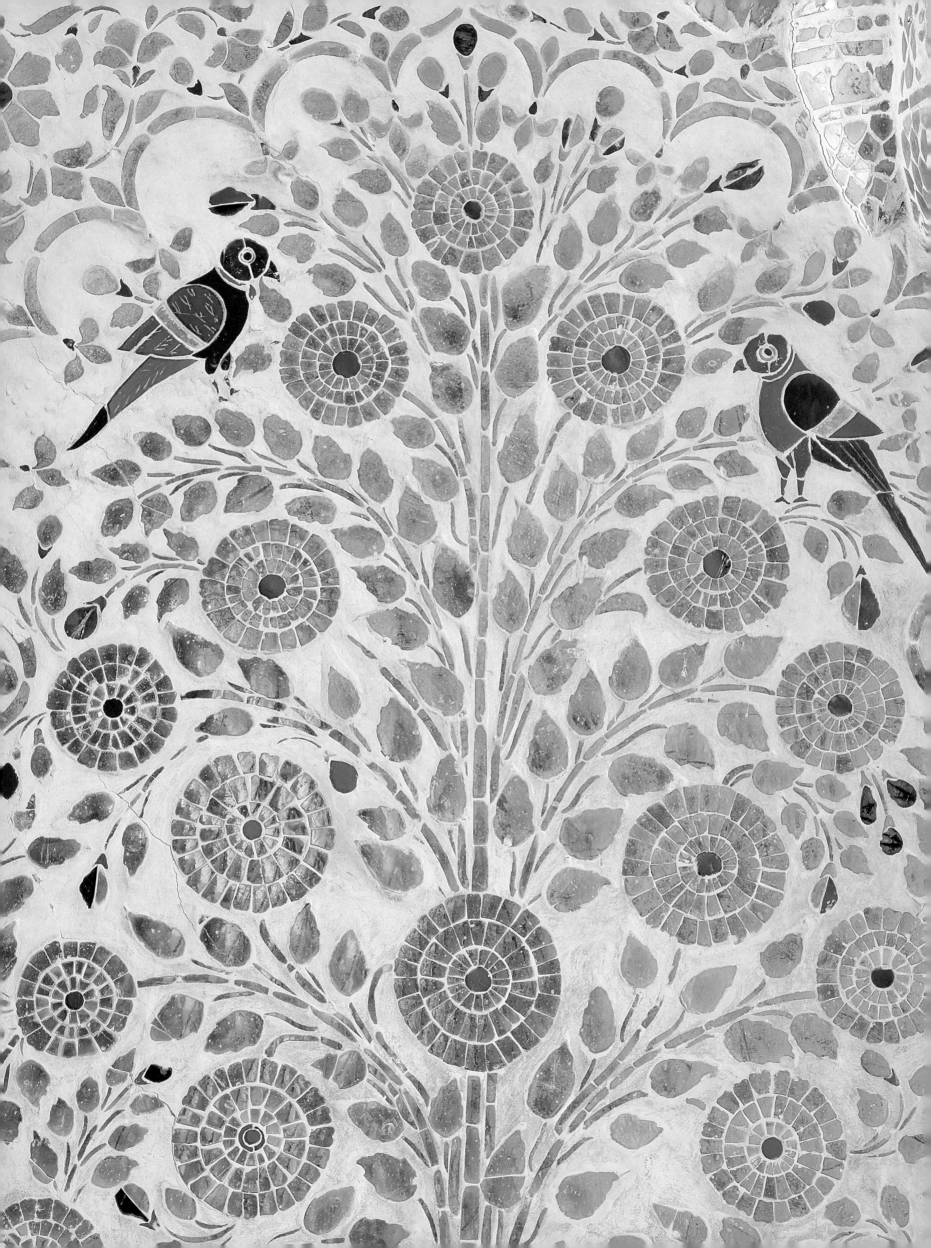

RAINY SEASON BEETLES flew by in many colors. From each hole in the floor came a mouse as if tailored for size, tiny mice from the tiny holes, big mice from big holes, and the termites came teeming forth from the furniture, so many of them that when you looked, the furniture, the floor, the ceiling, all seemed to be wobbling.

But Gyan did not see them. His gaze itself was a mouse; it disappeared into the belladonna sleeve of Sai's kimono and spotted her elbow.

"A sharp point," he commented. "You could do some harm with that."

Arms they measured and legs. Catching sight of her foot—

"Let me see."

He took off his own shoe and then the threadbare sock of which he immediately felt ashamed and which he bundled into his pocket. They examined the nakedness side by side of those little tubers in the semidark.

Her eyes, he noted, were extraordinarily glamorous: huge, wet, full of theater, capturing all the light in the room.

But he couldn't bring himself to mention them; it was easier to stick to what moved him less, to a more scientific approach.

With the palm of his hand, he cupped her head. . . .

"Is it flat or is it curved?"

With an unsteady finger, he embarked on the arch of an eyebrow. . . .

Oh, he could not believe his bravery; it drove him on and wouldn't heed the fear that called him back; he was brave despite himself. His finger moved down her nose.

The sound of water came from every direction: fat upon the window, a popgun off the bananas and the tin roof, lighter and messier on the patio stones, a low-throated gurgle in the gutter that surrounded the house like a moat. There was the sound of the *jhora* rushing and of water drowning itself in this water, of drainpipes disgorging into the rain barrels, the rain barrels brimming over, the little sipping sounds from the moss.

The growing impossibility of speech would make other intimacies easier.

As his finger was about to leap from the tip of Sai's nose to her perfectly arched lips—

Up she jumped.

"*Owwaaa*," she shouted.

He thought it was mouse.

It wasn't. She was used to mice.

"*Oooph*," she said. She couldn't stand a moment longer, that peppery feeling of being traced by another's finger and all that green romance burgeoning forth. Wiping her face bluntly with her hands, she shook out her kimono, as if to rid the evening of this trembling delicacy.

"Well, good night," she said formally, taking Gyan by surprise. Placing her feet one before the other with the deliberateness of a drunk, she made her way toward the door, reached the rectangle of the doorway, and dove into the merciful dark with Gyan's bereft eyes following her.

She didn't return.

But the mice did. It was quite extraordinary how tenacious they were—you'd think their fragile hearts would shatter, but their timidity was misleading; their fear was without memory.

—KIRAN DESAI, *THE INHERITANCE OF LOSS*

ABOVE: *An intricate marble tile peacock mosaic in the dining room of the Udai Bilas palace in Dungarpur, Rajasthan.*

OPPOSITE: *A detail of the spectacular inlaid glass and mirror work of the seven-story Juna Mahal palace, in Dungarpur. This masterpiece was built in the 13th century.*

PAGES 84–85: *The elaborately hennaed hand of a young woman at a wedding in Jaisalmer. In use since the 12th century, henna was brought to India by Arabic Muslims. Here the art form has blossomed into its own unique style, called* mehndi, *which is used on auspicious occasions. At a wedding, henna artwork symbolizes the love between husband and wife.*

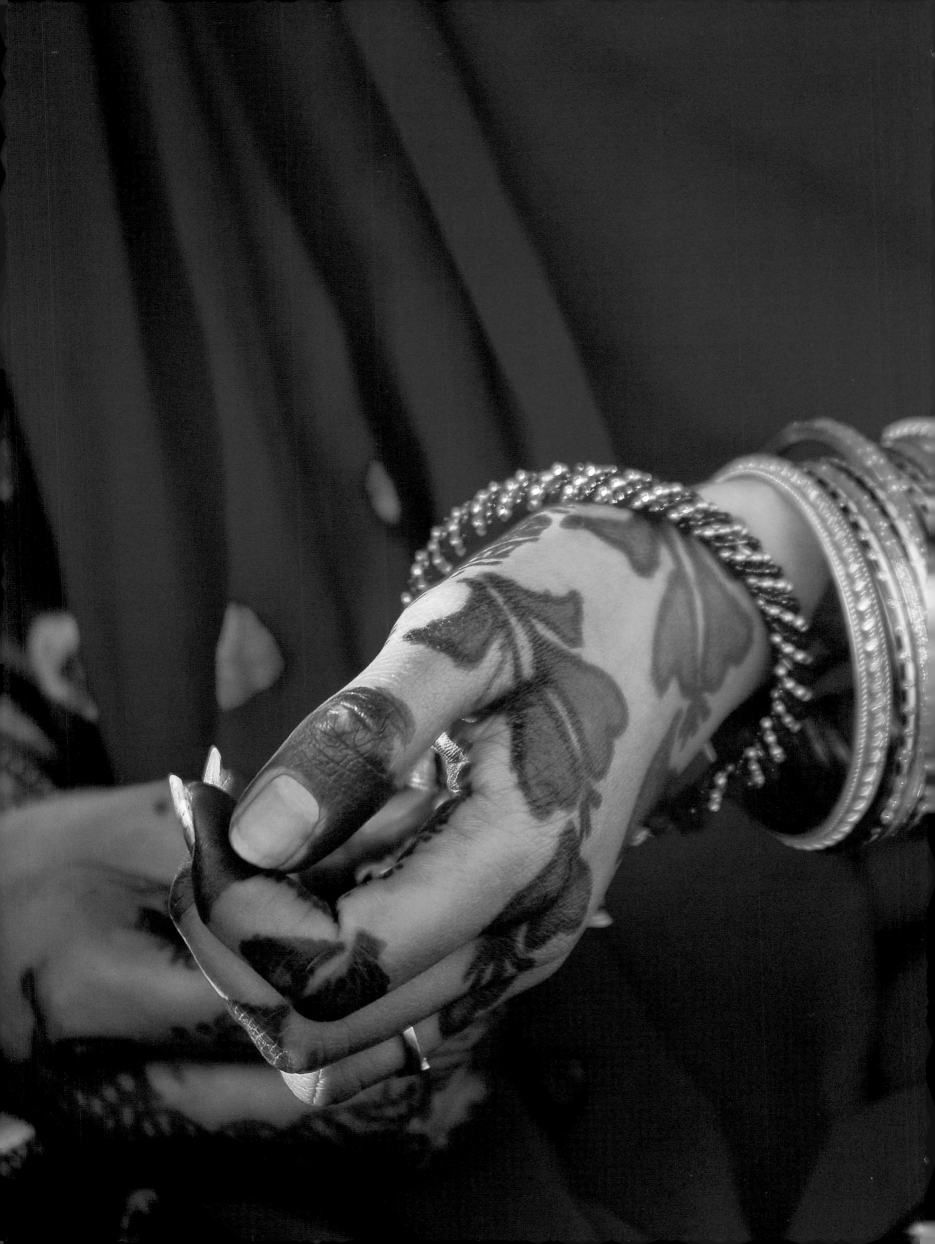

SOMEWHERE IN THE DARKNESS is a bevy of scents. It hovers beyond his reach. Perfumes perch along the periphery of his perception, flitting away at his approach. He follows a riddle of spice—cumin, or turmeric, perhaps—it flashes through the air and escapes without being caught. There are flowers here, and fruits, too, and the smell of mud and oil and rain.

When the gods descend, Vishnu knows, it is by their scents that he will recognize them. Ganesh will smell of the fruits he loves, Varuna will smell of the sea. River breezes will herald the arrival of Saraswati, Indra will bring the rain. Krishna will smell of all that's sweet, of milk and gur and tulsi. Of sandalwood and kevda flowers, of saffron, of ghee, of honey.

And Lakshmi. Lotuses will flower beneath her feet, scenting each step with their fragrance. Mangoes will turn the color of the sun, filling the world with their ripeness. Tulsi plants will wave in the wind, whispering their secrets to the air. The earth will stretch out, rich and fragrant, and await her touch against its skin.

Vishnu inhales, and the air is sweet with lotus. He thinks his senses are deceiving him, and inhales again. The scent is overpowering, as if thousands of flowers have opened, as if the steps, the walls, the ceiling, are all awash with blossoms. Mixed in with their sweetness is the spiciness of basil, barely detectable at first, but becoming more intense by the second, until that is all he smells, and he thinks that a million tulsi leaves are being rubbed between invisible fingers. And then come wafts of mango, waves that begin to wash over the tulsi, each swelling stronger than the one before, and redolent of all the different varieties he knows. Vishnu recognizes the wildness of Gola mangoes, the tartness of Langda, the cloying sweetness of Pyree, the perfect refinement of Alphonso. The perfume is so thick and potent that he can feel it press against his face. Except that now it is the earth his nostrils are pressed against, earth that is wet and aromatic, earth that smells sweet and loamy, with the pungency of dung mixed in. Vishnu inhales this new fragrance. It is the scent of the land, the scent of fertility, the scent that has existed since civilization began, and Vishnu marvels at its immutability.

And then all the scents he has smelled are upon him, blending together to form a new aroma, an aroma fruitful and flowerful and profound, that conveys unmistakable femininity. It is an aroma he has never before smelled, but recognizes instantly.

Vishnu looks up at the stairs leading into the darkness. Tonight is the night he will see his beloved. Tonight is the night that Lakshmi will descend.

—MANIL SURI, THE DEATH OF VISHNU

OPPOSITE: A tribal woman stands in the courtyard of her house near the town of Rohetgarh. Located near Jodhpur in a rural area of Rajasthan called the Marwar region, Rohetgarh was the fortified desert home of the descendants of the 16th-century Rathore clan.

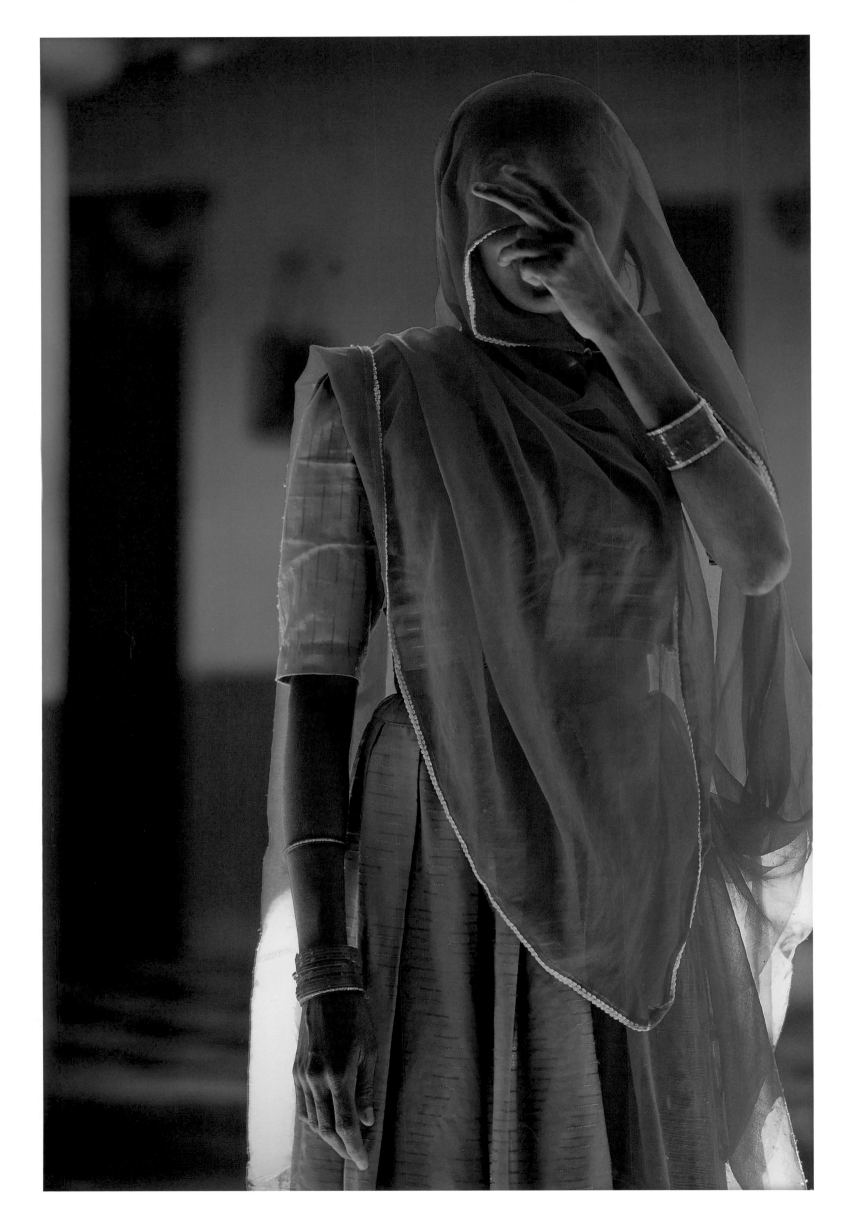

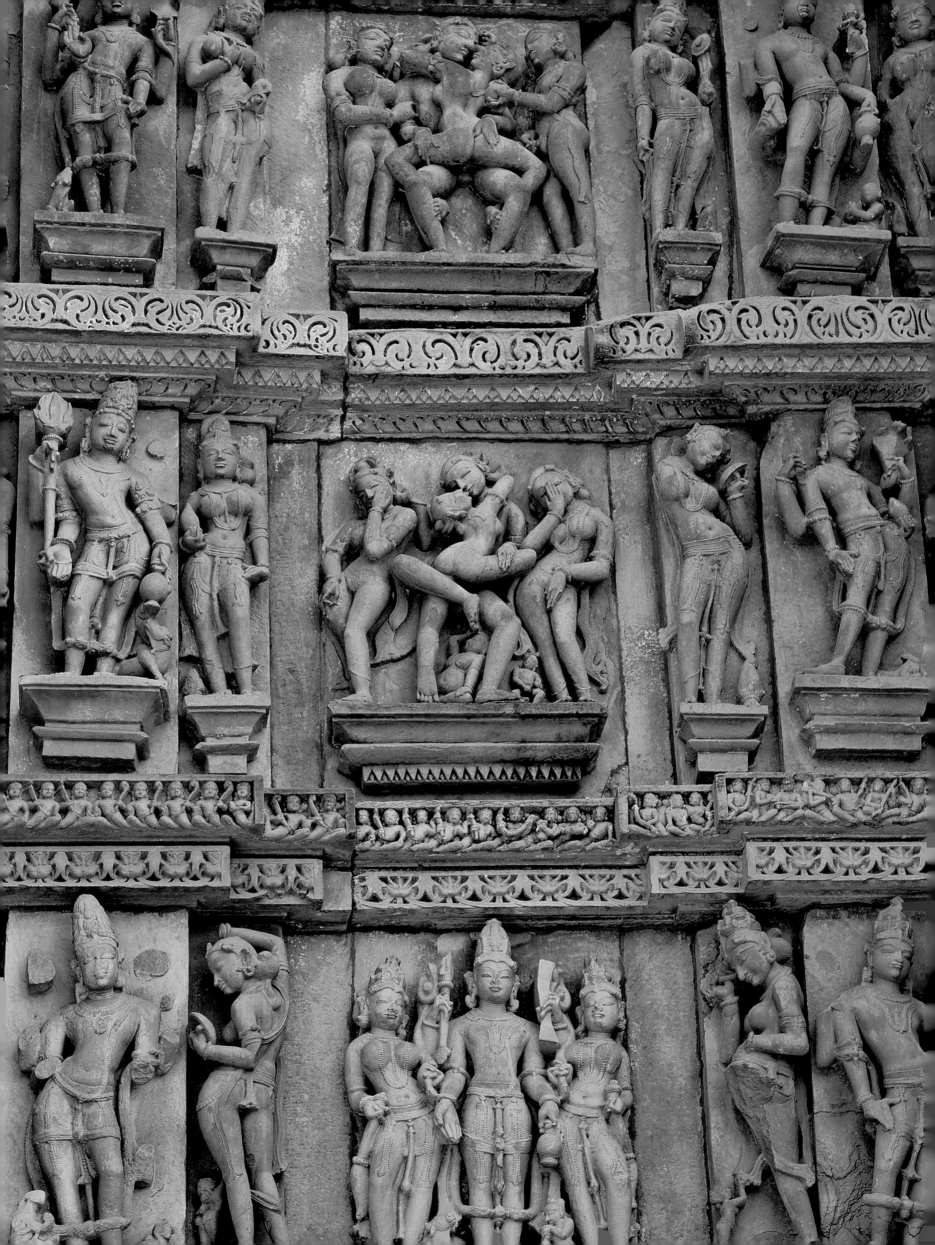

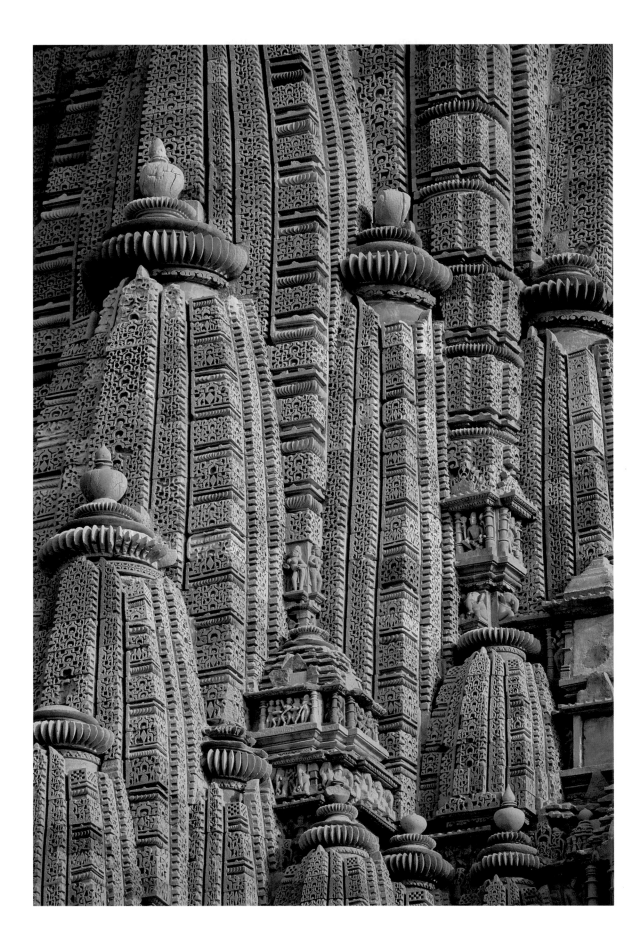

ABOVE: *The main shikhara, or spire, of Kandariya Mahadev, rises more than 90 feet, its 84 surrounding smaller spires symbolically creating an impression of Mount Kailash, the home of Shiva.*

OPPOSITE: *Detail of the erotic sculptures adorning the facades of the Kandariya Mahadev temple at Khajuraho, built during the 9th and 10th centuries in Madhya Pradesh. More than 800 sculptures of gods and goddesses cover the facade, but it is the erotic scenes for which Khajuraho is famous.*

PAGES 90–91: *Women gather at a wedding celebration in the small courtyard of a house near Jodhpur.*

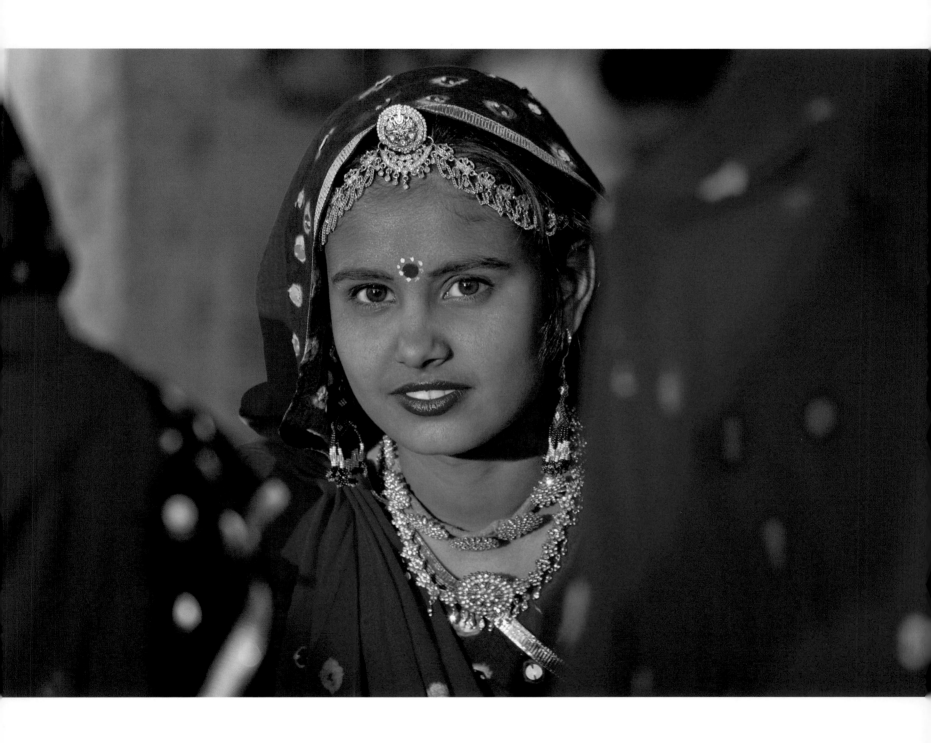

ABOVE AND OPPOSITE: *A shy young Rajput woman at the annual fair in Jaisalmer.*

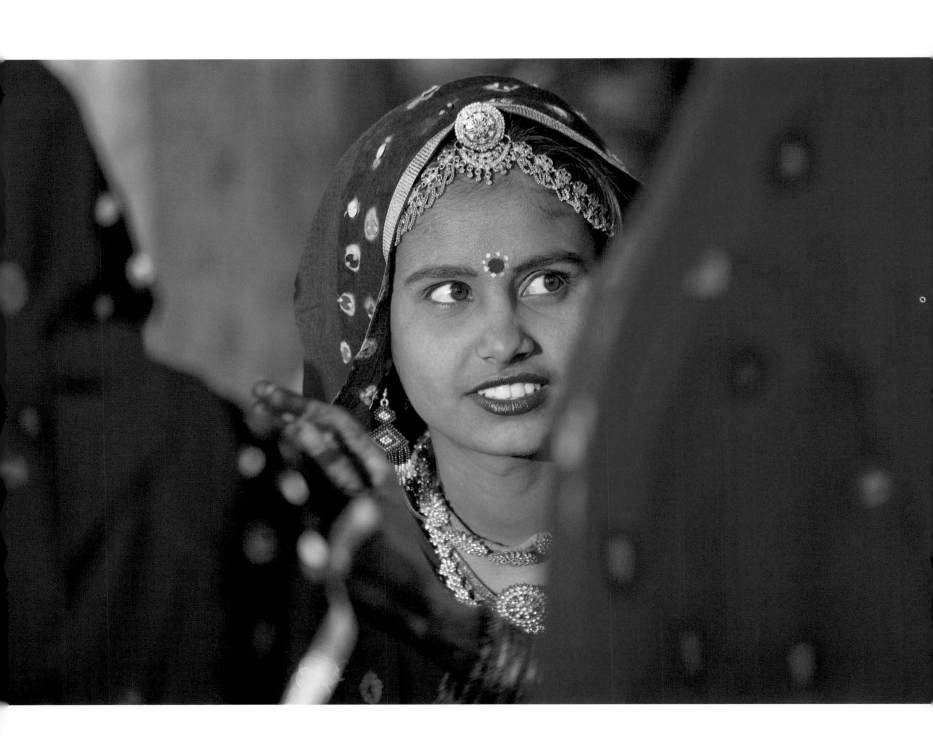

THIS COMMON INTEREST brought us close together. Wherever we were she kept talking to me on the various subtleties of the art, its technicalities, and explaining as to a child its idioms. She seemed to notice our surroundings less and less. In Gaffur's car as we sat she said, "You know what a *pallavi* is? The time scheme is all-important in it. It does not always run in the simple style of one-two, one-two; it gets various odds thrown in, and at a different tempo." She uttered its syllables, "Ta-ka-ta-ki-ta, Ta-ka." It amused me. "You know, to get the footwork right within those five or seven beats requires real practice, and when the tempo is varied . . ." This was something that Gaffur could safely overhear, as we went up the hill, as we came out of a shop, as we sat in a cinema. While seeing a picture, she would suddenly exclaim, "My uncle has with him a very old song written on a palm leaf. No one has seen it. My mother was the only person in the whole country who knew the song and could dance to it. I'll get that song too from my uncle. I'll show you how it goes. Shall we go back to our room? I don't want to see more of this picture. It looks silly."

We immediately adjourned to Room 28, where she asked me to remain seated, and went into the anteroom and came back with her dress tucked in and tightened up for the performance. She said, "I'll show you how it goes. Of course, I'm not doing it under the best of conditions. I need at least a drummer. . . . Move off that chair, and sit on the bed. I want some space here."

She stood at one end of the hall and sang the song lightly, in a soft undertone, a song from an ancient Sanskrit composition of a lover and lass on the banks of Jamuna; and it began with such a verve, when she lightly raised her foot and let it down, allowing her anklets to jingle, I felt thrilled. Though I was an ignoramus, I felt moved by the movements, rhythm, and time, although I did not quite follow the meaning of the words. She stopped now and then to explain: "*Nari* means girl—and *mami* is a jewel. . . . The whole line means: 'It is impossible for me to bear this burden of love you have cast on me.'" She panted while she explained. There were beads of perspiration on her forehead and lip. She danced a few steps, paused for a moment, and explained, "Lover means always God," and she took the trouble to explain further to me the intricacies of its rhythm. The floor resounded with the stamping of her feet. I felt nervous that those on the floor below might ask us to stop, but she never cared, never bothered about anything. I could see, through her effort, the magnificence of the composition, its symbolism, the boyhood of a very young god, and his fulfillment in marriage, the passage of years from youth to decay, but the heart remaining every fresh like a lotus on a pond. When she indicated the lotus with her fingers, you could almost hear the ripple of water around it. She held the performance for nearly an hour; it filled me with the greatest pleasure on earth. I could honestly declare that, while I watched her perform, my mind was free, for once, from all carnal thoughts; I viewed her as a pure abstraction. She could make me forget my surroundings. I sat with open-mouthed wonder watching her. Suddenly she stopped and hung her whole weight on me with "What a darling. You are giving me a new lease on life."

—R. K. NARAYAN, *THE GUIDE*

OPPOSITE AND PAGES 96–97: *Women perform the garba in the small village Chakra, in Gujarat state. This dance form is more similar to Western social dancing than are other Indian dances. Traditionally, the garba is performed during a nine-day festival called Navarati, which celebrates a good harvest and is dedicated to Durga, the Mother goddess. Hinduism is the only religion in the world that emphasizes the motherhood of God to such an extent.*

PAGES 98–99: *Women singing on the way home on a road in Rajasthan. They carry their food in small three-tiered metal containers called Tiffin boxes.*

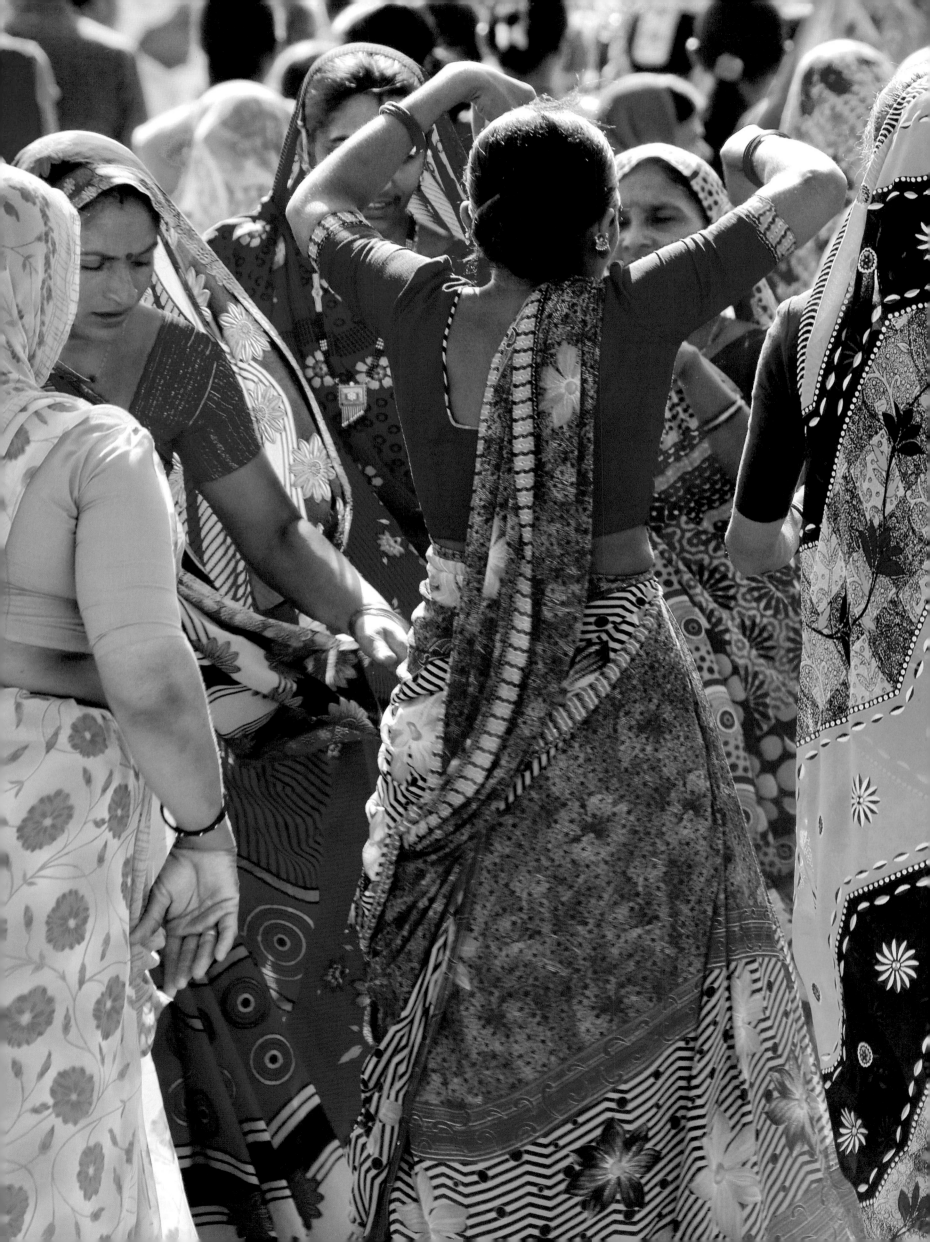

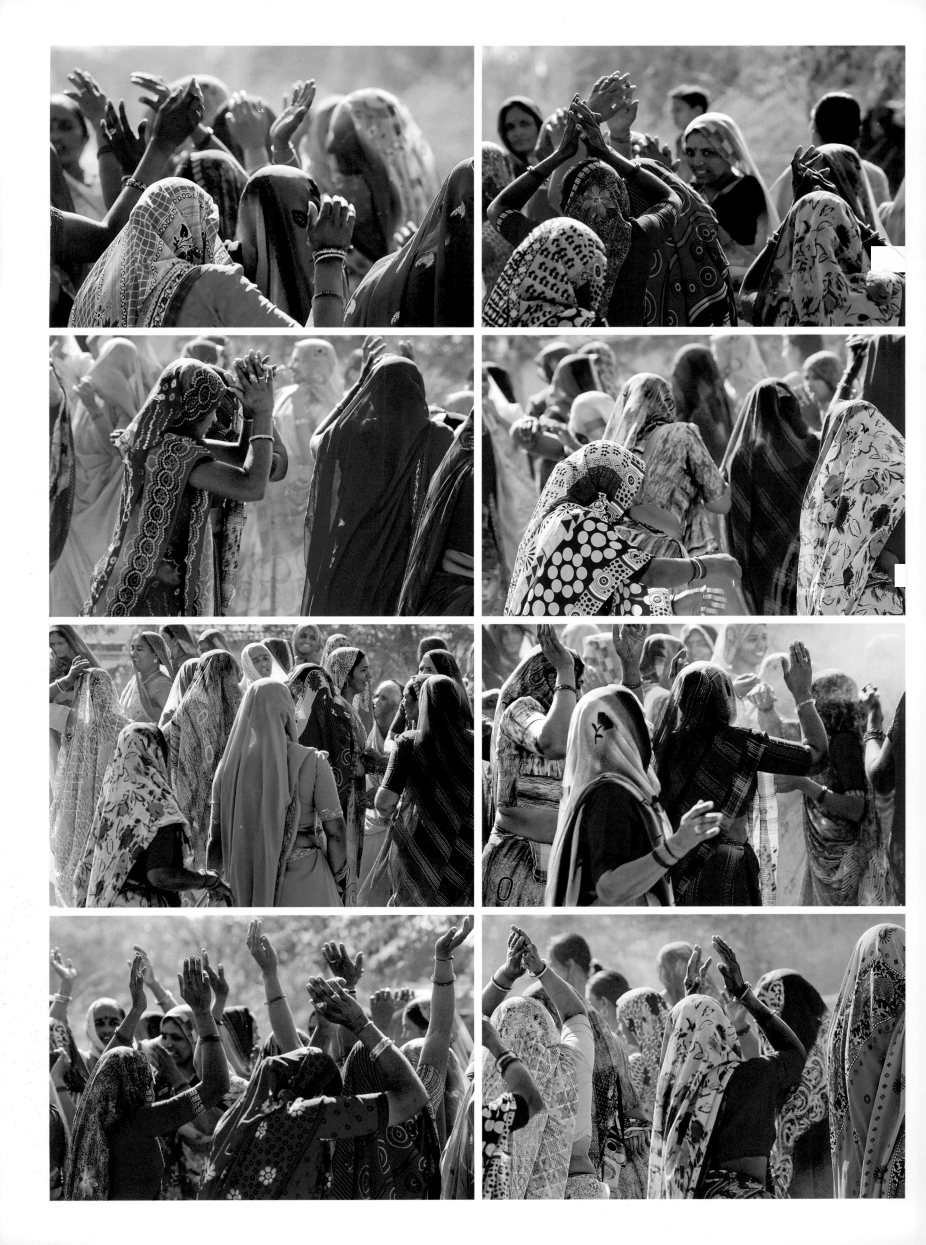

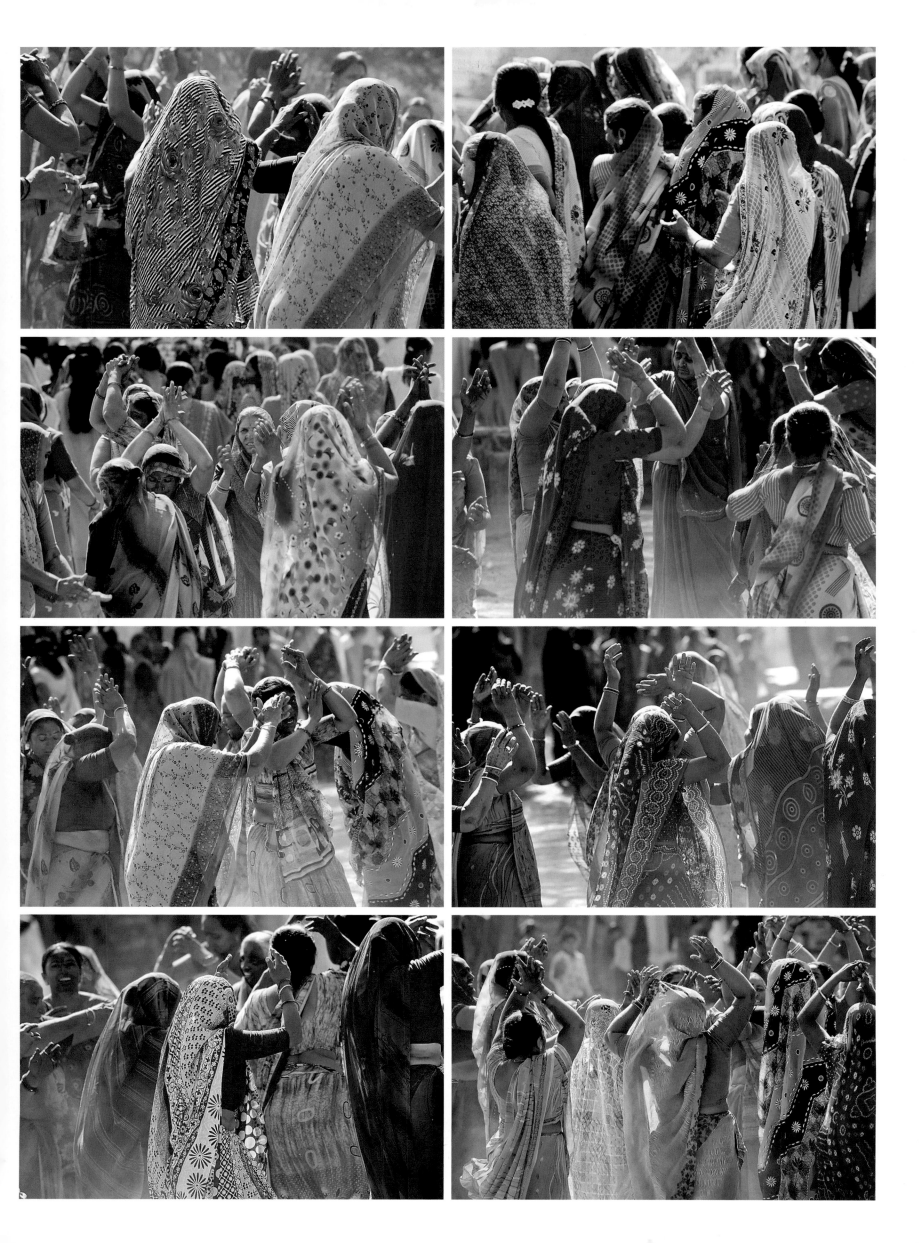

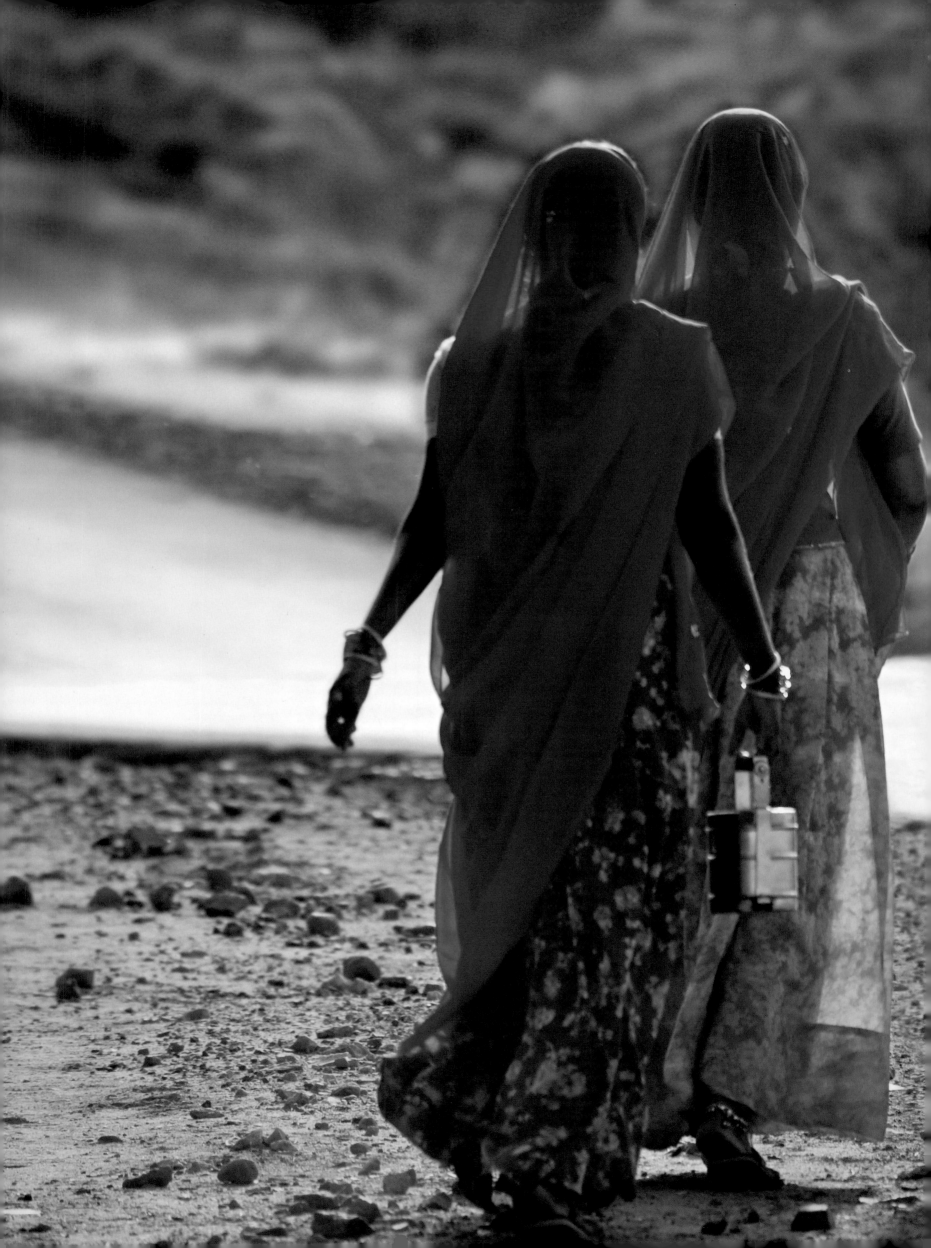

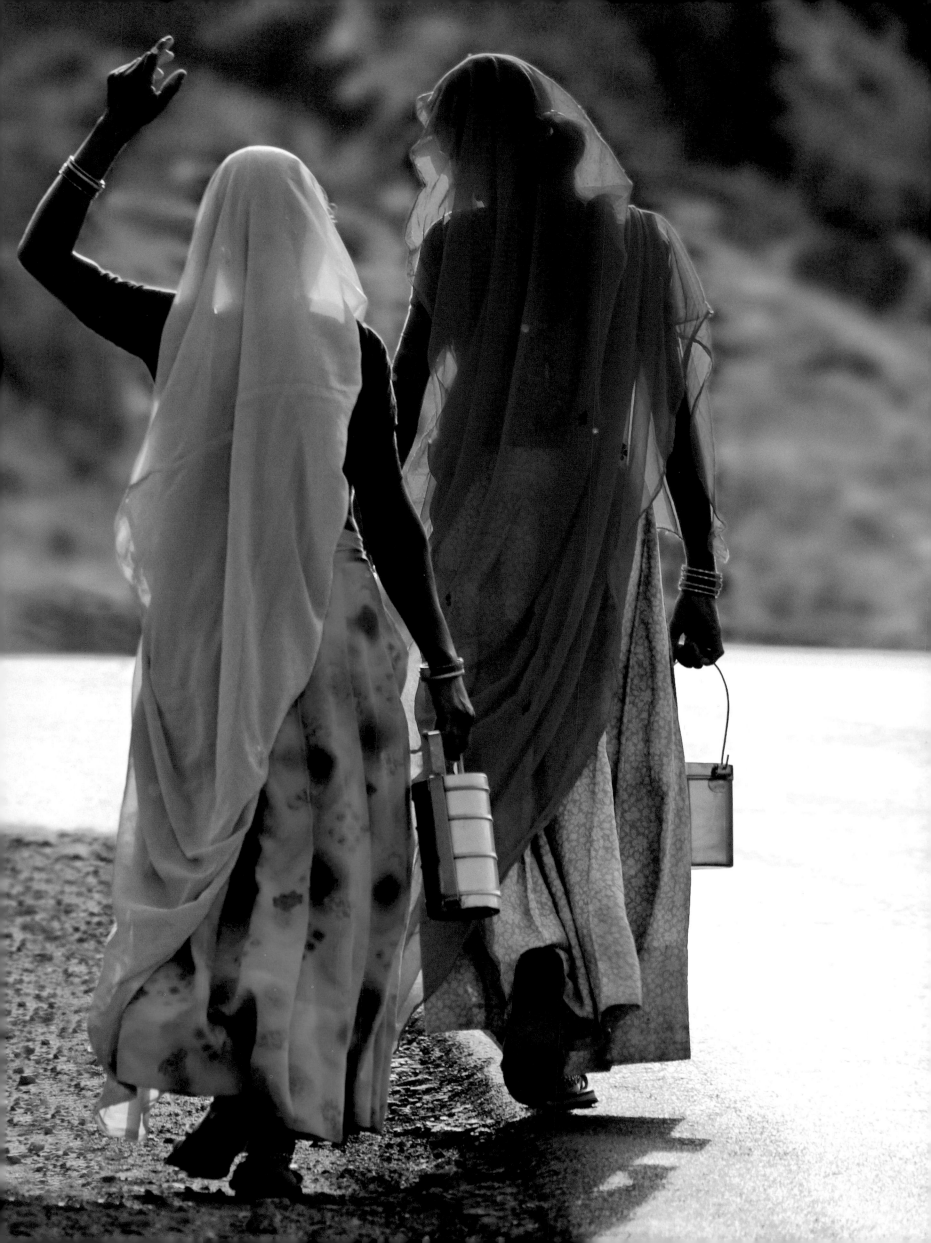

The Housewife
Ruth Prawer Jhabvala

She had her music lesson very early in the morning before anyone else was awake. She had it up on the roof of the house so no one was disturbed. By the time the others were up, she had already cooked the morning meal and was supervising the cleaning of the house. She spent the rest of the day in seeing to the family and doing whatever had to be done, so no one could say that her music in any way interfered with her household duties. Her husband certainly had no complaints. He wasn't interested in her singing but indulged her in it because he knew it gave her pleasure. When his old aunt, Phuphiji, who lived with them, hinted that it wasn't seemly for a housewife, a matron like Shakuntala, to take singing lessons, he ignored her. He was good at ignoring female relatives, he had had a lot of practice at it. But he never ignored Shakuntala. They had been married for twenty-five years and he loved her more year by year.

It wasn't because of anything Phuphiji said but because of him, who said nothing, the Shakuntala sometimes felt guilty. And because of her daughter and her little grandson. She loved all of them, but she could not deny to herself that her singing meant even more to her than her feelings as wife and mother and grandmother. She was unable to explain this, she tried not to think of it. But it was true that with her music she lived in a region where she felt most truly, most deeply herself. No, not herself, something more and higher than that. By contrast with her singing, the rest of her day, indeed of her life, seemed insignificant. She felt this to be wrong but there was no point in trying to struggle against it. Without her hour's practice in the morning, she was as if deprived of food and water and air.

One day her teacher did not come. She went on the roof and practiced by herself but it was not the same thing. By herself she felt weak and faltering. She *was* weak and faltering, but when he was there it didn't matter so much because he had such strength. . . .

It was a relief to her when her husband came home, for he was the one person who was always satisfied with her. Unlike the others, he wasn't interested in her secret thoughts. For him it was enough that she dressed up nicely before

his arrival home and oiled her hair and adorned it with a wreath of jasmine. She was in her early forties but plump and fresh. She loved jewelry and always wore great quantities of it, even in the house. Her arms were full of bangles, she had a diamond nose ring and a gold necklace around her smooth, soft neck. Her husband liked to see all that; and he liked her to stand beside him to serve him his meal, and then to lie next to him on the bed while he slept. That night he fell asleep as usual after eating large helpings of food. He slept fast and sound, breathing loudly, for he was a big man with a lot of weight on him. Sometimes he tossed himself from one side to the other with a grunt. Then Shakuntala gently patted him as if to soothe him; she wanted him to be always entirely comfortable and recognized it to be her mission in life to see that he was. When she fell asleep herself, she slept badly and was disturbed by garbled dreams.

But the next morning the teacher was there again. He wasn't ill at all anymore, and when she inquired after his health, he shrugged as if he had forgotten there had ever been anything wrong with it. She sang so well that day that even he was satisfied—at least he didn't make the sour face he usually wore while listening to her. As she sang, her irritation and anxiety dissolved and she felt entirely clear and happy. The sky was translucent with dawn and birds woke up and twittered like fresh gurgling water. No one else was up in the whole neighborhood, only she and the teacher and the birds. She sang and sang, her voice rose high and so did her heart; sometimes she laughed with enjoyment and saw that in response the shadow of a smile flitted over the teacher's features as well. Then she laughed again and her voice rose—with what ease—to even greater feats. And the joy that filled her at her own achievement and the peace that entered into her with that pure clear dawn, these sensations stayed with her for the rest of the day. She polished all the mirrors and brass fittings with her own hands, and afterward she cooked sweet vermicelli for her husband, which was his favorite dish. Phuphiji, at once aware of her change of mood, was suspicious and followed her around as she had done the previous day and looked at her in the same suspicious way; but today Shakuntala didn't mind, in fact she even laughed at Phuphiji within herself.

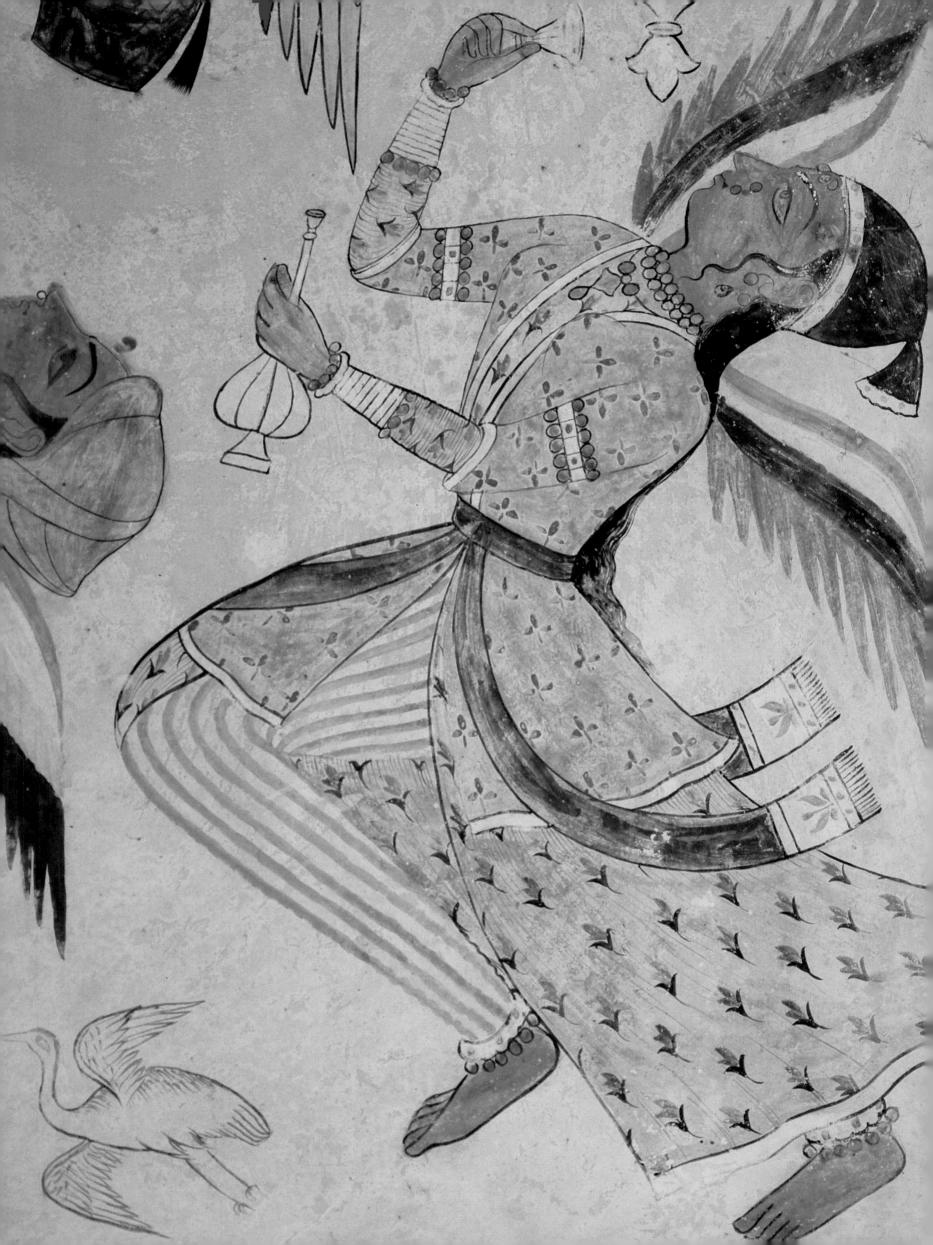

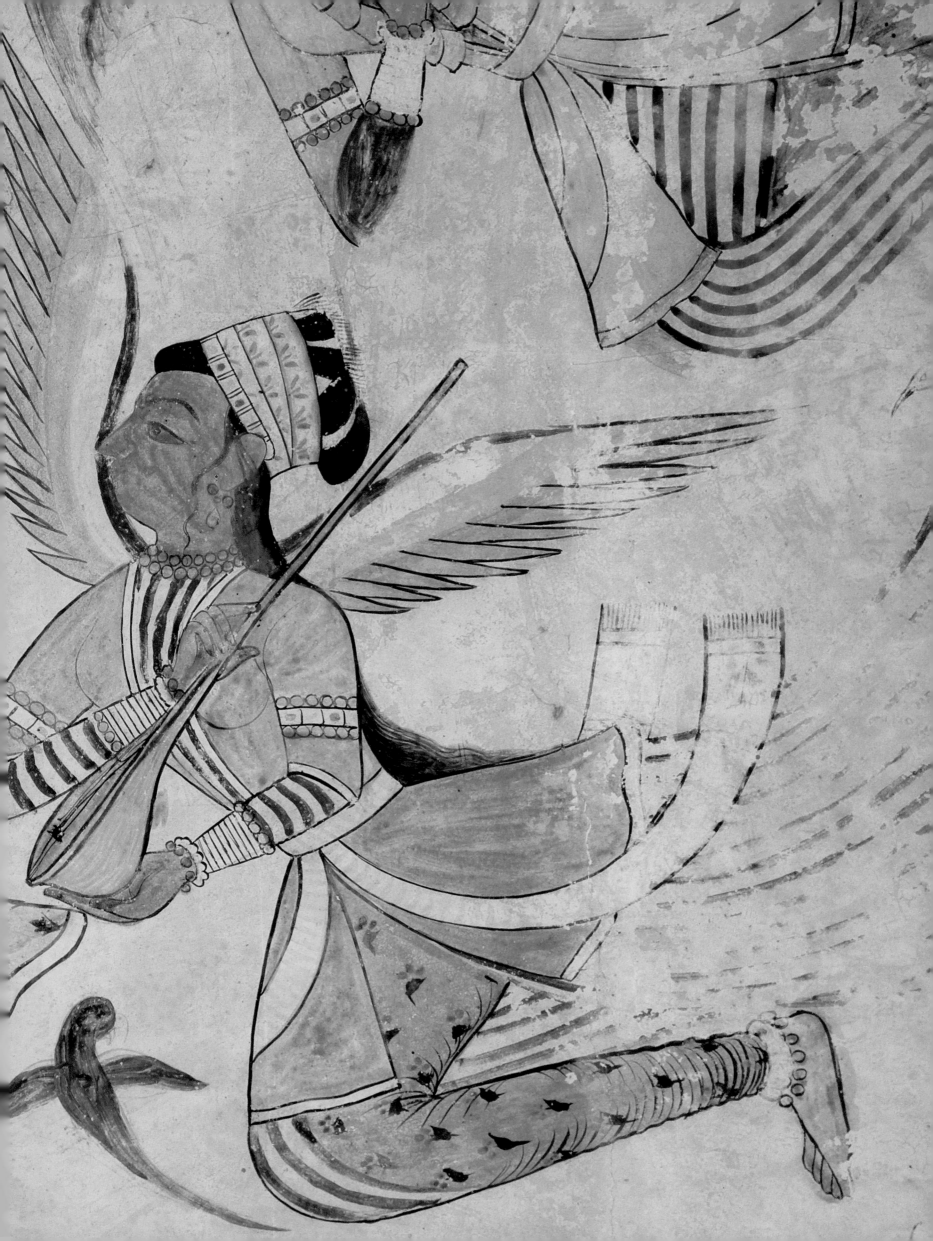

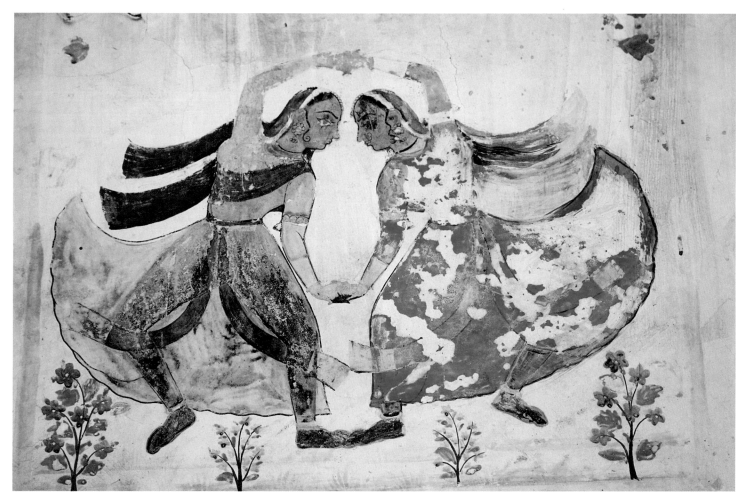

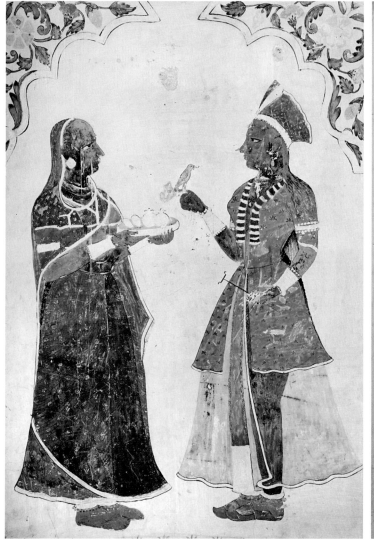

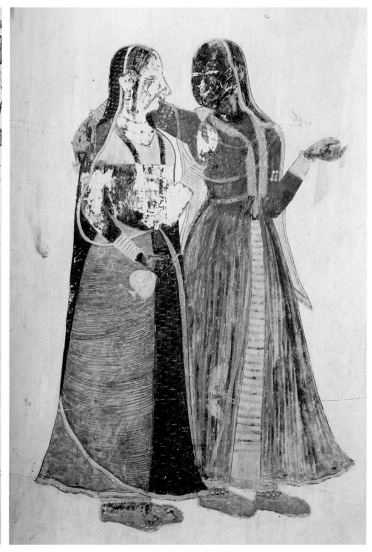

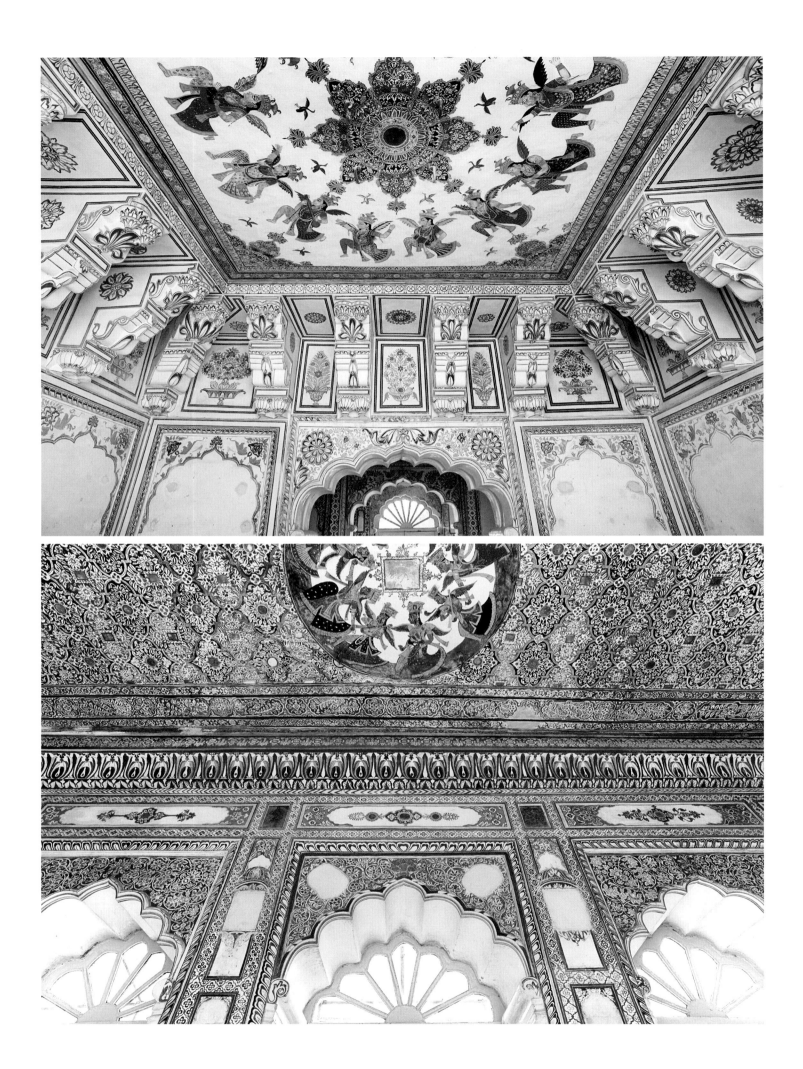

PAGES 102–103, ABOVE, AND OPPOSITE: *The Rajput- and Mughal-influenced palaces and buildings of the 12th-century Ahichhatragarh Fort in Nagaur, located halfway between Bikaner and Jodhpur, contain some of India's most remarkable frescoes. Nagaur was a strategic trade center.*

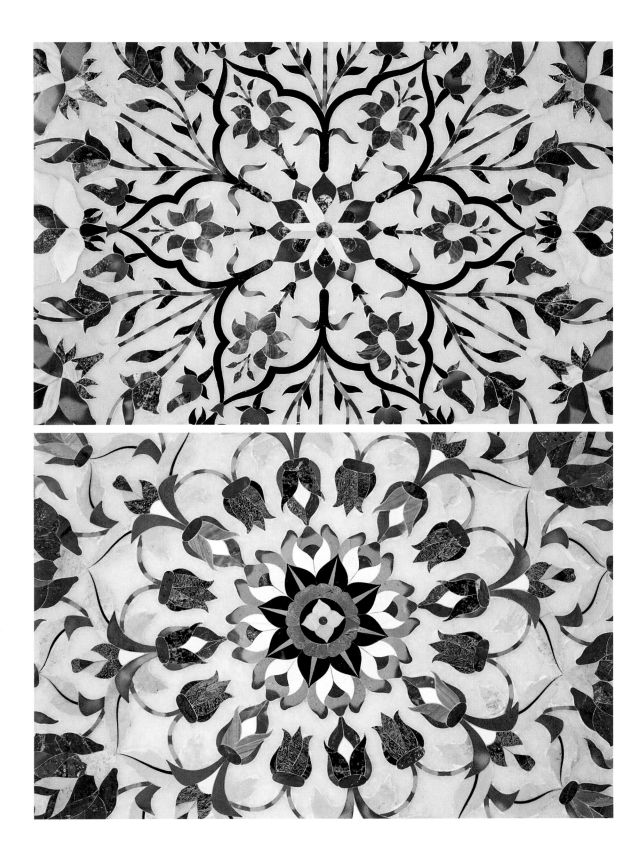

ABOVE AND OPPOSITE: *Intricate inlaid mosaic marble work is used throughout India, not only in building but also in other ways. Precious and semi-precious stones, such as cornelian, topaz, mother of pearl, coral, and lapis lazuli, are shaped and set in shallow chases carved in the marble. The most frequently used decorative motif is the arabesque. Agra, in Uttar Pradesh, remains a thriving center for marble work.*

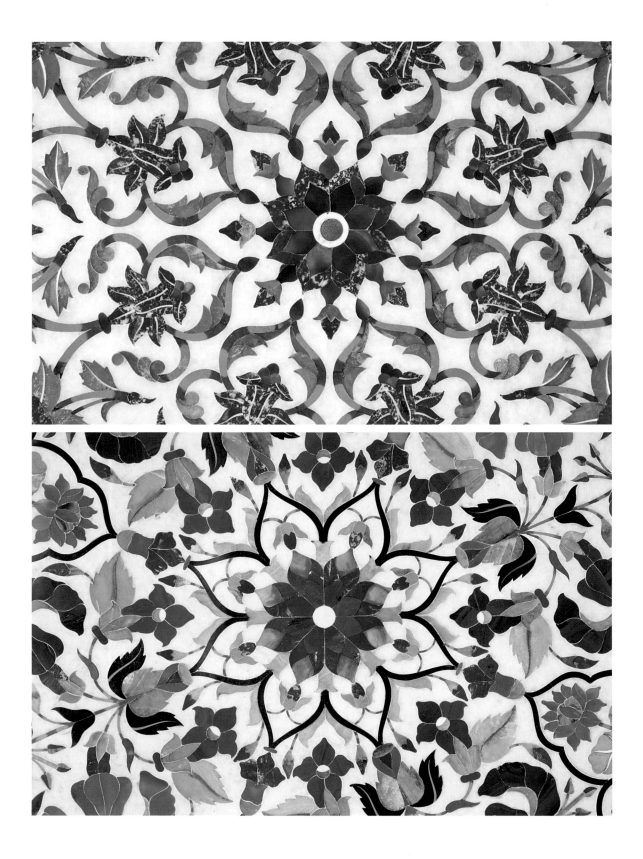

PAGES 108–109: *Ceiling of a cupola of the Ganesh Pol, the spectacular three-story Mughal entryway to the Amber Fort, near Jaipur. It was built in 1640 by Jai Singh I.*

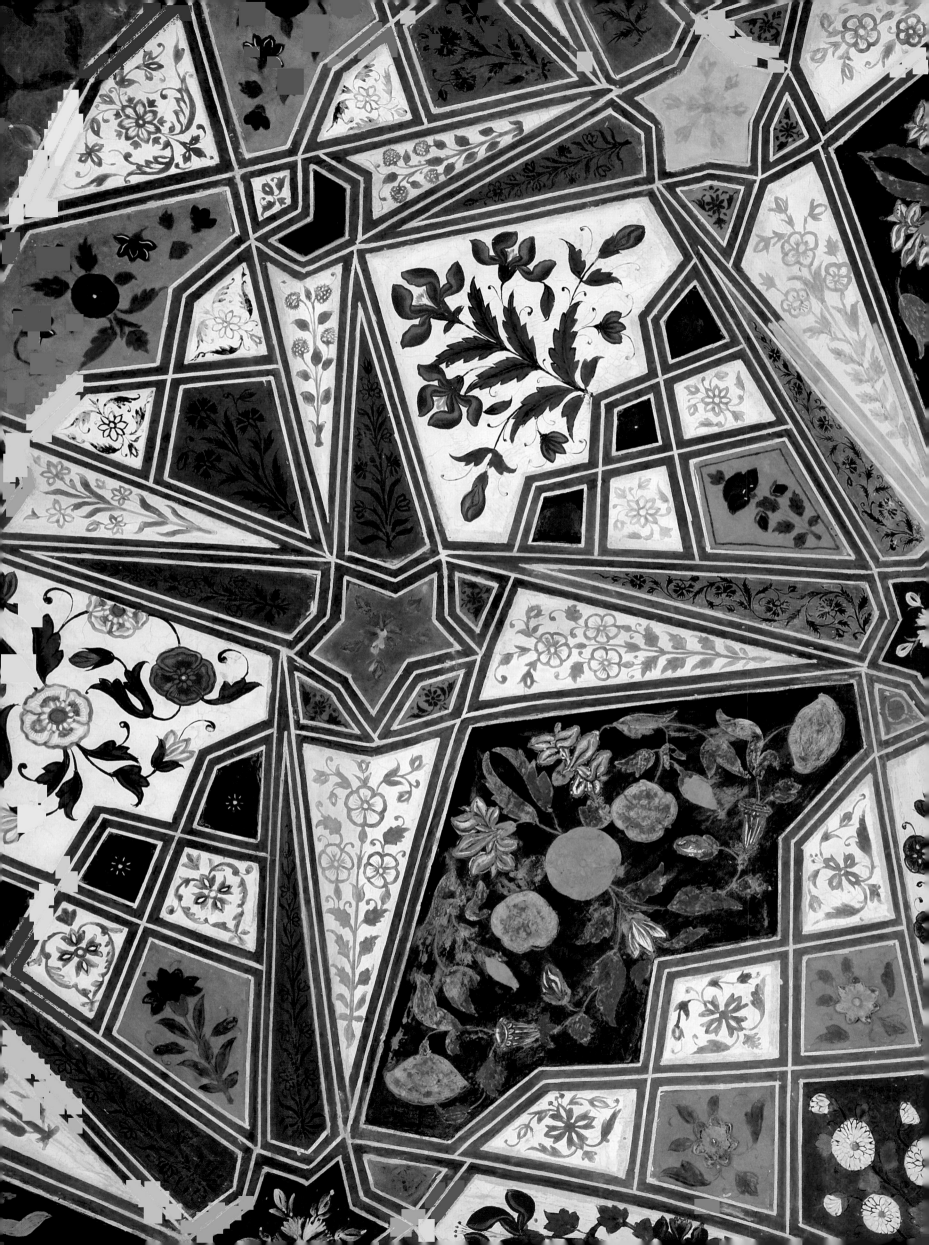

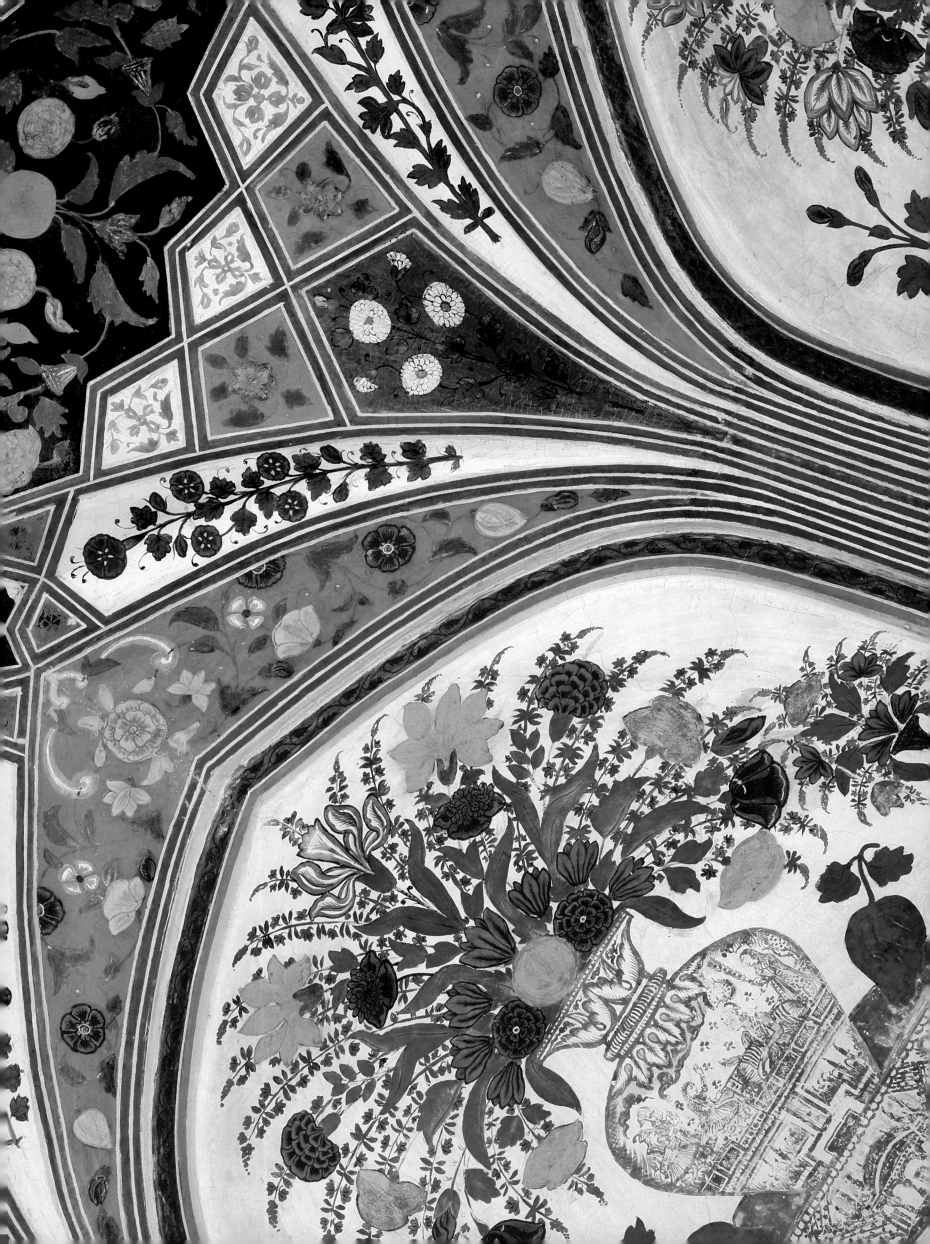

INTERPRETER OF MALADIES
JHUMPA LAHIRI

THEY REACHED KONARAK AT TWO-THIRTY. The temple, made of sandstone, was a massive pyramid-like structure in the shape of a chariot. It was dedicated to the great master of life, the sun, which struck three sides of the edifice as it made its journey each day across the sky. Twenty-four giant wheels were carved on the north and south sides of the plinth. The whole thing was drawn by a team of seven horses, speeding as if through the heavens. As they approached, Mr. Kapasi explained that the temple had been built between A.D. 1243 and 1255, with the efforts of twelve hundred artisans, by the great ruler of the Ganga dynasty, King Narasimhadeva the First, to commemorate his victory against the Muslim army.

"It says the temple occupies about a hundred and seventy acres of land," Mr. Das said, reading from his book.

"It's like a desert," Ronny said, his eyes wandering across the sand that stretched on all sides beyond the temple.

"The Chandrabhaga River once flowed one mile north of here. It is dry now," Mr. Kapasi said, turning off the engine.

They got out and walked toward the temple, posing first for pictures by the pair of lions that flanked the steps. Mr. Kapasi led them next to one of the wheels of the chariot, higher than any human being nine feet in diameter.

"'The wheels are supposed to symbolize the wheel of life,'" Mr. Das read. "'They depict the cycle of creation, preservation, and achievement of realization.' Cool." He turned the page of his book. "'Each wheel is divided into eight thick and thin spokes, dividing the day into eight equal parts. The rims are carved with designs of birds and animals, whereas the medallions in the spokes are carved with women in luxurious poses, largely erotic in nature.'"

What he referred to were the countless friezes of entwined naked bodies, making love in various positions, women clinging to the necks of men, their knees wrapped eternally around their lovers' thighs. In addition to these were assorted scenes from daily life, of hunting and trading, of deer being killed with bows and arrows and marching warriors holding swords in their hands.

It was no longer possible to enter the temple, for it had filled with rubble years ago, but they admired the exterior, as did all the tourists Mr. Kapasi brought there, slowly strolling along each of its sides. Mr. Das trailed behind, taking pictures. The children ran ahead, pointing to figures of naked people, intrigued in particular by the Nagamithunas, the half-human, half-serpentine couples who were said, Mr. Kapasi told them, to live in the deepest waters of the sea. Mr. Kapasi was pleased that they liked the temple, pleased especially that it appealed to Mrs. Das. She stopped every three or four paces, staring silently at the carved lovers, and the processions of elephants, and the topless female musicians beating on two-sided drums. . . .

"Who's that?" Mrs. Das asked. He was startled to see that she was standing beside him.

"He is the Astachala-Surya," Mr. Kapasi said. "The setting sun."

"So in a couple of hours the sun will set right here?" She slipped a foot out of one of her square-heeled shoes, rubbed her toes on the back of her other leg.

"That is correct."

She raised her sunglasses for a moment, then put them back on again. "Neat."

Mr. Kapasi was not certain exactly what the word suggested, but he had a feeling it was a favorable response. He hoped that Mrs. Das had understood Surya's beauty, his power. Perhaps they would discuss it further in their letters. He would explain things to her, things about India, and she would explain things to him about America. In its own way this correspondence would fulfill his dream, of serving as an interpreter between nations. He looked at her straw bag, delighted that his address lay nestled among its contents. When he pictured her so many thousands of miles away he plummeted, so much so that he had an overwhelming urge to wrap his arms around her, to freeze with her, even for an instant, in an embrace witnessed by his favorite Surya. But Mrs. Das had already started walking.

PAGES 112–113: *Detail of the gopura, or temple gateway, at the Adikumbheshvara temple at Kumbakonam, state of Tamil Nadu. It is entirely covered in thousands of stucco figures of deities, mythical animals, and monsters painted in vivid colors.*

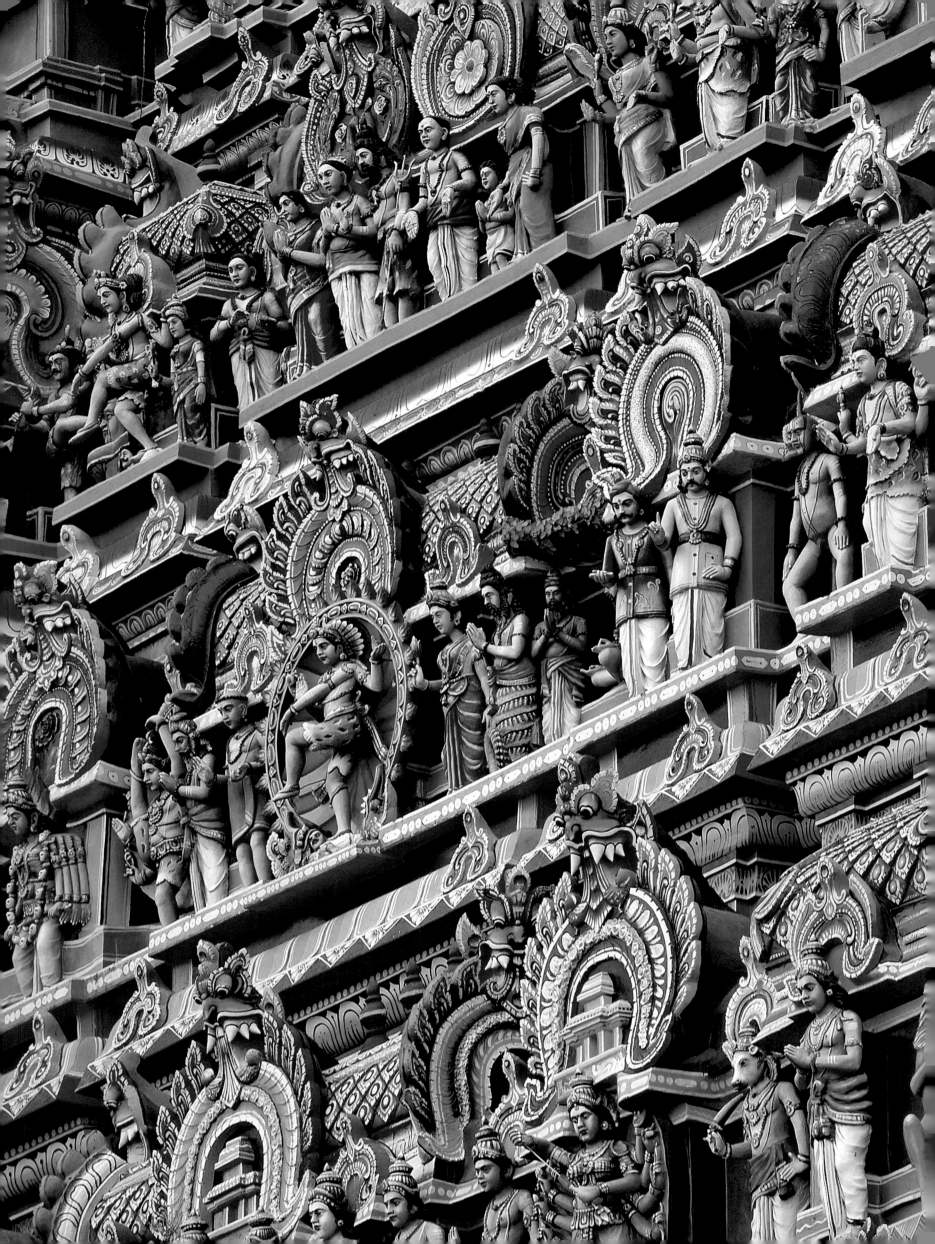

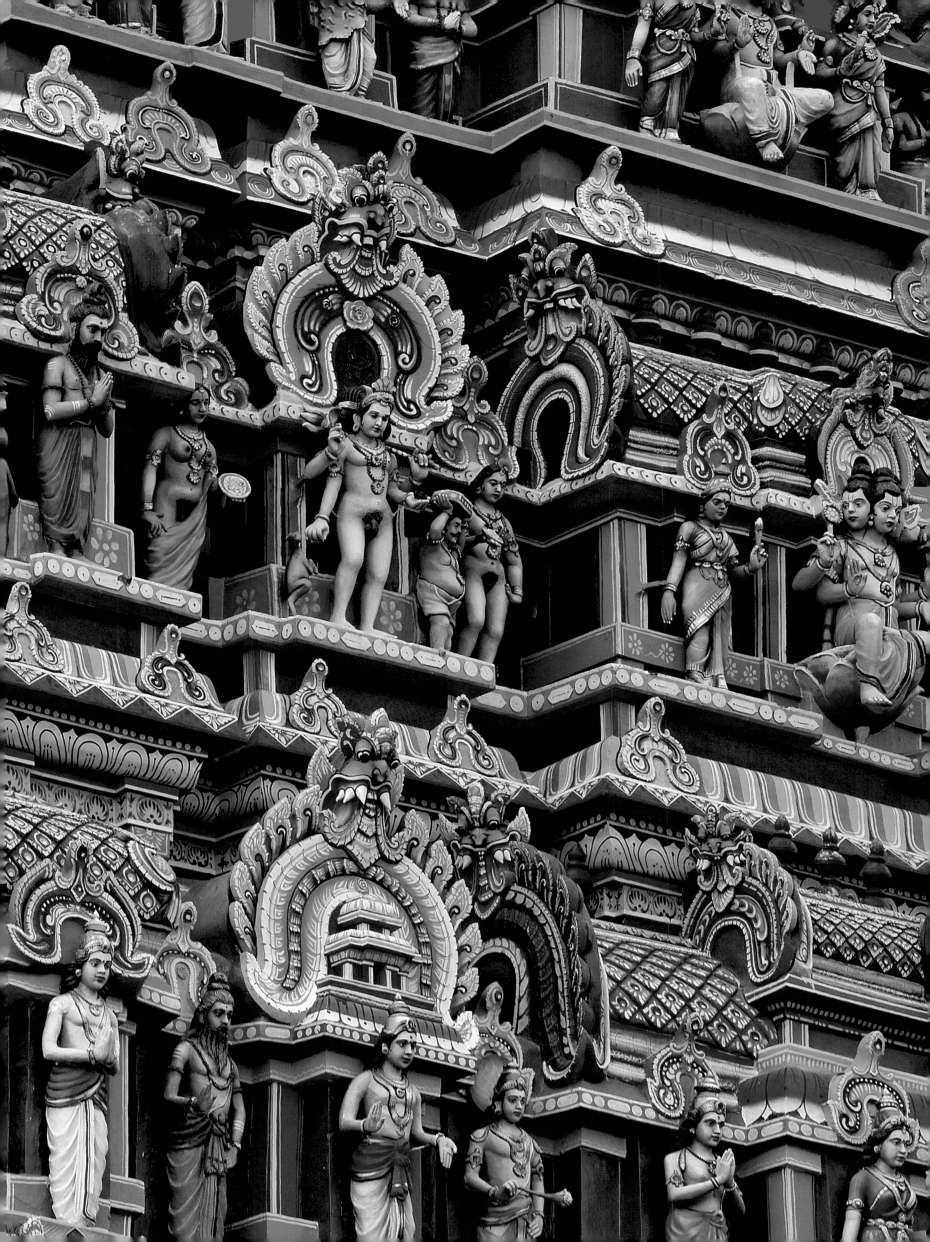

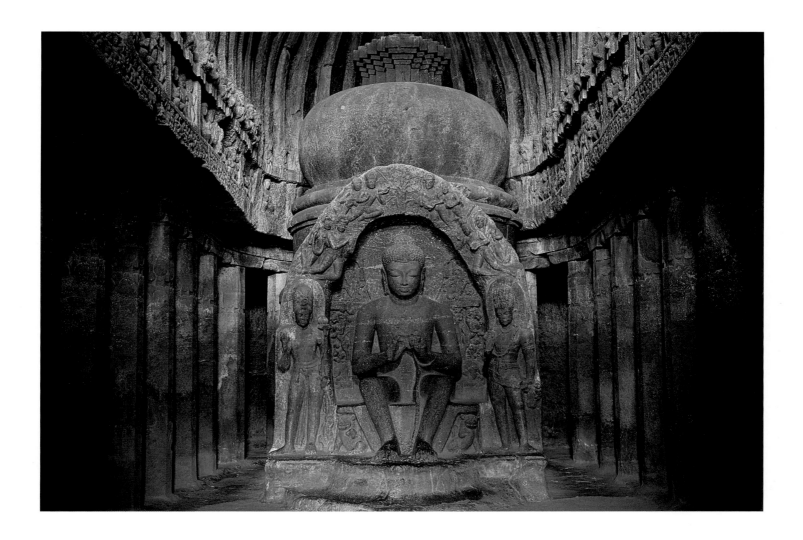

ABOVE: *Dating from the seventh century, this rock-cut figure of the Teaching Buddha in front of a votive stupa is in Cave 10 at Ellora. Well over thirty caves are carved along the Ellora escarpment.*

OPPOSITE: *The face of Avalokitesvara is the most venerated Bodhisattva, or "enlightened being," in the Mahayana pantheon. The earliest and finest examples of Buddhist painting are in the Ajanta caves. These murals were executed between the second century* B.C. *and the fifth century* A.D.

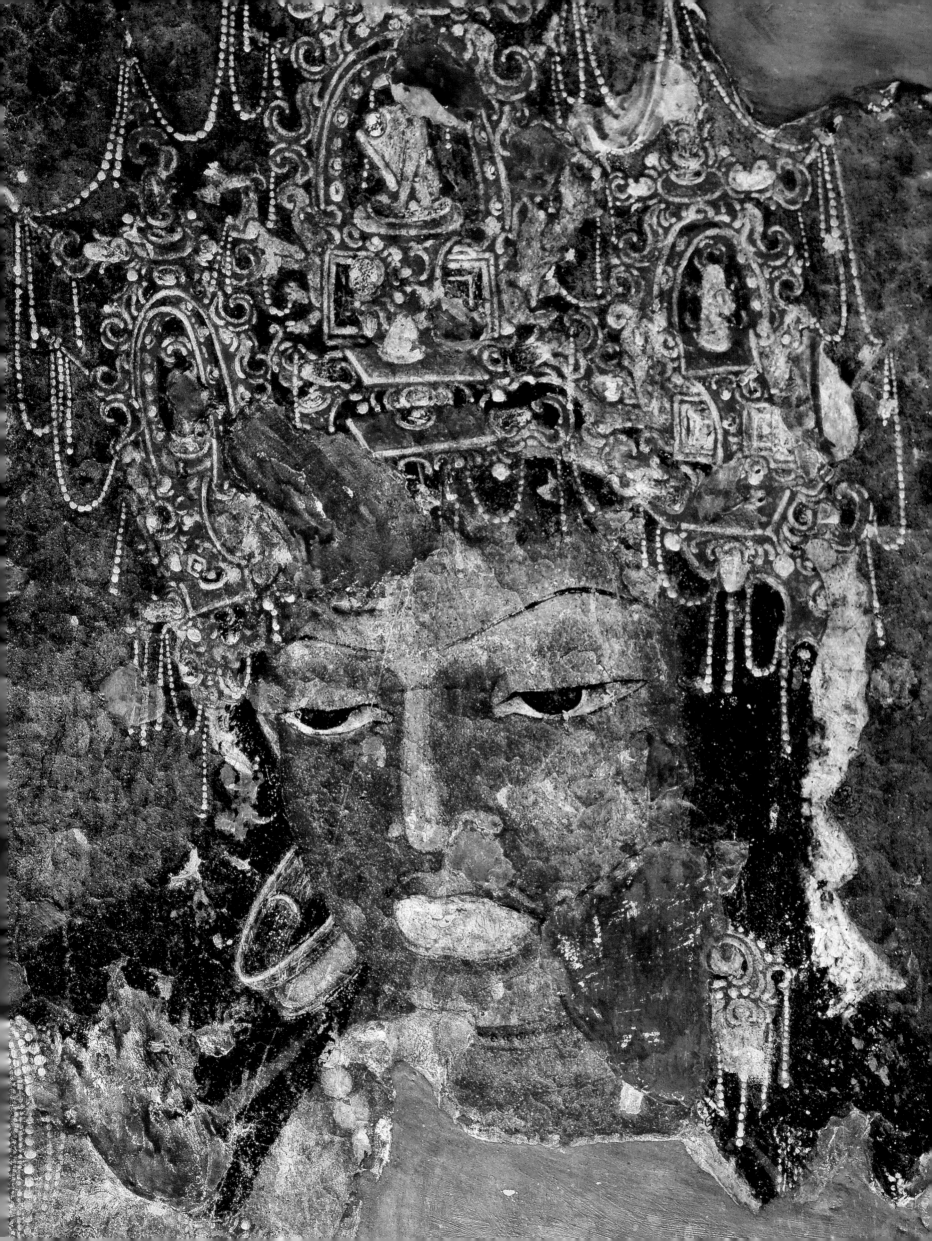

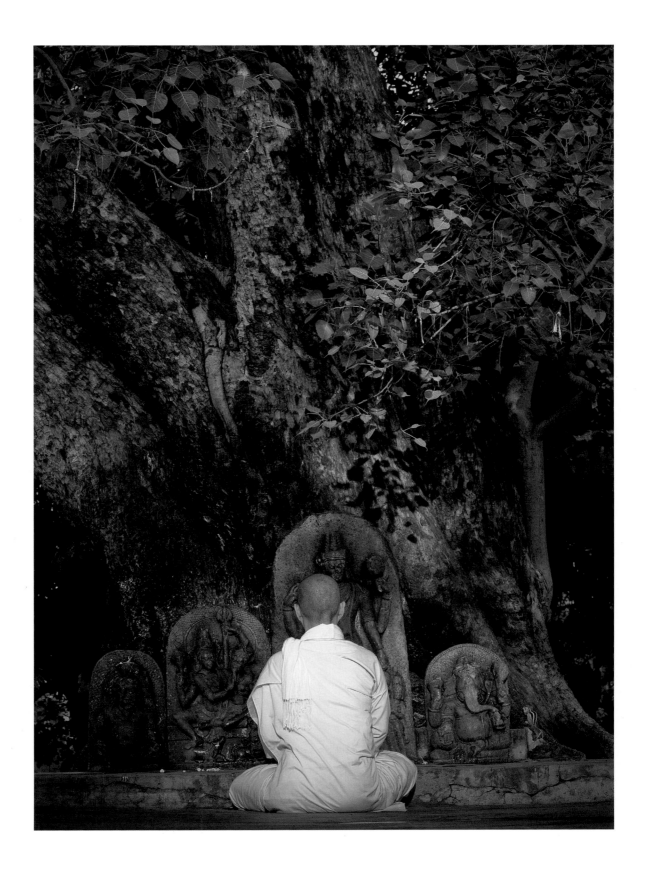

ABOVE: *A monk prays beneath a sacred bodhi tree at Bodh Gaya, state of Bihar. Siddhartha Gautama, the spiritual teacher and founder of Buddhism, is said to have achieved enlightenment here under a bodhi tree.*

OPPOSITE: *The soaring spire of the Mahabodhi temple at Bodh Gaya marks the site where Siddhartha meditated on the causes of human suffering and found the answers he was seeking, thereby becoming the Buddha, or the "Enlightened One."*

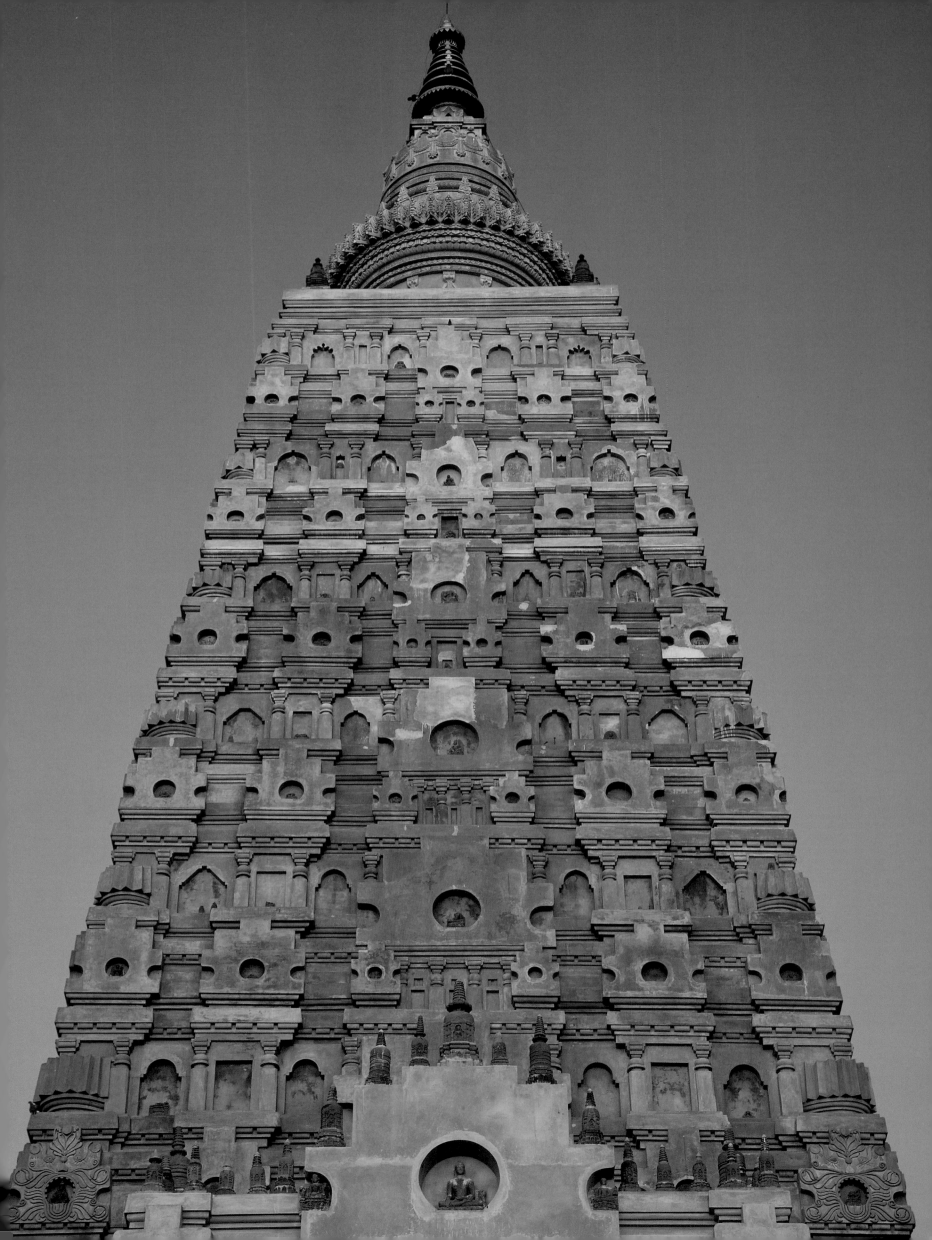

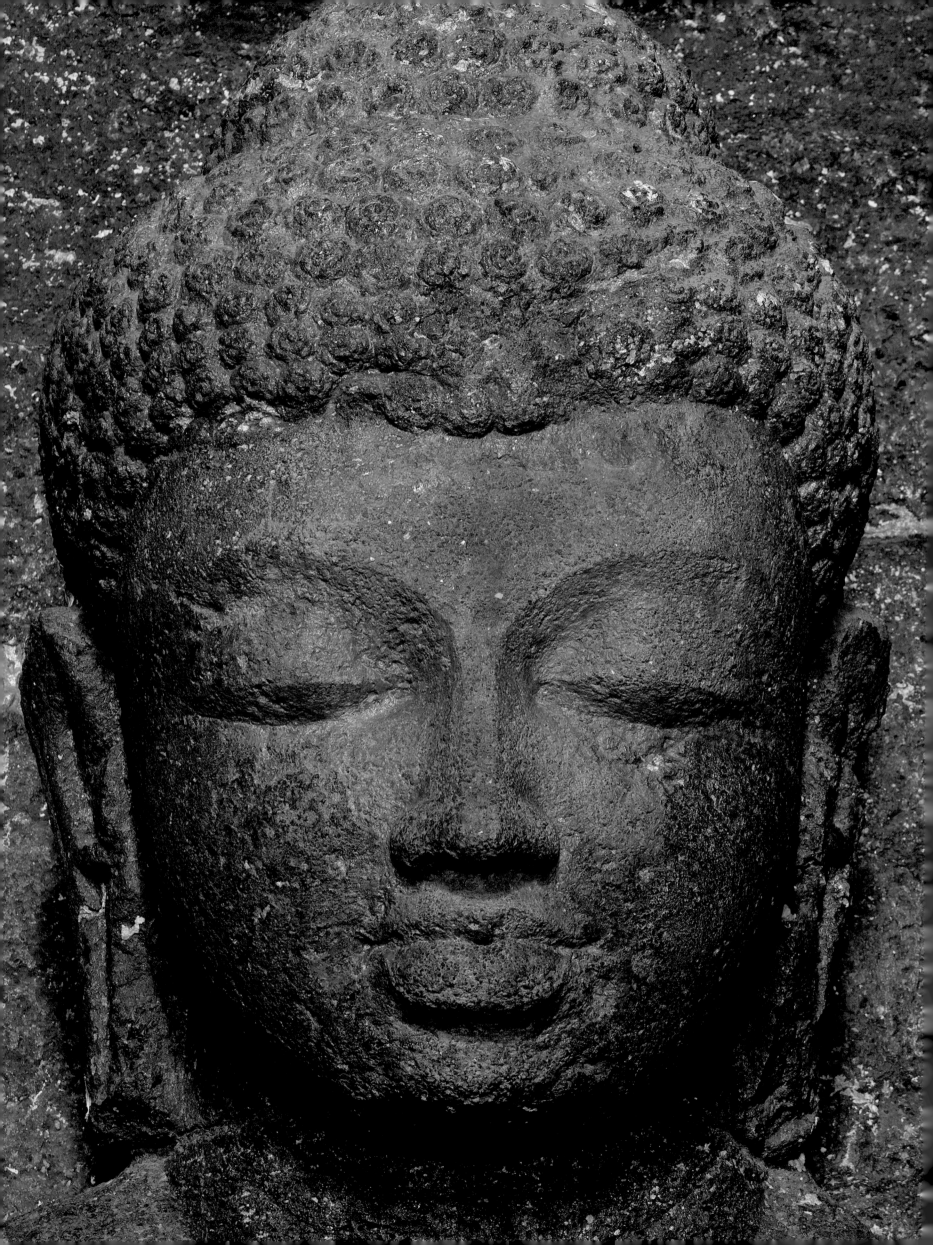

THE WAY IS EIGHTFOLD.
There are four truths.
All virtue lies in detachment.
The master has an open eye.

This is the only way,
The only way to the opening of
 the eye.
Follow it.
Outwit desire.

Follow it to the end of sorrow.

When I pulled out sorrow's shaft
I showed you the way.
It is you who must make the effort.
The masters only point the way.

But if you meditate
And follow the law
You will free yourself from desire.

"Everything arises and passes away."
When you see this, you are above
 sorrow.
This is the shining way.

—Dhammapada, Chapter 20: The Way

CURLING UP ON THE MAT, around Mira-masi's comfortable lap, one hand on her thumping, wagging knee, Uma would listen to her relate those ancient myths of Hinduism that she made sound as alive and vivid as the latest gossip about the family. To Mira-masi the gods and goddesses she spoke of, whose tales she told, were her family, no matter what Mama might think—Uma could see that.

She never tired of hearing the stories of the games and tricks Lord Krishna played as a child and a cowherd on the banks of the Jumna, or of the poet-saint Mira who was married to a raja and refused to consider him her husband because she believed she was already married to Lord Krishna and wandered through the land singing songs in his praise and was considered a madwoman till the raja himself acknowledged her piety and became her devotee. Best of all was the story of Raja Harishchandra who gave up his wealth, his kingdom and even his wife to prove his devotion to the god Indra and was reduced to the state of tending cremation fires for a living; his own wife was brought to him for her cremation when at last the god took pity on him and restored her to life. Then Uma, with her ears and even her fingertips tingling, felt that here was someone who could pierce through the dreary outer world to an inner world, tantalizing in its color and romance. If only it could *replace* this, Uma thought hungrily.

—ANITA DESAI, *FASTING, FEASTING*

OPPOSITE AND PAGE 122: *Celebrated all over India since ancient times, the festival of Holi commemorates various events in Hindu mythology. It also provides the rare opportunity for Hindus to indulge in merrymaking and rejoice in the colorful arrival of spring. People throw colored powders, water, and oils at one another.*

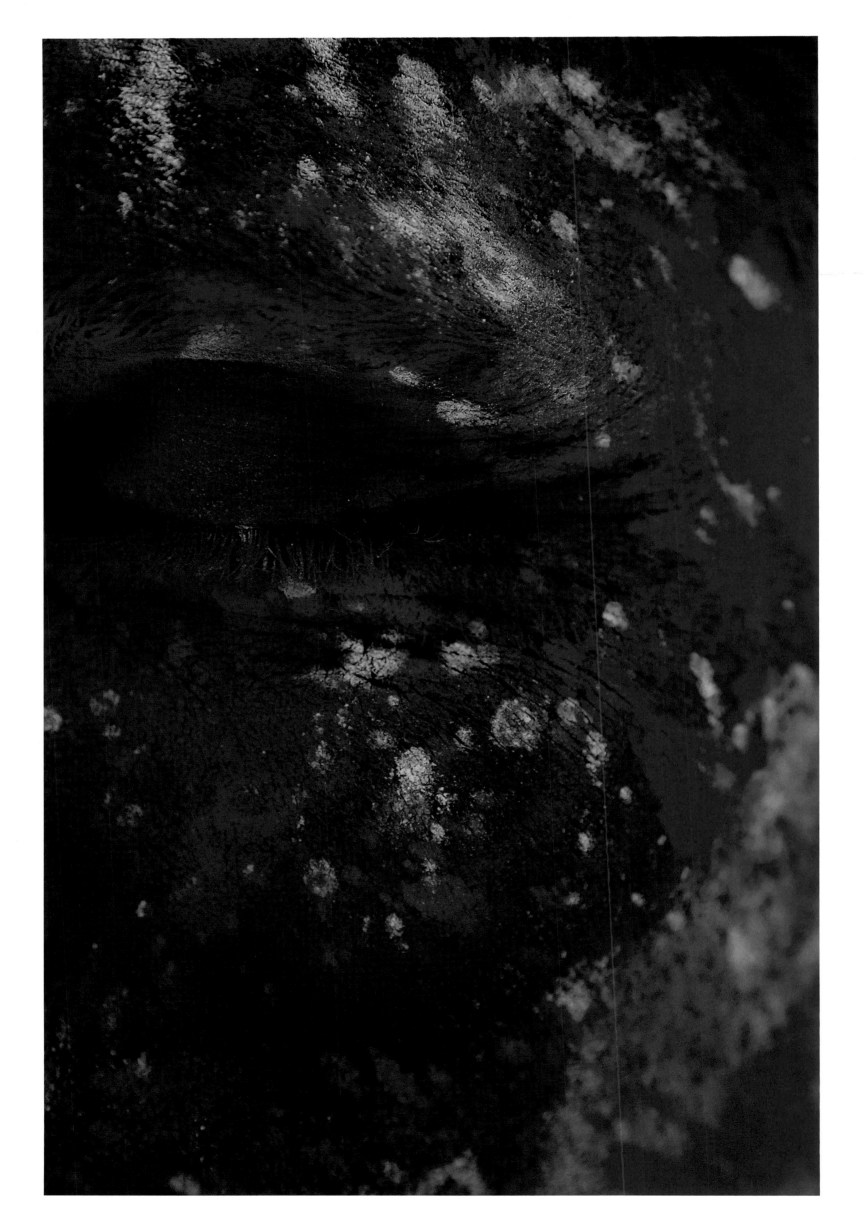

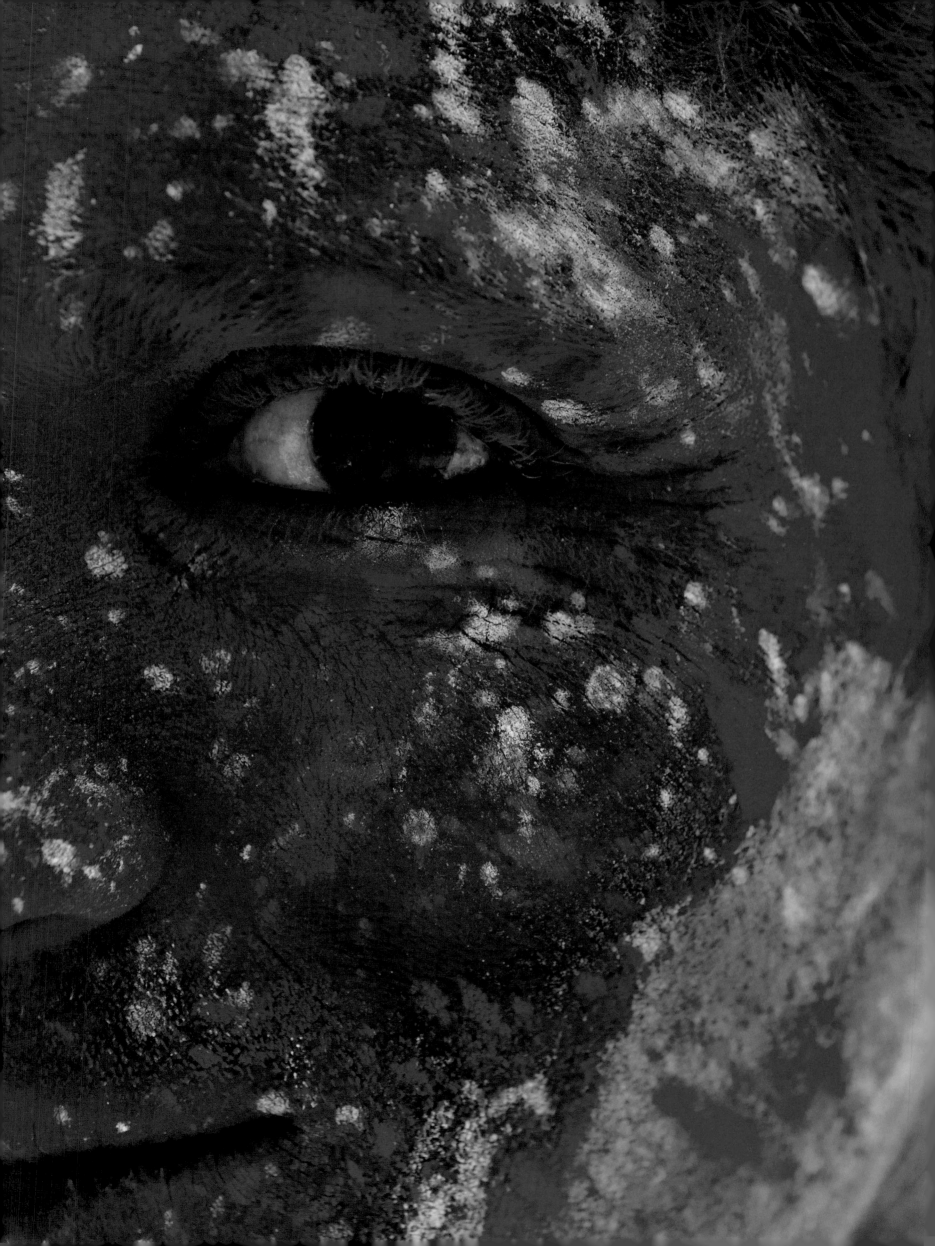

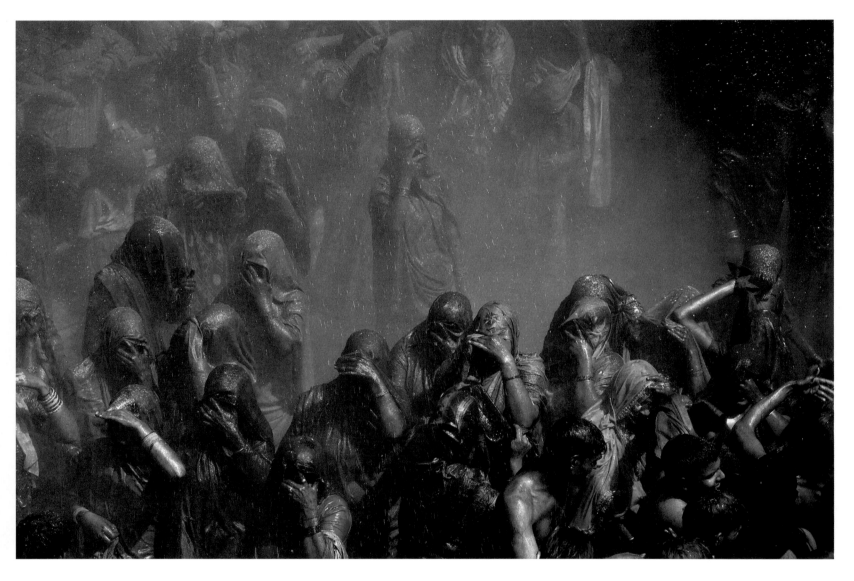

ABOVE AND PAGES 124–125: *The festival of Rang Gulal, or Holi—the "festival of colors"—is celebrated with great abandon and intensity in the town of Mathura, the birthplace of Lord Krishna.*

PAGES 126–127: *Gulal ghotas for sale in a market in Jaipur, Rajasthan. Gulal is a colored powder made from lac (a resinous substance deposited on the twigs of trees in southern Asia by the female lac insect). The ghotas are thrown playfully during Holi as part of the celebration.*

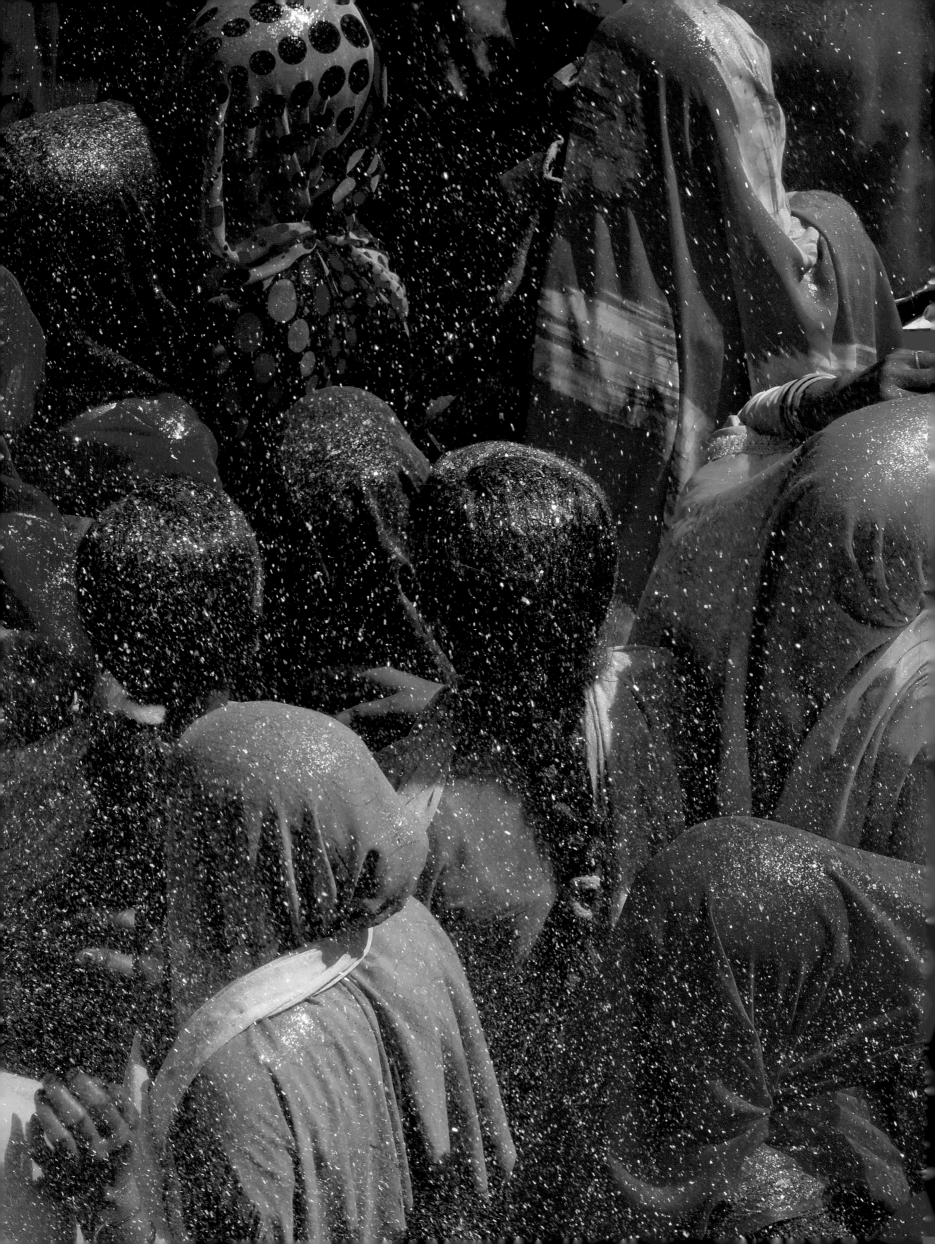

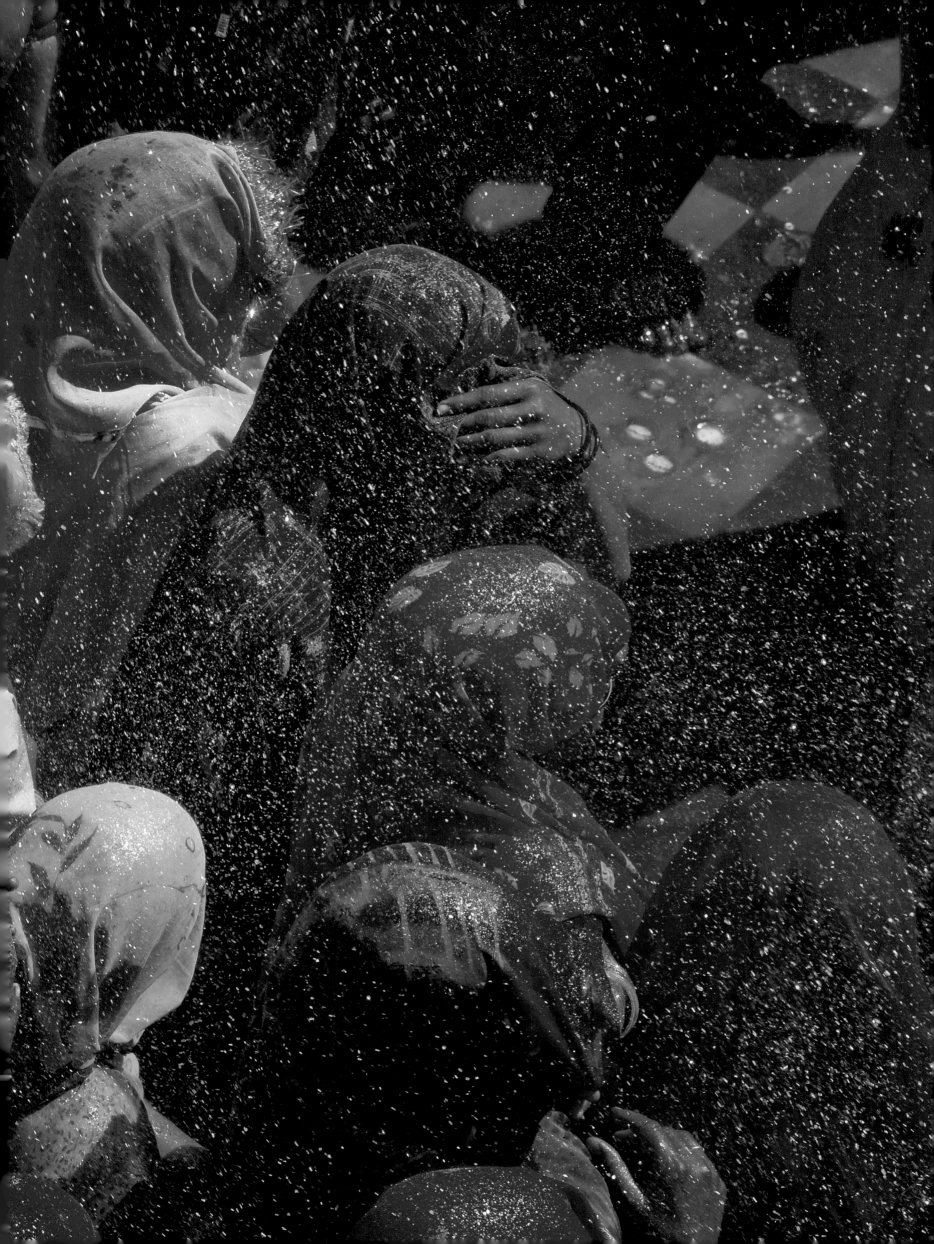

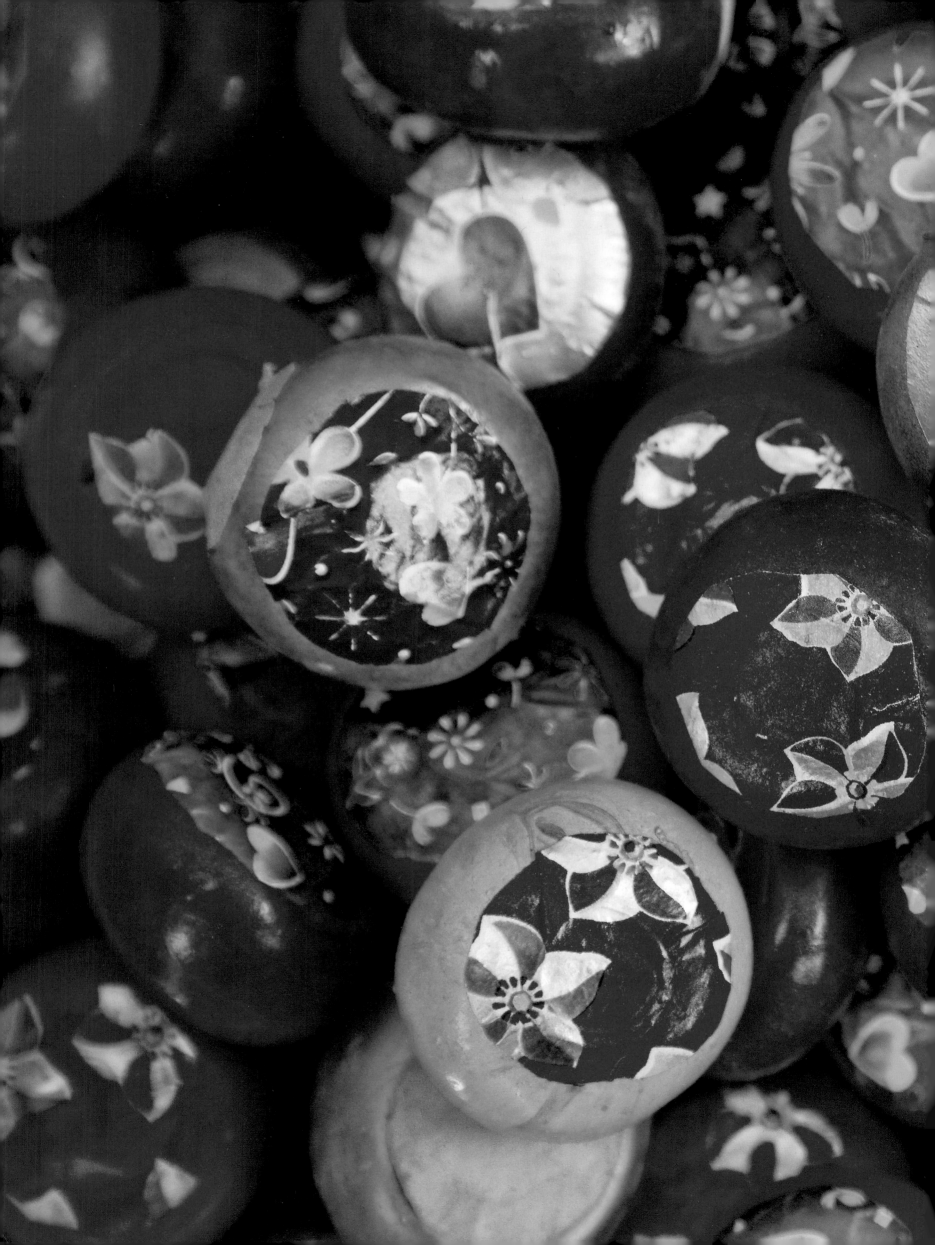

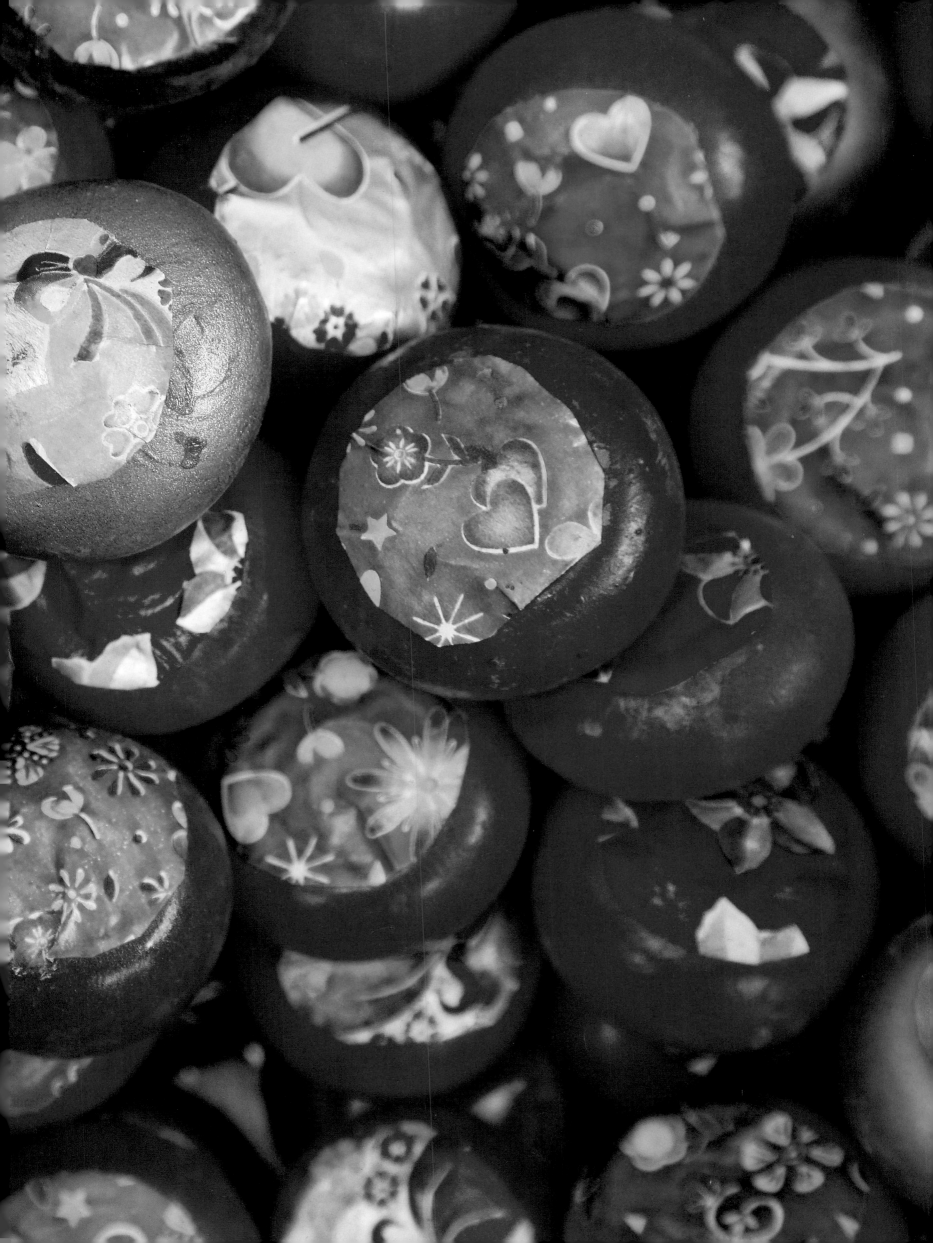

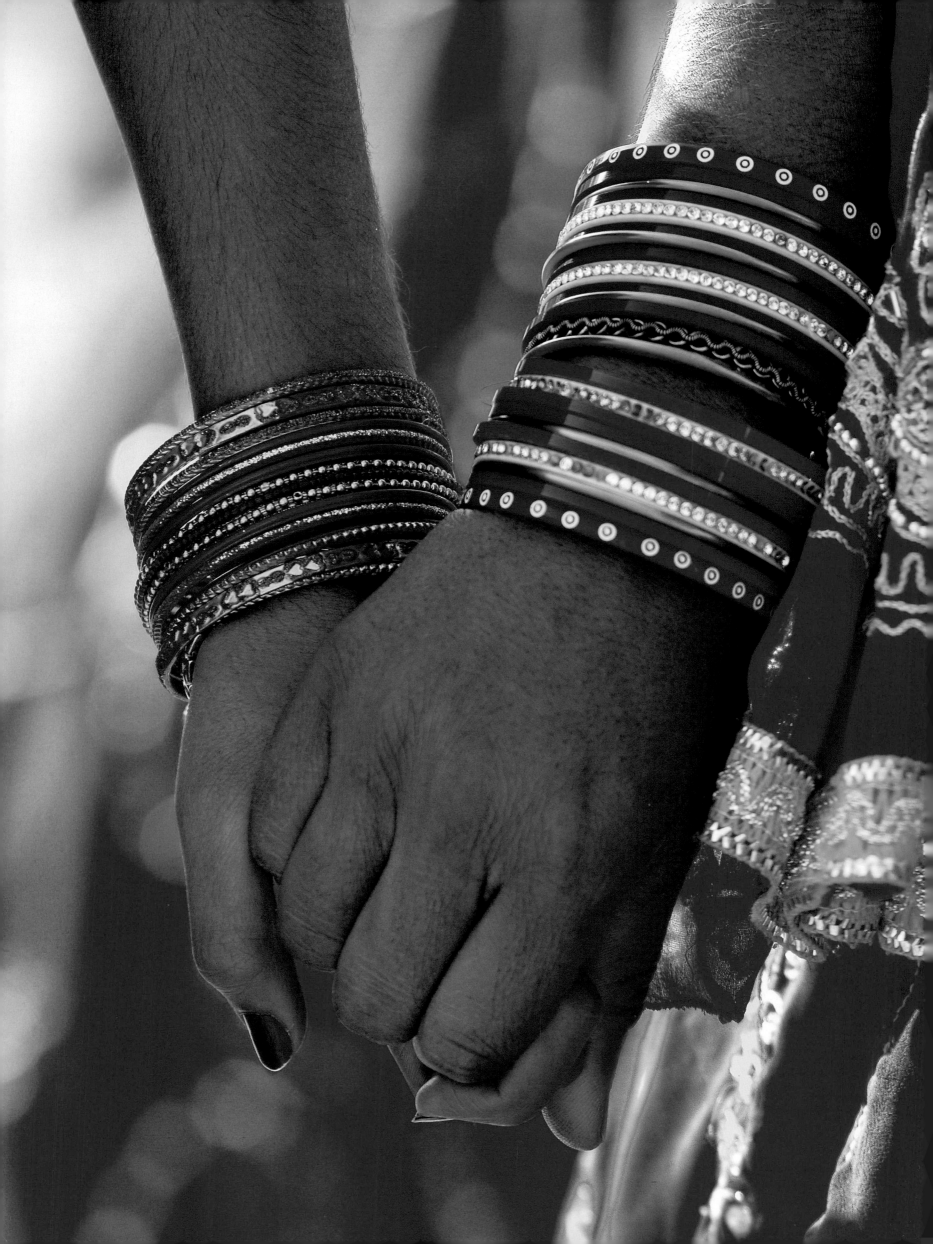

ONE FRIDAY EVENING, Mamima and Sandeep's mother sat in front of the dressing-table and applied a tracing of kaajal to their eyes, a faint gloss of lipstick to their lips, a line of kumkum powder in the parting of their hair, and pressed a red kumkum dot in the center of their foreheads. They took gold bangles out of a cupboard and slipped them onto their slender wrists (the gold did not dazzle, as gold never does, but blended with the luster and color of their skin), and they wore firmly pressed, shimmering saris around their bodies, like bright wrapping paper around a lozenge. They gazed into the mirror and at each other with vague, approving looks, and sometimes bent down to help each other with their hair. Like lilypads, they floated on a surface of images. They dabbed themselves with perfume; each drop of strong perfume could spread like a rumor around the room and then the house. If Mamima or Sandeep's mother had been somewhere, you could tell by the fragrance they left behind; they became strange creatures; the house became a strange forest.

They were preparing to visit relatives—an old couple who lived far away on the southern tip of Calcutta, somewhere near the road leasing out from the city. It was difficult to understand why they were fussing so much about this simple visit to these simple people, unless they were using it as a pretext or an excuse to devote their passionate ardour to themselves. Devotion—that was the word: the immemorial tradition of applying kaajal and kumkum, and other ancient cosmetics like sandalwood paste and mehndi, belonged more to the world of intricate, systematic ritual than to the world of fashion; in fact, the craftsman-like way in which the women made themselves up ("making oneself up"—the same, after all, as creating oneself) reminded one of the Bengali artisans who decorate and lay the immeasurably delicate finishing touches on their idols on the day before the festival. Looking critically into the mirror, they appraised their faces and hands with a detached aesthetic interest, as if they were someone else's face and hands waiting to be adorned from simplicity to a complexity that was oddly, unmistakably feminine. And deep down, the women also knew that the old couple living in the darkness of the suburbs would be disappointed if it were otherwise: for them, the younger relatives dressing up with such extravagance was a form of entertainment which they would talk about for days; it would be a welcome distraction in their small, clear lives; the old lady would finger the texture of their saris and ask questions; the old man would inhale the perfume without appearing to do so and sit with a pleased expression on his face.

—AMIT CHAUDHURI, A STRANGE AND SUBLIME ADDRESS

OPPOSITE: *Friends hold hands at the annual desert fair in Jaisalmer.*

ABOVE AND OPPOSITE: *The petals of hundreds of different types of flowers are sold in markets throughout India. Each variety of flower has its own special quality and spiritual meaning: The iris, for instance, symbolizes beauty; jasmine, purity; the water lily, wealth, and zinnia, endurance.*

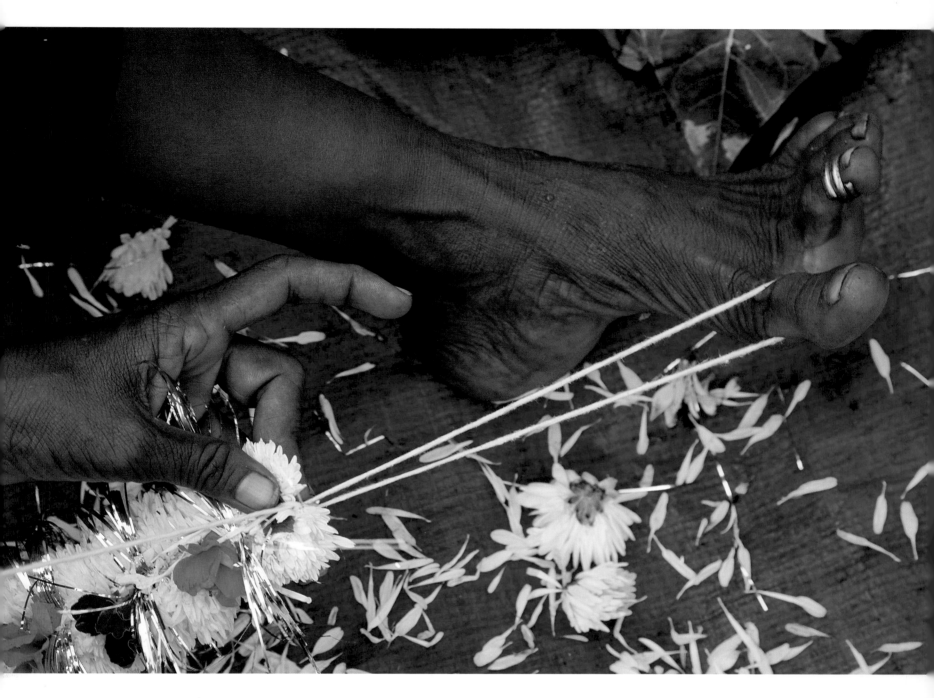

AMONG COLORED FLOWERS we had, of course, the highly perfumed Bussora rose, and the scentless hibiscus—the red, the light pink, and the pendulous; also the *Hibiscus mutabilis*, which we did not look upon as a hibiscus at all but called "land lotus," the ixora, and the canna. Curiously enough, we never had oleanders. What passed as oleander or *Karavi* with us was a yellow, nectar-bearing, bell-shaped flower, to whose mildly poisonous fruit hysterical women bent on spiting their husbands by committing suicide sometimes had recourse. We, the children, loved all the flowers equally well. But our elders never thought much of any of the colored flowers except the red hibiscus which was indispensable for worshipping the goddess Kali. Even the sweet-smelling Bussora rose

Using their feet to anchor the strings, vendors quickly tie elaborate garlands of exotic flowers.
These are for sale in the market in Mumbai during the festival of Ganesh Chaturthi.

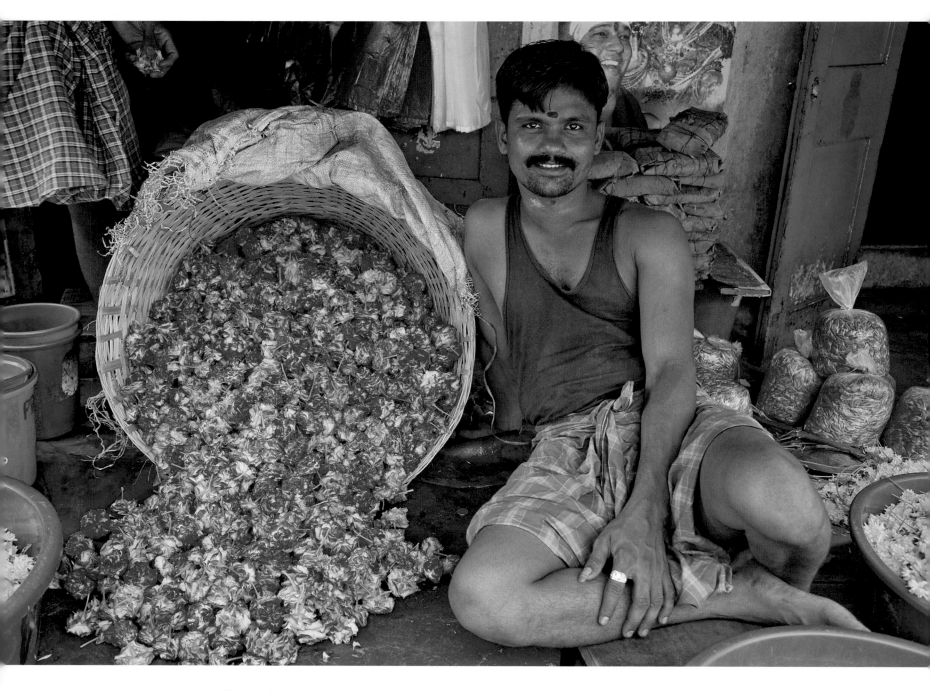

was out of court because it was looked upon as an Islamic flower. China had got accepted at our hands, but neither Iran nor Araby.

It was an essential part of our education to be able to weave garlands of three kinds of flowers—the jasmine, the Night-blooming Flower of Sadness, and the Bakul. We sat still with needlefuls of thread pricking our way through the fine stalks of all these minute flowers. But when this task of infinite patience was over, we put the garlands round our neck for a few minutes and then tore them and threw them away on the ground to be trampled under foot. Our floors and inner courtyard in the summer were almost always strewn with the loose ends of garlands.

—Nirad C. Chaudhuri, *My Birthplace*

Roses for sale during the festival of Ganesh Chaturthi, in Mumbai.

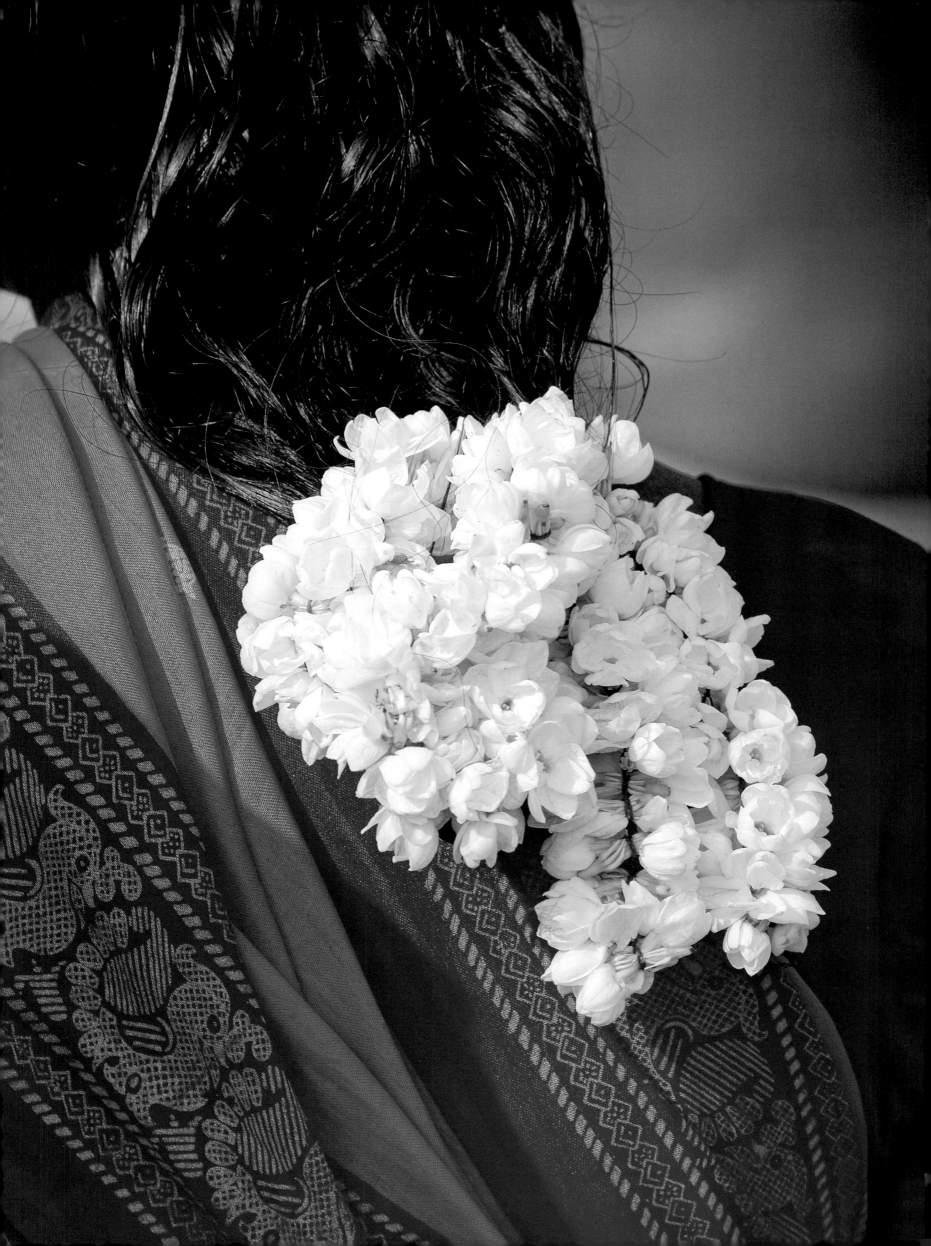

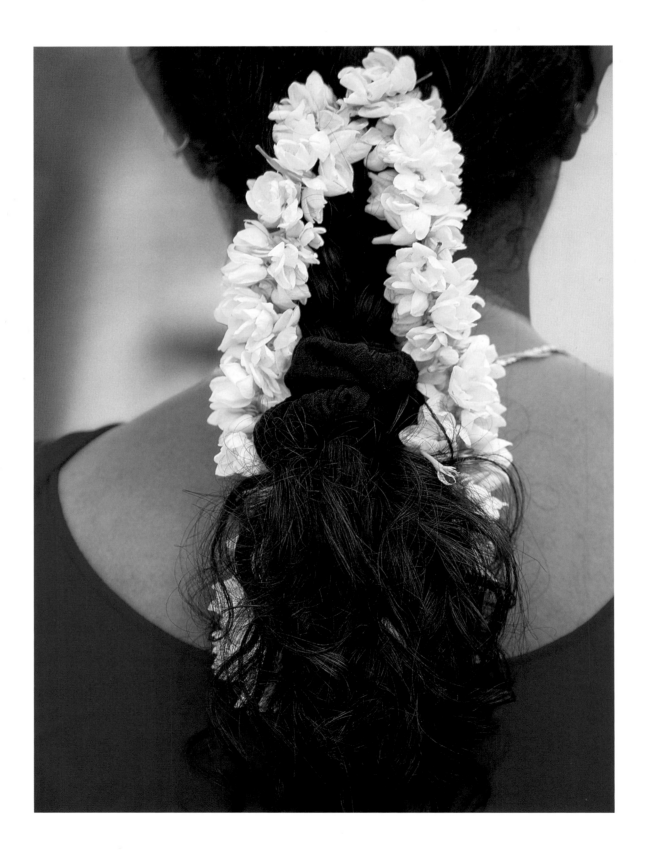

ABOVE, OPPOSITE, AND PAGE 137: *During the festival of Batkamma at Warangal, Andhra Pradesh, women wear beautiful sprays of jasmine and other flowers in their hair. Batkamma, a celebration of womanhood held in the Telangana region, begins just before Dussehra, with elaborate feasts and dances continuing for nine days.*

SHE APPLIED A LITTLE SCENTED OIL to her hair, and combed it with great care. She braided and coiled it very neatly. She washed her face with soap and water, and applied very lightly a little face-powder. She had given up using face-powder and scented oil years ago. She stood before the mirror, applied a little perfumed paste between her eyebrows and pressed a very elegant pinch of vermilion on it, and trimmed its edges with her little finger to make it perfectly round. He always liked the forehead marking to be a little large. She stood close to the mirror, with her nose almost touching the glass. She was more or less satisfied with her appearance, except for two stray strands of grey hair which she had just discovered; she smoothed them out and tucked them cunningly into an under-layer. The glass clouded with the moisture of her breath; she wiped the moisture and saw herself once again. . . .

She went out into the garden and plucked some jasmine and red flowers, strung them together, and placed them in a curve on the coil at the back of her head—he always liked the red flowers to be interspersed with the white jasmine, and always admired the curved arrangement.

—R. K. NARAYAN, *The Dark Room*

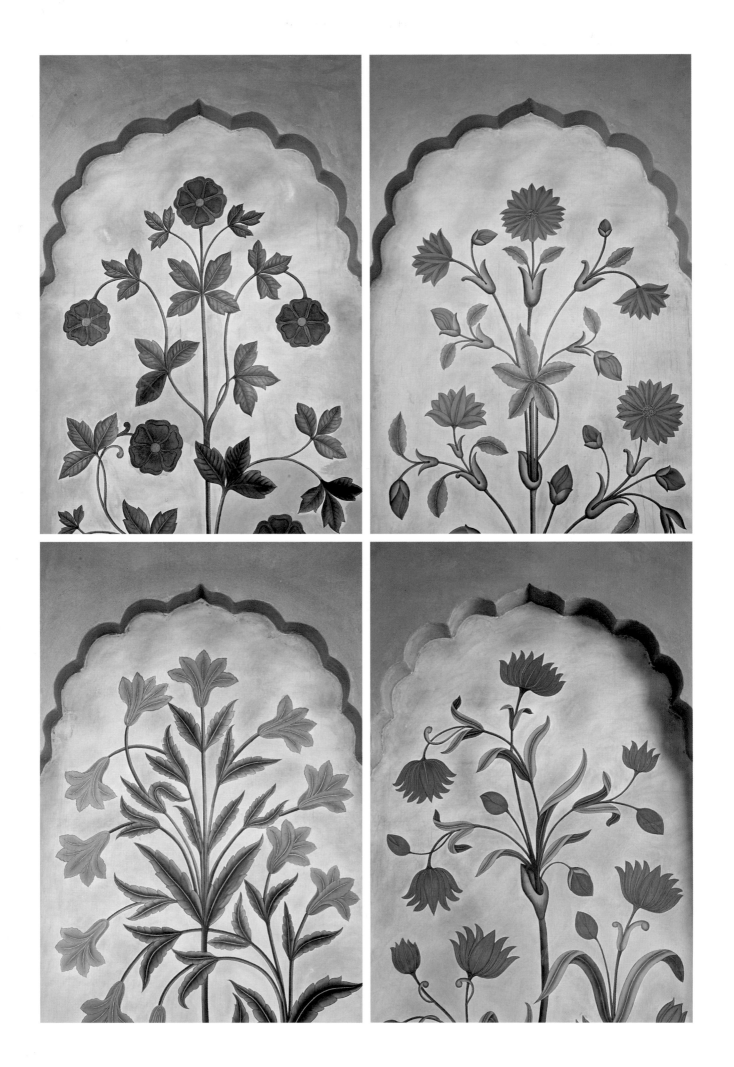

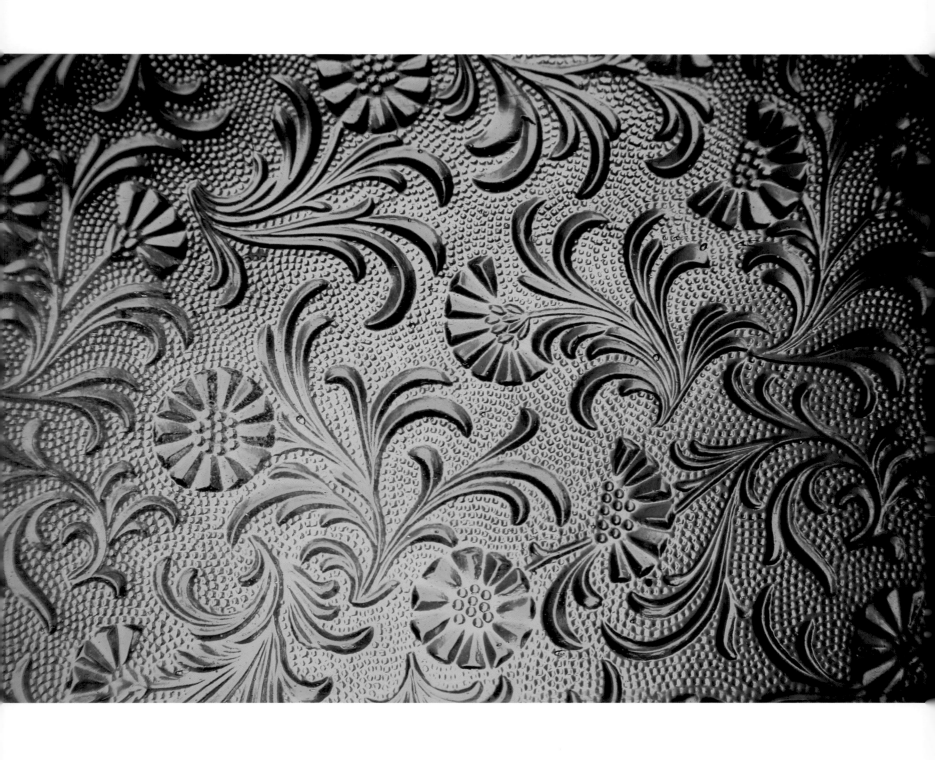

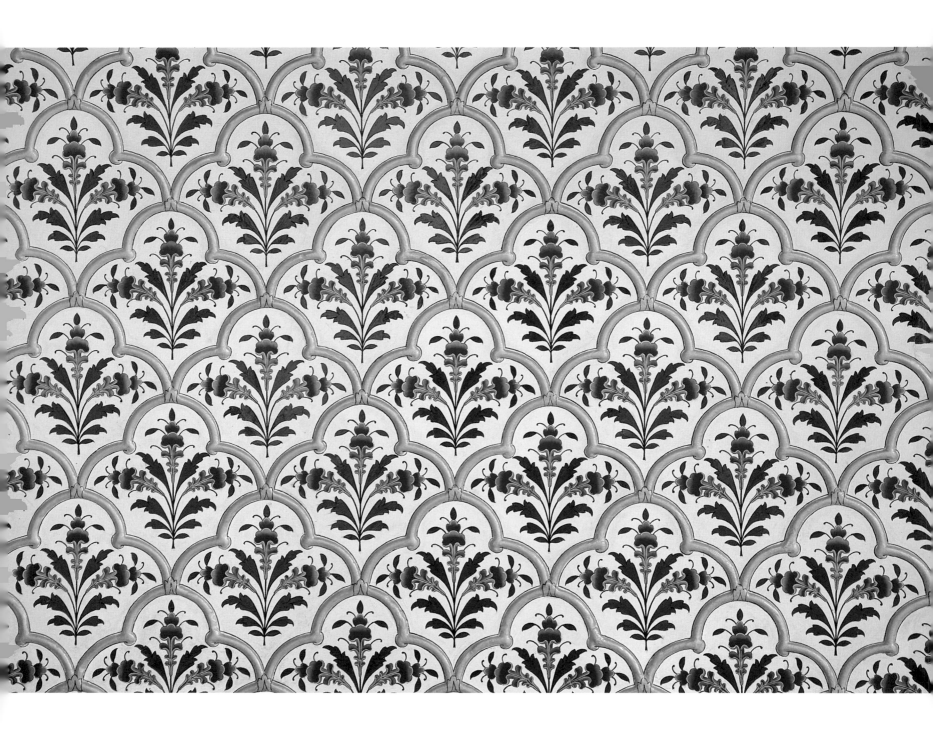

ABOVE: *Detail of a wall from the Maharajah's palace in the fort at Jaisalmer.*

OPPOSITE: *Detail of a colored glass panel in the Bhanwar Niwas Hotel in the Rampuria Haveli in Bikaner. Archaeological discoveries in India reveal the existence of glass over 2000 years ago.*

PAGES 142–143: *A detail from one of several brilliantly colored 19th-century mosaics of dancing peacocks in the Mor Chowk, or "Peacock Courtyard," of the City Palace in Udaipur.*

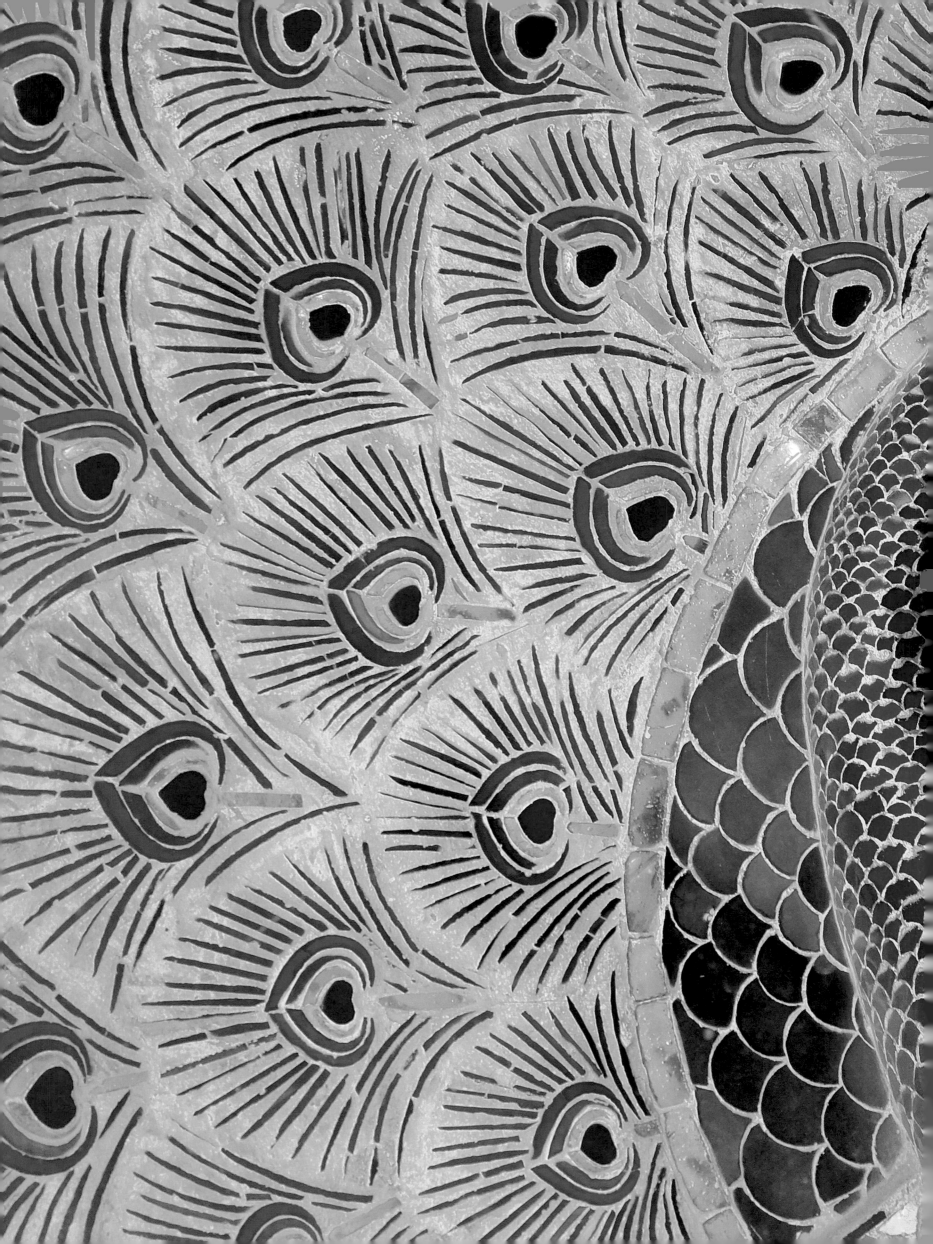

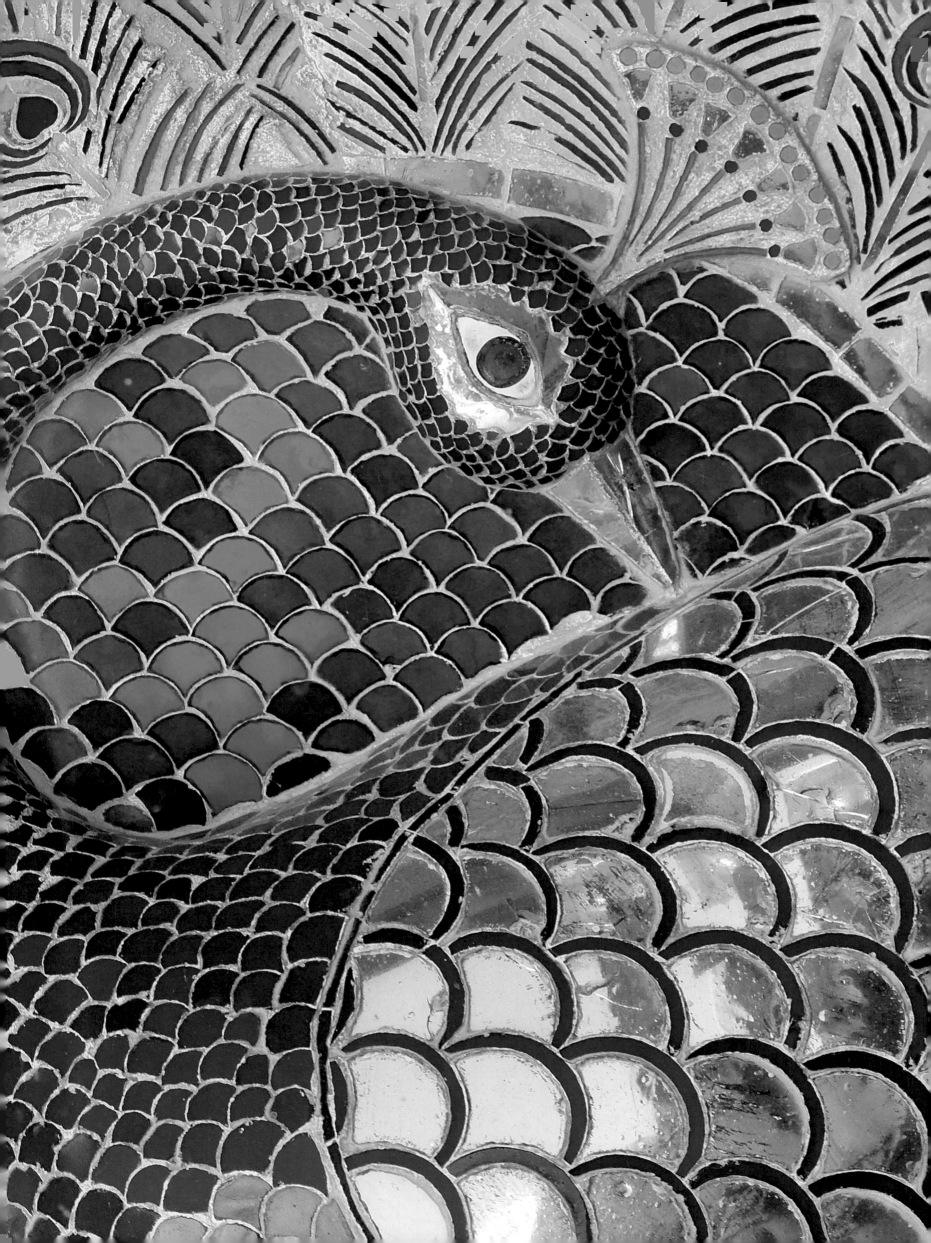

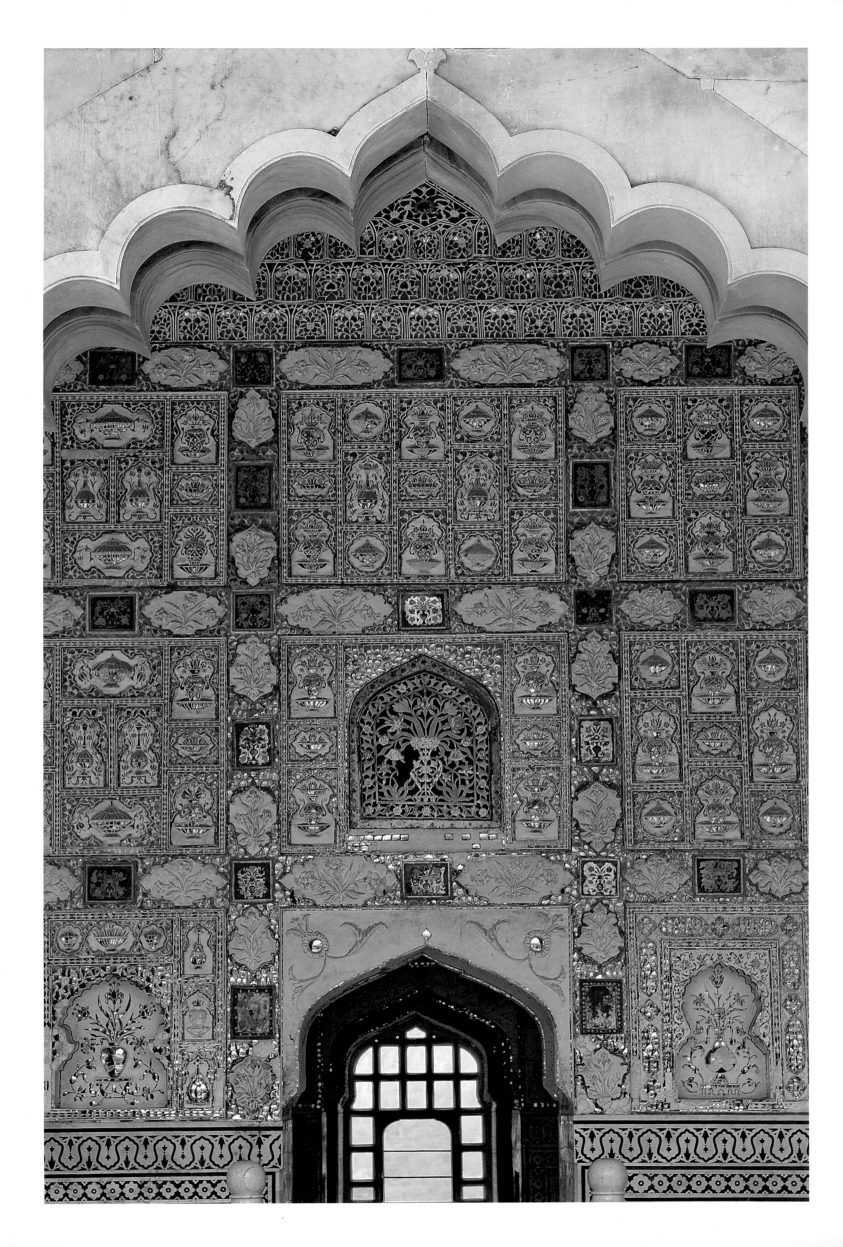

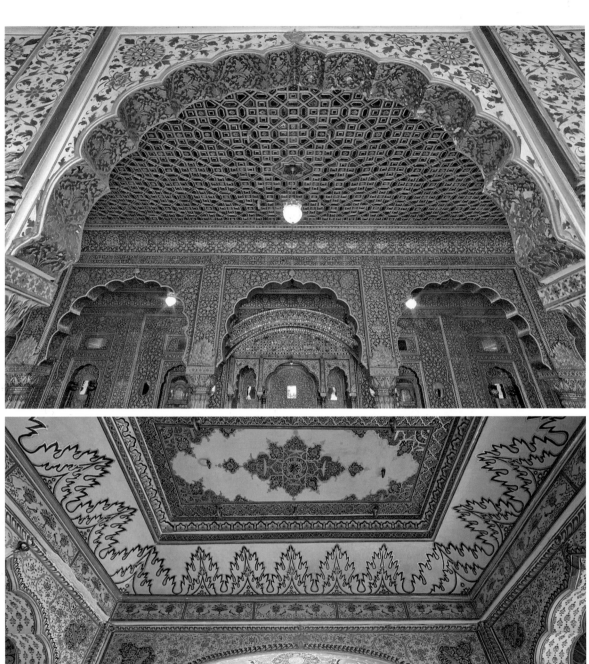

ABOVE TOP: *Intricate inlaid ornamental lacquer work of the Anup Mahal in the Junagarh Fort in Bikaner, built by Maharajah Anup Singh in 1690 as his private audience hall.*

ABOVE BOTTOM: *Ceiling of a bedroom of the Maharajah's palace in the Jaisalmer Fort.*

OPPOSITE: *The Amber Fort, near Jaipur, includes the spectacular Sheesh Mahal, where the flame of a single candle reflected in the tiny mirrors is transformed into a star-filled night sky.*

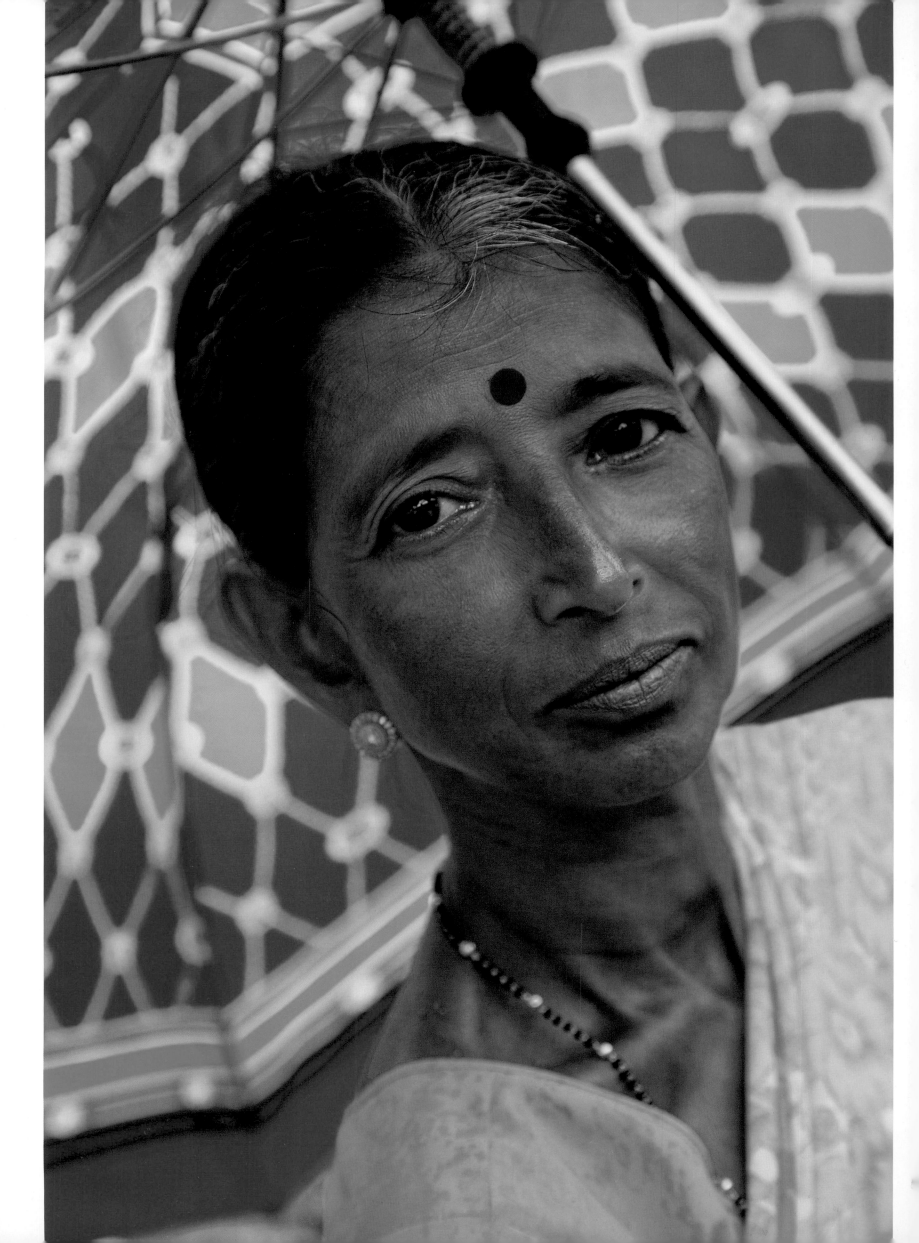

But one of the most attractive and engaging sights of the season was to be seen in the inner courtyard of our house, when there was a heavy downpour. The rain came down in what looked like closely packed formations of enormously long pencils of glass and hit the bare ground. At first the pencils only pitted the sandy soil, but as soon as some water had collected all around they began to bounce off the surface of water and pop up and down in the form of miniscule puppets. Every square inch of ground seemed to receive one of the little things, and our waterlogged yard was broken up into a pattern which was not only mobile but dizzily in motion. As we sat on the veranda, myriads of tiny watery marionettes, each with an expanding circlet of water at its feet, gave us such a dancing display as we had never dreamt of seeing in actual life. It often went on for the best part of an hour but had a trick of stopping suddenly. No magic want could make elves vanish more quickly. The crystalline throng was brushed off even before the rustle of rain ceased in our ears.

—Nirad C. Chaudhuri,
My Birthplace

ABOVE: *Detail of small stained glass arches set into the stone at the Udai Bilas palace in Dungarpur.*

OPPOSITE: *A woman selling flowers sitting under her umbrella on a rainy day in Mumbai.*

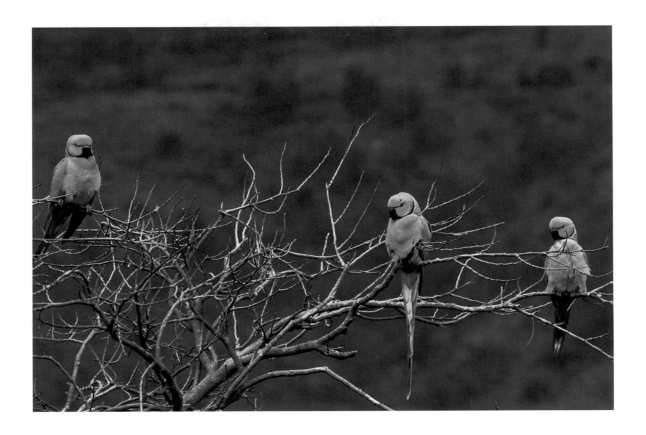

ABOVE: *At dusk, rose-ringed parakeets fill the barren tree branches surrounding the Jaigarh Fort near Jaipur.*

PAGES 152–153: Pareva, *a local bluish-gray stone, was used in the construction of the Udai Bilas palace, in Dungarpur. The palace, commissioned by Maharawal Udai Singhji II, a great patron of art and architecture, was built in the mid-19th century and overlooks Lake Gaibsagar, south of Udaipur.*

as no human attention ever was. He felt the muscle in him relax, and as time drew on he felt strangely calm, felt his thoughts drop away and a strange strength enter into him, a numbness seeping into his limbs. From exhaustion, or resignation, or faith in some new inspiration, who knows? He could not fell the trunk of his body anymore, but his senses were not numbed. They grew sharper and he was acutely aware of every tiny sound, every scent and rustle in the night: the stirrings of a mouse in the grass, the wings of a faraway bat, the beckoning scent that drew the insects to hover and buzz somewhere beyond the orchard. Underground, he could hear water gurgling, could hear it being drawn into the trees about him; he heard the breathing of the leaves and the movements of the sleeping monkeys.

Here and there in the branches near him, the season's last guavas loomed from amidst the moonlit leaves. One, two, three of them . . . so ripe, so heavy, the slightest touch could make them fall from the tree.

He picked one. Perfect Buddha shape. Mulling on its insides, unconcerned with the world. . . Beautiful, distant fruit, growing softer as the days went by, as the nights passed on; beautiful fruit filled with an undiscovered constellation of young stars.

He held it in his hand. It was cool, uneven to his touch. The hours passed. More stars than sky. He sat unmoving in this hushed night.

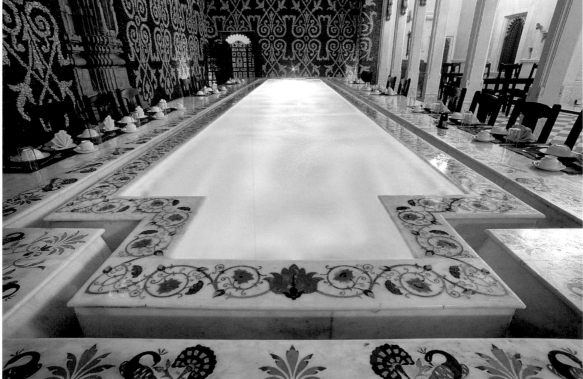

ABOVE TOP: *The "African Room" at the Udai Bilas palace in Dungarpur, containing the trophies of the safaris of the maharajahs.*

ABOVE BOTTOM: *The opulent new dining room at the Udai Bilas palace in Dungarpur, with its dining table and narrow pool surrounded by exquisitely inlaid marble.*

OPPOSITE: *A faded photograph of the Maharajah Maharawal Singh hangs on the porch of the Udai Bilas palace in Dungarpur, Rajasthan.*

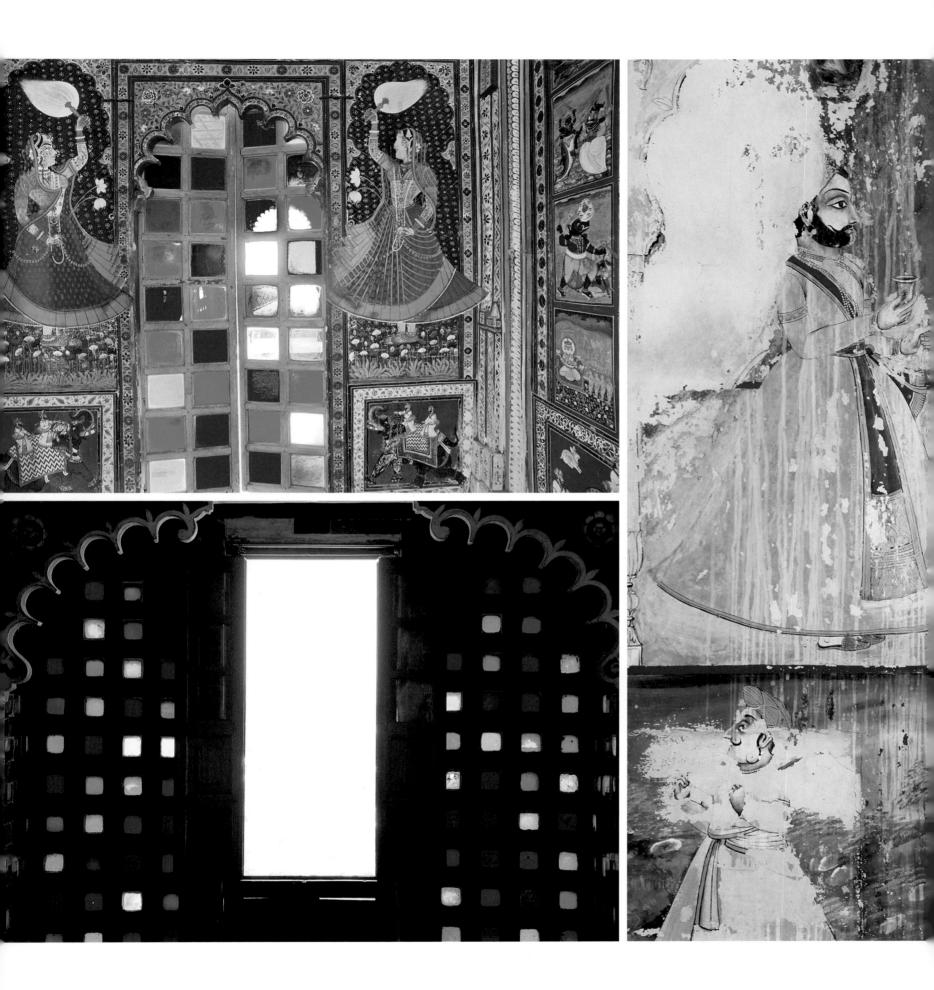

ABOVE AND RIGHT: *The fading interiors of the Juna Mahal palace, near Dungarpur, are resplendent with frescoes, glass, tile, mirror work, and miniature paintings.*

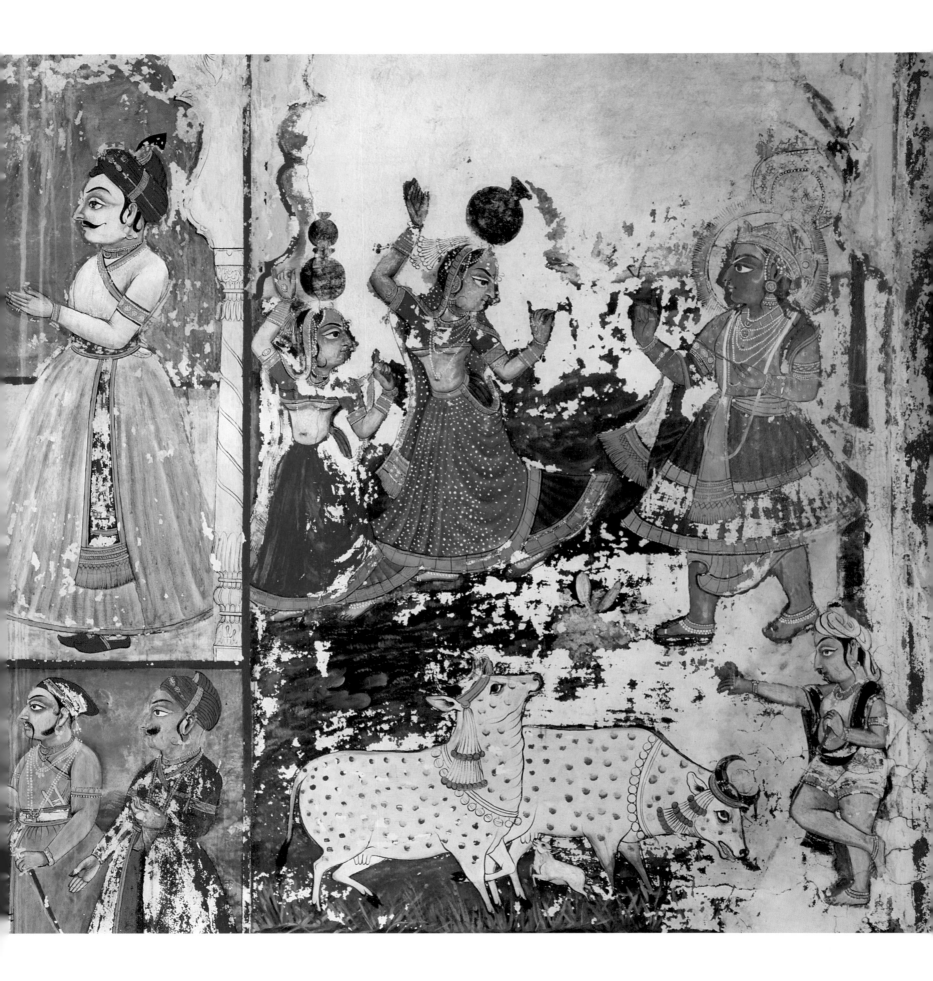

ABOVE AND OPPOSITE: *A painted wall and elaborate doorway of the Poddar School in Nawalgarh. Known for the painted havelis of India's leading merchant families, the Shekhawati region still evokes much of its original splendor. Havelis—with their frescoed walls such as this one depicting gods and goddesses flying kites—were built between the late 18th and early 20th centuries by local Marwari merchants.*

PAGES 160–161: *The murals in the caves at Ajanta were executed with the use of a binding medium applied to a thin coat of dried lime wash. Here, King Mahajanaka, or Buddha, surrounded by attendants, renounces the pleasures of his royal status and worldly life.*

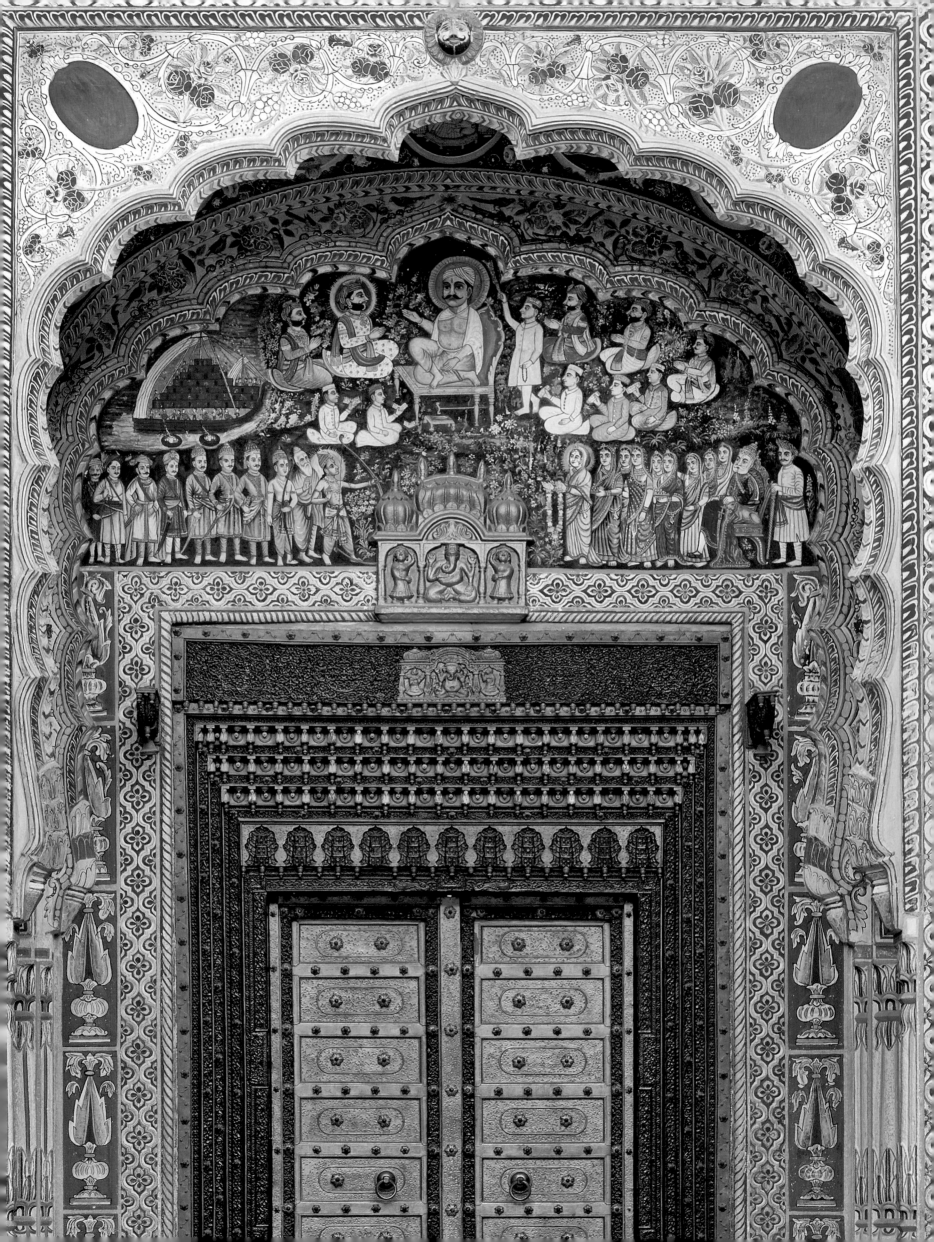

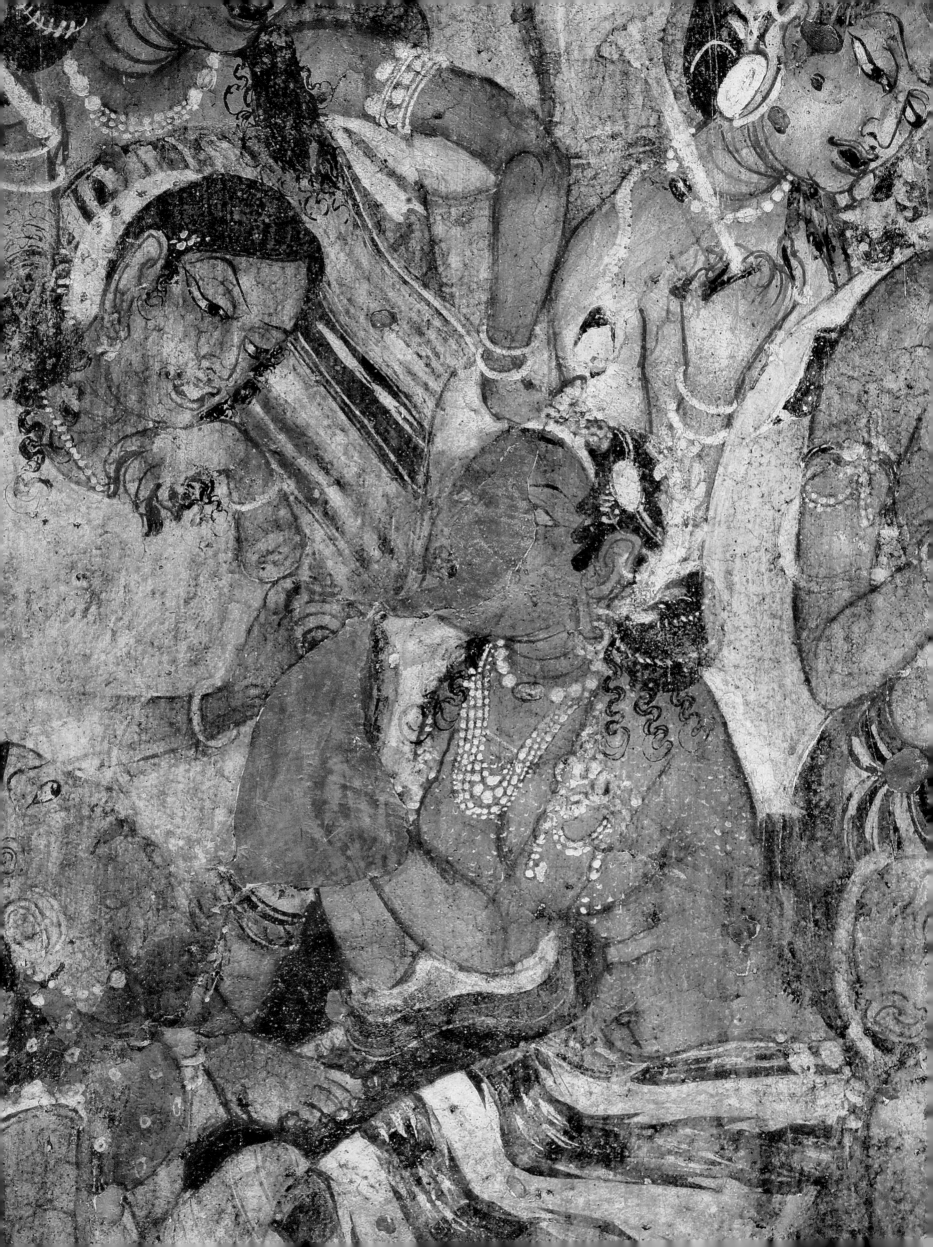

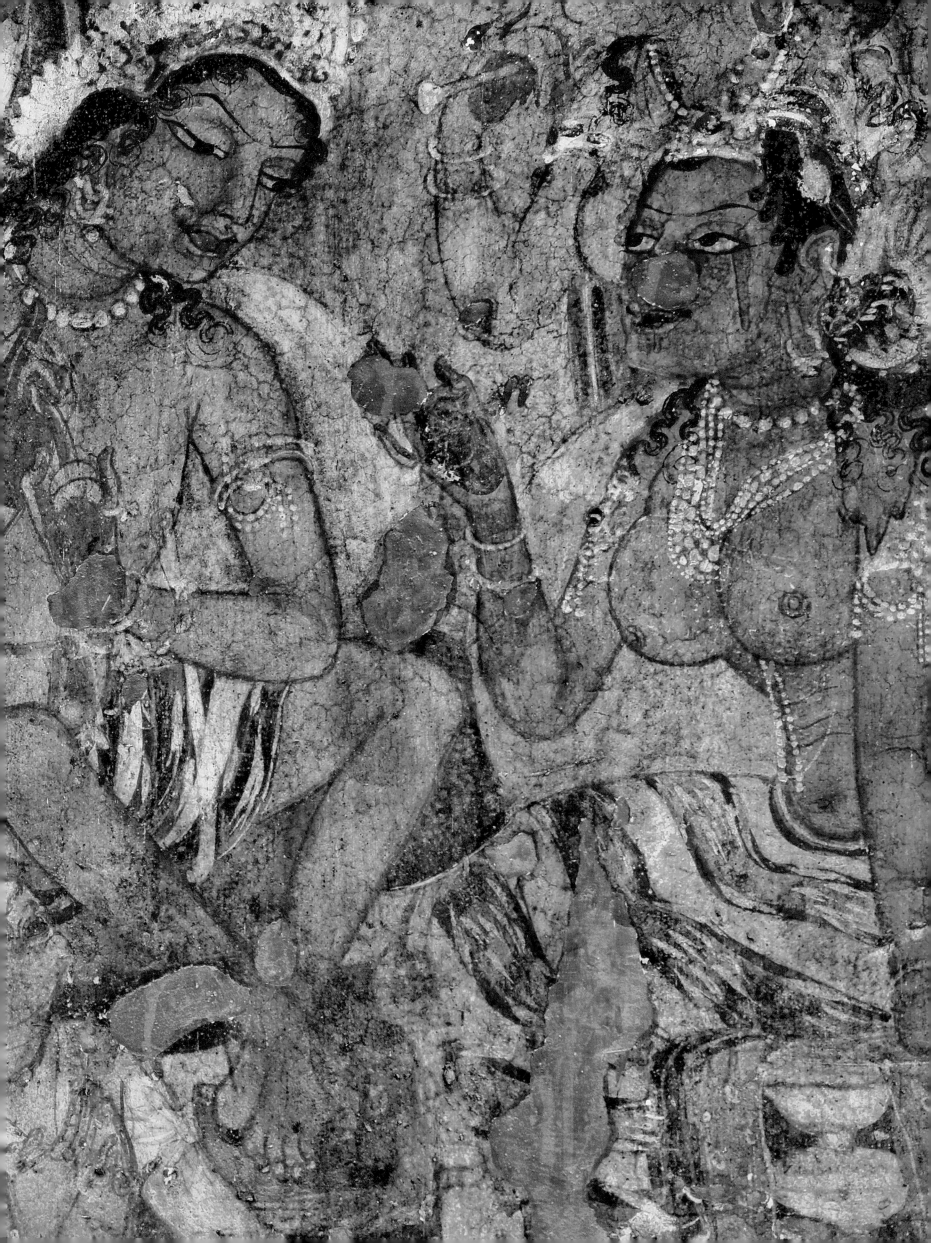

WHILE, AT THE OLD FORT, monkeys scream among ramparts. The ruined city, having been deserted by people, is now the abode of langurs. Long-tailed and black-faced, the monkeys are possessed of an overriding sense of mission. Upupup they clamber, leaping to the top-most heights of the ruin, staking out territories, and thereafter dedicating themselves to the dismemberment, stone by stone, of the entire fortress. Padma, it's true: you've never been there, never stood in the twilight watching straining, resolute, furry creatures working at the stones, pulling and rocking, rocking and pulling, working the stones loose one at a time...every day the monkeys send stones rolling down the walls, bouncing off angles and outcrops, crashing down into the ditches below. One day there will be no Old Fort; in the end, nothing but a pile of rubble surmounted by monkeys screaming in triumph...and here is one monkey, scurrying along the ramparts—I shall call him Hanuman, after the monkey god who helped Prince Rama defeat the original Ravana, Hanuman of the flying chariots. Watch him now as he arrives at this turret—his territory; as he hops chatters runs from corner to corner of his kingdom, rubbing his rear on the stones; and then pauses, sniffs something that should not be here... Hanuman races to the alcove here, on the topmost landing, in which the three men have left three soft gray alien things. And, while monkeys dance on a roof behind the post office, Hanuman the monkey dances with rage. Pounces on the gray things. Yes, they are loose enough, won't take much rocking and pulling, pulling and rocking...watch Hanuman now, dragging the soft gray stones to the edge of the long drop of the outside wall of the Fort. See him tear at them: rip! rap! rop!...Look how deftly he scoops paper from the insides of the gray things, sending it down like floating rain to bathe the fallen stones in the ditch!...Paper falling with lazy, reluctant grace, sinking like a beautiful memory into the maw of the darkness; and now, kick! thump! and again kick! the three soft gray stones go over the edge, downdown into the dark, and at last there comes a soft disconsolate plop. Hanuman, his work done, loses interest, scurries away to some distant pinnacle of his kingdom, begins to rock on a stone.

—SALMAN RUSHDIE, *MIDNIGHT'S CHILDREN*

OPPOSITE: *A monkey perches in an alcove of the Chittorgarh Fort in Rajasthan.*

ABOVE: *The silk-covered prayer room of the 15th-century Thikse monastery in the Indus Valley, near Leh. One of the most beautiful monasteries of Ladakh, it serves as residence to approximately eighty monks of the Gelugpa Order of Buddhism.*

OPPOSITE: *A dragon on the door of the Salugara monastery near Siliguri, in the Deejeeling district, protects it from the evil spirits of the world.*

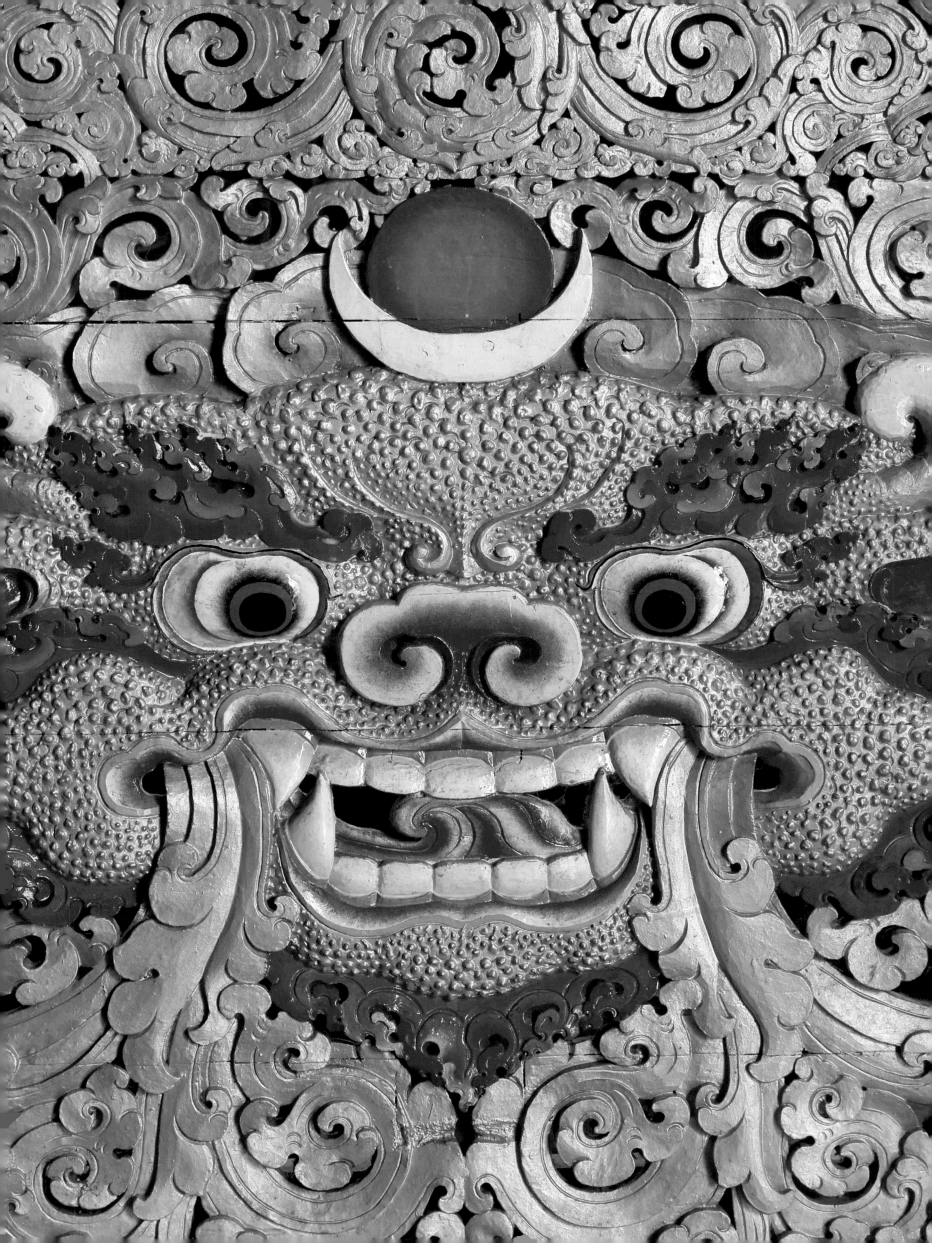

ABOVE AND OPPOSITE: *Dragons and phoenixes (the mythical sacred fire bird) adorn the entryway and ceiling of the unusual Pal Tergar Rigdzin Khacho Dargye Ling temple in Bodh Gaya.*

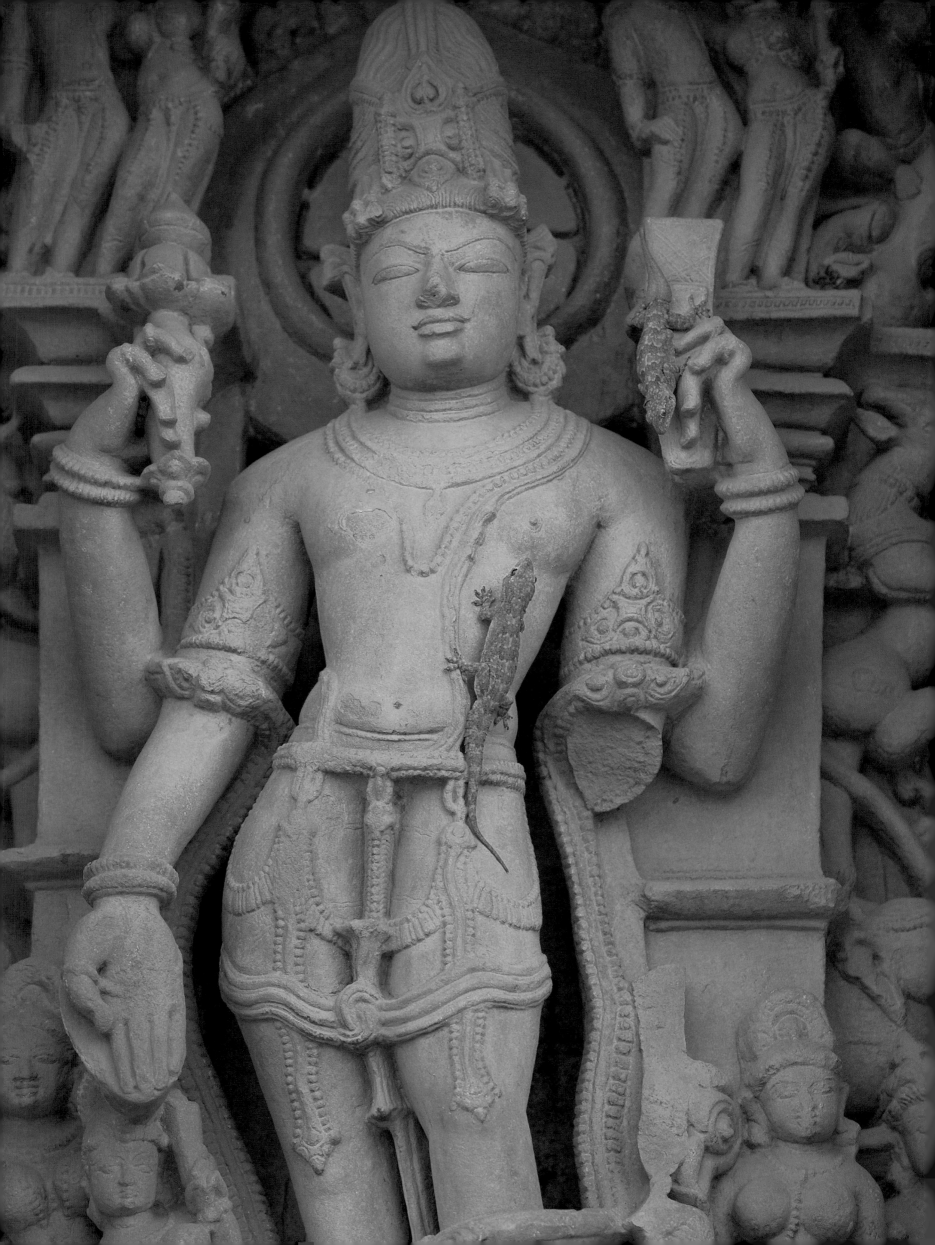

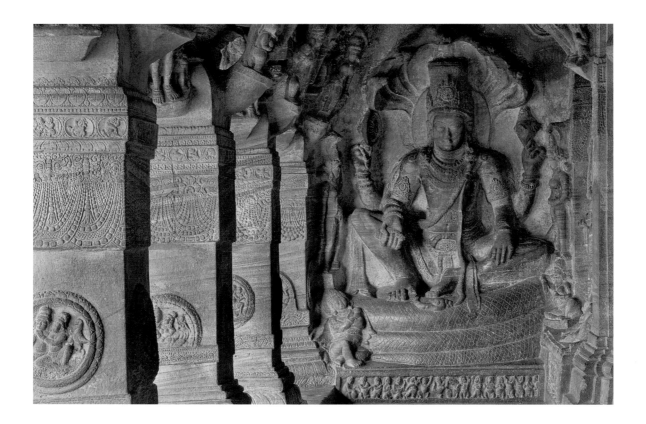

ABOVE: *The alcove of Cave 3 at Badami, in the state of Karnataka, contains this enormous four-armed figure of Vishnu seated atop Adisesha the serpent, whose five hoods open protectively over his crown.*

OPPOSITE: *Vishnu, in the Lakshman temple at Khajuraho. Erotic sculptures adorn the facades and sanctums of the temples at Khajuraho, built during the 9th and 10th centuries by the Chandela dynasty, which dominated central India at that time.*

PAGES 170–171: *Situated on a hilltop near the town of the same name, the Chittorgarh Fort sprawls across 692 acres. The target of successive invaders, this was the largest of Rajasthan's forts.*

◆◆◆ **THE TEMPLE RELIEF SHOWED THE GOD VISHNU ASLEEP** on a multiheaded serpent. Above the reclining chief god were other, lesser divine manifestations, seated on lotuses or winged bulls. At Vishnu's feet sat his spouse, goddess Lakshmi, dutifully massaging the god's tired calf muscles. Below, separated from all the gods by a wall of serpentine coils, were mythological human figures.

I was entranced not by craftsmanship but by the inspired and crazy vision, by the enormity of details. Nothing had been excluded. As viewer, I was free to concentrate on a tiny corner of the relief, and read into the shape of a stone eyelid or stone finger human intrigues and emotions. Or I could view the work as a whole, and see it as the story of Divine Creation. For me, it was a reminder that I had almost lost the Hindu instinct for miraculous transformation of the literal. Not only was Vishnu the chief god, but the serpent supporting Vishnu was also the god Vishnu, given a magical, illusory transformation. My years abroad had made me conscious of ineradicable barriers, of beginnings and endings, of lines and definitions. And now, the preparation for the visit to India was setting off an explosion of unrelated images. Reptile, lotus, flying bull, gods, and heroes: All functioned simultaneously as emblem and as real.

—CLARK BLAISE AND BHARATI MUKHERJEE, *DAYS AND NIGHTS IN CALCUTTA*

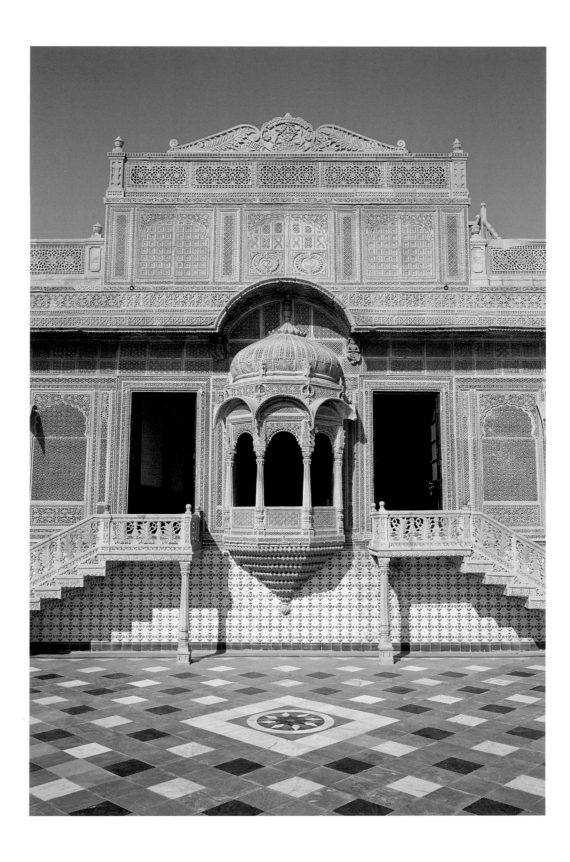

ABOVE: *Jaisalmer's havelis are among its greatest attractions. Built in the 19th century by rich merchants, the old mansions dominate the small back streets of this desert town. Many more recently built structures, such as the Mandir Palace Hotel (pictured), emulate this style.*

OPPOSITE: *Geese walk by a horse on a sleepy back street of Jaisalmer.*

PAGES 174–175: *A mother grooms her daughter after bathing in the waters of the Kaveri river near Tiruchirapalli, in the state of Tamil Nadu. The Kaveri, one of the nine sacred rivers of India, is glorified in Hindu mythology as the personification of Brahma's daughter.*

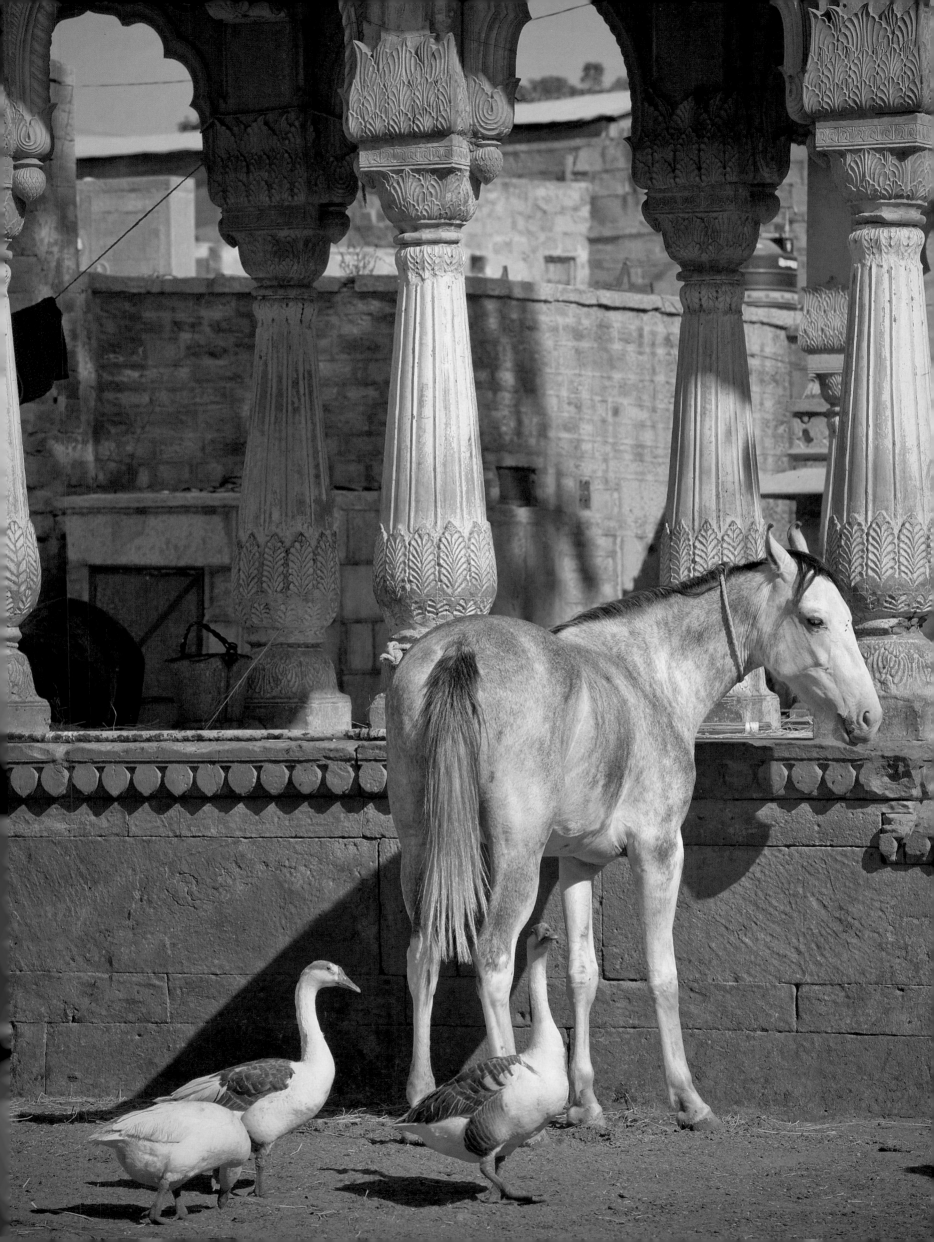

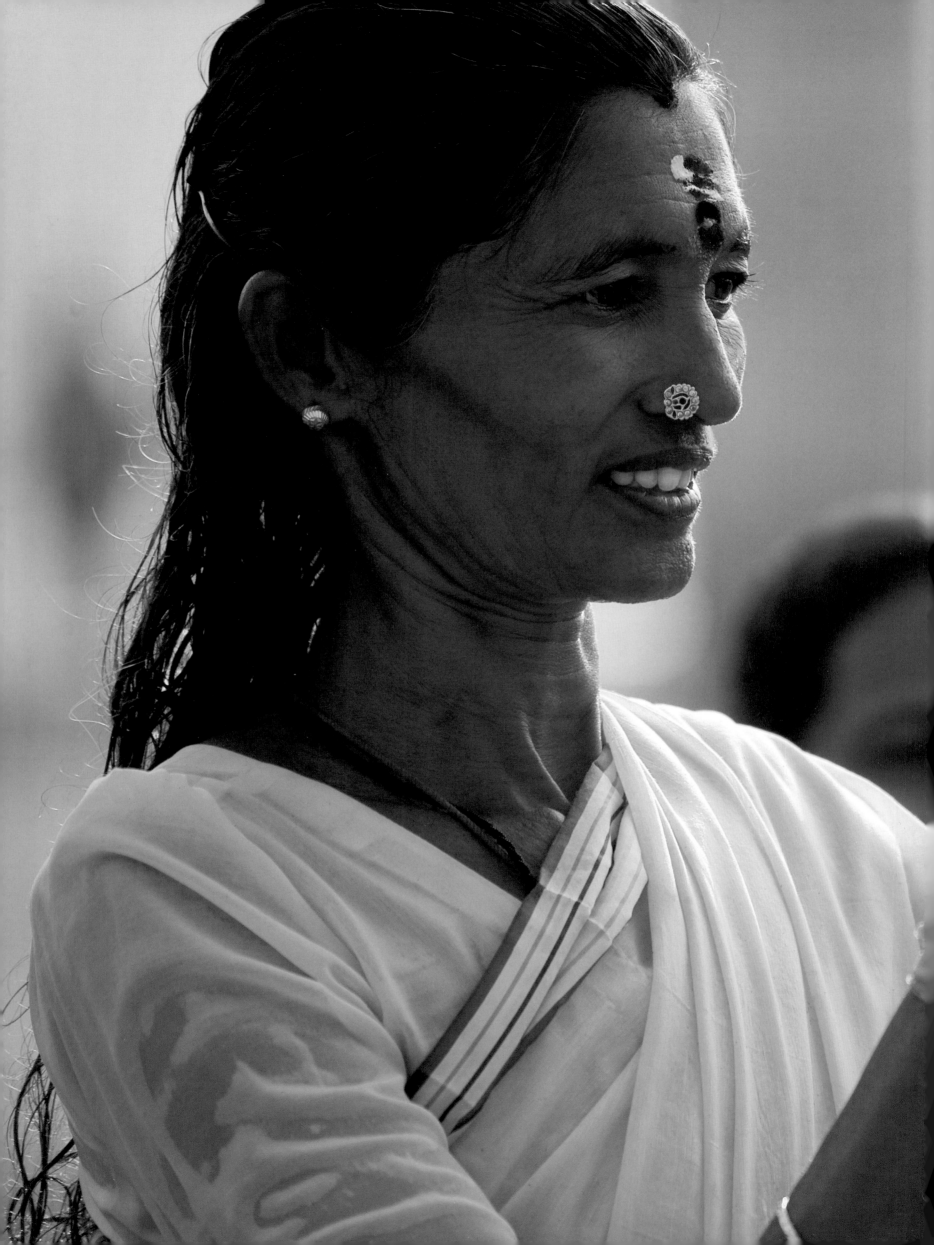

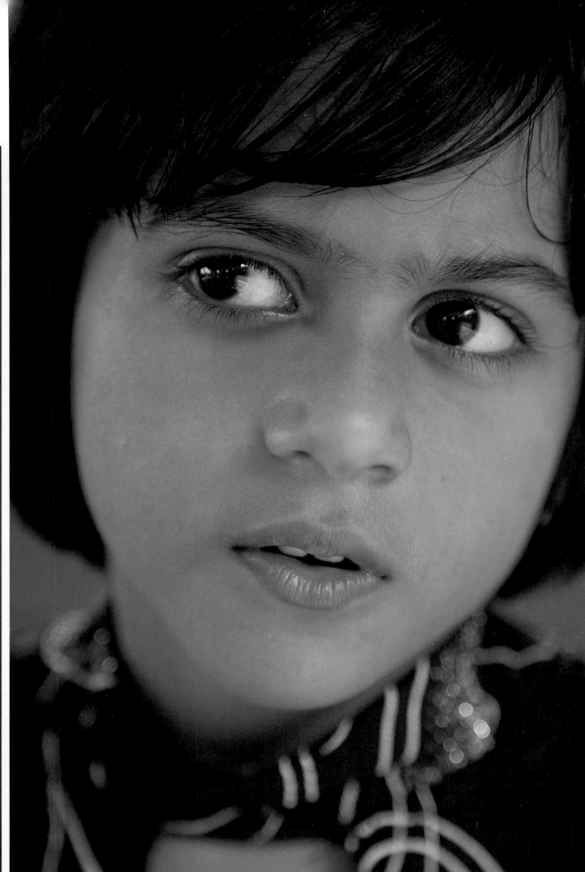
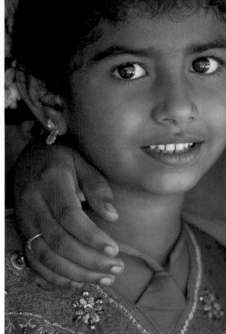

SUBHA

RABINDRANATH TAGORE

WHEN THE GIRL WAS NAMED SUBHASHINI, 'she who speaks sweetly,' who could have known that she would be dumb? Her two elder sisters were called Sukeshini and Suhasini. It was to preserve the rhyme that her father named her Subhashini. Everyone now called her Subha for short.

The two elder daughters had been married off after considerable enquires and expense. The youngest now remained like a silent weight on her parents' hearts.

Many people do not realize that one who does not speak might nevertheless feel, and so they would express their anxiety regarding the girl's future to her face. She had understood from childhood that she had been born in her father's house as a curse sent by God. Consequently she would always strive to conceal herself from the general view. She would think: 'It is best if people forget me.' But can anyone ever forget a grief? The thought of her was always waking in her parents' minds.

Her mother, in particular, thought of her daughter as a lapse on her own part. This is because a mother always sees a daughter, rather than a son, as part of herself—a lack in her daughter seems to her a special cause of personal shame. The girl's father, Banikantha, perhaps loved Subha a little more than his other daughters, but her mother, regarding her as a stain on her womb, was always displeased with her.

Subha had no words, but she had two long-lashed large black eyes—and her lips would tremble like a leafbud at the slightest touch of feeling.

What we express in language has largely to be constructed by our own efforts, somewhat like a translation; it is not always adequate, and through lack of skill may often be wrong. But dark eyes do not have to translate anything. The mind casts its own shadow upon them; feeling is of itself sometimes dilated in them, sometimes shut up; sometimes it flares up brilliantly, sometimes it fades into dimness; sometimes it looks out steadily like the setting moon, sometimes it darts in all directions like the swift inconstant lightning. The language of her eyes who has had no other language since birth than the expression of her face, is limitless, generous, of unplumbed depths. It is like the clear sky, from sunrise to sunset a silent arena for the play of light and darkness. In a speechless human being, there is a solitary greatness like that of immense Nature. For this reason, ordinary boys and girls had a certain fear of her, and would not play with her. She was like the lonely noontide, wordless and friendless.

II

The village was called Chandipur. The river was one of the little rivers of Bengal; like the daughter of a humble household, it did not flow far; slender, unresting, it would confine its work within its banks. It entered into some relation with everyone in the villages on either shore. On both sides, there was habitations, with high banks shaded by trees; below, the swift-flowing goddess of rural beauty, self-oblivious, with quick steps and a joyful heart, went about her innumerable acts of grace.

Banikantha's homestead was at the river's very edge. Its bamboo fences, eight-roofed dwelling-place, dairy, threshing barn, haystacks, tamarind grove, orchards of mangoes, jackfruit and bananas, would attract the attention of anyone passing in a boat. In the midst of all this domestic prosperity, I do not know if anyone noticed the dumb girl; but whenever she found respite from work, she would come and sit by the river.

Nature seemed to compensate her for the lack of language. It seemed to speak for her. The gurgling of the stream, the clamor of people's voices, the boatmen's songs, the calls of the birds, the rustling of the trees: all these, mingling with the comings and goings on every side, the movement, the stir, would come and break like the waves of the sea on the ever-silent shore of the girl's heart. These various sounds and motions of nature, too, were the language of the dumb: an extension into the universe of the language of Subha's long-lashed eyes. From the grassy earth, loud with the sound of crickets, to the world of the stars, beyond sound—everywhere only gesture, motion, song, tears, sighs.

And at noontide, when the boatmen and the fishermen would go home to eat, when the householders would sleep, when the birds did not sing, when the ferry was idle, and the populous world in the midst of all its tasks would suddenly come to a stop and take on an appearance of terrible desolation, then, under the fierce sky, only a dumb nature and a dumb girl would sit speechlessly face to face—the one in the sun's broad rays, the other in the narrow shade of a tree.

It was not that Subha did not have a few intimate friends. There were two cows in the cattle-shed, called Sarbashi and Panguli. They had never heard their names uttered by the girl, but they knew her footsteps—she had a wordless, tender crooning which they understood better than words. They could understand, better than her fellow human beings, when Subha was being loving, when she was scolding, when she was pleading.

Subha would enter the cattle-shed, put both her arms round Sarbashi's neck and rub her cheek against her ear, while Panguli would turn her liquid gaze upon her and lick her. The girl would visit the cattle-shed regularly three times a day, and would often come at other times as well. When she was made to hear hard words in the house, she would come to these two dumb friends of hers—and from her long-suffering, melancholy-stilled gaze, they would seem to fathom the girl's heartache with a kind of blind understanding, standing close to her and rubbing their horns against her arms to comfort her with wordless solicitude.

There were goats and kittens as well. With these Subha did not enjoy that friendship of equals which prevailed between her and the two cows, but they too showed great devotion to her. The kitten would take possession of Subha's warm lap at all times of the day and night and prepare for blissful slumber, indicating by signs that its sleep would be materially eased by the soft touch of Subha's fingers stroking its throat and its back.

PAGES 180–181: *Posters of faces ward off evil spirits in the flower bazaars during the festival of Batkamma in the small town of Warangal.*

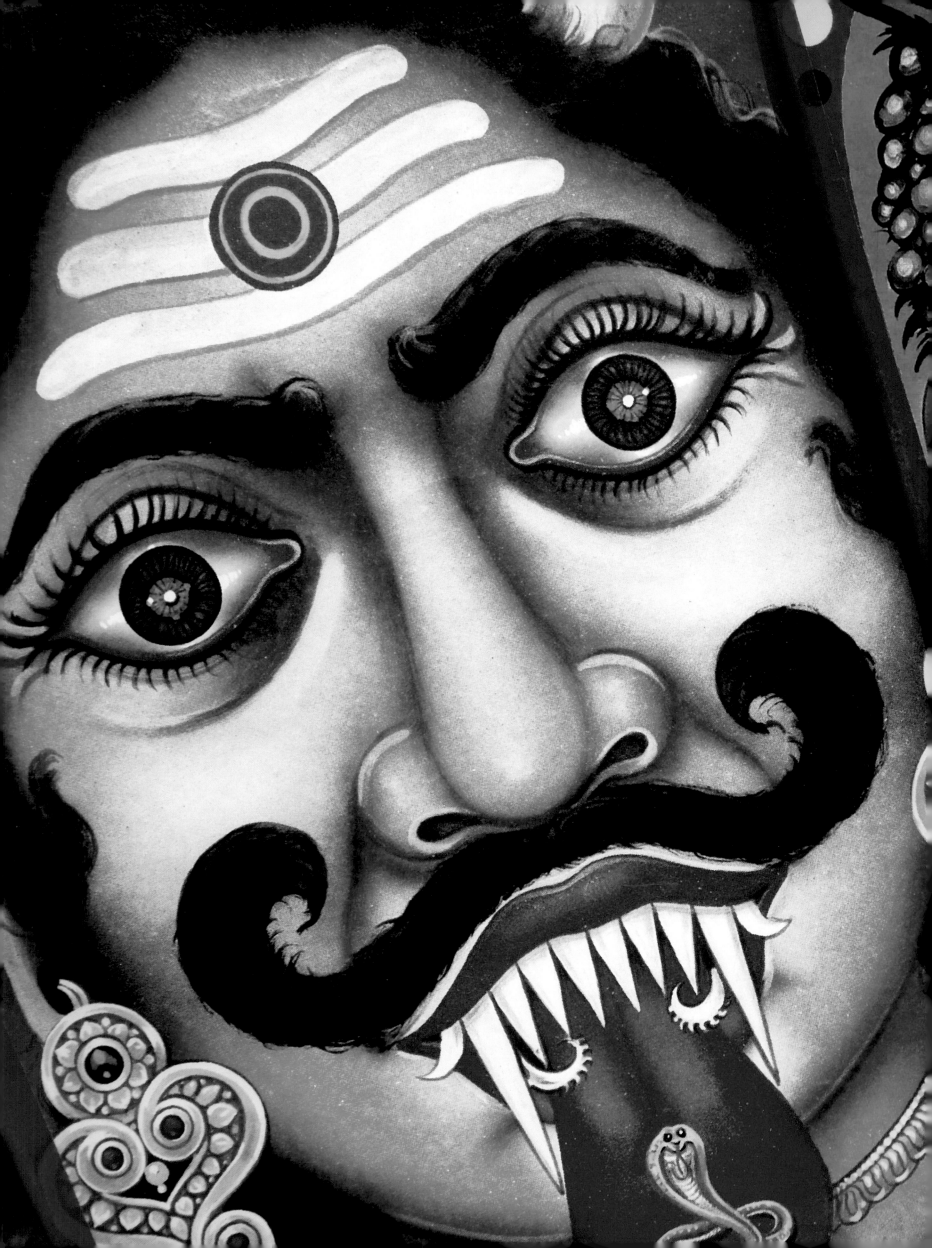

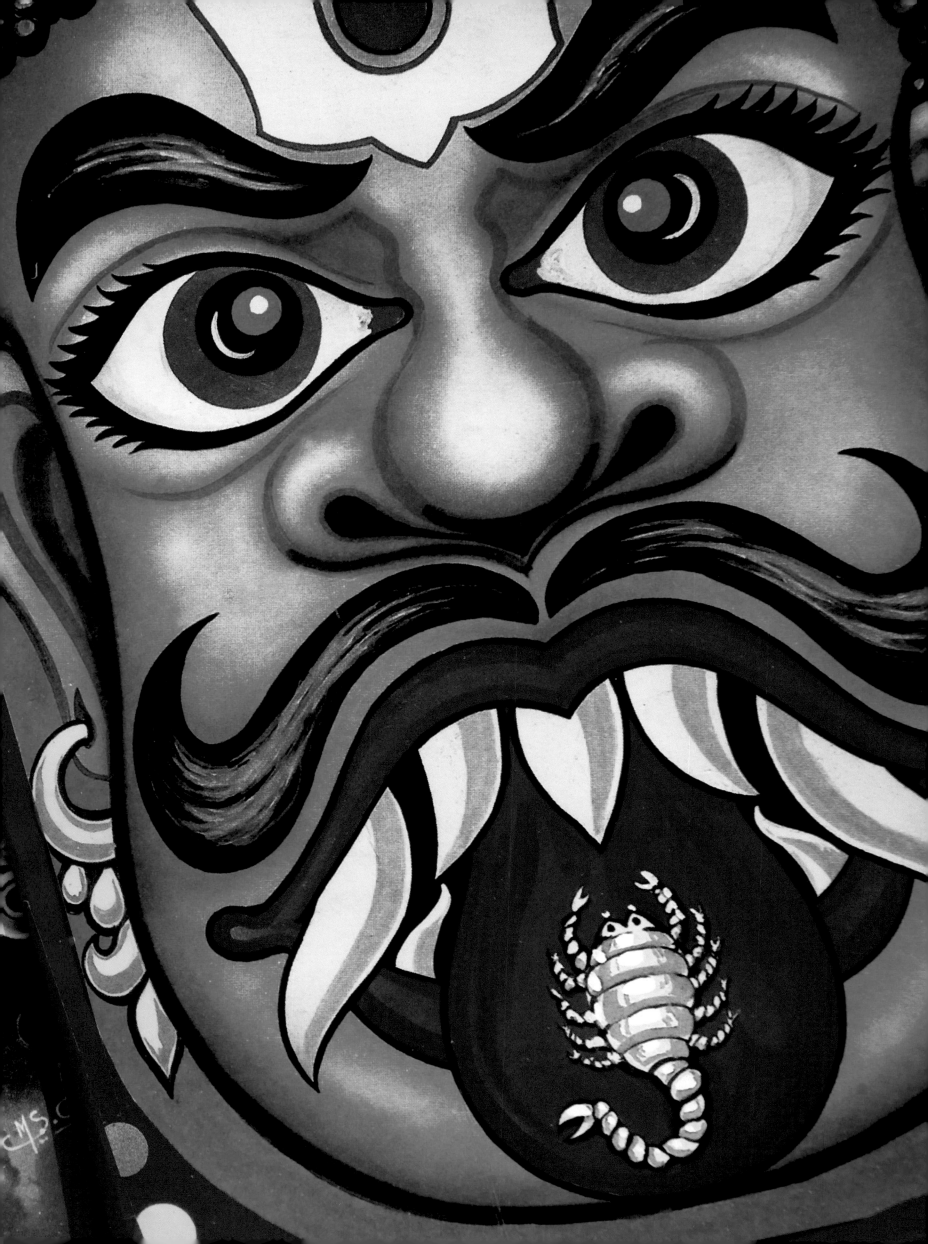

AND YET THIS WAS LATE SUMMER. The year before Madna had topped the charts, as it were, had been the hottest place in India. It had a few traditional rivals in the Indian Deccan but every year Madna's residents were almost always sure that their town and district would be hotter than those. In salutation (and to be fair, to avoid sunstroke), the residents tied a towel or a napkin over their ears and head at eight in the morning and took it off after sundown. Later he tied one too, quite enjoying himself, even getting himself photographed in his hood. And later still, he would think, that those who saw menace in an Indian summer, and called the sun angry and pitiless, and enervating, and words like that, merely reduced the sun to a petty anthropomorphic jumbo. Of course the heat did weaken the calves and dehydrate the head, but the sun, like so many things in Madna, was educative. It taught him the aphorisms of common sense: don't fight the processes of nature, it seemed to say; here, stay indoors as much as you can, if possible turn nocturnal. The world outside is not worth journeying out for, and any beauty out of doors is visible only in the dark, or in the half-light of dawn.

—UPAMANYU CHATTERJEE, *ENGLISH, AUGUST*

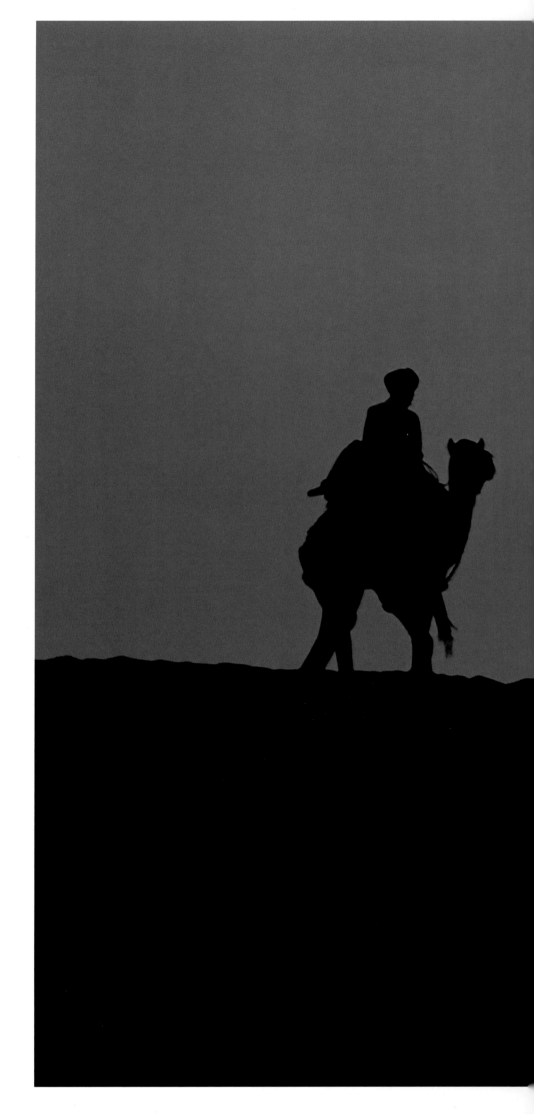

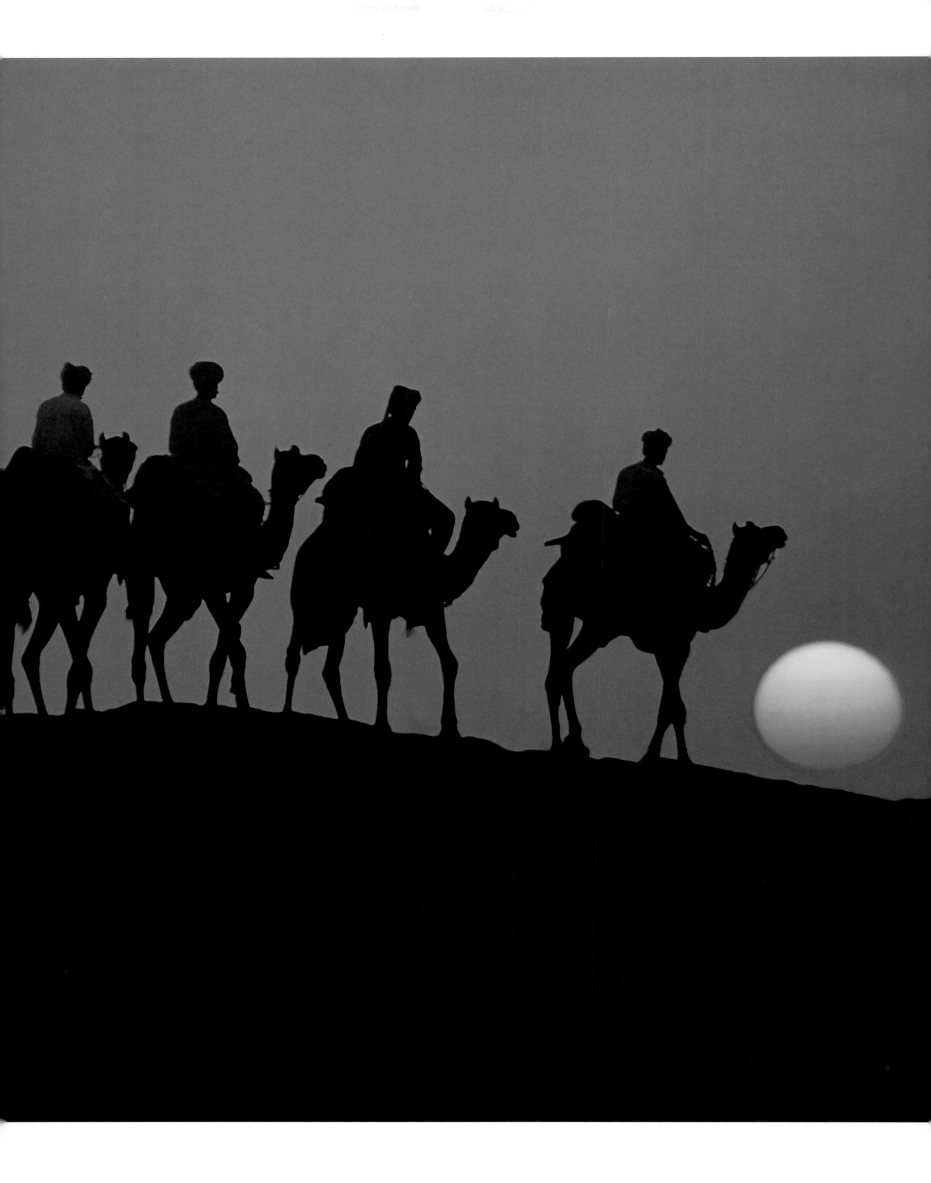

Near the desert outpost of Sam, a small caravan saunters on the dunes at sunset toward the town of Jaisalmer, which borders Pakistan.

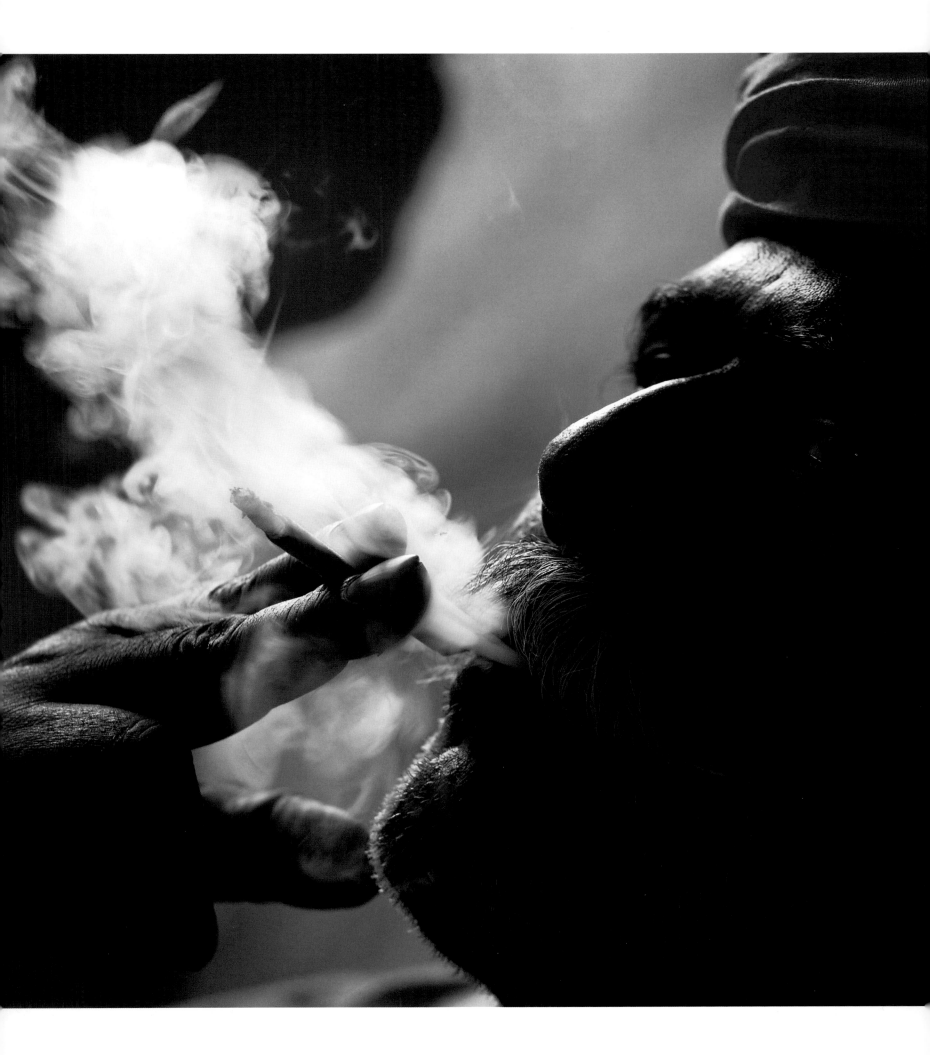

BEING A BIT OF A LAYABOUT, he lay about a bit. Like the lion that the village children had dubbed him when he first arrived, he spent very few hours in active labor, yawned a great deal, and even appeared to luxuriate in his dissatisfied dormancy, which he interrupted off and on by a roar or two and a mild bout of activity—perhaps a swim in the lake by the school, or a walk to a mango grove—for it was the mango season, and Maan was fond of mangoes. Sometimes he lay on his charpoy and read one of the thrillers lent to him by Sandeep Lahiri. Sometimes he looked over his Urdu books. Despite his not very energetic efforts, he was now able to read clearly printed Urdu; and one day Netaji lent him a slim selection of the most famous ghazals of Mir, which, since he knew large parts of them by heart, did not prove too difficult for Mann.

What did people do in the village, anyway? he asked himself. They waited; they sat and talked and cooked and ate and drank and slept. They woke up and went into the fields with their brass pots of water. Perhaps, thought Maan, everyone is essentially a Mr. Biscuit. Sometimes they looked upward at the rainless sky. The sun rose higher, reached its height, sank, and set. After dark, when life used to begin for him in Brahmpur, there was nothing to do. Someone visited; someone left. Things grew. People sat around and argued about this and that and waited for the monsoon.

—VIKRAM SETH, *A SUITABLE BOY*

LEFT: *A Bishnoi tribesman near Rohetgarh smokes a bidi and relaxes after a long day in the fields. The Bishnois worship nature in all its manifestations.*

PAGES 186–187: *Women pass the time in conversation on the steps of the Sankatha ghat in Varanasi, adjacent to the Ganges river, as they wait for their wash to dry in the early-morning sun.*

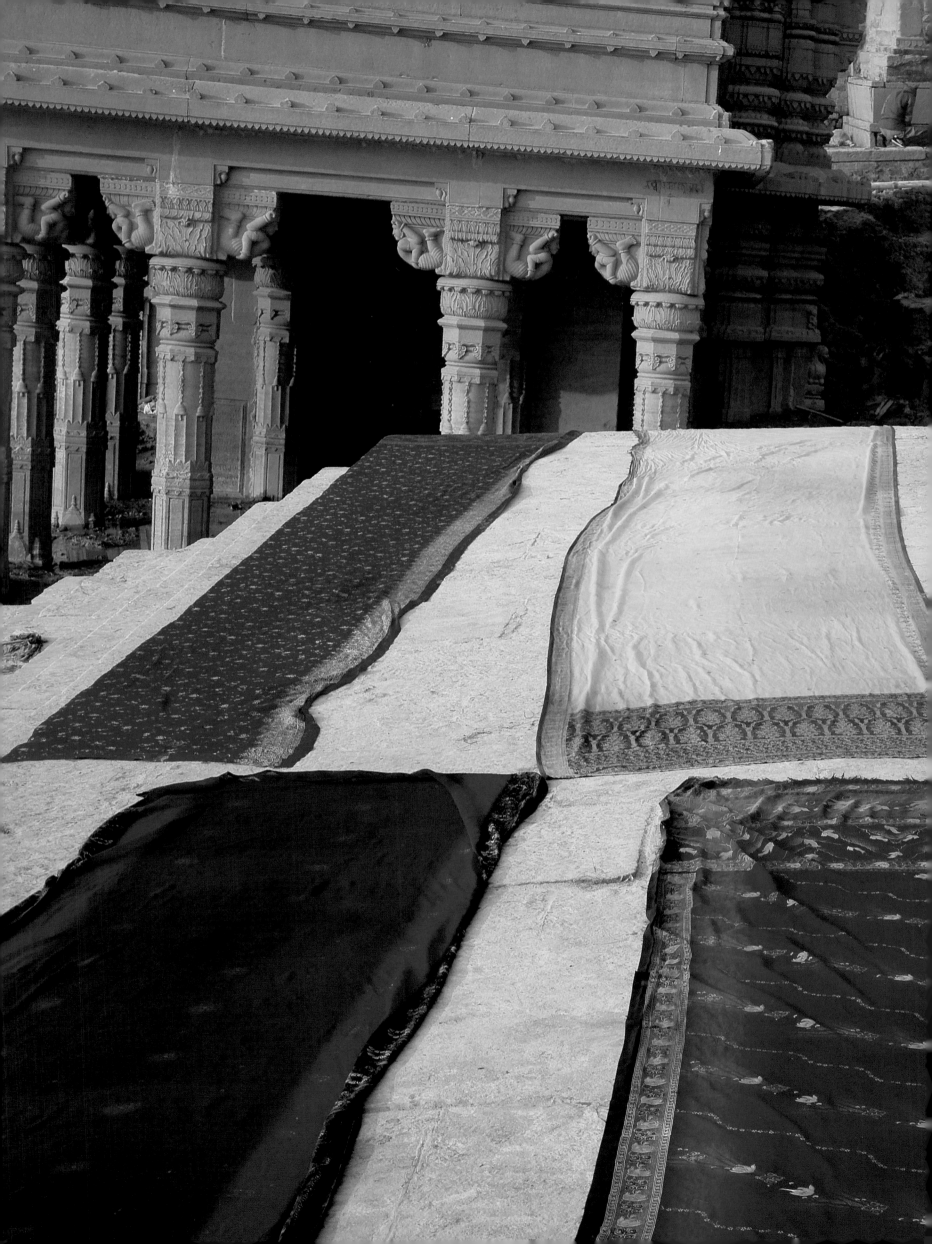

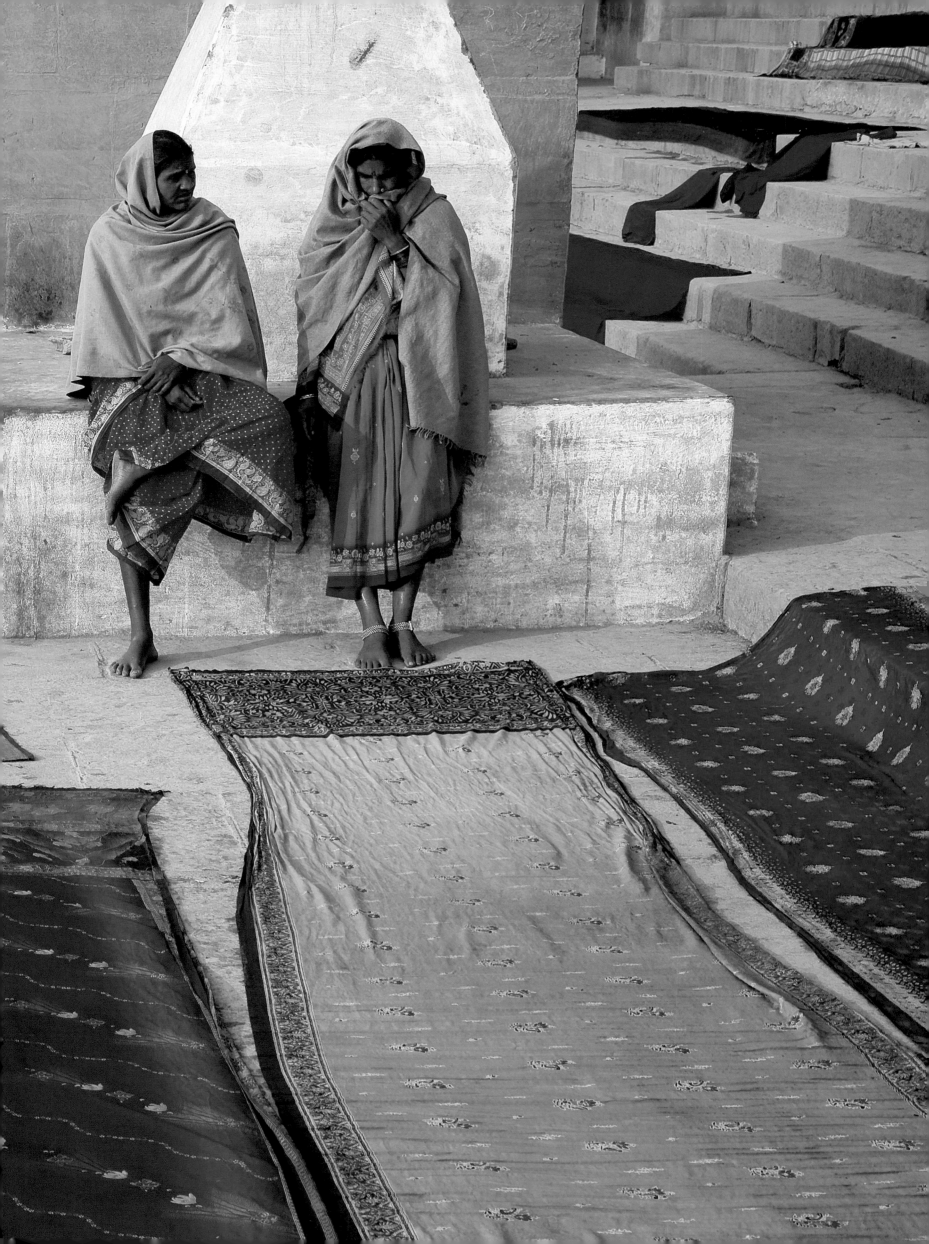

The doors of India, as varied as their religious, social, and architectural significance, reflect India's history of medieval palaces, maharajahs, and forts.

ABOVE TOP: This mud-walled tribal architecture is typical in the village of Khuri, south of Jaisalmer in western Rajasthan.

ABOVE MIDDLE: This playfully painted door is in the town of Rohetgarh, in Rajasthan.

ABOVE BOTTOM: An old wooden door leads through an archway to the desert town of Jaisalmer.

OPPOSITE: A beautifully enameled door of the City Palace in Jaipur, Rajasthan, home to the rulers of Jaipur since the first half of the 18th century.

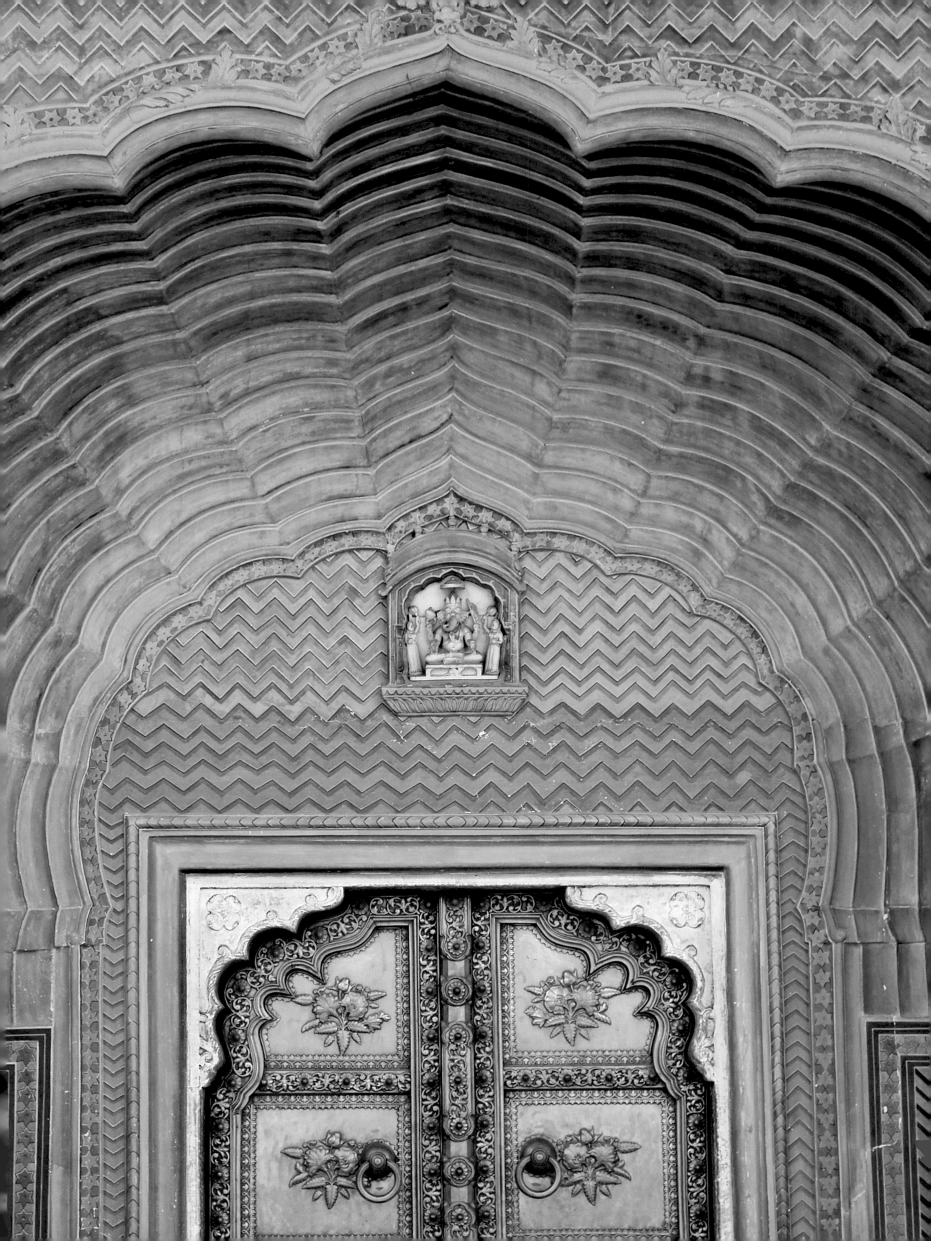

A Strange and Sublime Address
Amit Chaudhuri

SO THEY WENT OUT FOR A WALK.
They went through narrow, lightless lanes, where houses that were silent but gave out smells of fish and boiled rice stood on either side of the road. There was not a single tree in sight; no breeze and no sound but the vaguely musical humming of mosquitoes. Once, an ancient taxi wheezed past, taking a shortcut through the lane into the main road, like a comic vintage car passing through a film set showing the twenties into the film set of the present, passing from black-and-white into color. But why did these houses—for instance, that one with the tall, ornate iron gates and a watchman dozing on a stool, which gave the impression that the family had valuables locked away inside, or that other one with the small porch and the painted door, which gave the impression that whenever there was a feast or a wedding all the relatives would be invited, and there would be so many relatives that some of them, probably the young men and women, would be sitting bunched together on the cramped porch because there would be no more space inside, talking eloquently about something that didn't really require eloquence, laughing uproariously at a joke that

ABOVE: *An old rusted iron and wooden door in the town of Dungarpur, in Rajasthan. No two doors are the same.*

wasn't really very funny, or this next house with an old man relaxing in his easy-chair on the verandah, fanning himself with a local Sunday newspaper, or this small, shabby house with the girl Sandeep glimpsed through a window, sitting in a bare, ill-furnished room, memorizing a text by candlelight, repeating suffixes and prefixes from a Bengali grammar over and over to herself—why did these houses seem to suggest that an infinitely interesting story might be woven around them? And yet the story would never be a satisfying one, because the writer, like Sandeep, would be too caught up in jotting down the irrelevances and digressions that make up lives, and the life of a city, rather than a good story—till the reader would shout "Come to the point!"—and there would be no point, except the girl memorizing the rules of grammar, the old man in the easy-chair fanning himself, and the house with the small, empty porch that was crowded, paradoxically, with many memories and possibilities. The "real" story, with its beginning, middle, and conclusion, would never be told, because it did not exist.

The road ended, and it branched off, on one side, to a larger road, and on the other side to two narrower ones that led to a great field, a maidan, with a pair of poles at either end which were supposed to be goalposts. As they came closer, they noticed that the field was full of people whom they had not been able to discern at first in the darkness: now they came slowly into focus in the moonlight, like a negative becoming clearer and clearer as it was developed in a darkroom. There were all kinds and classes of people—college boys, schoolboys, couples, unemployed men, families, hawkers, groups of girls. The clammy heat had made them leave their houses or hovels in search of a breeze. It was a strange scene because, in spite of the number of people who had congregated together, there was scarcely any noise. The shadowiness of the place made them speak in low voices, as if they were in a theater or an auditorium where the lights had been dimmed meaningfully, and a film or a play was just about to begin. If there had been no power-cut, or if it had still been light, the maidan, needless to say, would have throbbed with its own din and activity. But the darkness had brought a strange lethargy and even peace to these otherwise highly strung men and women, and there was a perceptible sense of release, as if time was oozing by, and the world happening elsewhere.

PAGES 192–193: *Overlooking the "blue city" of Jodhpur (named for the indigo color of its "whitewashed" houses), the second-largest city in the state of Rajasthan.*

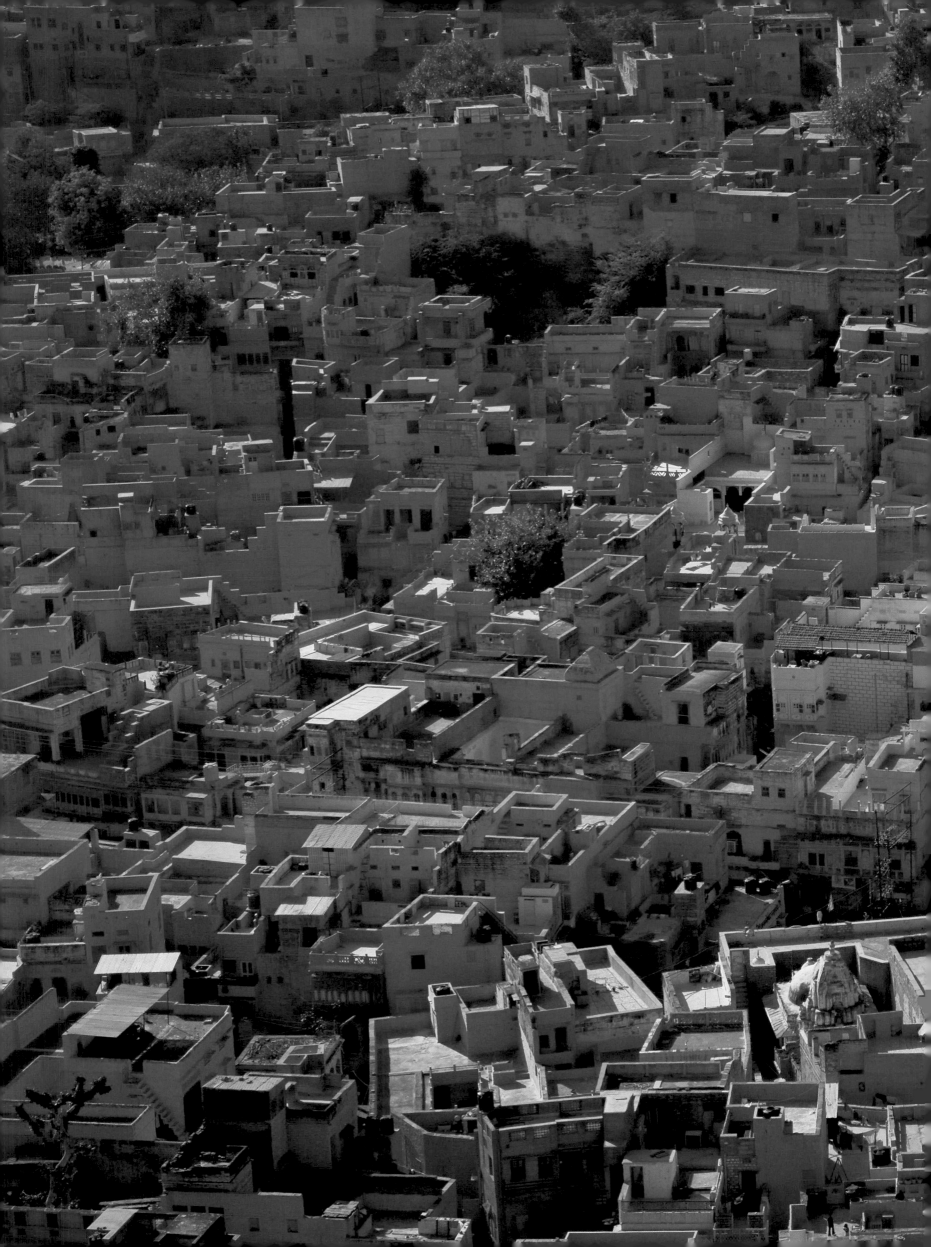

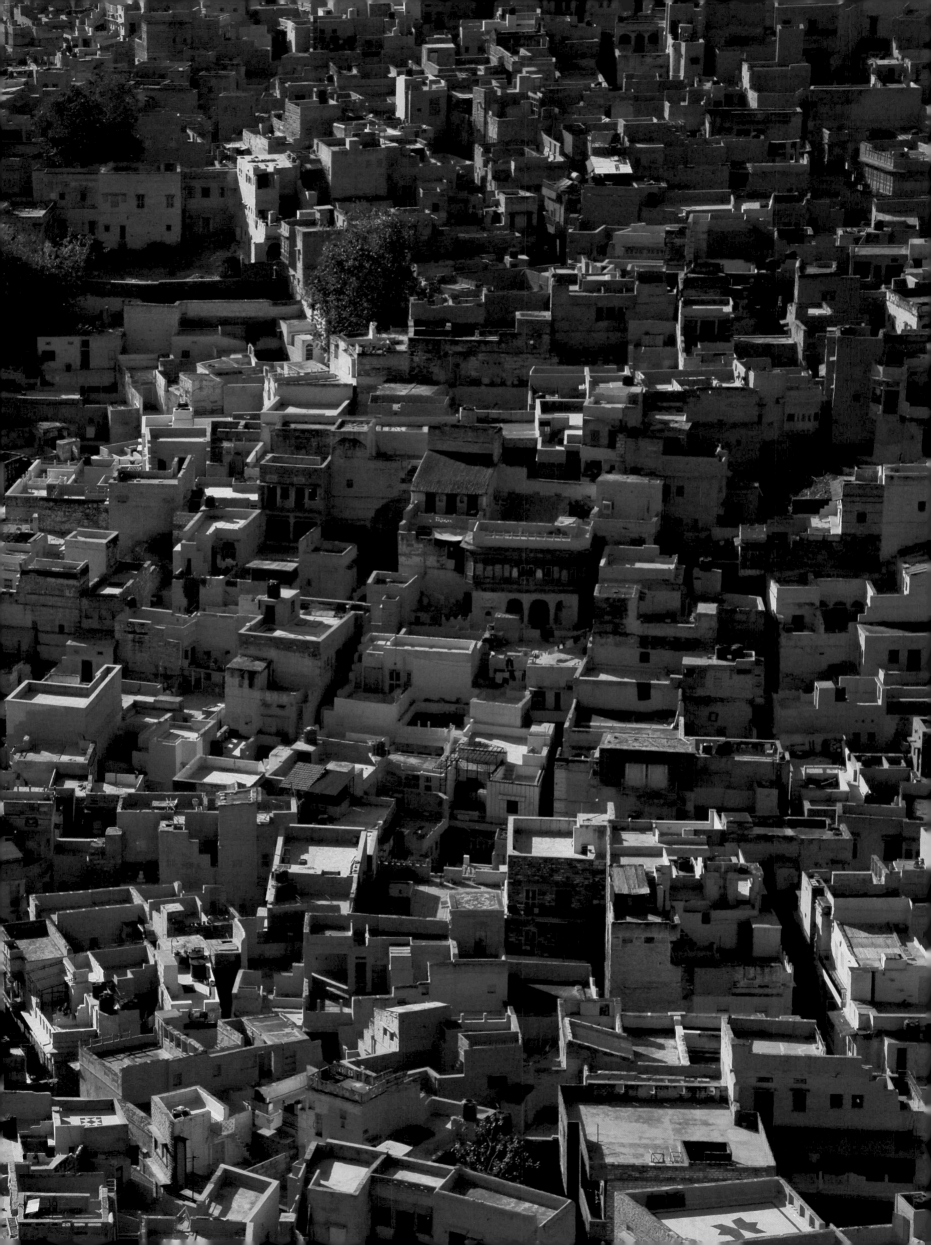

THE GOD OF SMALL THINGS
ARUNDHATI ROY

IT WAS A BOAT. A tiny wooden vallom.

The boat that Estha sat on and Rahel found.

The boat that Ammu would use to cross the river. To love by night the man her children loved by day.

So old a boat that it had taken root. Almost.

A gray old boatplant with boatflowers and boatfruit. And underneath, a boat-shaped patch of withered grass. A scurrying, hurrying boatworld.

Dark and dry and cool. Unroofed now. And blind.

White termites on their way to work.

White ladybirds on their way home.

White beetles burrowing away from the light.

White grasshoppers with whitewood violins.

Sad white music.

A white wasp. Dead.

A brittlewhite snakeskin, preserved in darkness, crumbled in the sun.

But would it do, that little vallom?

Was it perhaps too old? Too dead?

Was Akkara too far away for it?

Two-egg twins looked out across their river.

The Meenachal.

Graygreen. With fish in it. The sky and trees in it. And at night, the broken yellow moon in it.

When Pappachi was a boy, an old tamarind tree fell into it in a storm. It was still there. A smooth barkless tree, blackened by a surfeit of green water. Driftless driftwood.

The first third of the river was their friend. Before the Really Deep began. They knew the slippery stone steps (thirteen) before the slimy mud began. They knew the afternoon weed that flowed inward from the backwaters of Komarakom. They knew the smaller fish. The flat, foolish pallathi, the silver paral, the wily, whiskered koori, the sometimes karimeen.

Here Chacko had taught them to swim (splashing around his ample uncle stomach without help). Here they had discovered for themselves the disconnected delights of underwater farting.

Here they had learned to fish. To thread coiling purple earthworms onto hooks on the fishing rods that Velutha made from slender culms of yellow bamboo.

Here they studied Silence (like the children of the Fisher People), and learned the bright language of dragonflies.

Here they learned to Wait. To Watch. To think thoughts and not voice them. To move like lightning when the bendy yellow bamboo arced downwards.

So this first third of the river they knew well. The next two-thirds less so.

The second third was where the Really Deep began. Where the current was swift and certain (downstream when the tide was out, upstream, pushing up from the backwaters when the tide was in).

The third third was shallow again. The water brown and murky. Full of weeds and darting eels and slow mud that oozed through toes like toothpaste.

The twins could swim like seals and, supervised by Chacko, had crossed the river several times, returning panting and cross-eyed from the effort, with a stone, a twig or a leaf from the Other Side as testimony to their feat. But the middle of a respectable river, or the Other Side, was no place for children to Linger, Loll or Learn Things. Estha and Rahel accorded the second third and the third third of the Meenachal the defense it deserved. Still, swimming across was not the problem. Taking the boat with Things in it (so that they could [b.] *Prepare to prepare to be prepared*) was.

They looked across the river with Old Boat eyes. From where they stood they couldn't see the History House. It was just a darkness beyond the swamp, at the heart of the abandoned rubber estate, from which the sound of crickets swelled.

Estha and Rahel lifted the little boat and carried it to the water. It looked surprised, like a grizzled fish that had surfaced from the deep. In dire need of sunlight. It needed scraping, and cleaning, perhaps, but nothing more.

Two happy hearts soared like colored kites in a skyblue sky. But then, in a slow green whisper, the river (with fish in it, with the sky and trees in it), bubbled in.

Slowly the old boat sank, and settled on the sixth step.

And a pair of two-egg twin hearts sank and settled on the step above the sixth.

The deep-swimming fish covered their mouths with their fins and laughed sideways at the spectacle.

PAGES 196–197: *In the late-afternoon twilight of the Ganges delta, a man and his sons search the low-lying floodwaters for fish during the rainy season, near Patna, state of Bihar.*

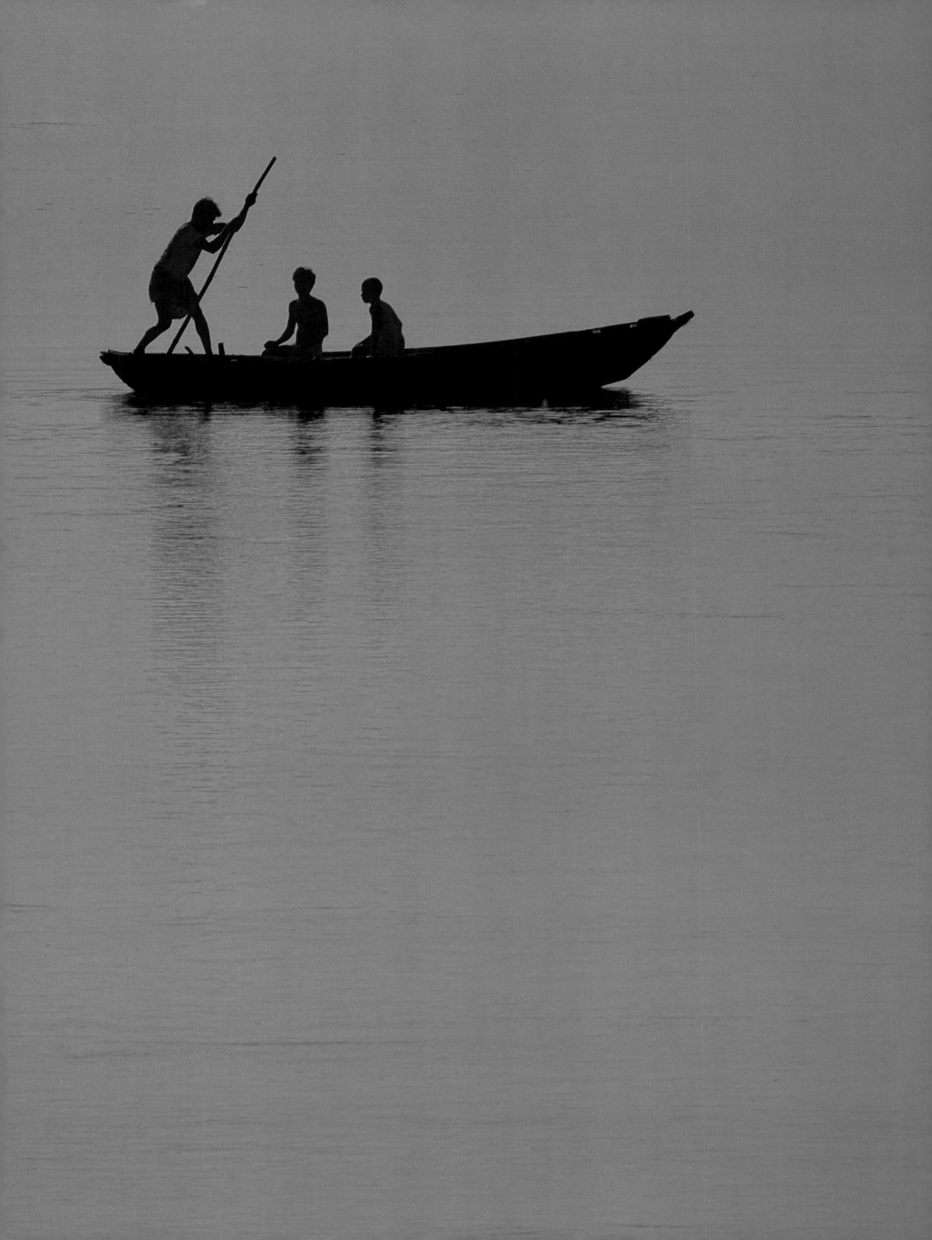

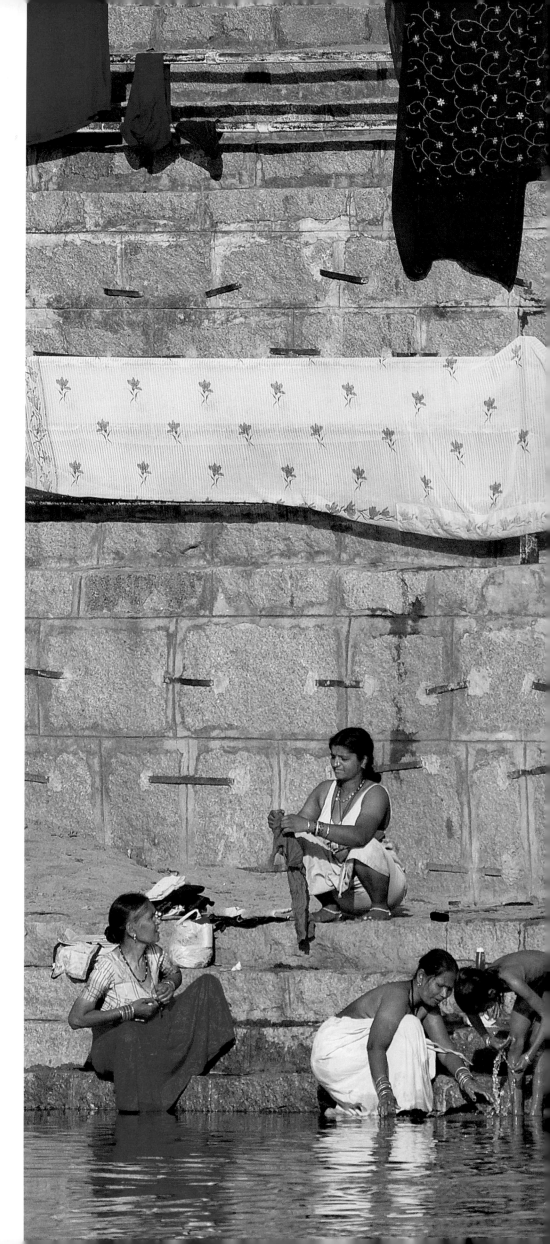

THE BEST PART of Mira-masi's visit would be the obligatory trip to the river that Mama and Papa themselves did not permit their children, saying it was too hot, too dangerous, too dusty, too diseased, too crowded—in every way inadvisable. But they could not refuse Mira-masi what was to her a taste of paradise, and allowed her, rather grimly, to take the children when she went for her ritual dip, first taking them aside to warn them not to go near the water, keep well away from the river's edge and keep a watch out for crocodiles and death by drowning.

The warning proved unnecessary for both Arun and Aruna who went no further than the top of the stone steps leading down to the river, looking down at its sluggish flow and the line of washermen and pilgrims and boatmen with disdain; neither of them would have considered putting a foot into it, or a toe: they were too mindful of their health and safety.

Only Uma tucked her frock up into her knickers and waded in with such thoughtless abandon that the pilgrims, the washermen, the priests and boatmen all shouted, "Watch out! Take care, child!" and pulled Uma back before she sank up to her chin and the current carried her away. It had not occurred to her that she needed to know how to swim, she had been certain the river would sustain her.

—ANITA DESAI, FASTING, FEASTING

RIGHT: *Families gather in the late afternoon sunlight at a small ghat to bathe, wash their laundry, and socialize, near the town of Orchha, Madhya Pradesh.*

PAGES 200–201: *Surrounded by a ring of hills, the majestic 18th-century Lake Palace of Udaipur glows in the light of sunrise on Lake Pichola.*

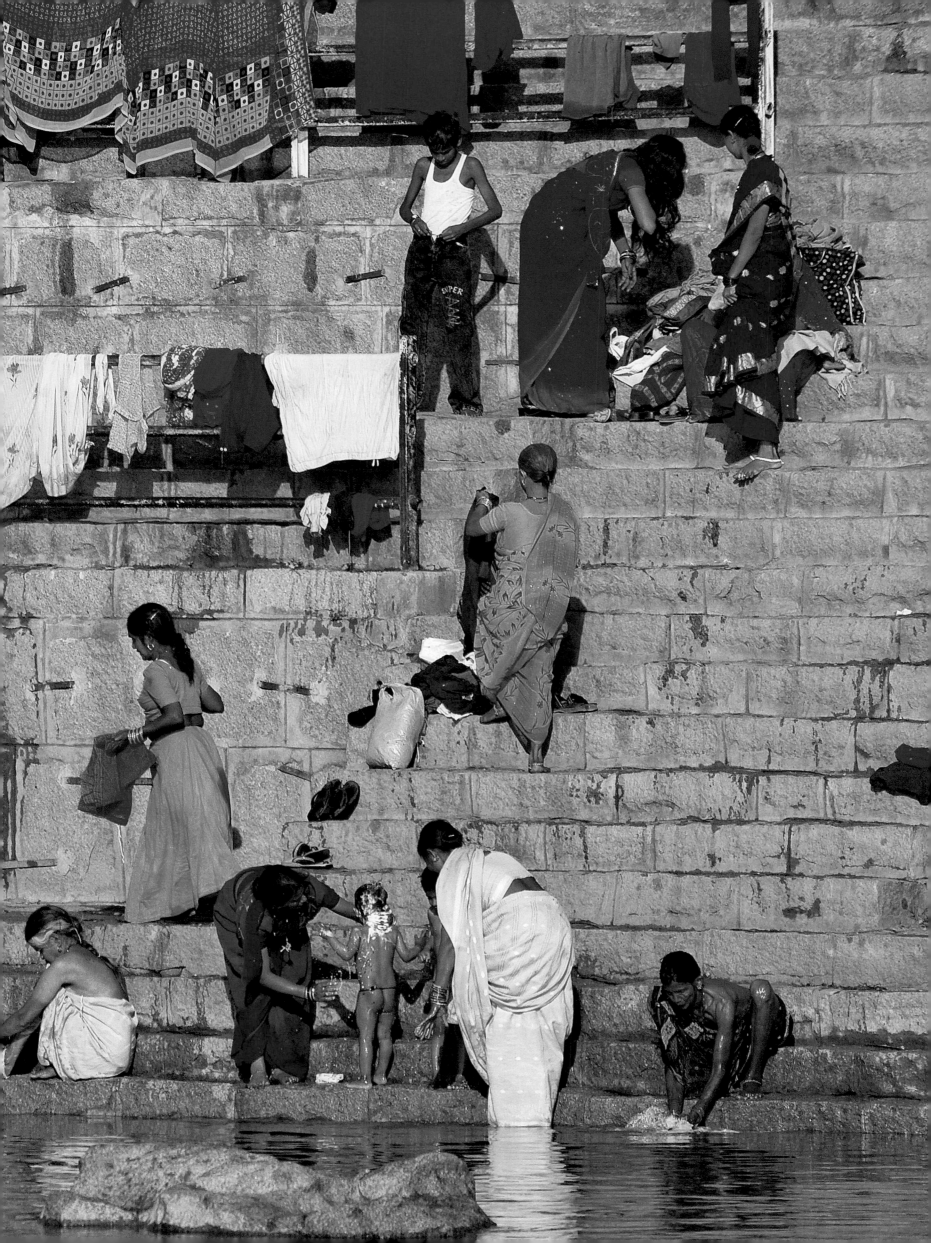

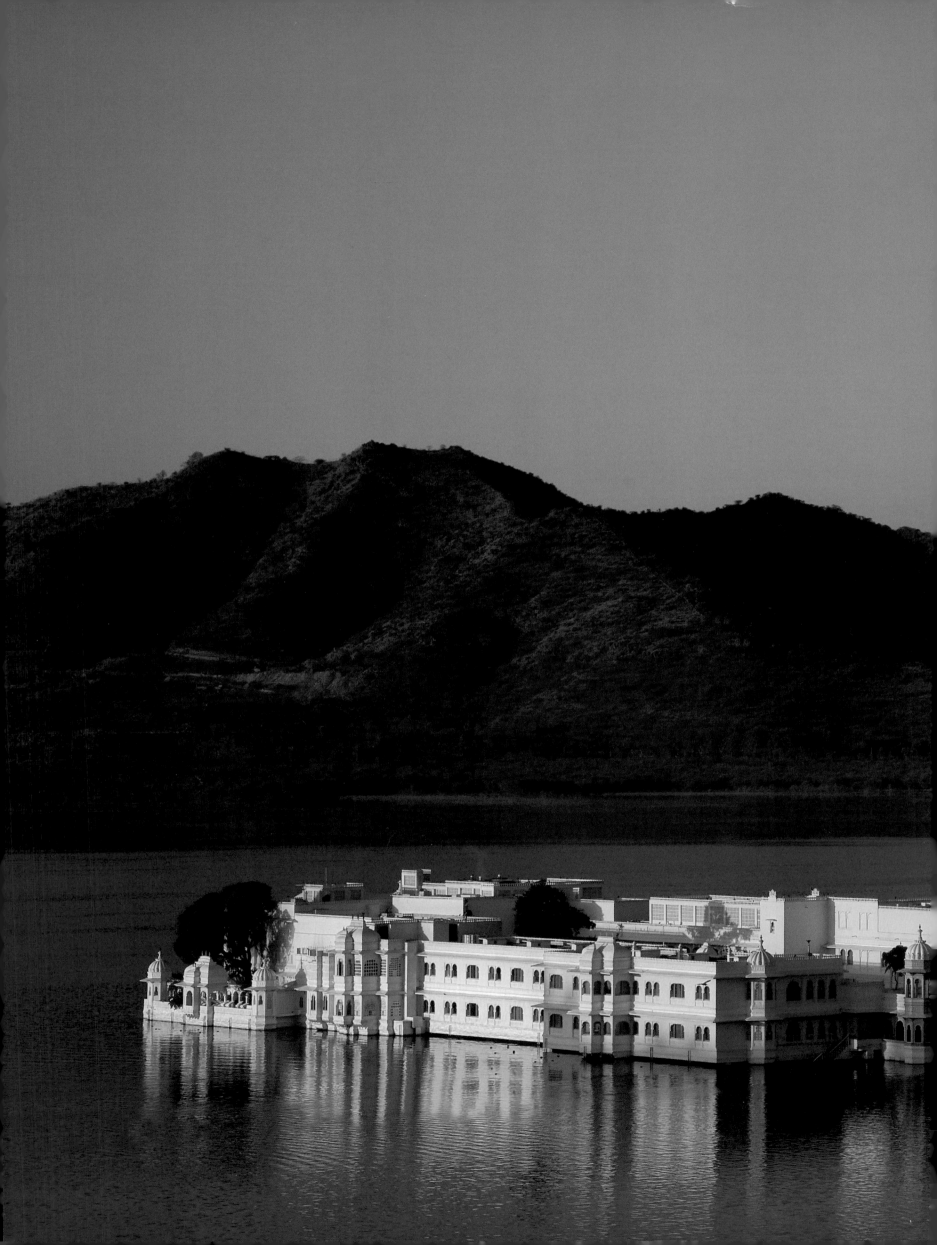

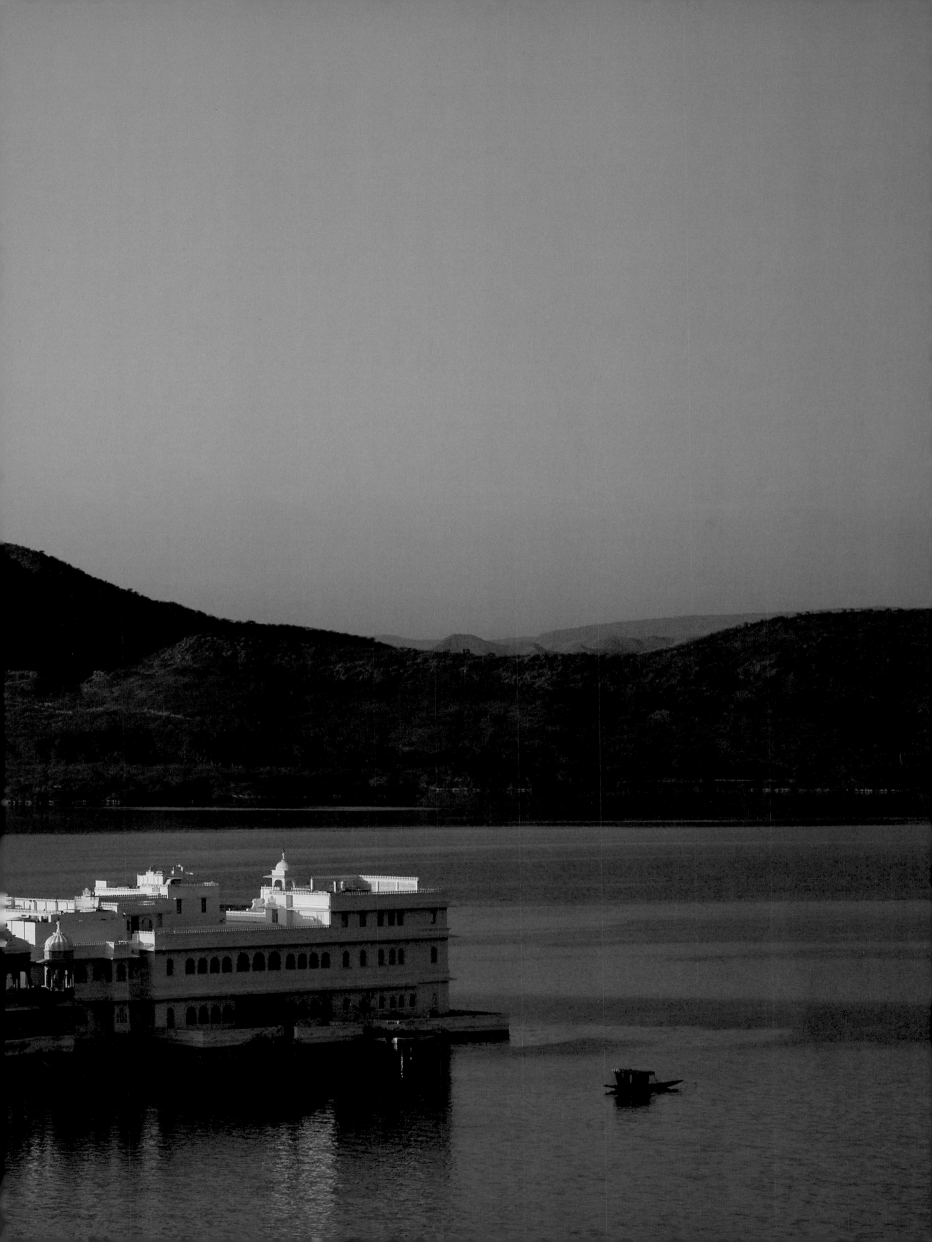

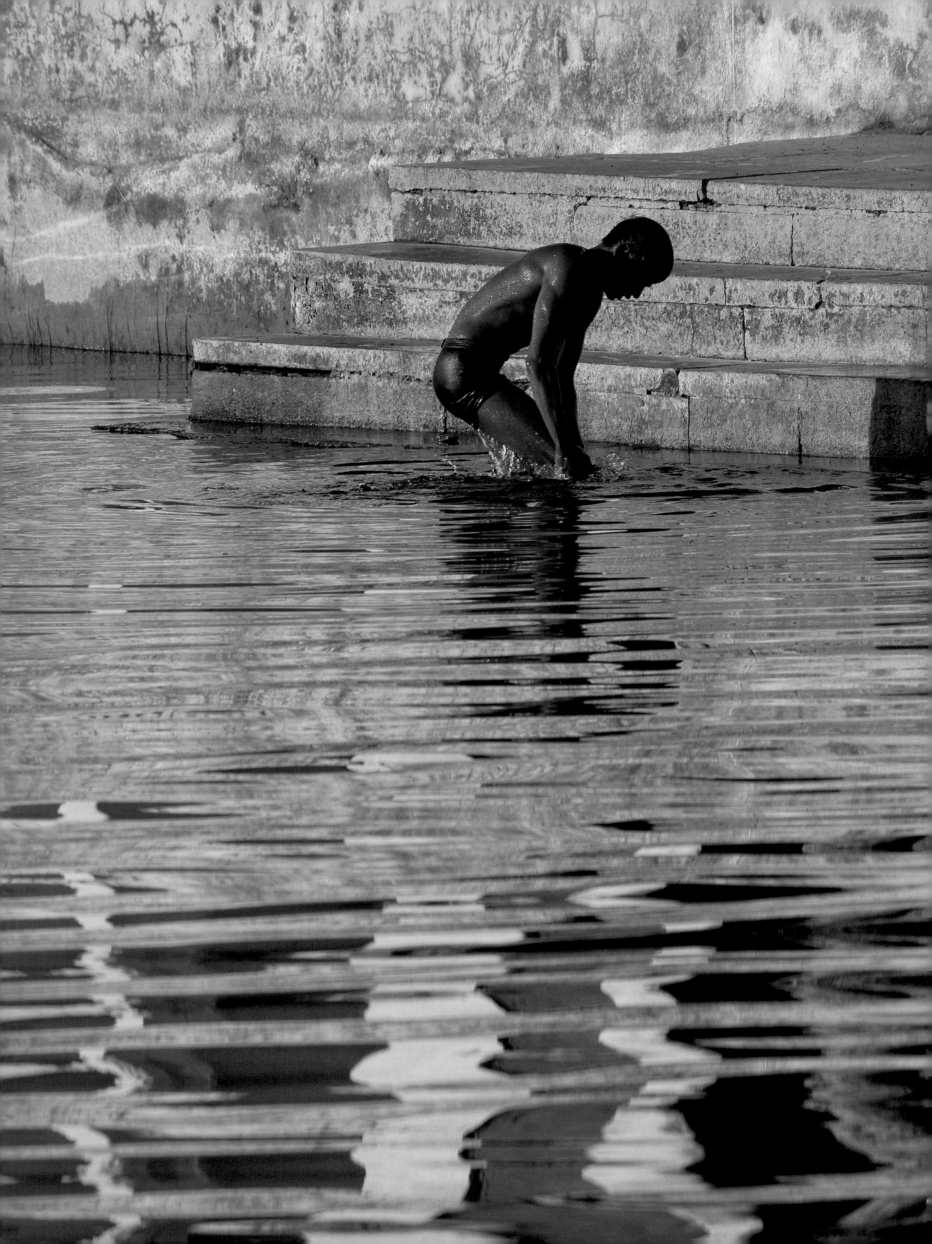

YEARS PASSED. Nangema Kutty was married off to another village, and Parameswaran had no one to talk to about the river. It was just as well, Parameswaran thought, these relationships obstruct the great flow.

Now Parameswaran stopped turning toward the source. *I have learnt all about the source*, he told himself, *what remains to be known is the sea.*

One day there was an unexpected bather, Krishnan-*vaidyan*, the medicine man from the next village.

"I seldom see you bathe at this spot, O *vaidyan*," Parameswaran said as the medicine man entered the water.

"I am on my way to visit a patient," Krishnan-*vaidyan* said. "Seeing the river I couldn't resist the temptation of a dip."

"It will do you good."

The medicine man finished his bath and went his way. "Goodbye, Parameswaran-ettan," he said. "Take care of yourself."

On his way back, after two hours, Krishnan-*vaidyan* found Parameswaran still sitting in the water.

"What are you doing?" the medicine man asked. "Haven't you finished your bath?"

Parameswaran merely turned a blank smile on his friend.

The medicine man continued, "You are not young anymore. Too much of this will make you ill."

Saying this, Krishnan-*vaidyan* resumed his journey. Parameswaran continued to sit in the water. For the first time in all these years, he sensed his feet grow light, as though the river was washing away old encrustations. As the river flowed away with the gross elements, a trail of awareness seemed to stem from his extremities and follow them on their journey. Soon he could sense the estuary, he felt he was sitting with his feet dipped in the far ocean.

It was noon and there were no bathers in the river. Parameswaran was relieved. Around him the waters grew vibrant, sentient. They washed away more of his gross matter, patiently undoing each successive layer. When his calves and thighs were pared away, his knowledge of the sea became larger. A sensuous fatigue came over him when he felt the river work on his hands and shoulders, and reach out to his neck. When all that dismembered matter flowed away he began sensing the current with his subtle spine. Joy flowered in his brain as a thousand-petaled lotus.

Parameswaran was now the lotus afloat in the river. How long had he waited for this flowering! In the radiance of the petals, in the pure knowledge of the flower, Parameswaran watched the flower itself dissolve.

The river became experience, it became knowledge and light. When the last petal dissolved, Parameswaran knew the whole of the river, and he laughed from mountain to sea.

—O. V. VIJAYAN, *THE RIVER*

OPPOSITE: *In the warmth of the morning sun, a man comes to pray and to bathe at a ghat in Udaipur. Ghats are also a social gathering place where the day begins with peace and reverence.*

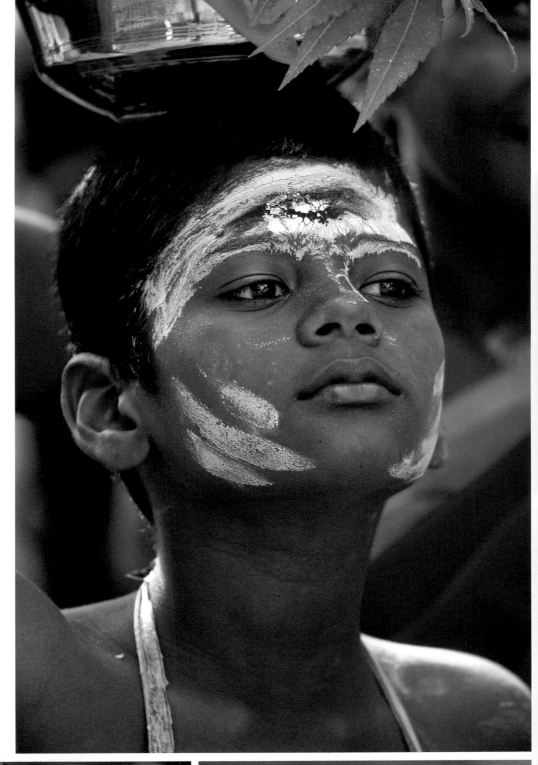

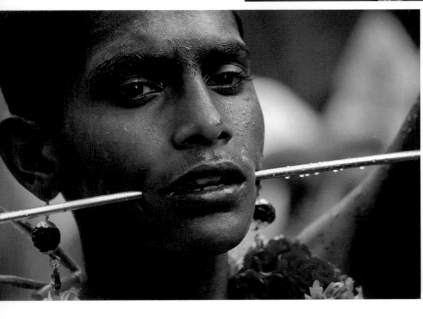

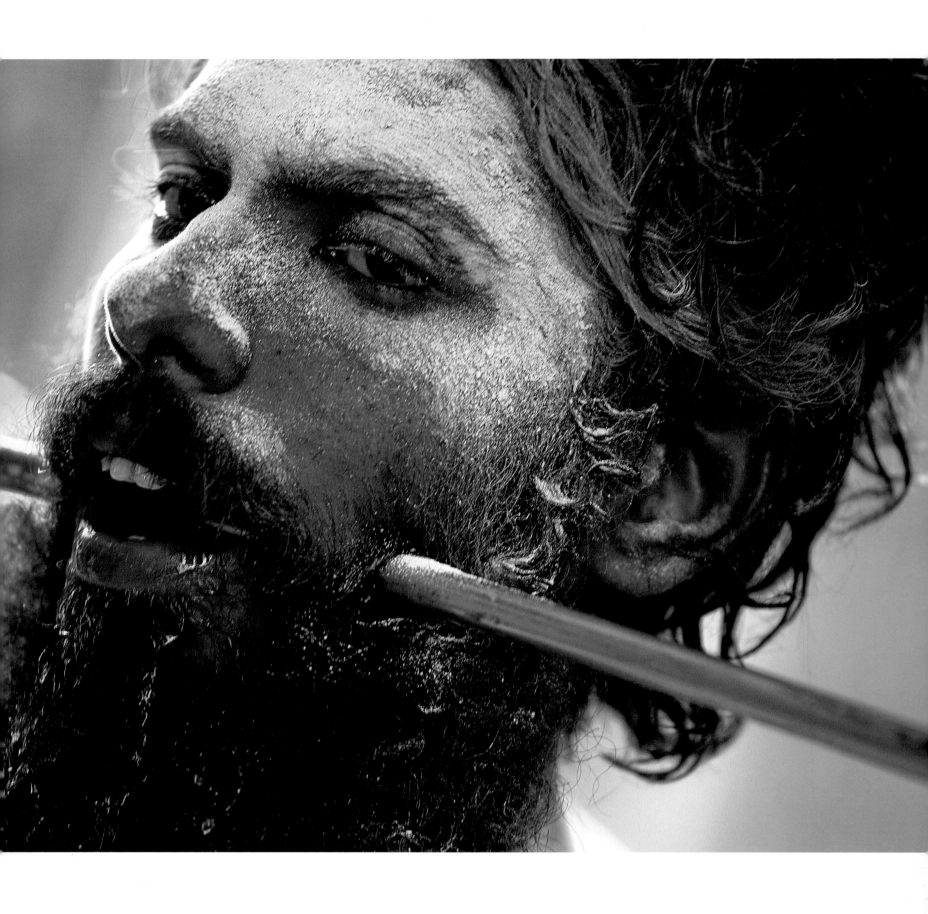

ABOVE AND OPPOSITE: *In Madurai, in the south of India, penitents shave their heads, lance their cheeks with steel rods, and make offerings of neem leaves as penance to Shiva—all part of the ceremonies in which the goddess Meenakshi and Shiva's wedding is celebrated. The great Meenakshi Sundareshvara temple at Madurai is dedicated to this couple.*

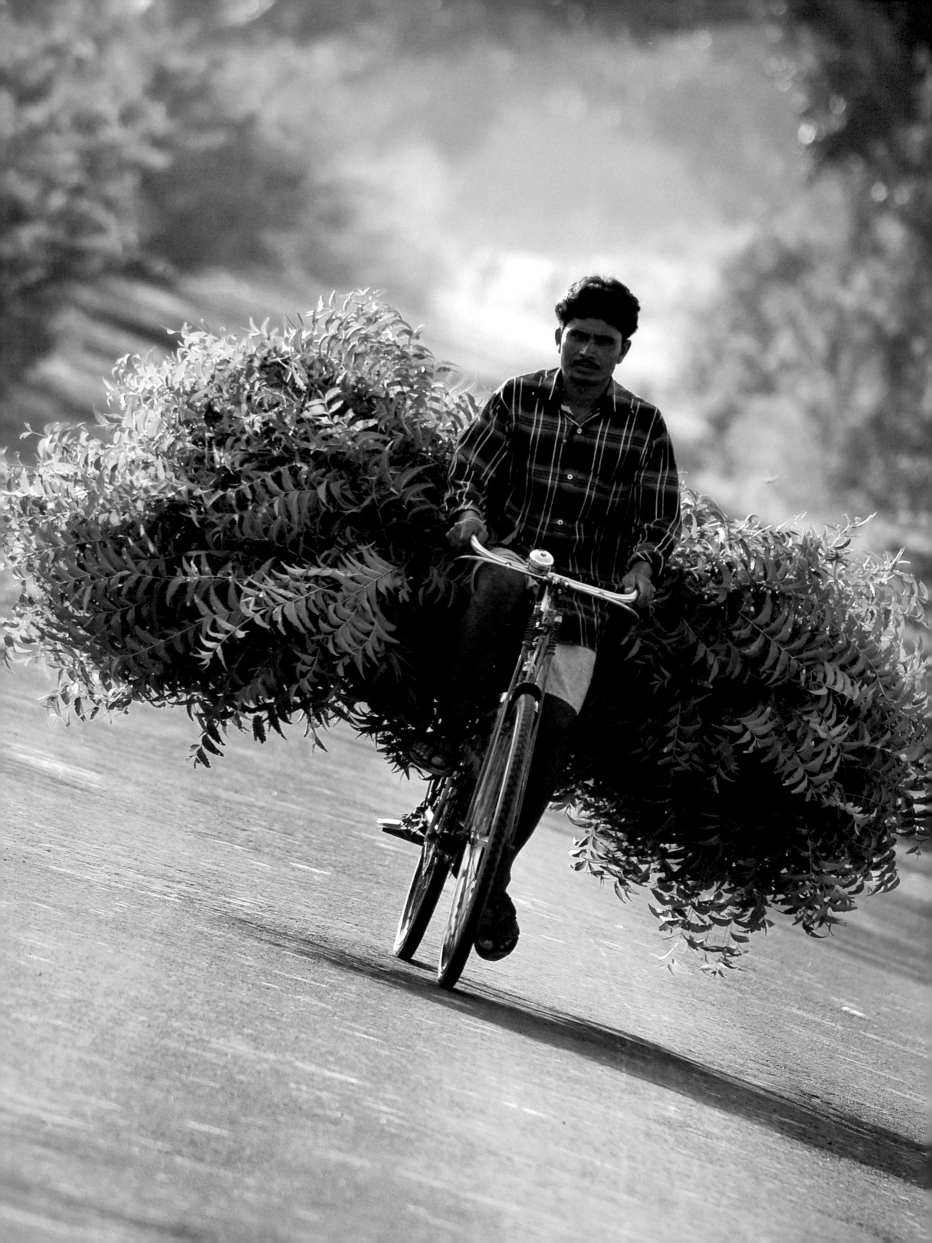

ABOVE: *Rural Indians call the neem tree their "village pharmacy" because it is said to cure diseases and disorders ranging from ulcers to malaria.*

OPPOSITE: *A man carries a huge load of neem leaves to market on the back of his bicycle along a country road near Madurai.*

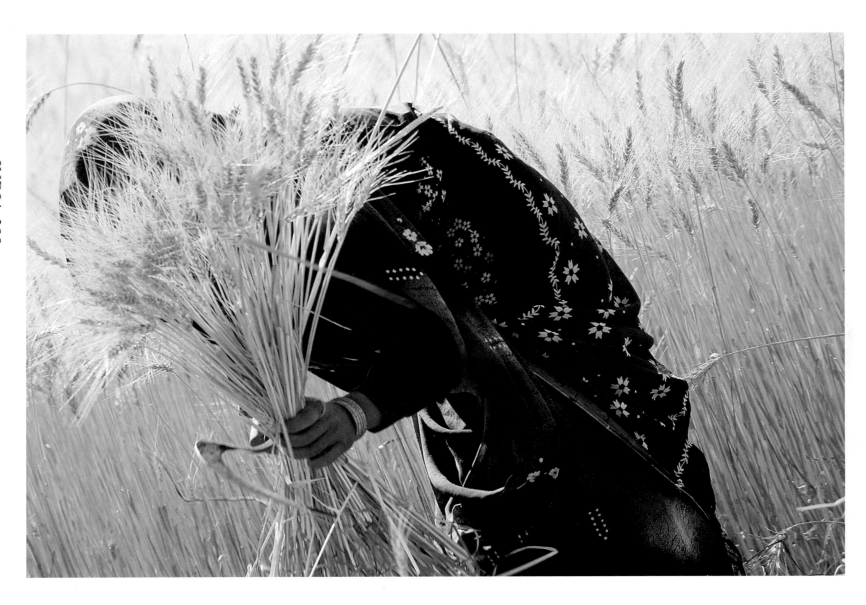

ABOVE AND OPPOSITE: *The area of eastern Gujarat state has some of the most fertile farmland in India, and the fields are filled with women harvesting the wheat as their ancestors did, with hand scythes.*

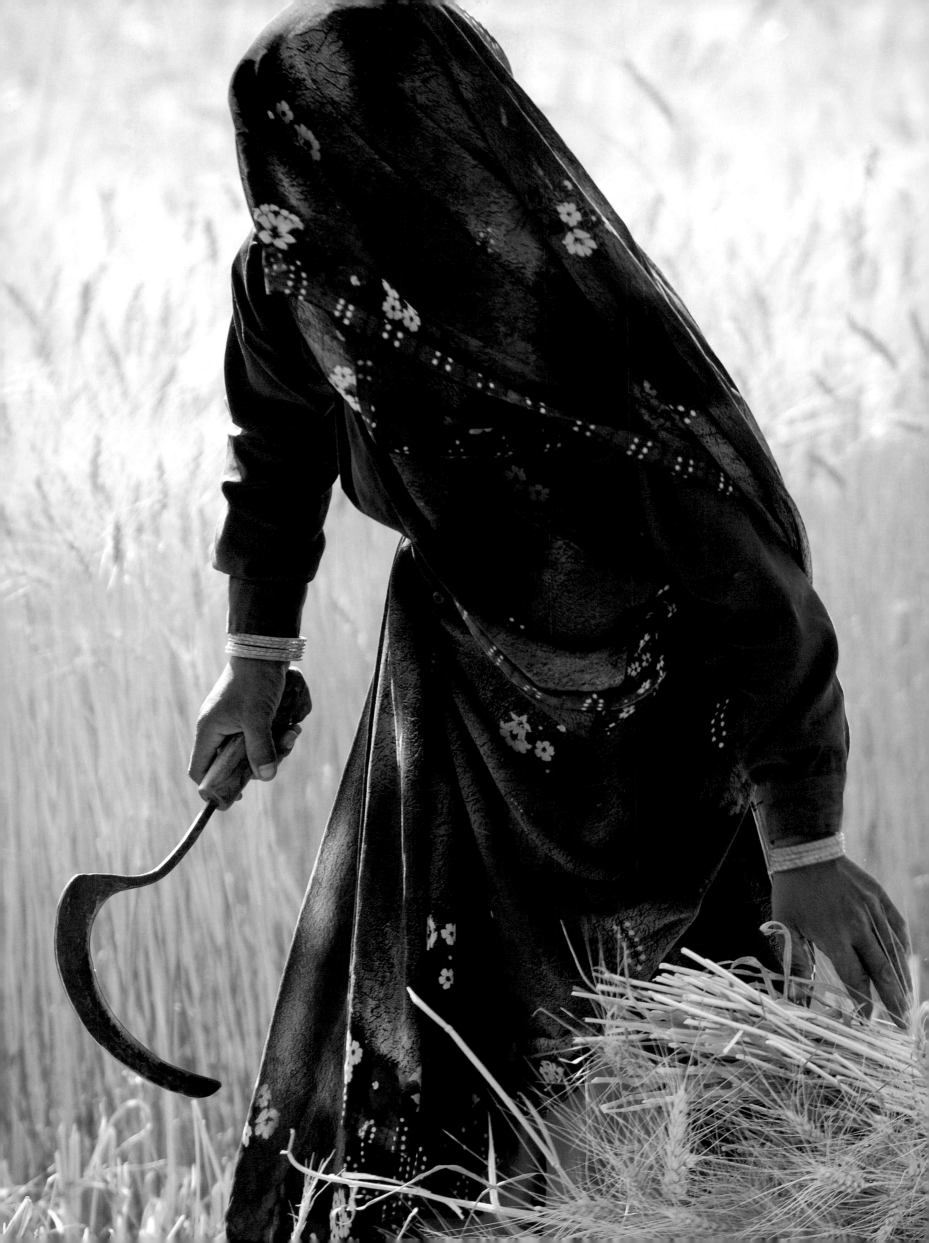

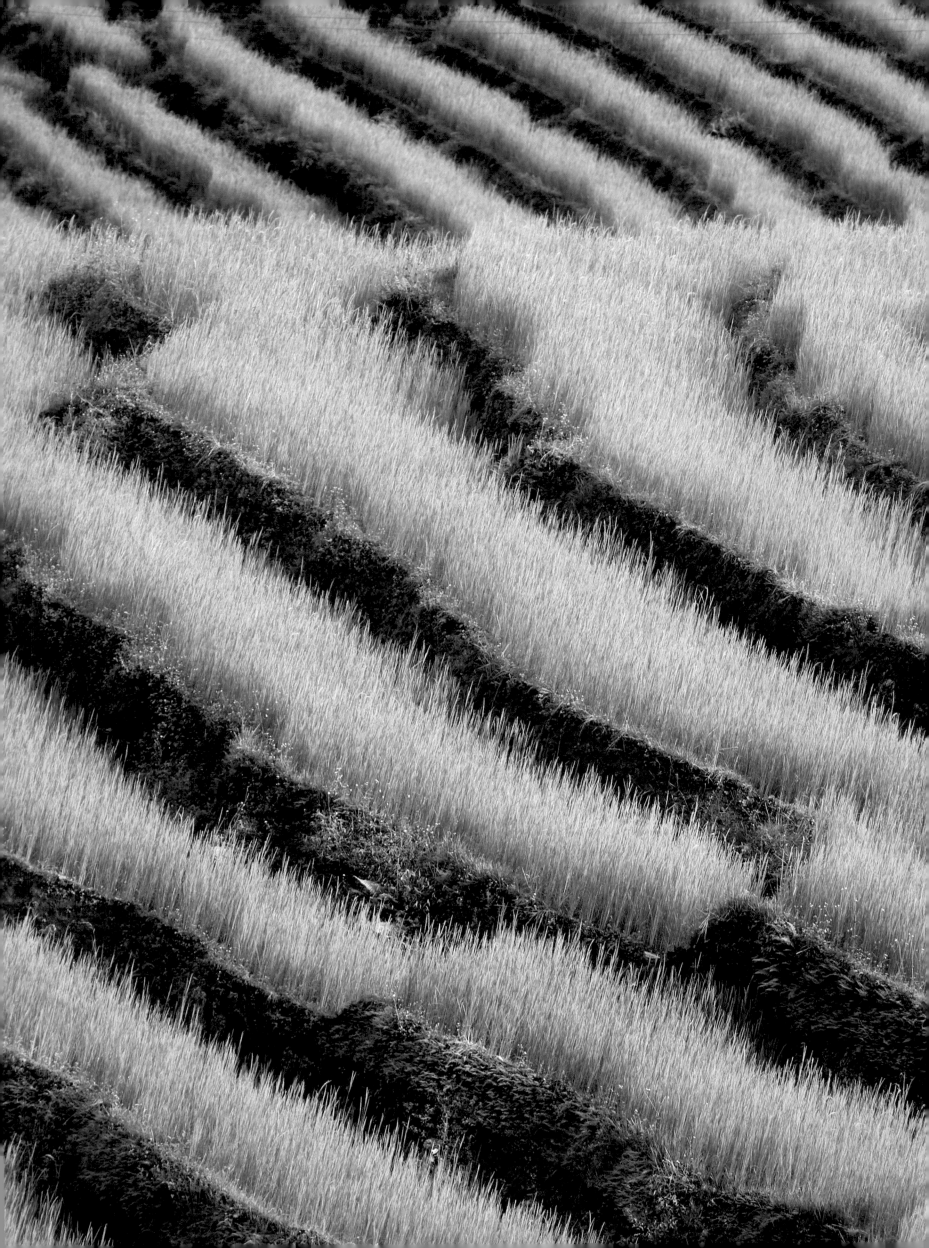

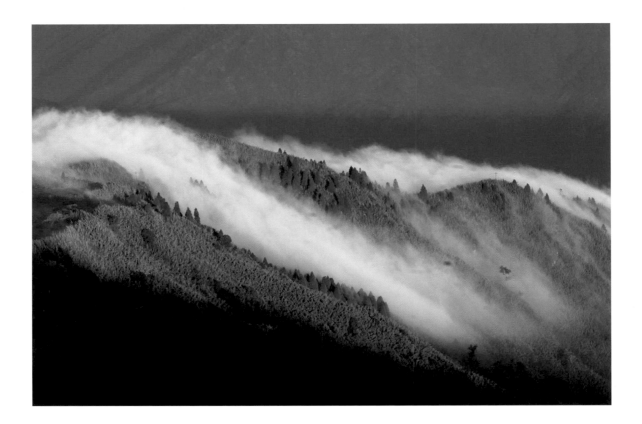

As soon as the rains were over, and the cracks in the earth had healed, and the land was moist and ready, we took our seed to our Goddess and placed it at her feet to receive her blessing, and then we bore it away and made our sowing.

When a few weeks had gone by, the seed sprouted; tender shoots appeared, thrusting upward with increasing strength, and soon we were able to transplant the seedlings one by one, and at first they stood out singly, slender, tremulous spires with spaces between: but grew and grew and soon were merged into one thick green field of rustling paddy. In that field, in the grain which had not yet begun to form, lay our future and our hope....

The sowing of seed disciplines the body and the sprouting of the seed uplifts the spirit, but there is nothing to equal the rich satisfaction of a gathered harvest, when the grain is set before you in shining mounds and your hands are whitened with the dust of the good rice; or the very act of measuring—of filling the measure, and topping it with a peak, careless of its height because you can afford to be, and also because you know in your prudence that the gains will see to it that you are not too generous, and slip and tumble down the sides of the measure if that peak be too tall. So many handfuls to one measure, so many measures to one sack; one after the other the sacks are filled and put away, with rejoicing and thankfulness.

Later we go to offer prayers, bearing camphor and kum-kum, paddy and oil. Our hearts are very grateful.

—Kamala Markandaya, *Nectar in a Sieve*

above: *The temperate climate of the Darjeeling district, in the lower range of the Himalayas, made it an ideal area for the British to develop tea plantations, which date back to the mid-19th century. Darjeeling teas are among the world's finest.*

opposite: *Although known primarily for their tea plantations, the terraced hills of the Darjeeling district in West Bengal are ideal for growing rice.*

pages 212–213: *A woman patiently and gracefully culls weeds in a field of winter wheat near the small village of Tonk, in southeastern Rajasthan.*

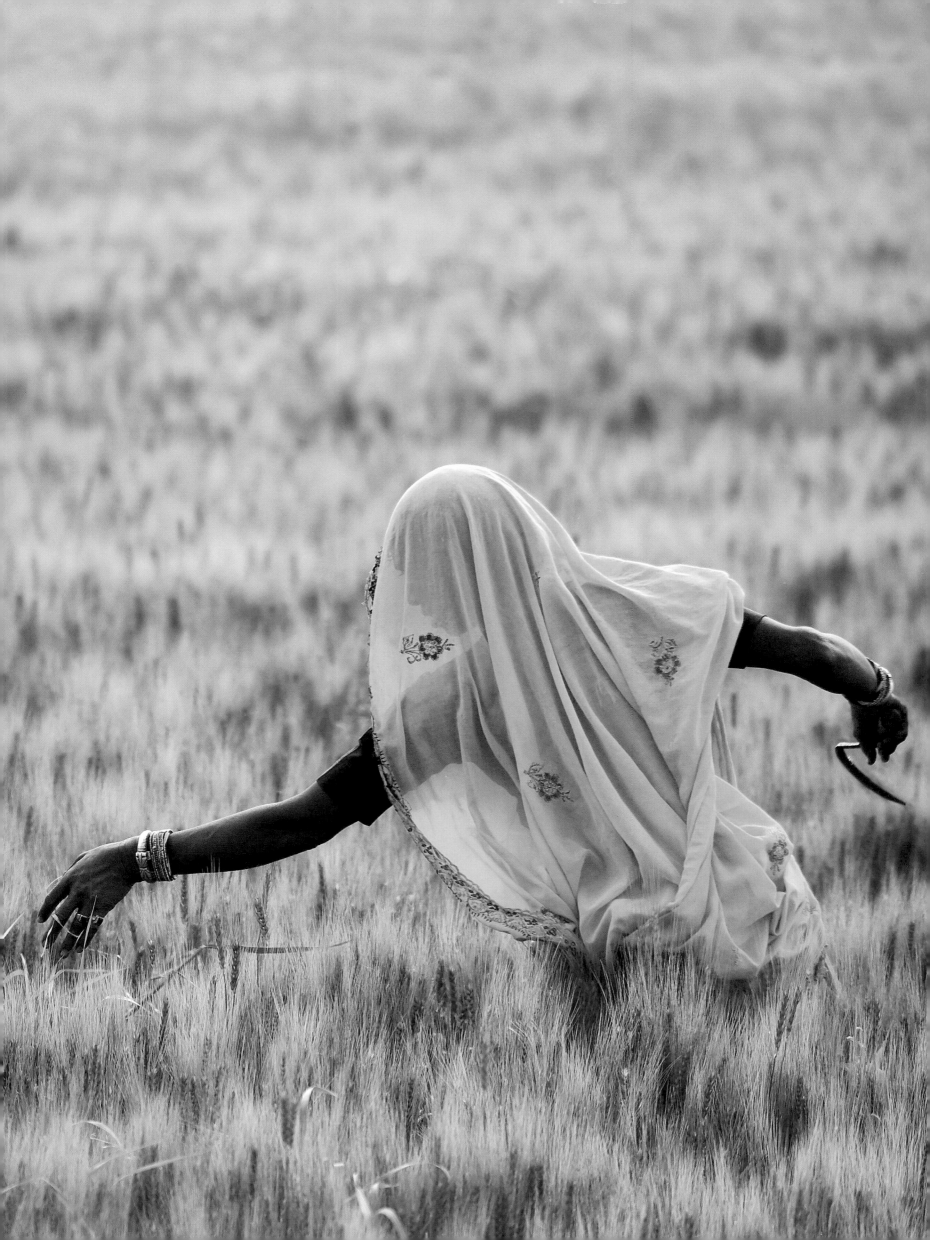

Sandeep's Visit

Amit Chaudhuri

ON SATURDAY, A COOL BREEZE SURPRISED THEM. It smelled of wet earth, sodden leaves. It had rained somewhere in the villages, in groves and fields, and the breeze had traveled to this lane, bringing news of rain from the far-off place of its beginnings. They had congregated after lunch on the double bed on the second storey, when it ran its fingers down their backs, making them break out in goose-flesh. There was something erotic about the first breeze that brought the monsoons.

"Did you feel that?" asked Mamima.

"Yes," said Sandeep's mother.

"And that smell…" said Chhotomama, breathing in deeply.

He had never known any smell like that of wet earth, her own sweet odor, earth-musk. The most natural and unpretentious fragrance.

A few days later, there was the first kal-baisakhi storm. A layer of grey clouds covered the sky, inverting it like a bowl, shutting out sunlight. Dead leaves and old newspapers streamed through the lane like a procession of protest-marchers. Someone cried out from a balcony. A woman's voice. "Ratna! Ratna, come in this instant!" The wind blew silent and straight. A woman walking alone on the road was teased by the wind; the loose end of her sari, the aanchal, flew helplessly, a lost fragment of color; it was the most beautiful movement seen on this rainy day. Crows hopped alertly. They sensed a presence, powerful and dangerous, though they could see nothing and no one. The nervous, toy-like city was set against the dignified advance of the clouds, as if two worlds were colliding. There was an end-of-the-world atmosphere. Then, lightning, sometimes a single, bright scar that flashed on a cloud's black face and was gone, and sometimes filling the grey space with light. A moment's heavy silence; then the thunder spoke—

guruguruguru

In obedience, the leaves began to tremble, and the branches moved uniformly, disciplined as a battalion doing exercises—Bend! Rise! Bend! Rise! And, slam! a door or a window banged shut without warning; ghosts and spirits were abroad, making mischief, distracting the servants, knocking at the windows. Only the children had time to investigate or smile at the spirits, because the grown-ups were busy, panicky. Saraswati bundled the clothes left to dry on the terrace, and brought them in before they got wet—with the wrinkled clothes in her arms, she looked like Mother Teresa carrying the light, wispy bodies of dying children. Mamima rushed to shut the windows, which were banging their wooden heads in a religious frenzy. She just managed to lock the last one in time. As if by common consent, it began to rain with a steady sibilant sound. They sat in the room with the windows closed, listening to the sound of the rain beating against the windows and falling on the tin roof of the next house. The children talked to each other, but sometimes they stopped and became attentive, listening, for no apparent reason, to that sound. The room became cool; the beds and floors became cool. When they opened the taps, the water sparkled. They rinsed their mouths with the water. Sometimes, Sandeep and Abhi opened a shutter and stared out into a world where arrows of rain fell continually. They stretched out their hands. They allowed the round, orb-like raindrops to settle on the back of their hands like dewy insects, though the drops lost shape as soon as they touched the flesh. Running to the smaller room at the back, Sandeep glanced out of the window and saw the palm tree dancing by itself, to itself. A silent wave of delight passed over him as he watched it dance.

PAGES 216–217: *Custard apples and other indigenous fruits and vegetables are available at almost any roadside market or large city outdoor market in India, as here in Mumbai.*

ABOVE AND OPPOSITE: *The state of Gujarat is home to many tribals, especially in a remote area known as the Rann of Kutch, near the town of Bhuj. This young Mir woman lives in a round mud house called a* bhoonga.

PAGES 220–221: *Each spring, the Thar desert comes alive with the festivities of the annual fair at Jaisalmer. Rajasthani men and women dressed in bright-hued costumes dance, sing, ride camels, and come together in a spectacular display of pageantry.*

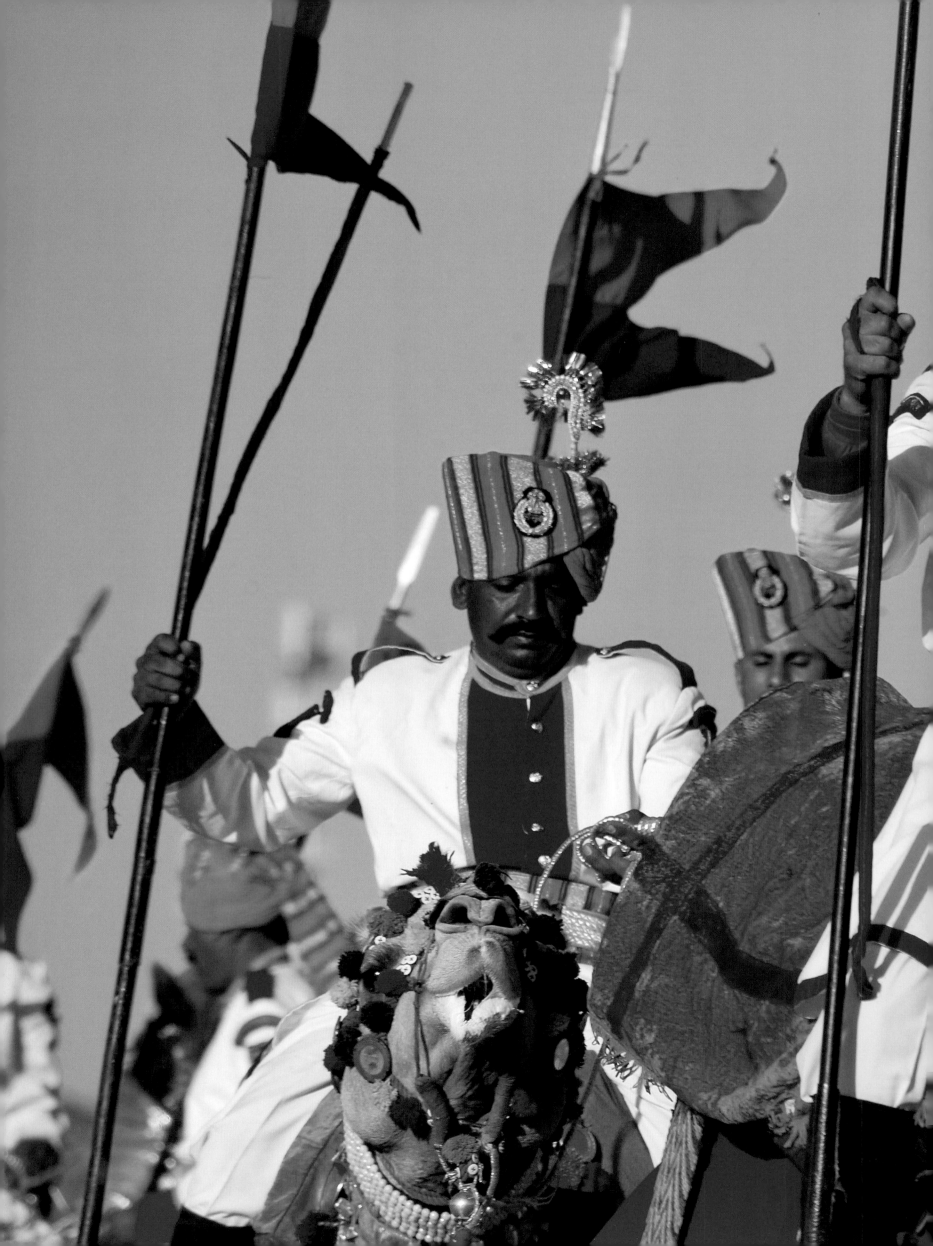

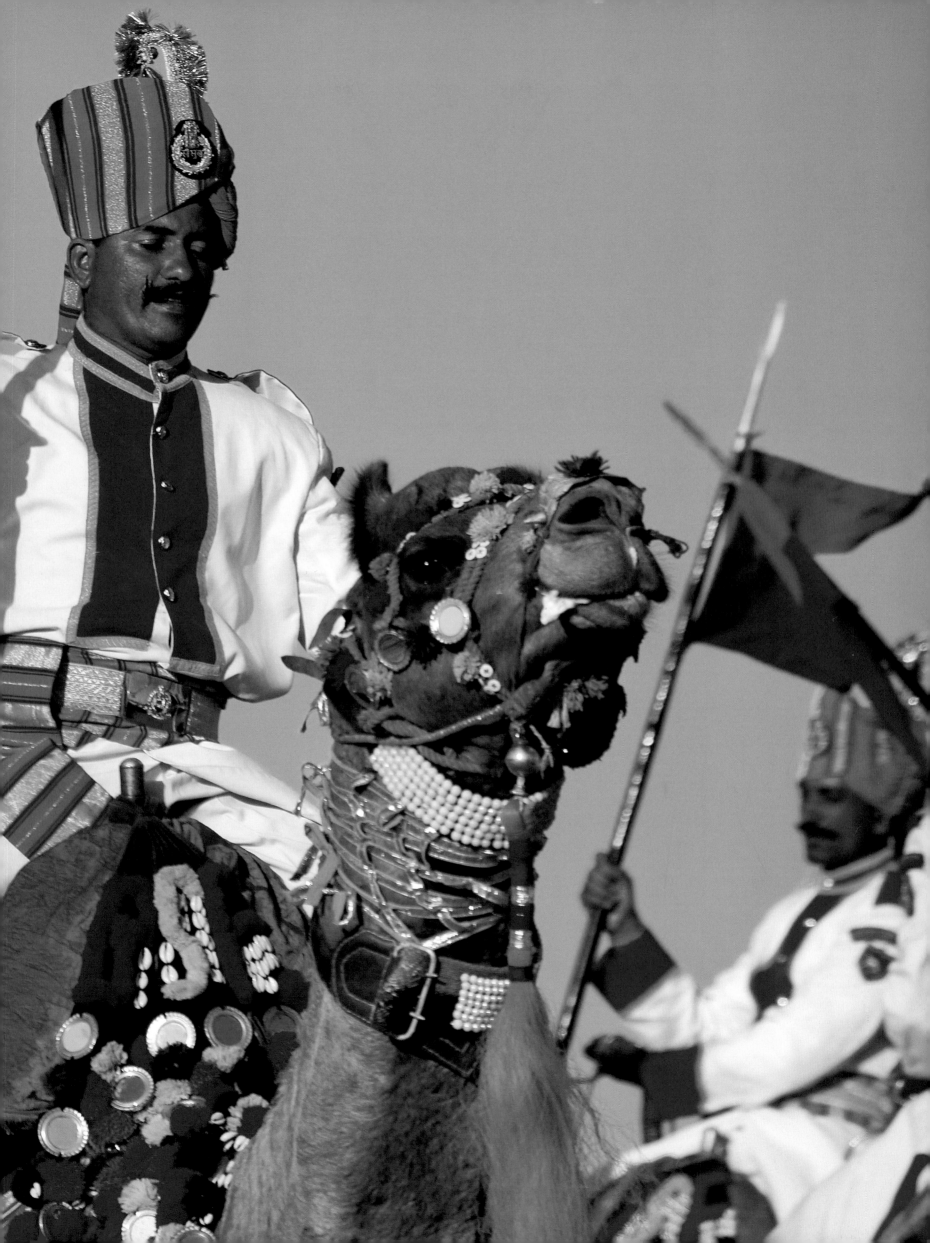

A River Sutra
Gita Mehta

To the entire household's astonishment, when I was six years old my father, who had never accepted a student from all the great musicians who had begged to sit at his feet, stretched out his hand, making a bridge for me to cross the gulf of praise that separated us, and offered to teach me music.

My first music lesson extended for several months. In all that time I was not permitted to touch an instrument. I was not even permitted to sing the seven notes of the scale: the *sa, re, ga, ma, pa dha, ni* that are the *do, re me, fa, so, la ti* of Western music.

Instead my father made me sit next to him in the evenings as the birds were alighting on the trees.

"Listen," he said in a voice so hushed it was as if he was praying. "Listen to the birds singing. Do you hear the half notes and microtones pouring from their throats? If I practiced for ten lifetimes I could not reproduce that careless waterfall of sound and sshh . . . listen closely."

I tried to imitate him, bending forward in my chair. "Hear? How that song ended on a single note when the bird settled into the tree? The greatest ragas must end like that, leaving just one note's vibrations on the air."

I nodded in enthusiasm, hoping to please him, but he did not see me. "Do you know why birds sing at dawn and at sunset? Because of the changing light. Their songs are a spontaneous response to the beauty of the world. That is truly music."

Then he told me that he would die happy if he were able to create such music five or ten times in a whole lifetime.

"Men are fools," my father said as we walked in the jungles behind our house. "They think only humans respond to beauty. But a feeding deer will drop its food to listen to music, and a king cobra sway its hood in pleasure. Listen. Do you hear that peacock's cry? It is the first note of the scale. *Sa.*"

Standing under the trees we waited to hear the peacocks cry again, and when they did my father's voice echoed them and the peacocks fell silent listening.

It seemed to me that we were wandering only for pleasure in the fields around our house or in the jungles. I did not realize my father was teaching me the seven notes of the scale as described in the classic texts.

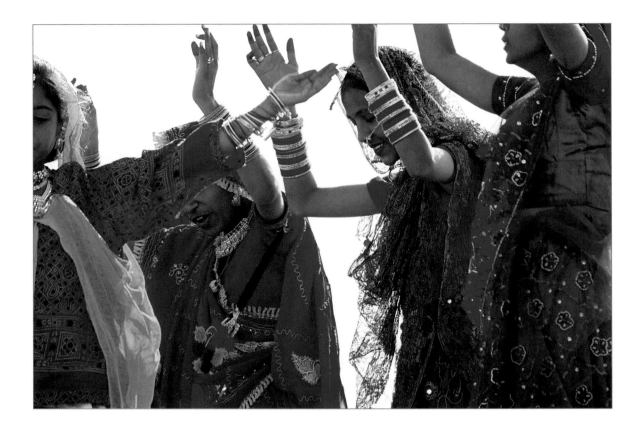

But at sunset we waited until the cowherds were driving their cattle back to their villages and my father said, "Can you hear that calf calling its mother? It is the note—*re*."

We watched my mother throwing vegetable peelings to the goats in our back field. "Hear the goats? If you sing *ga* three times, very quickly, it is the bleating of a goat."

We waded into the paddy fields behind the herons. "*Ma*, the cry of the heron."

At night, "*Pa*, the song of the nightingale."

In the bazaar streets as we followed the horse carriages, "*Dha*— the neighing of a horse."

And when the circus came to town, my father was excited at the opportunity of teaching me the last note of the scale. "Can you hear that *ni*—when the elephant trumpets?"

Then my father sang the notes of the scale so I could hear him imitating the animals we had seen—the strutting the peacock, the panic of a lost calf, the destructive antics of a goat, the sweeping flight of the heron, the nightingale nesting in a tree, the rearing of a horse, the power of an angry elephant—until the nature of the notes became second nature to me. He also sang the ragas in which each note predominated so that my uneducated ear became familiar with all the major ragas before I ever held an instrument in my hands.

"There was no art until Shiva danced the Creation," he said, explaining how melody was born. "Music lay asleep inside a motionless rhythm—deep as water, black as darkness, weightless as air. Then Shiva shook his drum. Everything started to tremble with the longing to exist. The universe erupted into being as Shiva danced. The six mighty ragas, the pillars of all music, were born from the expressions on Shiva's face, and through their vibrations the universe was brought into existence.

"The melodies of these six ragas sustain the harmonies of living things. When they fuse together they become the beat of Shiva's drum that brings the universe to destruction. But they are all male. And music can never be still, it can never be without desire. Life must create more life or become death. So each of the six ragas was given six wives, six raginis to teach them love. Their children are the putras, and in this way music lives and multiplies."

Then my father said I must see the emotions through which ragas and raginis communicated with each other. "Each raga is related to a particular season, a time of day, an emotion. But emotion is the key that unlocks a raga's soul."

So, every day for a month, we went together to the dance academy to study Shiva's dance of Creation. I watched girls my age struggle to convey emotions that they had never known but that were the basic moods of dance: Laughter, Wonder, Heroism, Anger, Grief, Pity, Love, Fear, Tranquility.

Sometimes I laughed at their inability to put sufficient gravity into their moods, and my father was displeased.

"Don't treat the arts so lightly. They are Shiva's gifts to mankind. If you choose to be a musician, you enter into a pact with Shiva himself. Remember, every note you play sends new music into the universe. You can never reclaim it."

I thought my father was speaking to himself because I did not understand his meaning. But at last I was able to ask the question that had always been in my mind. "And where does all that music go?"

"It returns to the sound that is so all-encompassing it is silent, the sound we call the secret of the Gandharva Veda."

"Have you ever heard it?"

"No, but every day I listen for it when I play. You must listen for it too. The Vedas say that by playing the veena with the correct rhythm, keeping its notes and its character intact, a man can hear that sound and attain salvation."

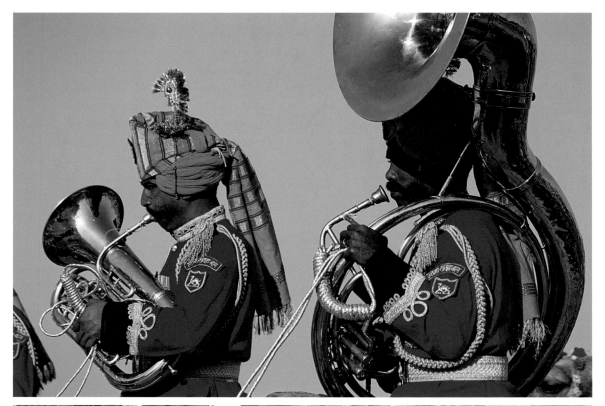

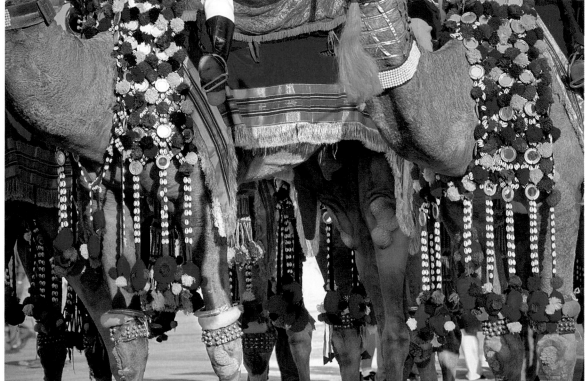

PAGE 223 AND ABOVE: *Traditional Rajput dancers and musicians perform at the Jaisalmer fair.*

PAGES 226–227: *A pink mirage rising from the edge of the Thar desert, the walled fort of Jaisalmer sits on Trikuta Hill, above the town. Built in the 12th century, this is the world's only "living fort," with about a quarter of the city's population living inside.*

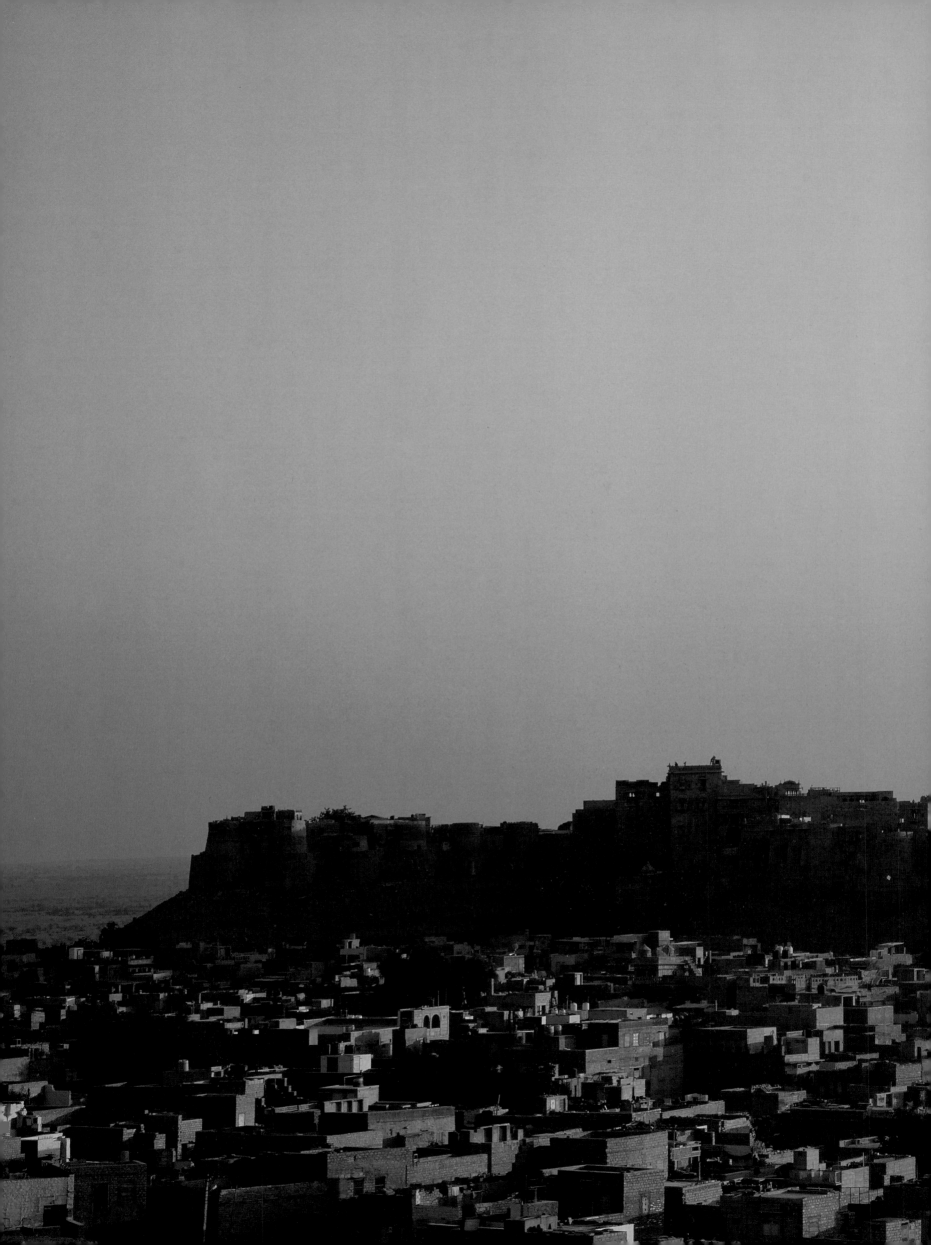

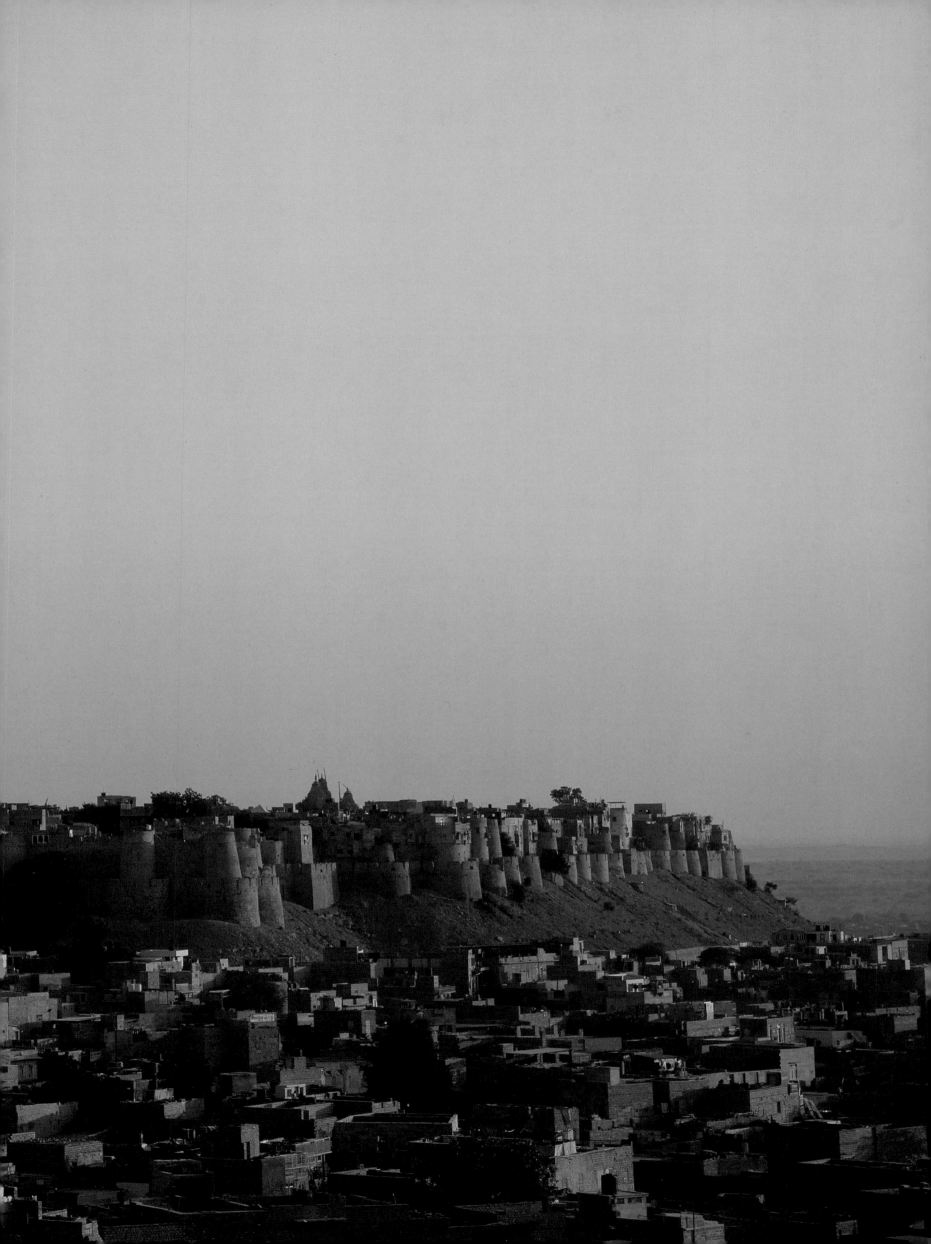

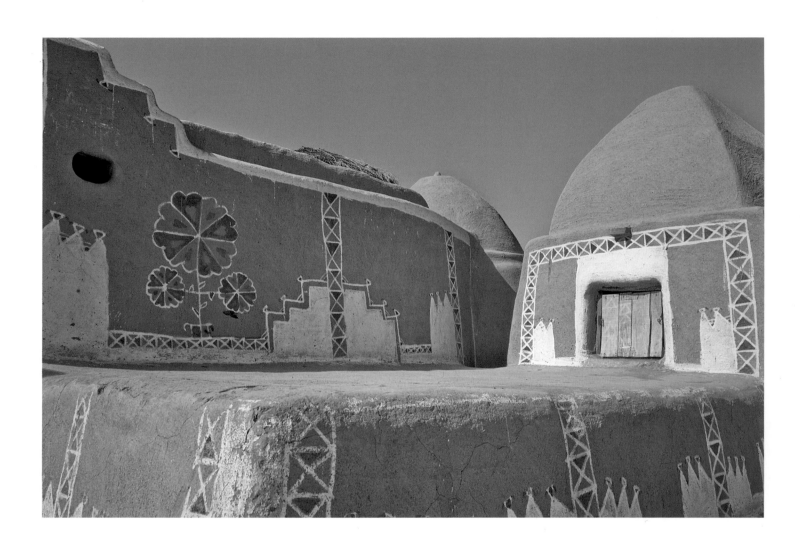

ABOVE: *Some of the most beautiful desert architecture can be found in the small village of Khuri, south of Jaisalmer. The thick mud walls of the houses, often decorated with geometric motifs, provide protection from the desert heat.*

OPPOSITE: *A Rajput woman on her way to the desert fair at Jaisalmer.*

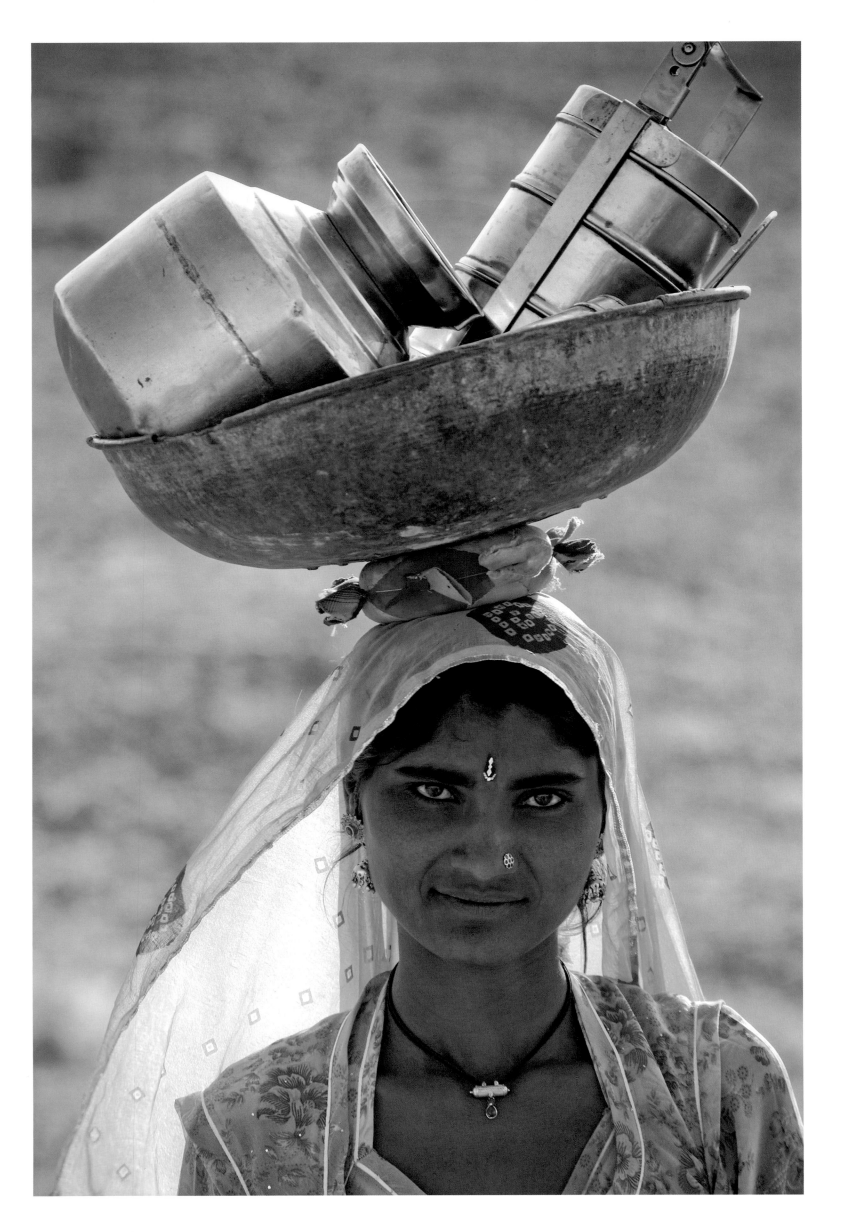

ABOVE AND OPPOSITE: *The ethnic influences of nearby China and Bhutan are evident in the faces of these schoolchildren in Kalimpong, Sikkim district.*

KASHMIR WAS COOLNESS AND COLOUR: the yellow mustard fields, the mountains, snow-capped, the milky blue sky in which we rediscovered the drama of clouds. It was men wrapped in brown blankets against the morning mist, and barefooted shepherd boys with caps and covered ears on steep wet rocky slopes. At Qazigund, where we stopped, it was also dust in sunlight, the disorder of a bazaar, a waiting crowd, and a smell in the cold air of charcoal, tobacco, cooking oil, months-old dirt and human excrement. Grass grew on the mud-packed roofs of cottages—and at last it was clear why in that story I had read as a child in the *West Indian Reader*, the foolish widow had made her cow climb up to the roof. Buses packed with men with red-dyed beards were going in the direction from which we had come. Another bus came in, halted. The crowd broke, ran forward and pressed in frenzy around a window through which a man with tired eyes held out his thin hand in benediction. He, like the others, was going to Mecca; and among these imprisoning mountains how far away Jeddah seemed, that Arabian pilgrim port dangerous with reefs over which the blue water grows turquoise. In smoky kitchen shacks Sikhs with ferocious beards and light eyes, warriors and rulers of an age not long past, sat and cooked. Each foodstall carried an attractive signboard. The heavy white cups were chipped; the tables, out in the open, were covered with oil-cloth in checked patterns; below them the ground had been softened to mud.

The mountains receded. The valley widened into soft, well-watered fields. The road was lined with poplars and willows drooped on the banks of clear rivulets. Abruptly, at Awantipur, out of a fairy-tale village of sagging wood-framed cottages there rose ruins of grey stone, whose heavy trabeate construction—solid square pillars on a portico, steep stone pediments on a colonnade around a central shrine, massive and clumsy in ruin—caused the mind to go back centuries to ancient worship. They were Hindu ruins, of the eighth century, as we discovered later. But none of the passengers exclaimed, none pointed. They lived among ruins; the Indian earth was rich with ancient sculpture.

—V. S. NAIPAUL, *AN AREA OF DARKNESS*

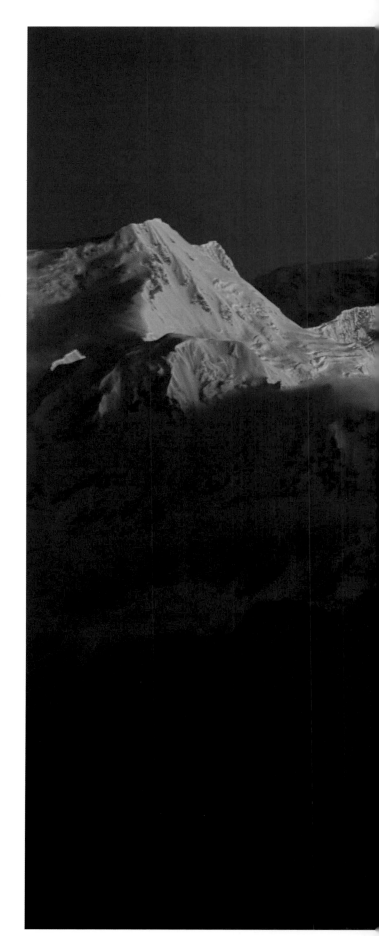

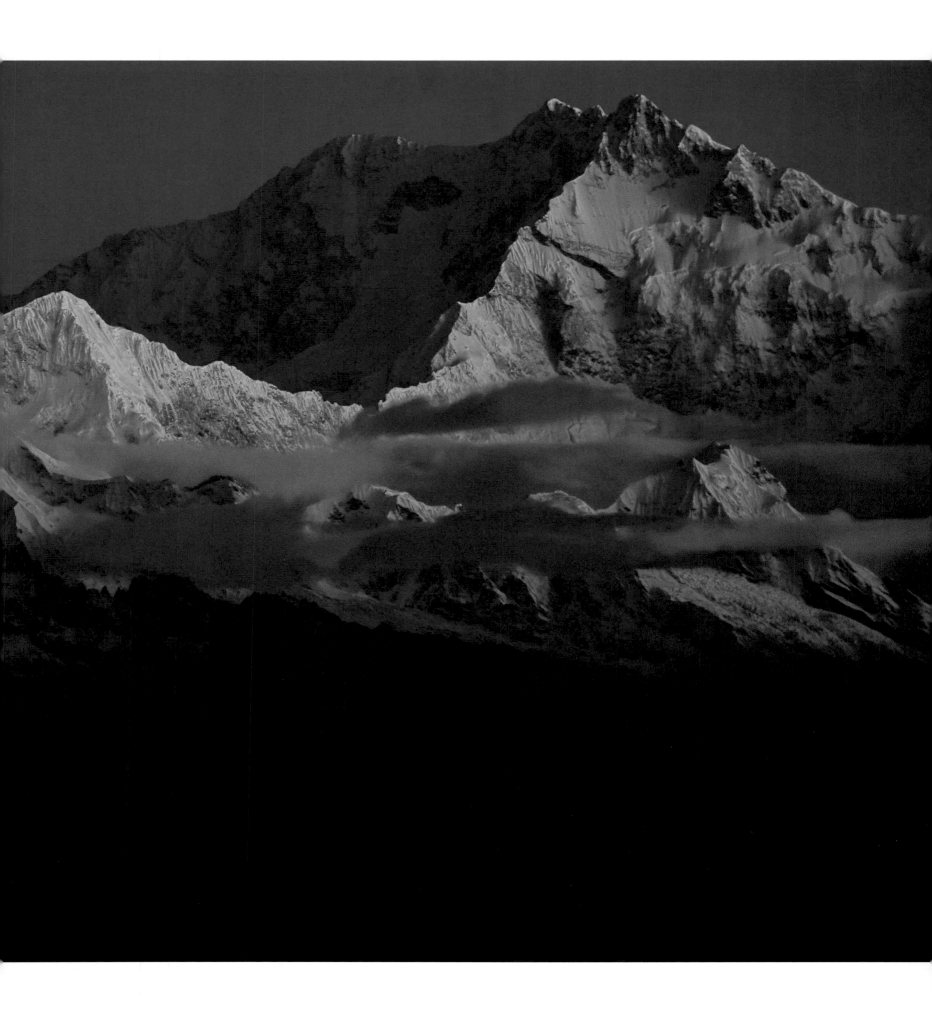

The view of Mt. Kanchendzonga from Observatory Hill dominates the town of Darjeeling, in West Bengal. At 28,209 feet, Kanchendzonga is the highest peak in India and the third-highest of the Himalayas.

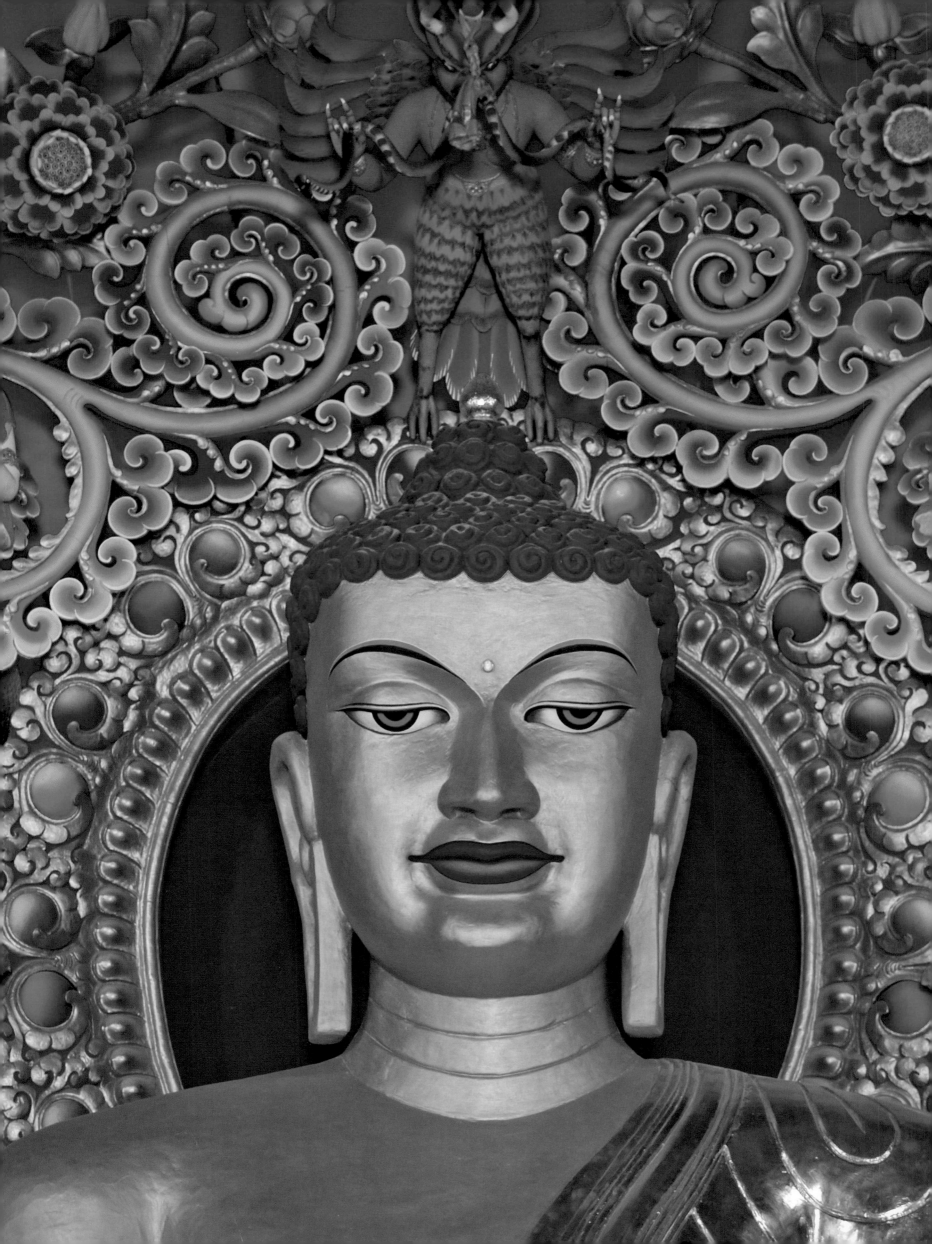

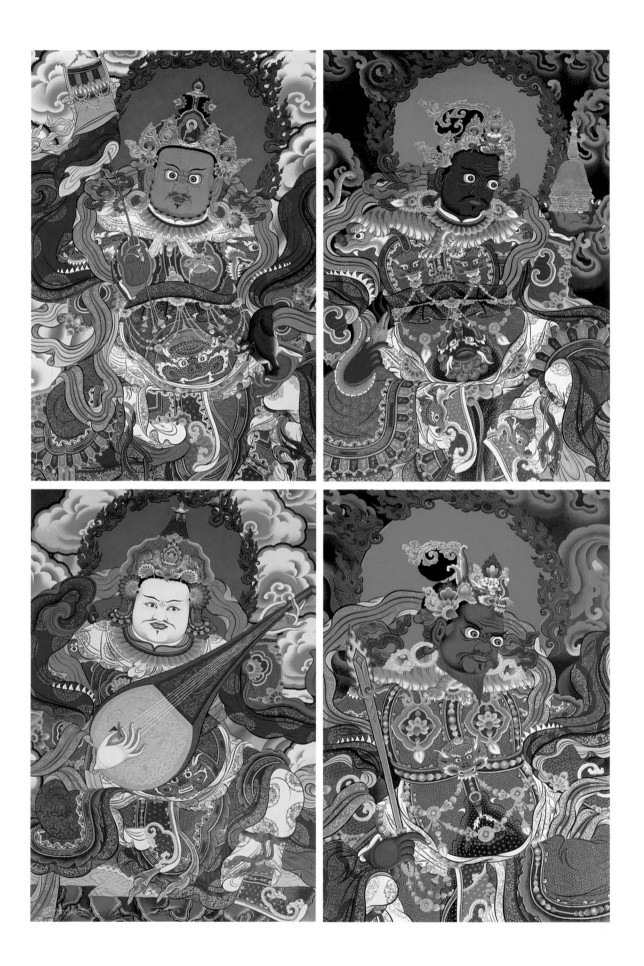

ABOVE: *The four heavenly kings, as painted on the walls of the Stakna monastery near Leh, in Ladakh. Clockwise from the upper left—North, South, West, and East. The kings, or lords, are the protectors of Buddhist law, and guard the four cardinal directions.*

OPPOSITE: *An unusual brightly painted and stylized Buddha at the Pal Tergar Rigdzin Khacho Dargye Ling temple in Bodh Gaya.*

ABOVE: *Stacks of prayer boxes at the Riga Choling monastery, near Darjeeling, hold hundreds of prayers.*

OPPOSITE: *This exquisite Manjushri, the Bodhisattva of compassion, sits serenely in the Salugara monastery, near Siliguri in West Bengal.*

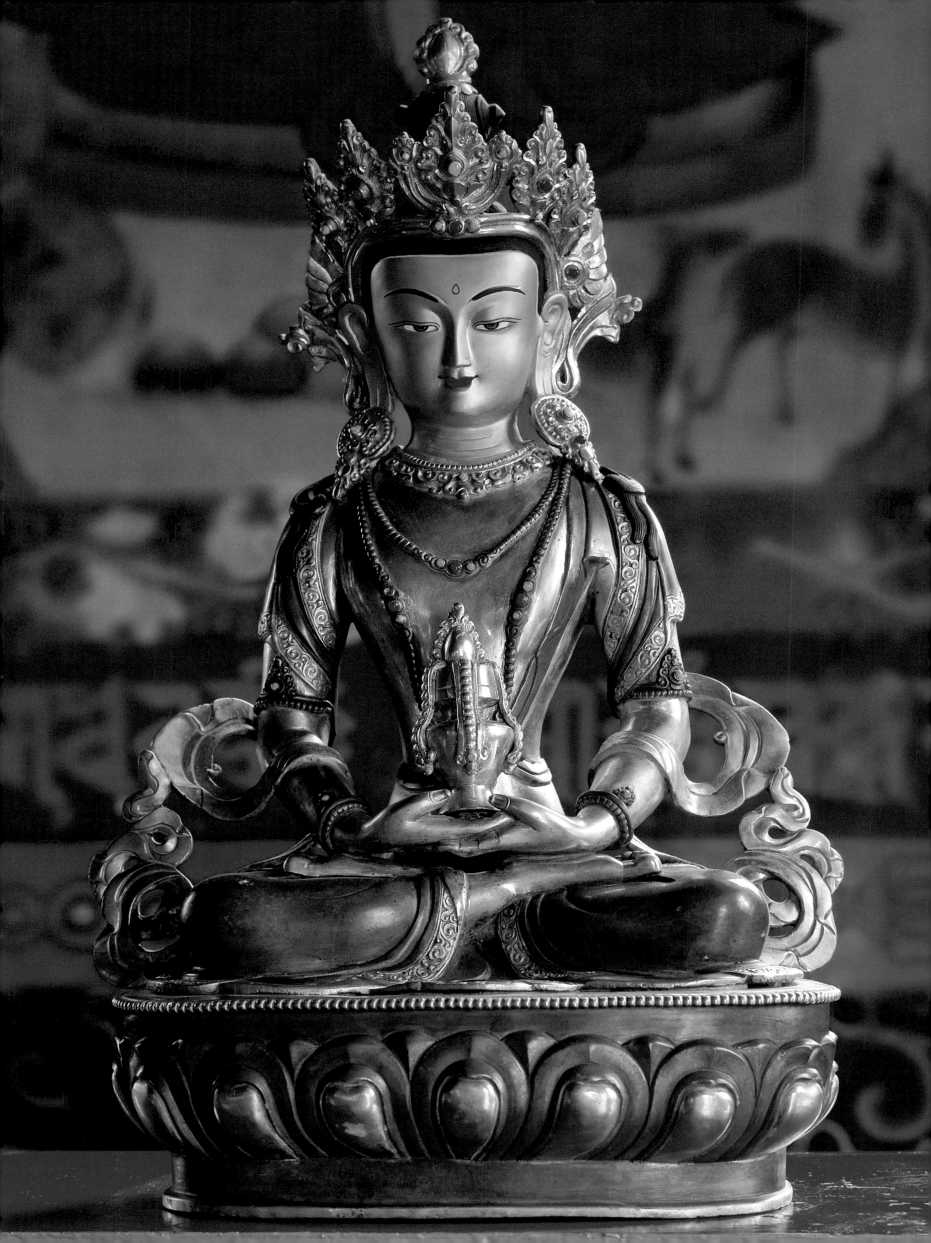

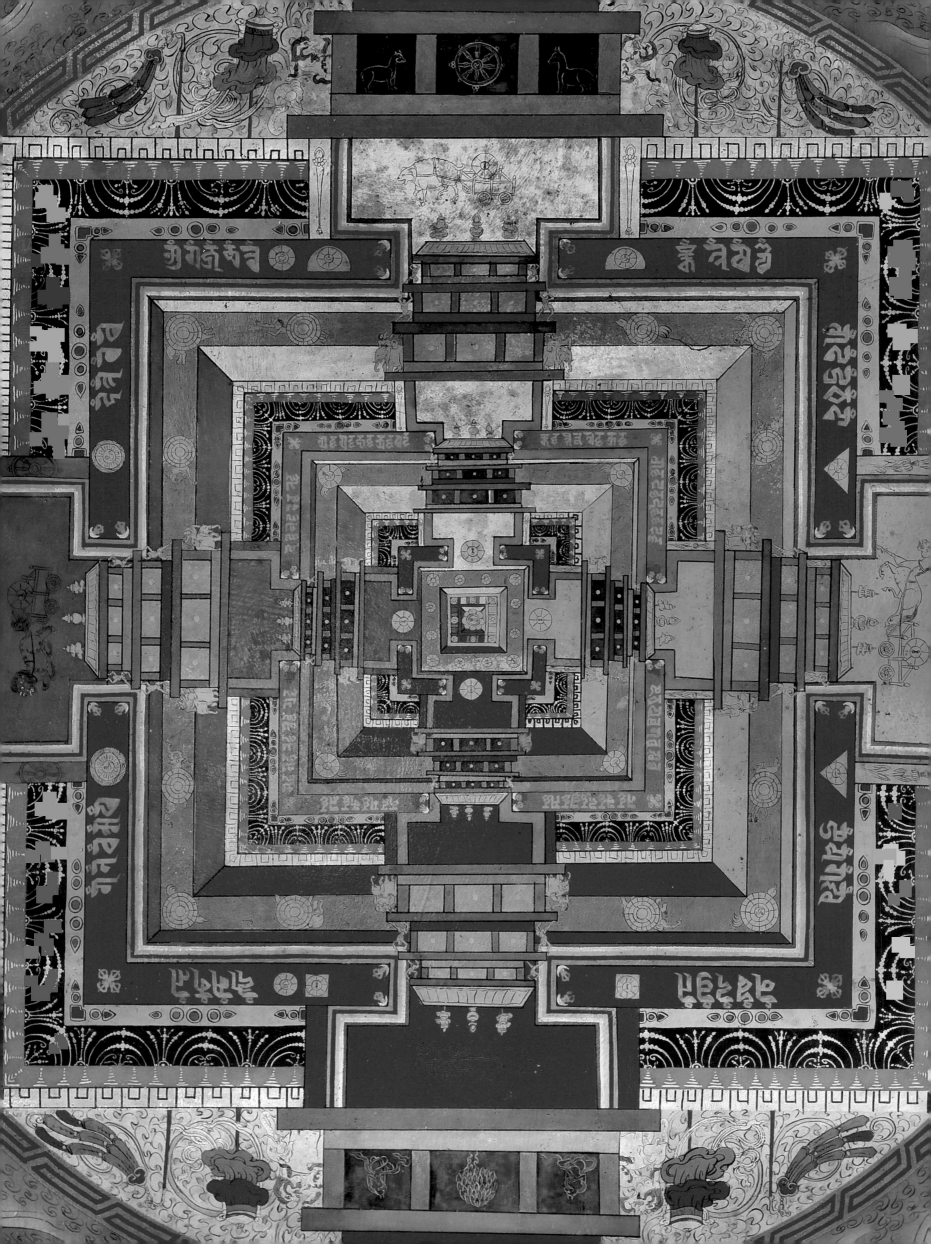

As time went by, Vinod found his anger spent. He felt a tranquility he could not remember having experienced before. He wondered about returning to the Swamiji, but was embarrassed to do so, in light of the abrupt way he had walked off almost three years ago. He suspected, though, that he might have attained what the Swamiji had challenged him about, so he did not think it crucial to return.

Now, when Vinod tried to clear his mind, he found he could. He would concentrate on the syllable *om*, and feel the force that it embraced. He would feel the energy from the trinity that flowed through to fill all of him. He would see the universe being created in a single exhalation of Brahma's breath. He would understand the delicacy with which Vishnu balanced everything between creation and death. The physical would subside as Vishnu's cycle came to an end. The lasting resonance of the syllable would sound inside him as Shiva's sphere began to ascend.

During the day, he sat on the balcony facing the street. Sometimes he saw the bullock-pulled watermelon cart roll by. He remembered how Sheetal would whistle at the melonwalla from the balcony and haggle with him using sign language. He remembered how he ran down the stairs to get the watermelon if the transaction was successful. The cart would turn the corner, and with it, the memory would fade from his mind.

When it became dark, he ate the vegetables and three chapatis the ganga brought him for his evening meal. Sometimes he still felt hungry afterward. When that happened, he took a biscuit from the tin he kept next to the tea things. He chewed it slowly on the balcony and listened to the sounds of the traffic at the signal downstairs.

On Sundays, he watched the worshipers congregate for mass at the church across the street. Once in a while he noticed Mr. Astrani among them. There were weddings on some days, and he looked at the young couples, so fresh and bright and innocent-looking, posing on the steps for photographs afterward.

Mostly, though, like this afternoon, he just sat there and tried to hear the sea. Even though at fifty he was not yet an old man, he rarely left his flat anymore. He had not seen the sea for months now, not since the last time he had gone downstairs and decided to walk to Breach Candy. Instead, he would sit on the balcony, and try to remember the rocks there, remember the waves at high tide crashing along the shore, and the seagulls hovering above the foam. He would try to imagine that the occasional raindrop on his face was the spatter of sea spray, that the voice calling his name from somewhere today was the wind sweeping through the bay. Then he would close his eyes, and let the water seep out of his mind. In its place he would wait for the calmness of the sound to descend. Soon the cells in his brain would begin to light up or switch off, to form the familiar pattern, and he would transcend the limitations of the finite, of the physical and the perishable, as he lost himself in the vibrations, as he lost himself in the harmony and the eternal resonance of the beautiful sound *om*.

—Manil Suri, *The Death of Vishnu*

opposite: *A spectacular mandala painted on the ceiling of the Salugara monastery, near Siliguri in West Bengal. The geometric patterns of mandalas, often used as spiritual tools to aid in meditation, symbolize the universe.*

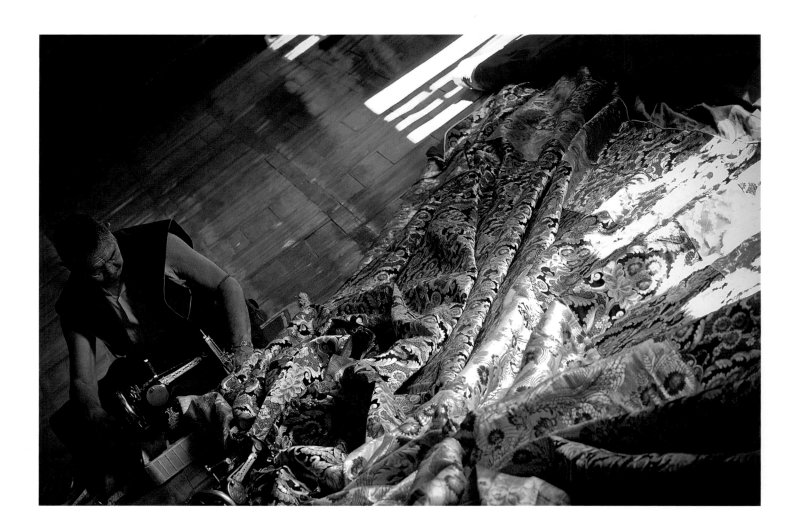

ABOVE: *A monk of the Gelugpa sect sews an elaborate* thanka, *an embroidered Buddhist banner that often depicts the life of Buddha, at the Thikse monastery, near Leh in Ladakh. Thankas are often hung in monasteries or carried by monks in ceremonial processions.*

OPPOSITE: *A young Buddhist monk, backlit by late afternoon sunlight reflected off a thanka at Thikse monastery near Leh.*

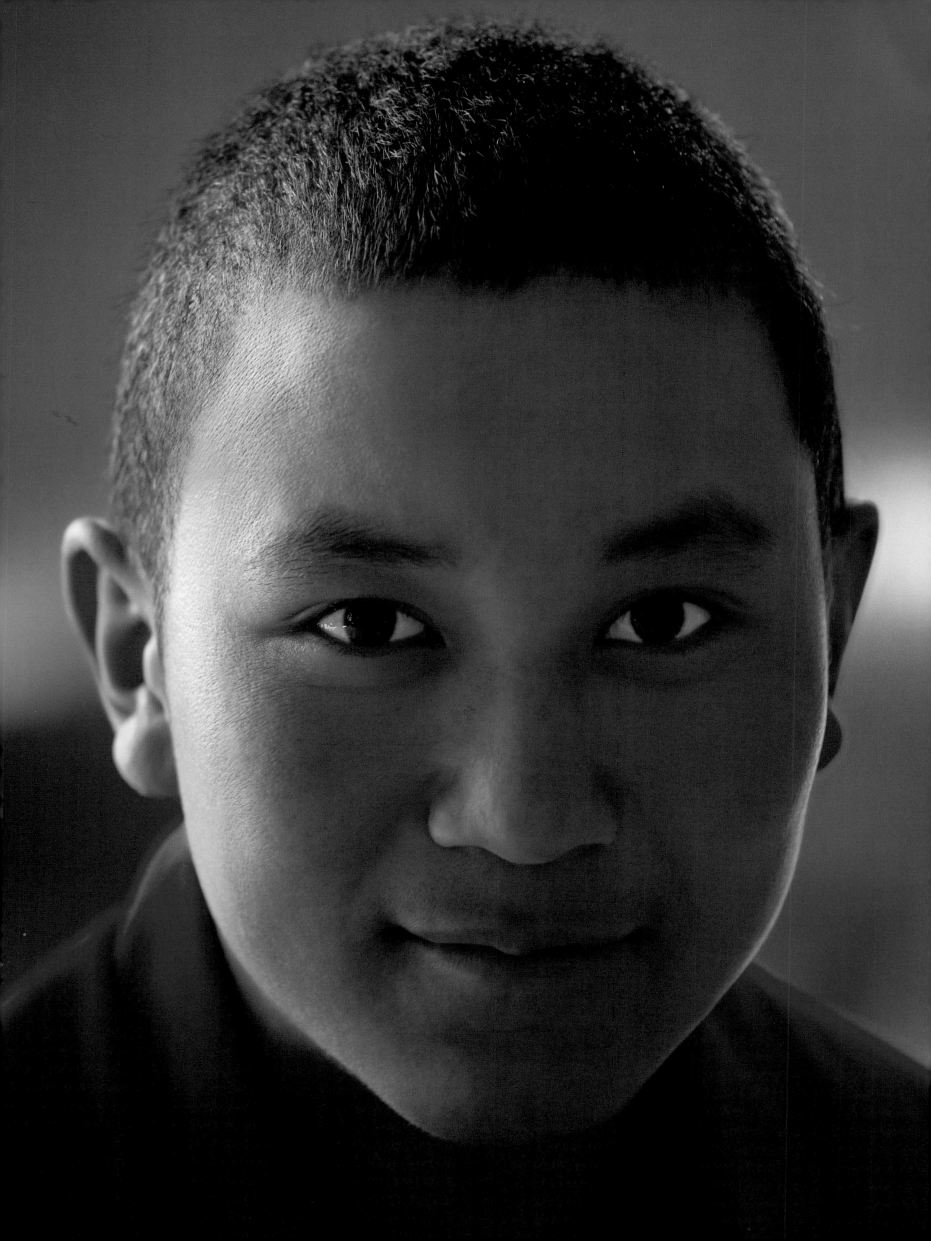

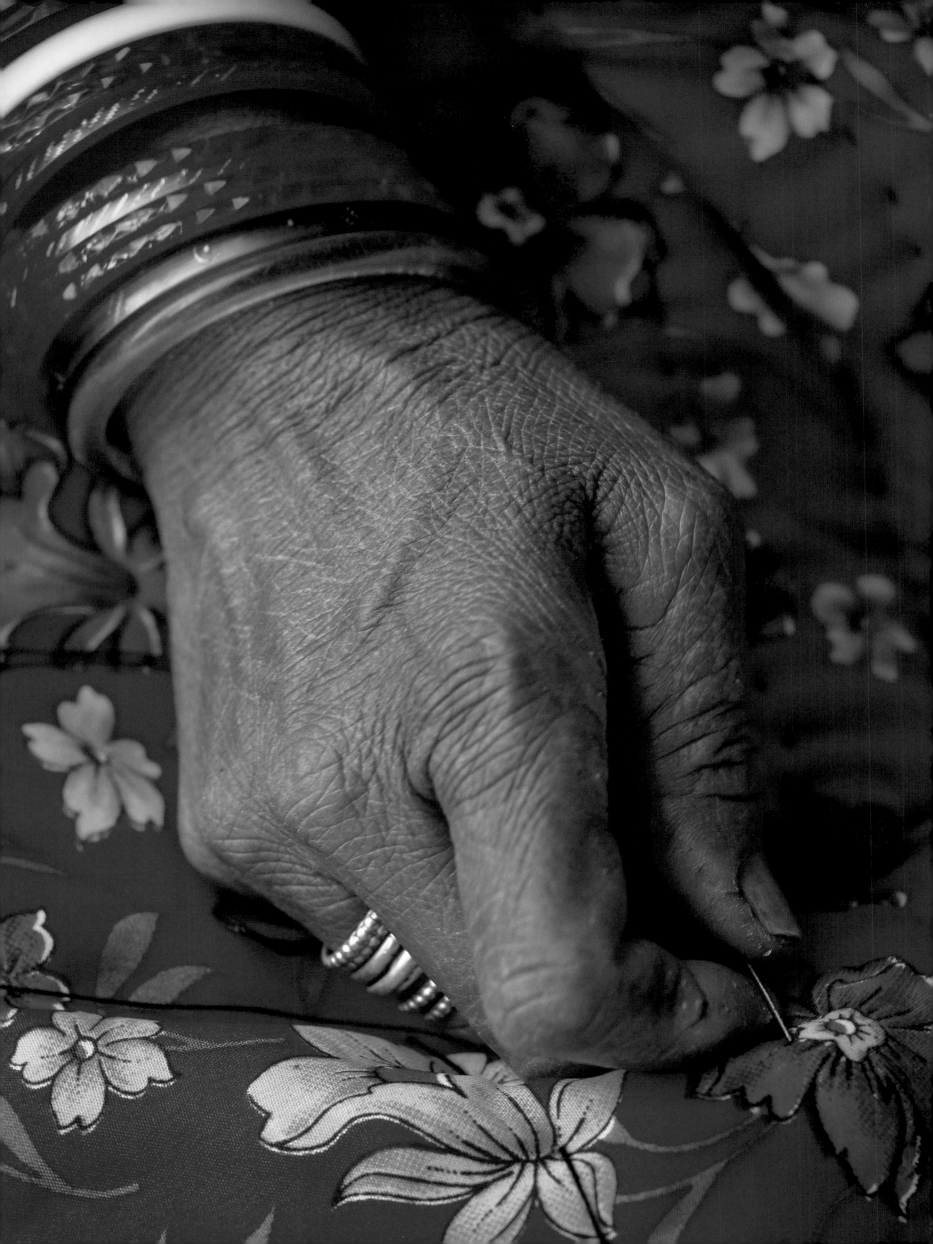

ONCE AGAIN a freshly laundered floor-covering was laid at the entrance of the room with the three doors, the *seh-dari*. Sunshine filtered through the chinks in the broken tiling on the roof and fell over the courtyard below in odd geometrical patterns. The women from the neighborhood sat silently, apprehensively, as if waiting for some major catastrophe to occur. Mothers gathered their babies to their breasts. Occasionally a feeble, cranky infant would let out a yell protesting an impediment in the flow of sustenance.

"No, no, my love," the thin, scrawny mother crooned, shaking the infant on her knees as if she were separating rice husks in a winnowing basket. How many hopeful glances were riveted on Kubra's mother's face today. Two narrow pieces of cloth had been placed together on one side, but no one had the nerve to measure and cut at this point. Kubra's mother held an exalted position as far as measuring and cutting were concerned; no one really knew how many dowries had been adorned by her small, shrunken hands, how many suits of clothing for new mothers had been stitched, nor how many shrouds had been measured and torn. Whenever someone in the neighborhood ran short of fabric and every effort to correctly mark off and snip had failed, the case was brought before Kubra's mother. She would straighten the bias in the fabric, soften the starch in it, sometimes rearranging the cloth in the form of a triangle, sometimes a square. Then, the scissors in her imagination would go to work, she would measure and cut, and break into a smile.

"You will get the front, back and sleeves from this. Take some snippets from my sewing box for the neck." And so the problem would be solved; proper measuring and cutting having been dealt with, she would hand over everything along with a neatly tied bundle of snippets.

But today the piece of fabric at hand was really insufficient. Everyone was quite sure Kubra's mother would fail to accurately measure and cut this time, which was why all the women were looking apprehensively at her. But on Kubra's mother's face, which bore a resolute look, there was not even a shadow of anxiety. She was surveying and patterning a four-finger length of coarse cotton. The reflection from the red twill lit up her bluish-yellow face like sunrise. The heavy folds on her face rose like darkening clouds, as if a fire had broken out in a dense forest. Smiling, she picked up the scissors.

A heavy sigh of relief rose up from the ranks of the women.

Infants were allowed to whimper, eagle-eyed virgins leapt up to thread their needles, newly wed brides put on their thimbles. Kubra's mother's scissors had begun their work.

—ISMAT CHUGHTAI, *THE WEDDING SHROUD*

ABOVE: *Exquisitely embroidered cloth on sale in a market in Mumbai.*

OPPOSITE: *A Rabari tribeswoman carefully sews a dress for her daughter, near the remote Rann of Kutch area of Gujarat.*

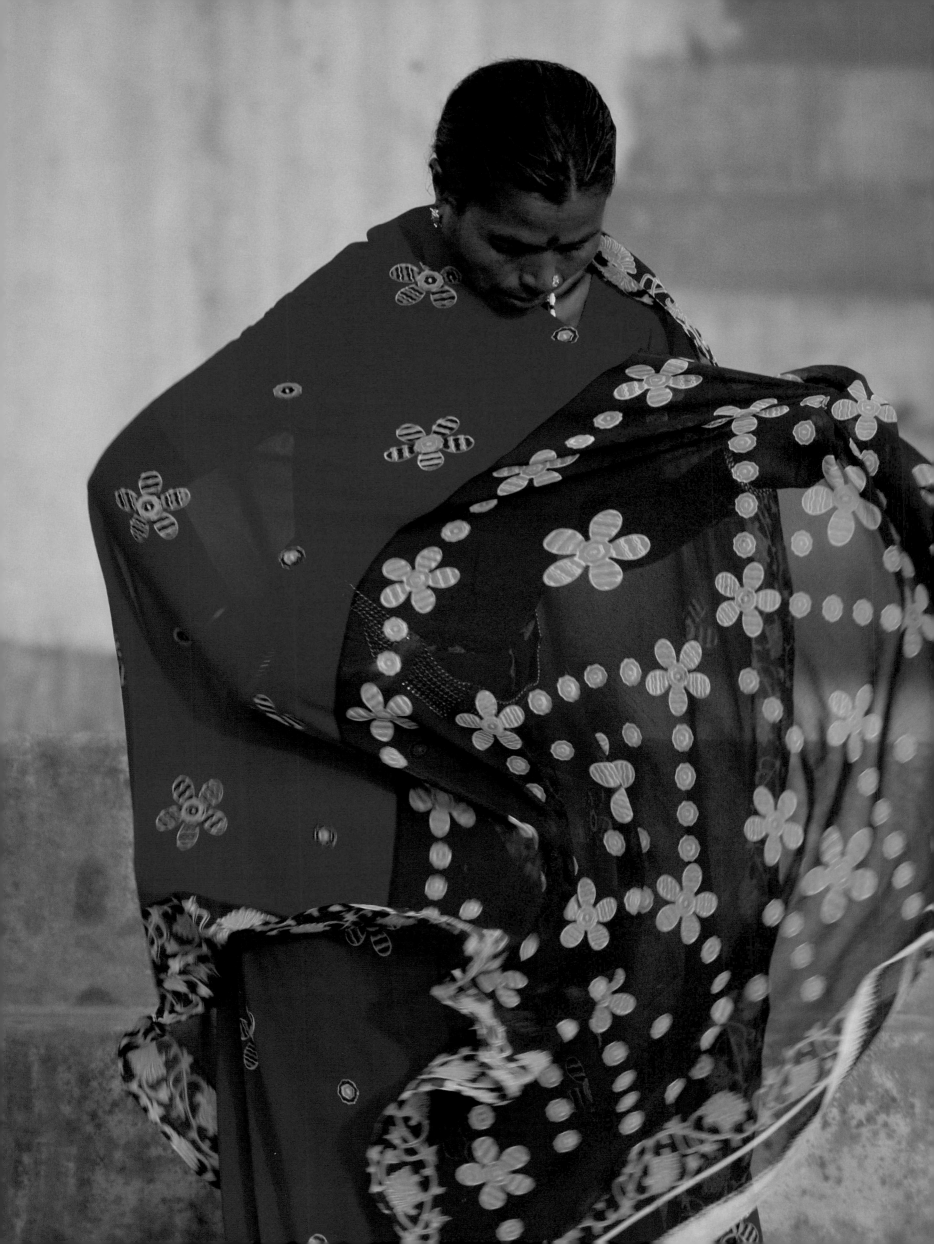

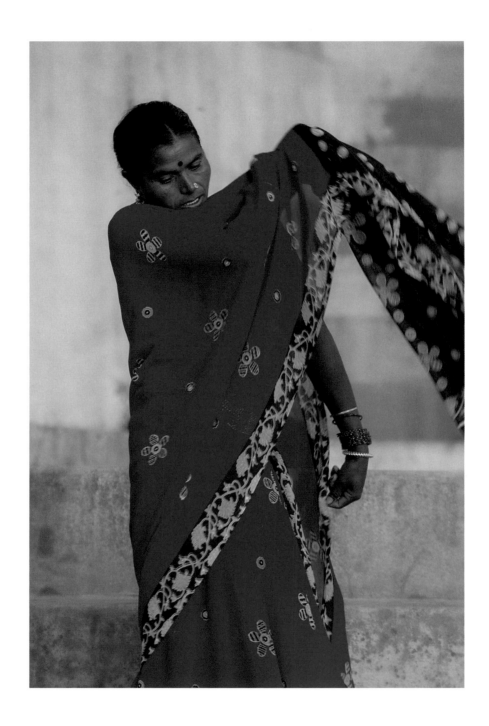

ABOVE AND OPPOSITE: *A Hindu woman on the steps of the Sankatha ghat in Varanasi carefully ties her sari after praying and bathing in the Ganges.*

The Autobiography
of an Unknown Indian
Nirad C. Chaudhuri

To this morphological dinginess the Bengali parts of Calcutta added the ebbs and flows of a functional dinginess: the first daily, the second seasonal, and the third yearly. The Bengalis wash (*i.e.* rinse in plain unsoaped water) their cotton *dhotis* and *saris* at home every day, and the Bengalis of Calcutta are even more fond of this daily washing than other Bengalis. Actually, the afternoon toilet of Calcutta women passes under the name of "washing" in thoroughbred circles. Then, at least twice a day, and sometimes more often, an immense amount of washing has to be hung up to dry. The front veranda, if there is any, or the roof is the place reserved for this purpose. In some houses there are a number of clothes-lines, in others the *dhotis* and *saris* are simply let down from the parapet or railing with the top ends tied to a pillar or rail. When wet they hang heavy and straight, dripping water on the footpath below, and when dry they flutter and twirl in the wind. As each piece is at least fifteen feet in length and forty-four inches in width, the houses when the washing is drying have the appearance of being draped in dirty linen. In addition, there always are subsidiary lines carrying the children's shirts, frocks, vests, and drawers, and the napkins and sheets of the very large number of babies that there always are in these houses, and on most occasions the exhibition of cotton garments is reinforced by bedclothes—mattresses and quilts, large and small, wetted by the children and the babies.

ABOVE: *Women at the Kumbh Mela take time out from the festivities to wash their saris in the Ganges and then hang them to dry. The Kumbh Mela is a Hindu pilgrimage that occurs four times every twelve years, rotating among four locations: Allahabad, Haridwar, Ujjain, and Nashik.*

OPPOSITE: *The Sanganer suburb of Jaipur is famous for its block-printed cotton. The local river's high mineral content "fixes" the dyes.*

PAGES 248–249: *The colorful saris of women provide wonderful contrast against a barren landscape with sparse vegetation. This pond in the rural village of Sar, near Jodhpur, is a hub of social activity in the morning.*

The gathering up of these articles in the afternoon is almost a ritual, like the hauling down of flags on warships in the evening. Except in the houses of the rich this is in the hands of the girls of the family. In the afternoon two or three comely persons appear on the veranda or roof, as the case may be, advance to the railing or parapet, and, leaning on the one or the other, carry out a composed survey of what is going on below. If anything particularly interests them they rest their chins on the rail or wall and contemplate it with wide open, round, solemn eyes. There never is any mobility or change in their expression, but suddenly a face is tossed up and an electric glance flashed toward the window across the street, where the presence of a lurking admirer is suspected. But this ripple passes away as soon as it makes its appearance. The face relapses into the usual immobile placidity, and the girls go on gathering up or pulling down the *dhotis* and *saris*, normally in a very unconcerned manner, but sometimes screwing a puckered mouth in undoing the knots. They move up and down, piling up the clothes on one of their shoulders or arms, and when at last they walk away they look like huge washerwomen.

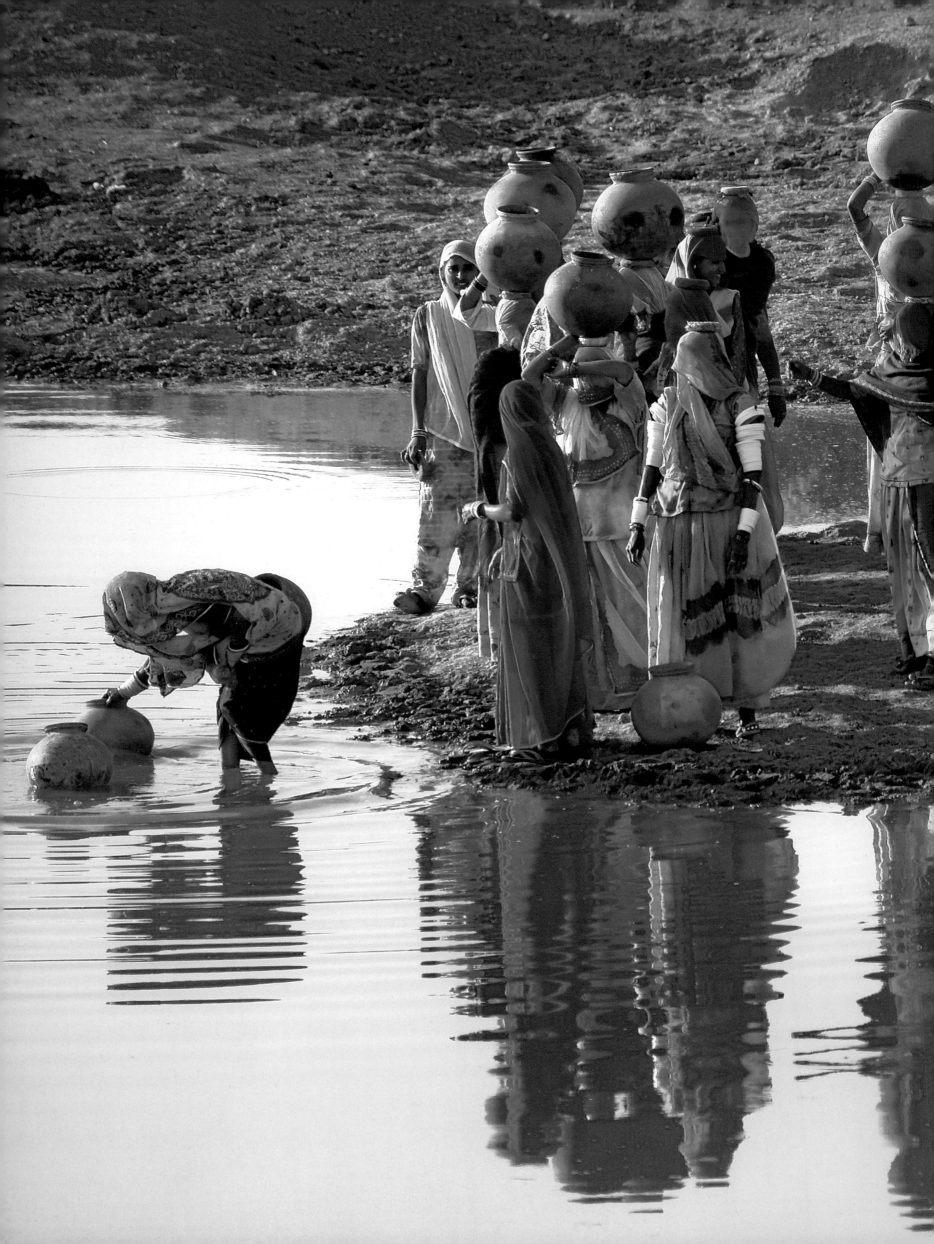

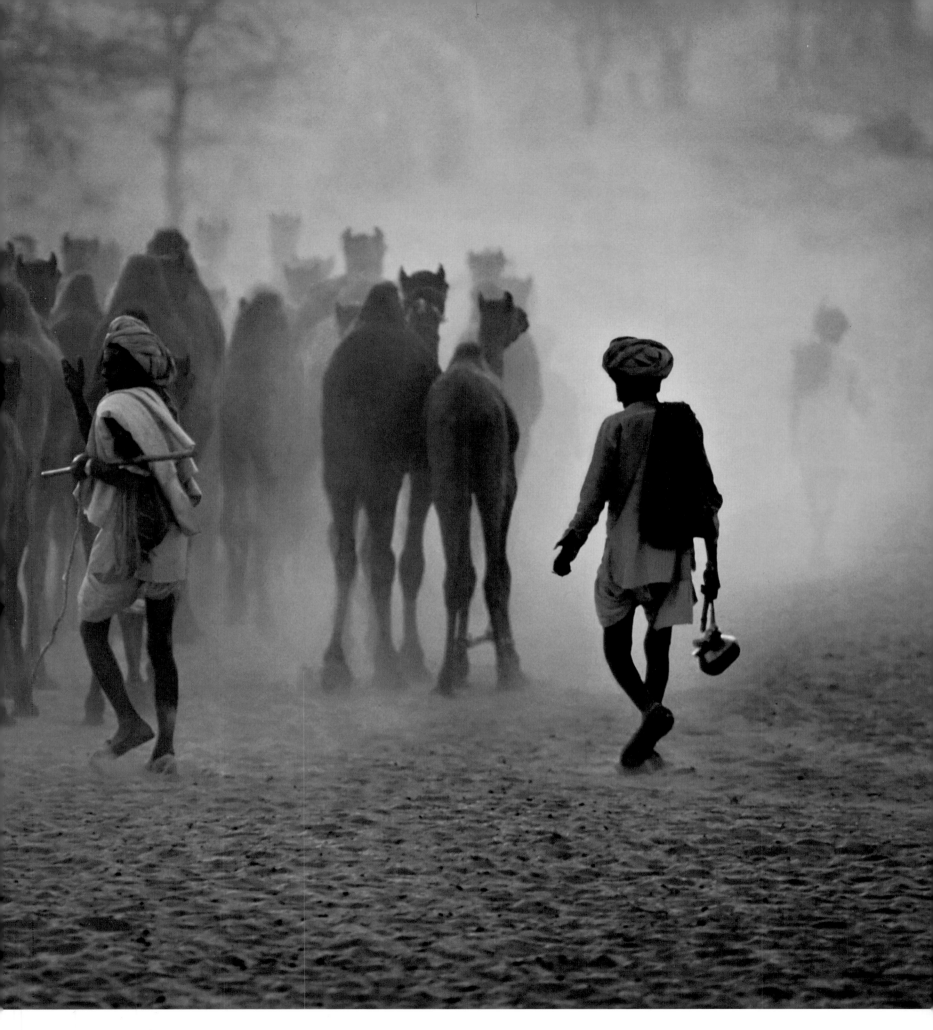

and in the early morning eastward. In addition, in every section of the road coinciding with each house-front, there were one or more bigger depressions, showing where the pariah dog or dogs belonging or voluntarily attaching themselves to that particular house had slept the night before.

—NIRAD C. CHAUDHURI, MY BIRTHPLACE

Pushkar, like Varanasi, is one of the five sacred dhams, or pilgrimage sites, for devout Hindus. In Hindu mythology, Pushkar is the place where the lotus fell. Surrounded by hills and sand dunes, Pushkar Lake, set in a valley six miles northwest of Ajmer, is one of the most sacred in India, with 400 temples and 52 ghats surrounding it.

One of the most popular and colorful fairs of India is the Pushkar camel fair, which goes on for five days. In the afternoons, people crowd the stalls, which sell a cornucopia of items, and camels, horses, and cattle are paraded, raced, and traded on the dunes.

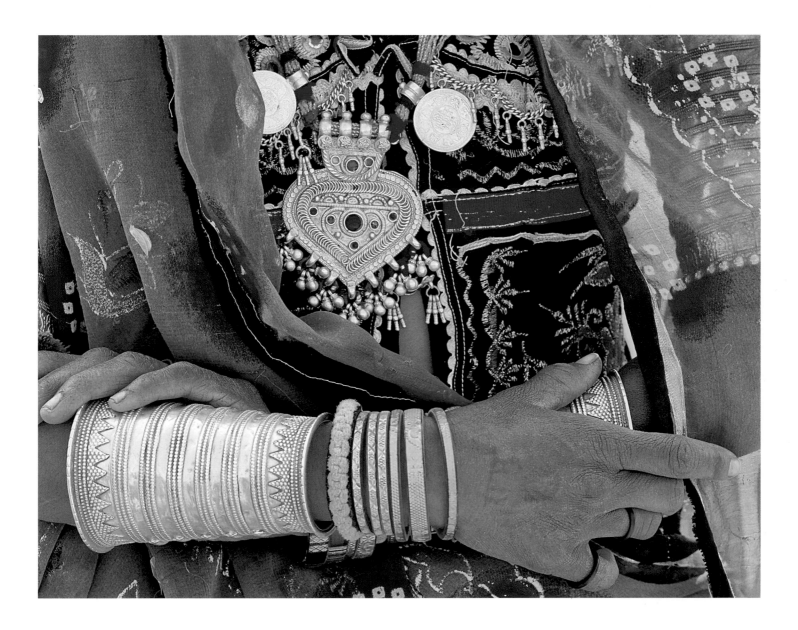

ABOVE AND OPPOSITE: *A nomadic woman of the Banjara caste, along the road to Jaipur, with her ornate, heavy silver jewelry.*

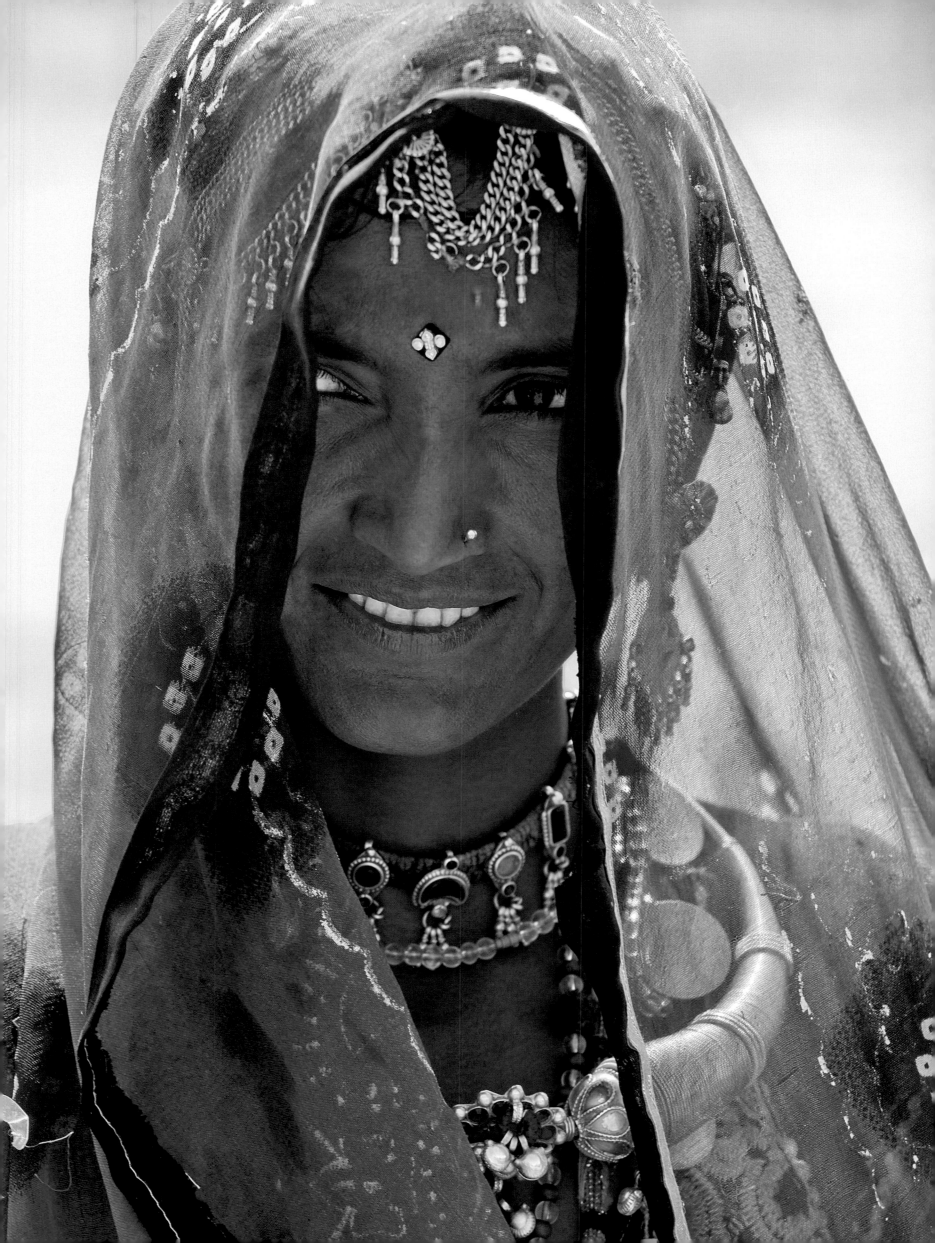

WHEN THE RESULTS APPEARED in the morning papers, Rakesh scanned them, barefoot and in his pajamas, at the garden gate, then went up the steps to the verandah where his father sat sipping his morning tea and bowed down to touch his feet.

"A first division, son?" his father asked, beaming, reaching for the papers.

"At the top of the list, Papa," Rakesh murmured, as if awed.

"First in the country."

Bedlam broke loose then. The family whooped and danced. The whole day long visitors streamed into the small yellow house at the end of the road, to congratulate the parents of this *Wunderkind*, to slap Rakesh on the back and fill the house and garden with the sounds and colors of a festival. There were garlands and *halwa*, party clothes and gifts (enough fountain pens to last years, even a watch or two), nerves and temper and joy, all in a multicolored whirl of pride and great shining vistas newly opened: Rakesh was the first son in the family to receive an education, so much had been sacrificed in order to send him to school and then medical college, and at last the fruits of their sacrifice had arrived, golden and glorious.

—ANITA DESAI, *A DEVOTED SON*

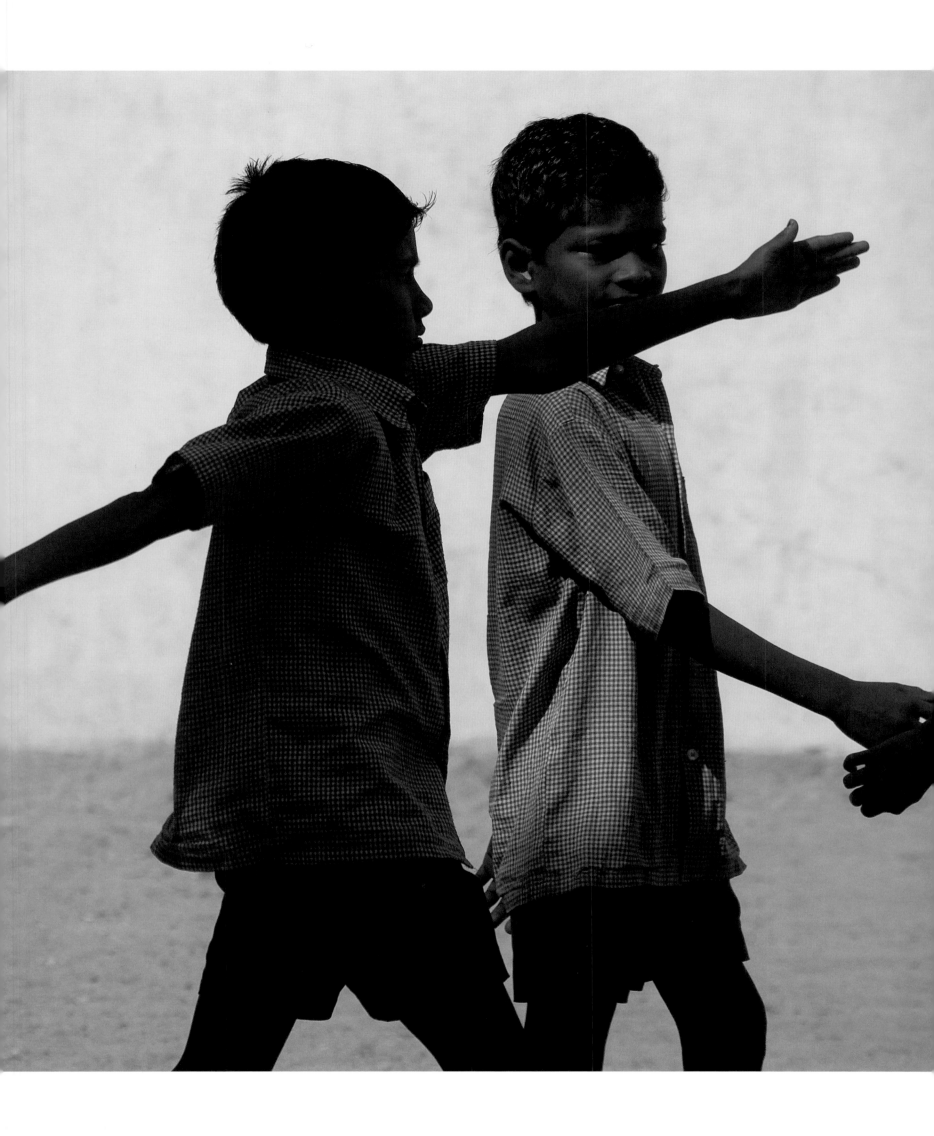

Schoolchildren in a rural village near Ahmedabad march back to class to the music of the "Colonel Bogey March," a popular piece written in 1914 by Lieutenant F. J. Ricketts, a British military bandmaster, and made famous by the movie The Bridge on the River Kwai.

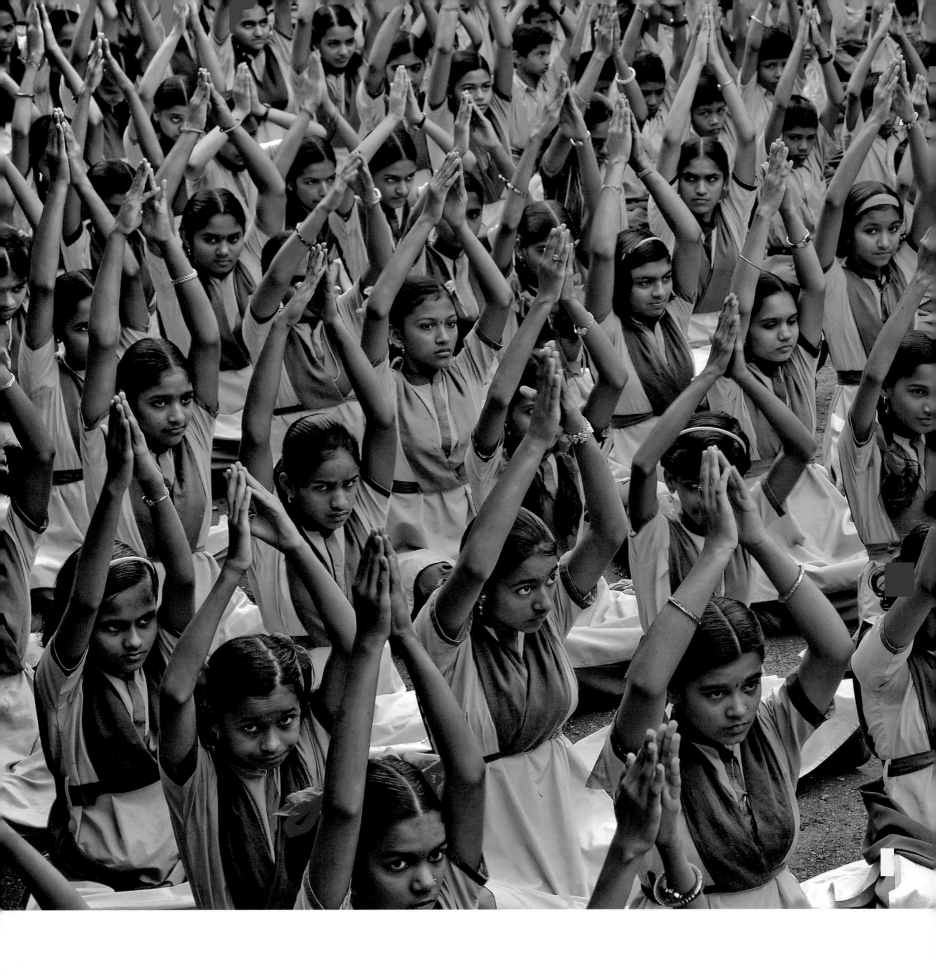

ABOVE AND OPPOSITE: *As part of their daily ritual, schoolchildren in the town of Aurangabad, Maharashtra, do calisthenics and exercises early each morning to prepare their bodies as well as their minds. The young children are incredibly attentive during the morning lessons, and they are often called upon to stand in front of the class and read from a poem or a book.*

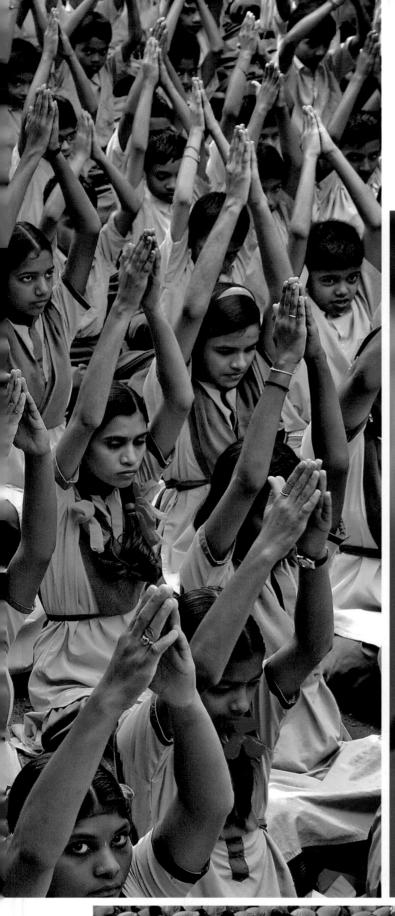

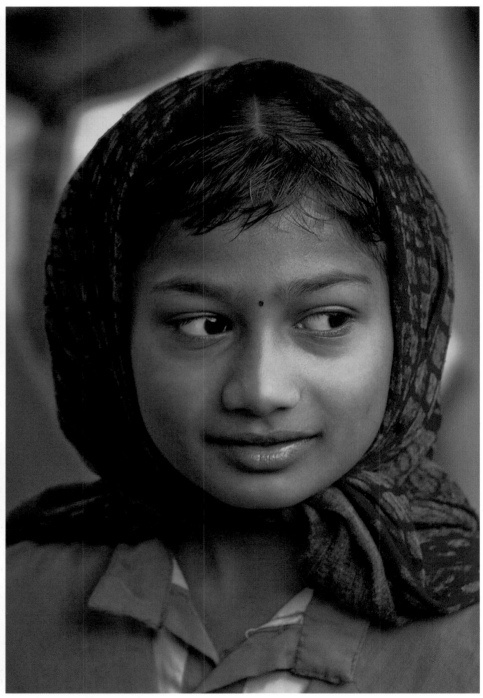

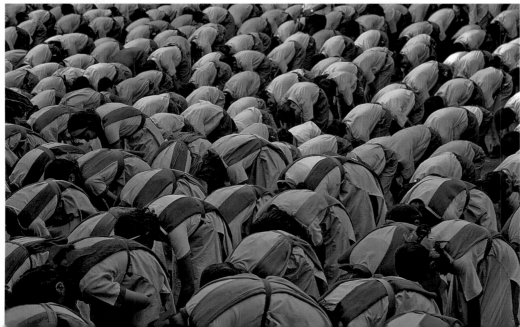

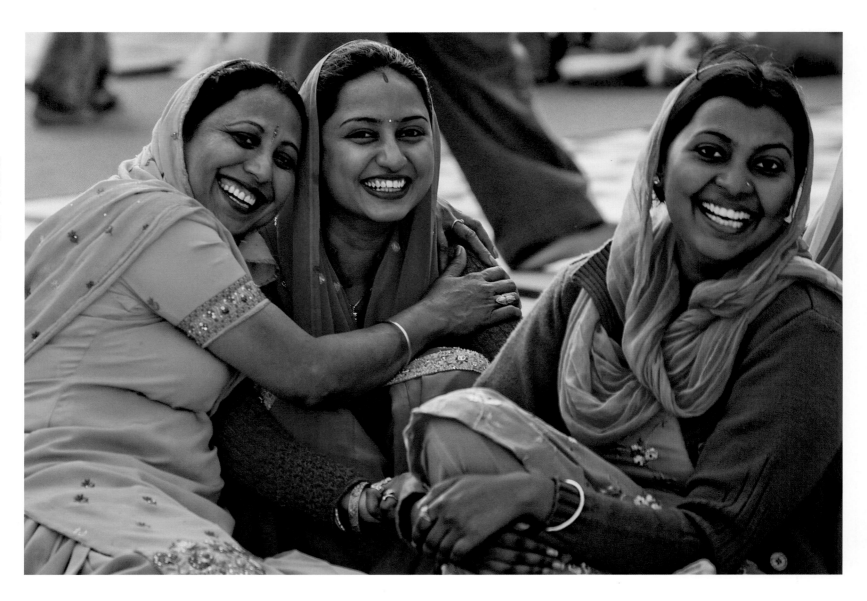

ABOVE: *Sikh families and friends gather in the afternoon to pray and socialize at the edge of the pool surrounding the Golden Temple at Amritsar, in the state of Punjab.*

OPPOSITE: *A contortionist mesmerizes an audience in Jaisalmer during the Jaisalmer fair.*

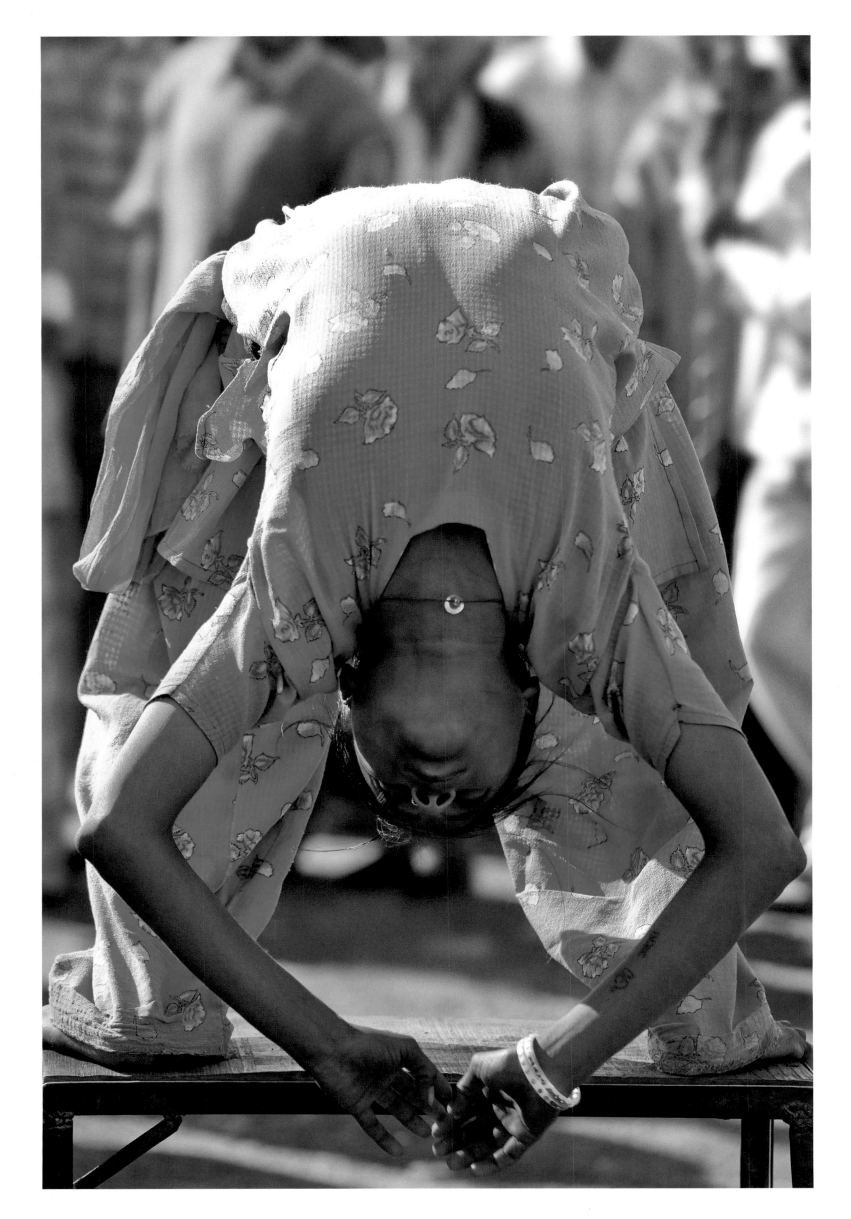

Nectar in a Sieve

Kamala Markandaya

Deepavali, the Festival of Lights, approached. It is a festival mainly for the children, but of course everyone who can takes part. I twisted cotton into wicks, soaked them in oil and placed them in mud saucers ready to be lit at night. To the children I handed out two annas apiece, to be spent on fireworks. I had never been able to do so before—in previous years we had contented ourselves with watching other people's fireworks, or with going down to the bonfire in the village, and even now I felt qualms about wasting money on such quickly spent pleasures; but their rapturous faces overcame my misgivings. It is only once, I thought, a memory.

As it grew dark we lit the tapers and wicks and encircled our dwelling with light. A feathery breeze was stirring, setting the flames leaping and dancing, their reflections in the black glistening oil cavorting too. In the town and in the houses nearby, hundreds of small beacons were beginning to flash; now and then a rocket would tear into the sky, break and pour out its riches like precious jewels into the darkness. As the night went on, the crackle and spit of exploding fireworks increased. The children had bought boxes of colored matches and strings of patt-has and a few pice worth of crackers, like small nuts, which split in two with a loud bang amid a shower of sparks when lit. The last were the most popular—the boys pranced around shrieking with laughter and throwing the crackers about everywhere, yet they were nimble enough to skip out of harm's way. All except Selvam, the youngest. He stood a safe distance away, legs apart and obviously ready to run, holding a stick of sugar cane nearly as tall as himself, which he had bought instead of fireworks.

"Go and play," I said to him. "Deepavali comes but once a year and this is the first time we have bought fireworks. Do not lose the opportunity."

"I am afraid," he said frankly, his small face serious.

After we had eaten, and rather well, and there were no crackers left, and the oil in the saucers had run dry, we walked to the town. Selvam refused to come. He was a stubborn child; I knew it was useless to try to persuade him. Ira stayed behind too, saying she preferred to stay with him. I think she was glad of the excuse he provided, for since her return she had not cared to be seen about, and of course there would be a large crowd in the town. Villagers from all around, like us, were converging toward the bonfire to be lit there; already smoke wisps were curling toward the clouds, torches were beginning to flare. The smell of oil was everywhere, heavy and pungent, exciting the senses. Our steps quickened. Quicker and quicker, greedy, wanting to encompass everything, to miss not one iota of pleasure. Then as happens even in the brightest moment, I remembered Janaki. Last year she had come with us, she and her children. This year who knew—or

cared? The black thought momentarily doused the glow within me; then, angered and indignant, I thrust the intruder away, chasing it, banishing it...tired of gloom, reaching desperately for perfection of delight, which can surely never be.

There was a great noise everywhere. Men, women and children from the tannery and the fields had come out, many of them in new clothes such as we too had donned, the girls and women with flowers in their hair and glass bangles at their wrists and silver rings on their toes; and those who could afford it wore silver golsu clasped around their ankles and studded belts around their waists.

In the center of the town the bonfire was beginning to smoulder. For many weeks the children had been collecting firewood, rags, leaves and brushwood, and the result was a huge pile like an enormous ant hill, into which the flames ate fiercely, hissing and crackling and rearing up as they fed on the bits of camphor and oil-soaked rags that people threw in.

In the throng I lost Nathan and the boys, or perhaps they lost me—at any rate we got separated—I pushed my way through the crush, this way and that, nobody giving an inch, in my efforts to find them; and in the end I had to give up. Before long, in the heat and excitement, I forgot them. Drums had begun to beat, the fire was blazing fiercely, great long orange tongues consuming the fuel and thrusting upward and sometimes outward as if to engulf the watchers. As each searching flame licked around, the crowd leaned away from its grasp, straightening as the wind and the flames changed direction; so that there was a constant swaying movement like the waving of river grasses. The heat was intense—faces gleamed ruddy in the firelight, one or two women had drawn their saris across their eyes.

Leaping, roaring to climax, then the strength taken from fury, a quietening. Slowly, one by one, the flames gave up their color and dropped, until at last there were none left—only a glowing heap, ashen-edged. The drumbeats died to a murmur. The scent of jasmine flowers mingled with the fumes of camphor and oil, and a new smell, that of toddy, which several of the men had been drinking—many to excess, for they were lurching about loud-mouthed and more than ordinarily merry. I looked about for my family and at last saw my husband. He seemed to have gone mad. He had one son seated on his shoulders and one son at each hip, and was bounding about on the fringes of the crowd to the peril of my children and the amusement of the people. I fought my way to him, "Have you taken leave of your senses?" I cried out above the din.

"No; only of my cares," he shouted gaily, capering about with the children clinging delightedly to him. "Do you not feel joy in the air?"

PAGES 262–263: *Jugglers, magicians, and fire-eaters vie for attention all day and night on the streets of India.*

PAGES 264–265: *Colored powders are sold throughout the Telangana region during the celebration of Batkamma—the festival of the goddess Parvati—when women seek the goddess's blessings. Color, flowers, and water are all intrinsic to the festivities, and the goddess herself is not rooted in a shrine but made of flowers, signifying both life and eternity.*

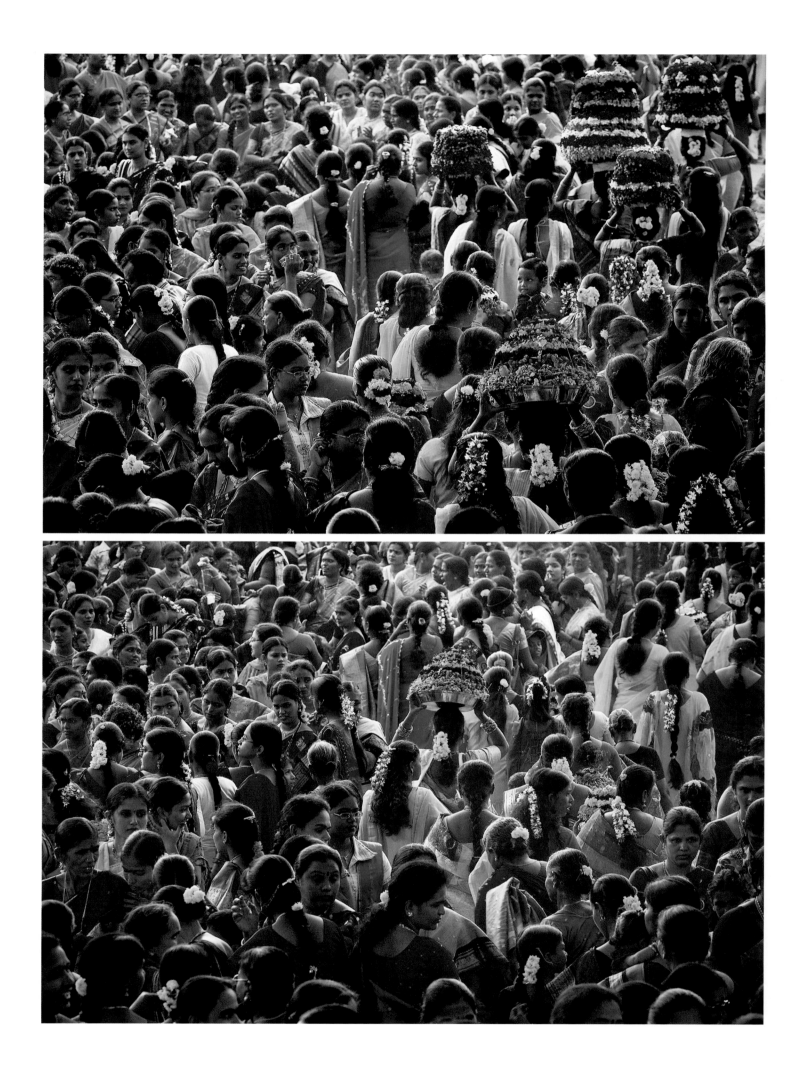

PAGES 266–267: *The gathering of women for the Batkamma festival is a spectacular display of intense color and emotion.*

ABOVE AND OPPOSITE: *The Batkamma festival in Warangal culminates in the placement of lavish arrangements of flowers, along with an idol of the goddess Parvati, in a lake or river.*

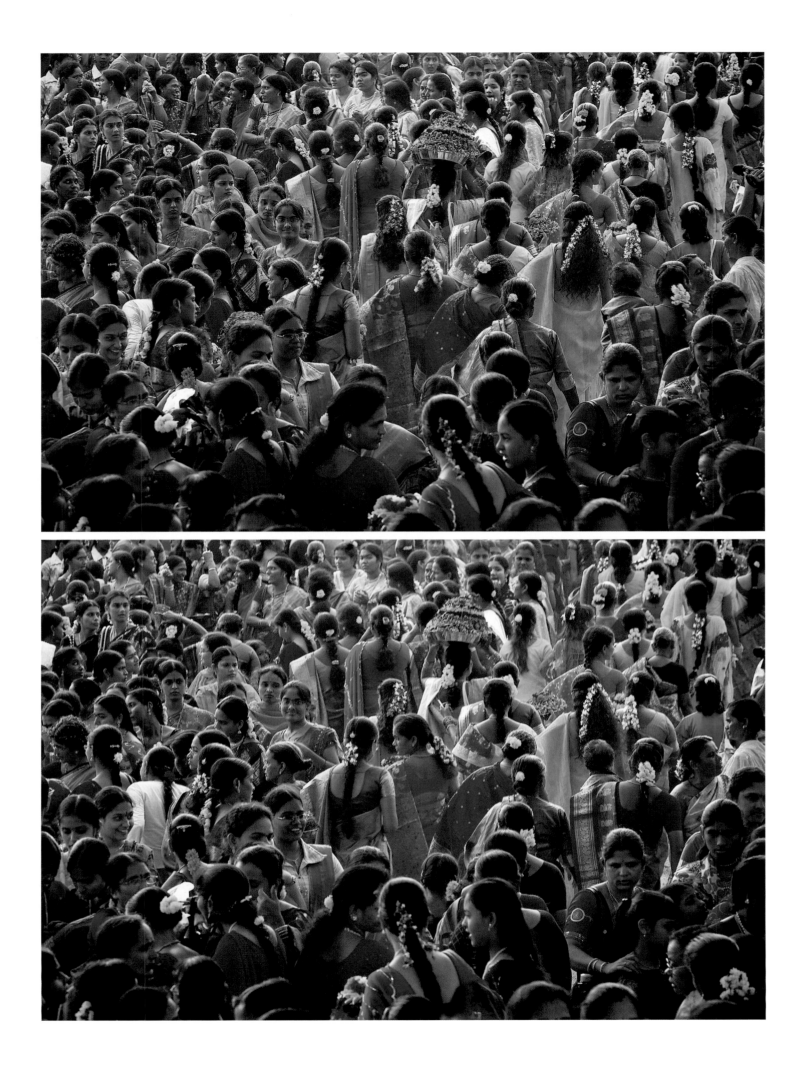

PAGES 270–271: *Women gather to chant mantras in a courtyard in Jodhpur during the Gayatri Yagna, or "fire rite." The chanting of mantras while performing sacrifices is expected to ensure fulfillment of specific desires, one's individual welfare, or the good of all of society. During this ceremony the women wear only yellow or red saris.*

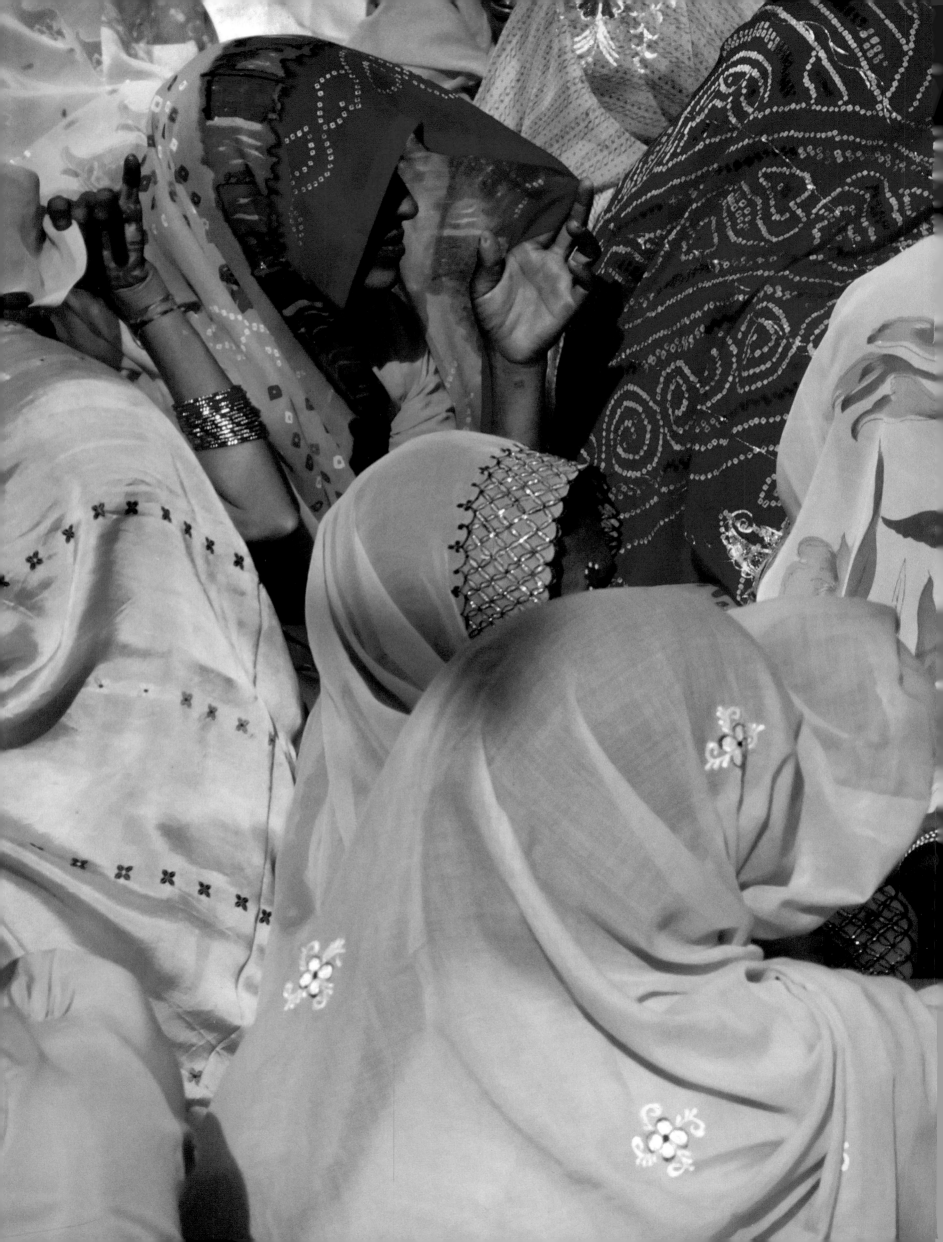

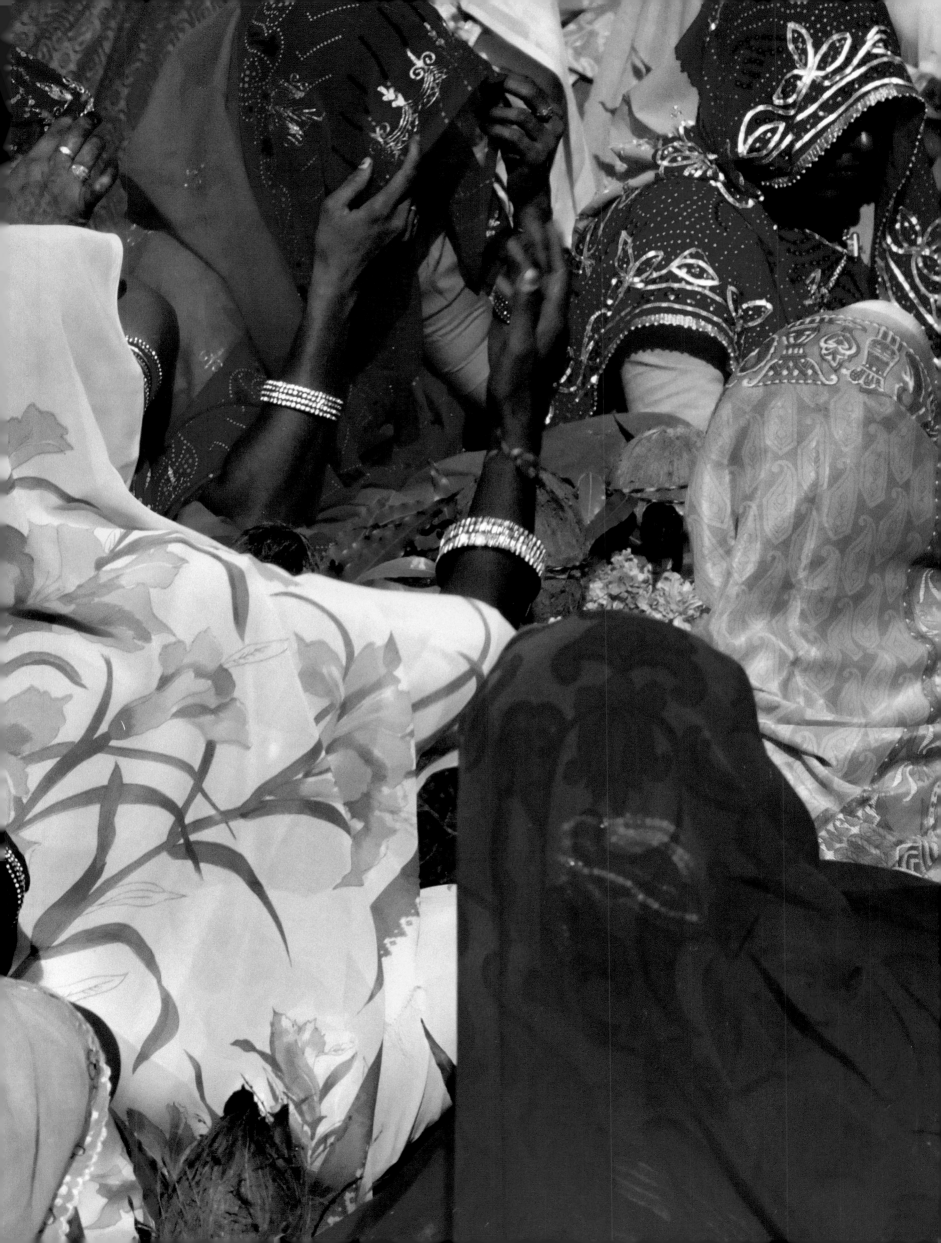

CREDITS